MODERNISM

University
for the
Creative Arts

Critical Views

In the same series

The New Museology
edited by Peter Vergo

Renaissance Bodies
edited by Lucy Gent and
Nigel Llewellyn

MODERNISM IN DESIGN

Edited by
Paul Greenhalgh

REAKTION BOOKS

Published by Reaktion Books Ltd
11 Rathbone Place, London WIP IDE, UK

First published 1990, reprinted 1997

Copyright © Reaktion Books Ltd 1990

Designed by Humphrey Stone

Photoset by Wilmaset, Birkenhead, Wirral

Printed and bound in Great Britain by
Redwood Books, Trowbridge, Wiltshire

British Library Cataloguing in Publication Data
Modernism in design.
1. Design, history
I. Greenhalgh, Paul
721.09
ISBN 0–948462–12–4
ISBN 0–948462–11–6 (pbk)

Contents

Photographic acknowledgements vi

Notes on the Editor and Contributors vii

Introduction *Paul Greenhalgh* 1

1 The Legacy of the Nineteenth Century *Clive Wainwright* 26

2 The Myth of Function *Tim Benton* 41

3 The Struggles within French Furniture, 1900–1930
 Paul Greenhalgh 54

4 The Cultural Politics of the German Modernist Interior
 Martin Gaughan 83

5 Building Utopia: Pioneer Modernism on the American
 West Coast *Wendy Kaplan* 101

6 'Design in Everyday Things': Promoting Modernism in Britain,
 1912–1944 *Julian Holder* 123

7 Henri Van de Velde and the Struggle of Belgian Modernism
 Between the Wars *Mimi Wilms* 145

8 Swedish Grace . . . or the Acceptable Face of Modernism?
 Gillian Naylor 164

9 'A Home for Everybody?': Design, Ideology and the Culture
 of the Home in Italy, 1945–1972 *Penny Sparke* 185

10 Radical Modernism in Contemporary Spanish Design
 Guy Julier 204

References 224

Select Bibliography 242

Index 245

Photographic Acknowledgements

The editor and publishers wish to express their thanks to the following for permission to reproduce illustrations: Fondation Le Corbusier p. 75 bottom; Julius Shulman pp. 107, 111 top and bottom, 115, 118, 119; San Diego Historical Society (photograph collection) p. 104 top and bottom.

Notes on the Editor and Contributors

PAUL GREENHALGH is a member of the Department of Research at the Victoria and Albert Museum and a tutor on the V&A/RCA design course. He also teaches students of ceramics, glass, metalwork and jewellery at the Royal College of Art. He has written for many journals and magazines. His first book *Ephemeral Vistas: The Expositions Universelles, Great Exhibitions and World's Fairs, 1851–1939* was published in 1988.

CLIVE WAINWRIGHT is a member of the curatorial staff of the Victoria and Albert Museum, with special responsibilities for its nineteenth-century collections. He has written extensively for journals, magazines and catalogues and recently published *The Romantic Interior: The British Collector at Home, 1750–1850* (1989).

TIM BENTON is Professor in the History of Art at the Open University. Since the Open University course 'History of Architecture and Design', with its series of publications (1975), he has specialised on Le Corbusier. His books include *The Villas of Le Corbusier* (1987) and he contributed to the Arts Council's exhibition catalogue, *Le Corbusier: Architect of the Century* (1987).

MARTIN GAUGHAN is a senior lecturer in the History and Theory of Art and Design, and course co-ordinator for Theoretical Studies on the MA Fine Arts course at the Faculty of Art and Design, South Glamorgan Institute of Higher Education, Cardiff.

WENDY KAPLAN has worked as a museum consultant. From 1979 to 1987 she was research associate at the Museum of Fine Arts, Boston, where she organised the exhibition 'The Art that is Life: The Arts and Crafts Movement in America, 1875–1920', and was principal author of the accompanying exhibition catalogue.

JULIAN HOLDER is an architectural historian. A former member of the Design History Society, he is associate lecturer in Design History at Loughborough College of Art and Design. He is a regular contributor to design magazines, particularly *Building Design*. He contributed to the Arts Council's W. R. Lethaby exhibition at the Central School of Art and Design (1984) and to the National Theatre exhibition, 'The Melodramatic Imagination', which coincided with the National Film Theatre's season, 'Hollywood as Melodrama'. He is currently writing a book on British design in the 1970s.

MIMI WILMS works as a design historian at SHIVKV, Genk, in Belgium. She has been involved in the promotion of design history and education on an international level, and has lectured on Belgian design throughout Europe.

GILLIAN NAYLOR is a senior lecturer at the Royal College of Art, and course leader of the V&A/RCA course in the History of Design. She has written many articles on nineteenth- and twentieth-century design, and her books include *The Bauhaus* (1968), *The Arts and Crafts Movement, The Bauhaus Reassessed* (1987), *William Morris, By Himself* (1989) and *Bloomsbury: Artists, Designers, Writers, By Themselves* (1990). She is currently working on aspects of design in relation to nationalism and Eastern Europe.

PENNY SPARKE is a senior lecturer at the Royal College of Art. A former lecturer at Brighton Polytechnic, she was in part responsible for the establishment there of a BA course in the history of design, one of the first of such courses anywhere. She has written very widely on twentieth-century design, and is author of the following books: *Sottsass* (1981), *An Introduction to Design and Culture in the Twentieth Century* and *Furniture* (both 1986), *Japanese Design* (1987) and *Italian Design* (1989).

GUY JULIER is a freelance design consultant. He studied the history of art at Manchester University and the history of design at the V&A/RCA. His book, *New Spanish Design*, will be published in 1991.

Introduction

PAUL GREENHALGH

For the greater part of this century, the word 'modern' has been relatively unproblematic with regard to design. It has meant whatever one wanted it to mean. It could be applied to any designed object, more or less, given the appropriate context and, accordingly, it could be construed as an insult or a compliment. It has meant so much that it has often meant nothing.

The advent of the Post-modern has changed all that, with its implication that something has happened, i.e., 'Modernism', which it, 'Post-modernism', has gone beyond. In this context, 'Modern' no longer means 'contemporary', 'now', 'the latest fashion', as one cannot have a 'post-now', but rather it implies specific methodologies and belief systems which are perceivably redundant. The specificity is important, as it pertains to design more than to any other area of the humanities. That is to say, Post-modernists, and those whose writings have been affected by the conditions of the Post-modern period, do not consider themselves to be beyond or against all the movements and styles in design which had occasion to be dubbed 'modern' in our century. One would be severely tested, for example, to tell the difference between much Art Deco design and the 'Post', or even 'Pop' and 'Post'. Rather Post-modernism is the practical and theoretical result of the apparent collapse of what I will from now on refer to as the Modern Movement. Thus, when Post-modernism as a term came into general usage in the 1970s, it didn't signify a new stylistic or conceptual phase so much as give a further measure of historiographic exactitude to the Modern Movement. By claiming that Modernism was over, or at least inadequate, the potential was created for historians to assess it more closely than ever before, since apparently we could see where it started and finished and what it had achieved.

The essays in this book will not explain the Modern Movement in design in all its aspects, nor will they uniformly defend, rebuke or

apologise for it. Rather they are intended to complicate it. The ongoing debate as to the status and worth of the Modern Movement has, to a considerable degree, veered towards caricature, either through exaggeration of its faults or inflation of its virtues. It has been cast into a monument, a single entity that has to be defended or attacked as an individual package. Both attack and defence often operate in the absence of a proper historiography. By providing new information, and new perspectives on old information, it is hoped that the present impasse can eventually be resolved. If this book comes to serve as one of many dedicated to achieving that resolution, then it will have succeeded.

Some of the essays are broadly based and will look at wide-ranging issues within the Modern Movement. The majority, however, will be case-studies from different national schools, focusing on periods when Modernism was of particular importance. Chronologically, the case-studies will range through the century and in most instances they will draw on material rarely dealt with in the English language before. Most important, taken as a whole, the essays will reflect no overall consensus of opinion; it is not the object of this book to prove the right or wrong of any one set of ideas, but rather to provide the scholar and general reader with a better idea of the kinds of thing that took place under the aegis of the Modern Movement during our century.

It is to be hoped that what will emerge will deepen the reader's perspective. If it leaves him or her ambivalent about the Modern Movement, then the book has probably served its purpose, since ambivalence, in my opinion, is all we can feel when we peruse the ideas and objects which have come down to us. Most emphatically, it must be remembered that this volume does not constitute a history of twentieth-century design, since most design in our century wasn't, and isn't, Modernist. These are essays about particular designers, objects and situations. More precisely, the book consists of a series of essays about a particular stance within twentieth-century design.

Viewed from the safe distance of the 1990s, we can perceive a chronology within the Modern Movement in design; it had two phases. The first I will fashion the Pioneer phase, this opening amid the deafening thunder of the guns of the First World War and closing with the demise of the key movements between 1929 and 1933. The second, opening in the early 1930s, I will label the International Style. Conveniently, there was an exhibition entitled 'The International Style' held at the Museum of

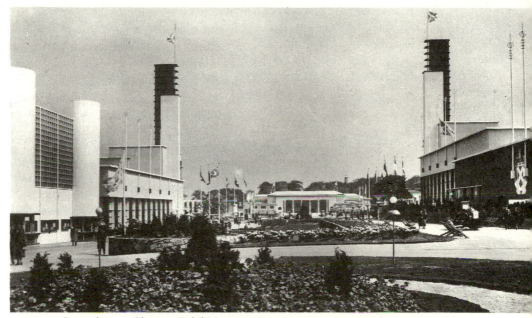

General view, Glasgow Exhibition, 1938; contemporary postcard.

Modern Art, New York, in 1932, this being accompanied by a book by the organisers, Philip Johnson and Henry-Russell Hitchcock. Whilst, in themselves, the exhibition and book contributed little to the existing discourse, they can be used as a conceptual watershed, an indicator of a shift in attitudes.[1] Despite challenges, the International Style rolled on until the end of the 1970s. The 1930s, therefore, were confusing years of transition from one state to another, with varying levels of 'pure' Modernism, as it were, in various countries.

Ideologically the movement cannot be described so easily but we can say that the first phase was essentially a set of ideas, a vision of how the designed world could transform human consciousness and improve material conditions. These ideas were expressed physically through manifestos, hundreds of prototypes and a handful of realised objects and buildings. The second phase was less of an idea than a style and a technology; a discourse concerned principally with the appearance of things and with their manufacture. It was expressed far more widely than the first phase, in thousands of buildings and millions of objects, especially after the Second World War.

During the 1930s the Modern Movement began to achieve official respectability, something vital for its success as a major style, but which

inevitably had consequences for its intended meanings. In 1930, an International Exhibition held in Stockholm showed a positive attitude towards Modernism both in its architecture and exhibits.[2] Others in Antwerp (1930), Chicago (1933–4), Paris (1937) and Glasgow (1938) displayed a similar enthusiasm in various sections.[3] Respectable associations all over Europe and America began to promote the idea that the International Style was the most appropriate one for the twentieth

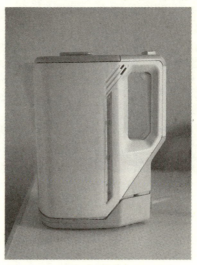

Kettle, Tefal.

century. The enthusiasm came to a peak in professional spheres in the 1960s, when town centres were reshaped, offices were refitted and products of all kinds were subjected to radical restyling. In the same decade, the millions of anonymous designers amongst us, the home-owners in Britain, painted their walls beige and boxed in their Victorian fixtures and fittings with hardboard. This was their oblique response to the Modernist call for the rejection of historical style and enhancement of purity. At the same time, the sleek simplicity of refrigerators, white plastic kettles and collapsible laminated furniture suggest a common parentage, even if most consumers have no idea who the parents were. And, as its name suggests, it is truly international. From Preston to the Punjab, the International Style has shaped urban skylines, middle-class kitchens, typing pools and wine bars. It is all around us, punctuating our vision at all points. In terms of quantity, the International Style is the most successful 'look' ever to have been invented.

Pioneer Modernism consisted of a series of movements and individuals who addressed themselves to the problem of an appropriate design for the twentieth century. They were very much concerned with three spheres of activity: architecture, furniture and graphics, the former of which undoubtedly held sway.[4] They were not the first to ponder the idea of an appropriate 'modern' style, neither did they invent all of their own ideas, technologies and stylistic mannerisms. Indeed, they invented few of them. Rather, what made them different from anything which had gone before was the holistic world-view they constructed from earlier, disparate ideas, and the absolutist nature of their vision. One gets a sense, when comparing the most progressive objects of 1880 with those of 1929, that one mode of design has drifted to its conclusion and another one has replaced it. This is not a qualitative observation so much as an ideological one.

The Pioneers brought clarity to what had been a fascinating mélange of activity between 1880 and 1914. This phase, which we might call 'Proto-modernism', had, in Modern Movement terms, most of the basic ingredients of Modernism, without having a completed framework; the beads without the thread. The Modern Movement provided the thread and made a careful selection of the beads which were to hang upon it. In terms of the avant-garde, we can now clearly perceive that there was more than one available direction for design to go in 1914. By 1925, it was equally clear that a single *modus operandi* had come to dominate avant-garde practice. In so far as this happened, the design world has had a different evolution from that of the fine and decorative arts, which continued to boast alternatives within the parameters of Modernism.

In the first instance, activity was most intense and directed in Holland, Germany, France and the newly formed Soviet Union. In all cases, there was a focus of some kind; a journal, institution, or gallery, which allowed designers and artists to come together to formulate a position and ultimately a movement.

In Holland, a small group of architects, designers and painters, cut off from the international community by the First World War, created a forum for themselves by founding a magazine. Its title was also that of their movement, De Stijl. The journal and the movement ran from 1917 through to 1931, when intellectual differences caused a final rift.[5] In Germany, the focus was not a journal but a school of art and design. The Bauhaus provided the nucleus for German Modernism – in the Fine Arts as well as in design – between 1919 and 1933, when it was closed by

the National Socialists.[6] The Bauhaus remains perhaps the most potent symbol in twentieth-century design, its ideas, methodologies and styles being virtually synonymous with Modernism. In Paris, several publications, culminating in the journal *L'Esprit Nouveau* (1920–25), provided a public profile for the Purist movement.[7] More than any other, this movement remains significant for the writings and work of a single personality, Charles Edouard Jeanneret, or Le Corbusier as he was better known.[8] In the USSR, Constructivism and Suprematism came to the fore in the wake of the Revolution, going into a final decline with the advent of Stalin.[9] In material terms, the Soviets probably contributed more to the fine arts than to the field of design, but their politics and aesthetics provided significant examples for succeeding generations.

These movements held exhibitions, published manifestos and created prototype objects and buildings with great fervour, between them establishing the terrain of the debate. By 1925, their proselytising had paid dividends, for there was Modernist activity of one kind or another in most Western countries, especially in those where the debate as to the rôle of design had been vociferous at the end of the last century. In Belgium, Britain, Sweden and America, for example, a healthy 'Pioneer' activity came to rapid maturity, the implications of the new design being seized upon and adapted to local demographic, industrial and political conditions. Ironically, by 1940, there were few traces of the original movements left in Germany and the USSR, but by then they had reached the point of widespread legitimacy.

Summing up the collective belief systems which went to make up the Pioneer Modern Movement is a difficult, if not thankless, task. Not all of the principles of one school were followed by the others and each school had its own particular emphases and proscriptions. Between 1920 and 1930 Modernists throughout Europe argued violently through letters, articles and personal confrontations and by 1935 they had drifted apart in terms of their actual design work. Accepting this, it is still possible to discern a core of common ideas. I have identified twelve, of which some are closely based on the published manifestos, some are distillations from broadly held (and voiced) ideas of the time and some are observations made from the safe haven of 1990. My aim, therefore, is not to define in specific detail the nature of the Modern Movement (even if this were possible) but to identify the theoretical features which characterised the broad sweep of its activity before the advent proper of the International Style. I shall list the features and then I will go on to discuss them at some length:

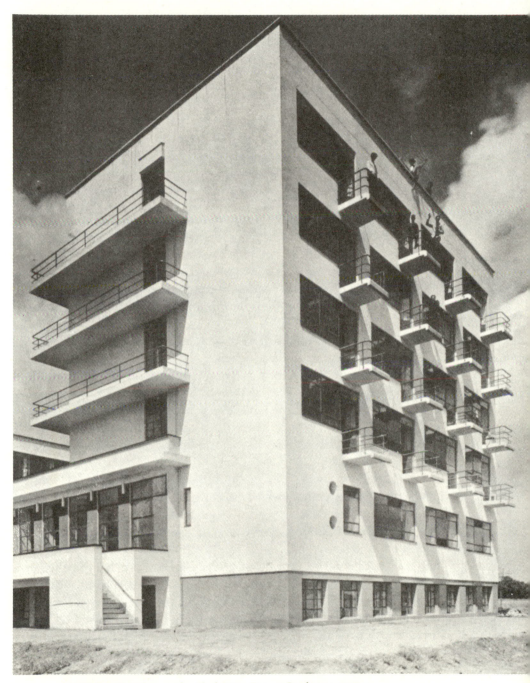

Walter Gropius, student lodgings, Dessau Bauhaus, *c.*1925.

1. Decompartmentalisation
2. Social morality
3. Truth
4. The total work of art
5. Technology
6. Function
7. Progress
8. Anti-historicism
9. Abstraction
10. Internationalism/universality
11. Transformation of consciousness
12. Theology

The over-arching concern of the Modern Movement was to break down barriers between aesthetics, technics and society, in order that an appropriate design of the highest visual and practical quality could be produced for the mass of the population. Perhaps this idea, of the *decompartmentalisation* of human experience, was the single most important ideal.[10] Most of the points that follow relate back to this initial premise.

Design was to be forged into a weapon with which to combat the alienation apparent in modern, urban society. It was therefore construed to be fundamentally a political activity, concerned with the achievement of a proper level of *social morality*. It was meant to improve the conditions of the population who consumed it: 'I have the unfashionable conviction that the proper concern of architecture is more than self-display. It is a thesis, a declaration, a statement of the social aims of the age.'[11]

By 1920, it was widely accepted by intellectuals on the left that the masses had been brutalised by the economic and political processes which shaped their lives: 'Owing to the extensive use of machinery and to [the] division of labour, the work of the proletarians has lost all individual character, and, consequently, all charm for the workman. He becomes an appendage of the machine . . . Hence, the cost of production of a workman is restricted, almost entirely, to the means of subsistence that he requires for his maintenance, and for the propagation of his race.'[12] For Marxists, the combination of capital and industry had led to the alienation of the worker from the processes and objects of production, with far-reaching effects: 'Thus alienated labour turns [Man] . . . into an alien being and into a *means* for his *individual existence*. It alienates from Man his own body, external nature, his mental life and his human life. A direct consequence of the alienation of Man from the

product of his labour . . . is that *Man* is *alienated* from other *Men.*'[13] Alienation thus became an intense psychological impoverishment, characterised as the negation of the spiritual essence of humankind: 'We arrive at the result that Man (the worker) feels himself to be freely active only in his animal functions – eating, drinking and procreating, or at most also in his dwelling and personal adornment – while in his human functions he is reduced to an animal. The animal becomes human and the human becomes animal.'[14] The subject was prevented from taking control of, and transforming, the circumstances he or she found themselves in. Because of this, the alienated masses were understood to have been perpetual victims of capitalism, spectacularly so in the form of the First World War.

Design was inextricably bound up with commodity production, which in turn was the driving force behind the creation of wealth. It was reasoned, therefore, that it had the potential to transform the economic and social conditions of the masses. By doing so, the spectre of alienation could be vanquished.

'A question of Morality; a lack of *Truth* is intolerable, we perish in untruth.'[15] Truth as a moral value was transposed into being simultaneously an aesthetic quality. Within the terms of the construction and appearance of objects, truth meant the avoidance of contrivances which created an illusion or false impression. The designer had to avoid 'formalistic imitation and snobbery' which often 'distorted the fundamental truth'.[16] The way an object was made had to be apparent and its visual attractiveness had to come directly out of those processes of construction. Truth as an ideal led, therefore, to a wholesale rejection of decoration, especially when it was perceived to be an element added after the major constructional work had taken place. Decoration could only mask the structural and spatial honesty of the object. In the Fine Arts there was a similar transposition of the idea of truth into the aesthetic arena, with the rejection of the use of modelling, perspective and other devices for the creation of illusory space. Illusion or disguise of any kind in any of the visual arts was synonymous with a lie.

Following this idea to its logical conclusion, objects had to be self-consciously proud of what they were and how they had arrived in the world, much in the way that the democratised masses were encouraged to be proud of their origins and their status as workers. Indeed, an object had to reveal its mode of work and its ability to perform it in order to be fully Modern.

Within themselves, the various visual arts had to work in conjunction

in order that they created a *total work of art* (*Gesamtkunstwerk*).[17] The fine, applied, decorative and design arts should be a single continuum, allowing for their different practical functions and production techniques. All Modernists, particularly those at the Bauhaus, resented the privileged status enjoyed by some arts over others. Such privileging was perceived to mirror the class system at work in society. The Fine Arts, in a Modernist world, would integrate completely with other disciplines. It would be wrong to assume, however, that the Pioneer Moderns successfully addressed the design issue in every medium.

Technology had to be used in its most advanced forms in order to facilitate economy and, from this, availability. Mass production and prefabrication were embraced as being the means through which Modernism would arrive on the streets. Beyond this, the standardisation of components would allow for the rapid erection and repair of objects. 'Mass production, the inevitable purpose for which the first power-driven machine, the modern tool, was invented, today can be utilised for the production of essential elements for the millions who at the moment lack them . . . Mass production and prefabrication of all essential structural parts of the simplest dwellings could contribute some form of standardised architecture.'[18] It must be stressed, however, that amongst the Pioneers at least, mass production remained an idea. Virtually nothing that was designed in the first phase of Modernism went into mass production, or, indeed, was designed so as to be capable of adaptation to genuine standardisation. It was an ideal, the likes of Henry Ford being an exemplar of a designer they talked about but could not, at that stage, emulate. Mass-produced Modernism only became a reality when the International Style achieved legitimacy.

There was also a strong sense in some schools of thought that the application of new technology to objects gave them an appearance which the masses could understand. Technology functioned not only in a practical way then, but in a symbolic one also.

The successful *functioning* of all designed produce was deemed of great importance. Connected to the desire for technology expressed above, therefore, was a pronounced rationalism. 'In the conviction that household appliances and furnishings must be rationally related to each other, the Bauhaus is seeking – by systematic, practical and theoretical research in the formal, technical and economic fields – to derive the design of an object from its natural functions and relationships.'[19] Objects had to be planned in order to work effectively, and when things were planned effectively, it was suggested, they tended to be beautiful. The proof of this

aesthetic was in the machine, which was beautiful because its form had been largely determined by the way it worked: 'A good modern machine is . . . an object of the highest aesthetic value – we are aware of that.'[20]

'Civilizations advance. They pass through the age of the peasant, the soldier and the priest and attain what is rightly called culture.'[21] The concept of *progress* was a central driving force. The world was perceived to have been in a chaotic, if not overtly evil, condition; every aspect of humanity had to be advanced towards a higher form, away from this previous state. The advent of democracy and the anticipation of socialism appeared, for many, to indicate social progress; indeed, it was a precondition for all Marxists that such progress was an historical phenomenon. Equally, social-Darwinism was a potent influence. Belief in the biological advance of humankind along Darwinian lines suited Modernists, despite its heinous implications for non-industrial societies.[22] New technologies demonstrated a virtual model of linear advance in the sciences. Design could do the same. Modernists believed in the idea of aesthetic advance, rather than simply of aesthetic change.

Following from this, historical styles and technologies had to be eliminated wherever possible. If the human race was in a process of advance, and if the past represented the unsatisfactory condition society was striving to move away from, then past styles were both aesthetically and morally undesirable. As the majority of ornament was historical, *anti-historicism* was therefore synonymous with anti-decoration: 'The evolution of culture is synonymous with the removal of ornament from utilitarian objects'.[23] Compounded with the idea of aesthetic truth, this principle effectively eliminated the possibility of a Modern Movement decoration. Having said this, it would be wrong to assume that the Pioneers didn't use the ideas of the great designers and artists of the past. Rather, they were against the use of previous styles when these were intended simply to evoke memory of the past: 'Modern architecture has nothing but the healthiest lessons to learn from the art of the . . . past, if that art be studied scientifically and not in a spirit of imitation.'[24]

Anti-historicism also led to a redefinition of the meaning of the word 'style'. Prior to the twentieth century, styles were associated with particular periods or cultural groups and used in order to reflect their meaning in the object. It had been previously inconceivable that a designer could have his own style, or that an object of aesthetic value could have no style.

Abstraction was the key aesthetic device employed by the majority of designers. The first pure, non-objective abstract art was produced by

painters in the wake of Cubism: Frantisek Kupka, Vasili Kandinsky, Sonia and Robert Delaunay all abandoned figuration during the course of 1911–12. Between 1914 and 1919, Piet Mondrian, Kasimir Malevich and many others took it to its logical conclusion.[25] Essentially, abstract art was understood to be that which eliminated figurative or symbolic elements in favour of the manipulation of 'pure' form. The search for purity was closely related to the idea of truth: 'Although one has always to operate more or less speculatively in the domain of abstraction, there is good reason to accept this latter manner of visionary thinking about plastic art as true.'[26]

Obviously abstraction implied an outright rejection of figurative elements in design and, consequently, a severe reduction in the potential of the object as a conveyor of narrative or symbol. In European design, much of the narrative conveyed by an object had been via its ornament; the embracing of abstraction led therefore to a yet further assault on the viability of ornamentation. The abstract form of an object was normally developed within the parameters of the structure, rather than as an addition to it.

Internationalism and universality are two ideas which to all intents and purposes came to mean virtually the same thing for Pioneer Moderns. If barriers between disciplines and classes of consumer were to be eliminated, and if historical styles as indicators of chronological divides were to be proscribed, then inevitably national differences had to go. The Modern Movement was therefore unavoidably internationalist in outlook, this being part of the quest for a universal human consciousness: 'The International of the Mind is an inner experience which cannot be translated into words. It does not consist of vocables but of plastic creative acts and inner intellectual force, which thus creates a newly shaped world.'[27]

The two ideas had both a political and an aesthetic rationale. The former is easily explicable in terms of the historical context. The First World War, fuelled by nationalism, raged while the various Modernist schools were forming. The humanitarian way of explaining the success of nationalism (which was largely irrational both historiographically and demographically[28]) was that it could only be successful in a climate of alienation. By offering the masses a sense of belonging, ancestry and identity, nationalism was the ultimate false religion. Since nationalism was both the spawn of, and a parasite on, alienated peoples, it was inevitable that Modernists would be internationalist in outlook. It was reasoned that if in its very appearance the new design was international,

this would facilitate cultural exchange and reduce the sense of Difference which often led to war. It would also encourage creativity in design outside of the hegemony of local politics.

The quest for a self-conscious internationalism was not new. Practitioners associated with Art Nouveau were the first to suggest it as an aesthetic solution to a moral discourse. They used nature as a common language. The substitution of nature with abstraction was the key to internationalism for the Pioneer Moderns, as it bypassed the need for the commonly held symbology and language which nature still demanded. Abstraction would enable the various national schools to work intuitively and still arrive at design solutions parallel with those of their colleagues abroad. In its exclusion per se of language, abstraction was the aesthetic which enabled the ethic, internationalism, to be realised.

The aesthetic rationale also pertained to the idea of universality. Many Modernists believed that beauty was a timeless, immutable value and that it could be exposed and utilised to produce a single, universal aesthetic. This could be (potentially) perceived by all. Geometric abstraction was the key device for the achievement of this universality, as it escaped immediate social contexts and contained the immutable truths of mathematics. Ancient sources were frequently cited to support the argument, giving weight to the idea of timelessness. For example, the catalogue of the exhibition 'Machine Art', held at the Museum of Modern Art, New York, in 1934, opened with a quotation from Plato: 'By beauty of shapes I do not mean, as most people would suppose, the beauty of living figures or pictures, but, to make my point clear, I mean straight lines and circles, and shapes, plane or solid, made from them by lathe, ruler and square. These are not, like many things, beautiful relatively, but always and absolutely.'[29]

Design was perceived to have the ability to *transform the consciousness* of those who were brought into contact with it. For example, if one were to redesign a city, this would not simply improve the environmental conditions of those who lived in it, it would have the potential to shift their psychological outlook. This attitude to visual stimuli was undoubtedly given additional credence by the ascendancy of Gestalt psychology in the first two decades of the new century. After this, Behaviourists produced evidence which seemed to support determinist ideas of design.[30]

Design therefore could function as a 'great improver', a sophisticated kind of mental therapy which could change the mood and outlook of a population. It followed, then, that once introduced to the right kind of design in the right conditions, the masses would come to accept it as being

the only viable way of making things. One would not need many styles or methodologies if one had a single correct one.

The logic of this argument was first clearly articulated in the nineteenth century by the more liberal of the utilitarian philosophers, particularly John Stuart Mill, as a corrective to their otherwise stark Populism.[31] Perhaps its greatest consequence was to naturalise the idea amongst all followers of Modernism that the rôle of the designer was central to the enhancement of the human potential of the masses. The Modern Movement was concerned almost wholly with means of production rather than with consumption; the perfection of production would lead to a higher form of society. Designers were in effect to be the equivalent of Plato's 'Philosopher Kings'.

There was an atmosphere of a crusade amongst all Moderns. Their programme went well beyond that of making functional goods to economic ends and was deeply concerned with 'the aesthetic satisfaction of the human soul'.[32] The Pioneer phase had a *theological* intensity about it: 'A great epoch has begun, / There exists a new spirit.'[33] Indeed, in their intellectual and emotional allegiances, some of the Pioneers pushed their commitment into a realm analogous to a religion. Numerous members of the De Stijl and Bauhaus communities actually practised theosophy and the Purists were infected with a Platonism which bordered on the mystical. This simply reinforced the idea that design was not to do with styles, but was a way of seeing the world. That world-view demanded singular allegiance and active commitment.

Presented so baldly, these appear to be a set of measures more likely to prevent the accomplishment of designs rather than to serve as a guide to production. They attempt to ride over time and place in their formulation of the proper (and final) methods for the construction of objects. This is not surprising, as they were meant to be timeless, universal principles. In themselves, they consciously avoided describing the social circumstances which prevailed when they were created; indeed, they reflected none of the social conditions that had ever existed in Europe. However, it is most important to remember that it was the specific conditions of the period 1900–30 which provided the stimulus for the creation of the various manifestos and it is in terms of that period that they are best understood. The significance of the time is easily grasped if Modern Movement writings are compared to those which came out of Dada and Surrealism.[34] Despite fundamental differences in formal language, a surprising

amount of common ground can be found. The desire to escape the specifics of time and place, to simultaneously transform the ideological fabric and the visual appearance of the world linked most radicals in the opening decades of our century. We can see now, not without irony, that timelessness was a concept evolved amidst the conditions of a very particular time.

A time of extremities and of endless possibilities, in which everything appeared to be capable of absolute reformation. A world full of violent extremes, of monarchs and peasants, ox-carts and aeroplanes, of cottages and skyscrapers. There were events taking place in the political, intellectual and economic arenas the importance of which it is hard for us to grasp: the creation of Germany and Italy, the Russian Revolution, the madness of the First World War. The secular materialism of Freud and Marx questioned the basis upon which people had thought and acted and a steadily increasing sense of democracy filtered into the consciousness of European populations. Crucially, there was the rapid industrialisation and urbanisation of mainland Europe. Technology, the motive force behind both, had, it appeared, the power not only to transform cityscapes, but also the relative social positions of the peoples located within them. Electricity, motorcars, telephones, cinema, skyscrapers; anything seemed possible. There was an ever-growing sense in every sphere of activity that the world was capable of fundamental change. This heady fusion of transformations exhilarated those who sought that change.

More than ever before, everything appeared to be in a state of flux. Unlike the Futurists, however, the Pioneer Moderns did not wish to celebrate this vortex of movement; rather, they wished to take advantage of it in order to arrive at a new and final stability. In the way that Plato sought to replace the Heraclitean flux he found all around him with an Order based on rational, eternal ideals, the Moderns hoped to create a new world from the disastrous mélange of the old. As with Plato, when the exact nature of the New World was described, rationalism became fused with religious mysticism. Indeed, the Platonism of the Purists or the theosophy of De Stijl sat uncomfortably with the technology and economy which enabled the creation of the major industries. Nevertheless they were understood at the time to be necessary bedfellows for the realisation of the new order.

Perhaps this latter point is the key to understanding Pioneer Modernism, and the explanation as to why it inevitably dispensed with much of its theoretical baggage as it became the International Style. In its fusion of

Romanticism and Rationalism, it was an inherently unstable com-
pound.[35] A voracious, realistic logic had created the urban/industrial
conditions which the Moderns saw as necessary for the transformation of
consciousness, but the transformation they sought was fundamentally
Romantic and idealist. In their determination to use technology and
industry to create Utopia, they brought together a means which, at that
time, most certainly defied the ends. Their worship of the idea of mass
production (in the absence of the political, economic, psychological and
ecological reality of it) demonstrated the extent of the space between
their quest and the material means with which they wished to accomplish
it; and, similarly, their commitment to progress, internationalism,
centralised planning and technology. As has been devastatingly demon-
strated all over the world since 1930, these ideas, if dissociated from
morality, are undoubtedly capable of becoming tools of oppression. It
cannot be denied that aspects of the social programmes at work in the
USSR, Romania, Czechoslovakia and East Germany up to 1989 haunt-
ingly echoed the logic of schemes proposed by members of the pioneer
Modern Movement; the successful struggle against the horrors of such
social engineering is in itself a demonstration of its fundamental
incompatibility with mass civilisation.

The space between futuristic idealism and contemporary reality was
dangerously wide in Modern Movement circles, for it is in such a space
that cynicism and exploitation normally thrive and where real decisions
concerning the fate of human beings are made.

The hope underneath the idealism was for a transformation of the
existing politico-economic structure, allowing the Moderns, in time, to
put their ideas into practice.[36] It was a hope William Morris had nursed
several decades before them and it was a tacit recognition that design in
itself does not change the world. Unlike many of the Modernists, Morris
never thought that it could. The Moderns were guilty, then, of a certain
circularism. They believed that design could *improve society* by trans-
forming mass consciousness, but they tended to accept also that *before* it
could do this, *society itself had to be improved.*

There were other contradictions within the theoretical structure. The
three ideas which survived the shift from the Pioneer to the International
phase unaltered were abstraction, internationalism and technology. The
last of these is self-evident within the continuing rhetoric, the first two
perhaps less so. Undoubtedly, they are the two most controversial ideas
within the Modern Movement and those which Post-modernists resent
the most. In successive waves, the latter have questioned the truth of

both, ultimately pursuing the matter into the very heart of Modernist theory, by casting doubt on the validity of the idea that design is a moral discourse.

There have been many who have suggested that rather than remedying the problem of alienation as it has been widely understood, design forms which are undifferentiated across geographical, linguistic and cultural boundaries are in themselves alienating. Internationalism as a style ethic, the argument has been put in recent years, leaves no room for the individual to identify himself, or to position himself in the world. Indeed, there were those living at the time of the Pioneer Movement who, despite sharing many of its goals, denied the viability of an internationalist approach to cultural activity. In 1918, in an essay condemning the use of Esperanto, the internationalist language, Antonio Gramsci asserted that whilst international co-operation was a vital component in the quest for a peaceful world, regional languages and customs were an essential part of social expression.[37] An international language benefited no one except those who frequently travelled abroad, he asserted, and such people tended, ironically, to be the wealthy rather than the poor. The implication was that internationalism could only be useful or beautiful to those who were able to move around to witness it. As such, it would seem that it was an idea forged amongst élite middle-class designers (albeit enlightened) for mass consumption. A single style for the people of Vladivostok, Marseilles and Wigan appeared to lack logic when set against the unlikelihood of their ever leaving their own regions. And for those who did not believe in the power of design to transform consciousness, the idea that such a style would prevent war made even less sense.

The rise of semiotics and structuralism as tools for the analysis of cultural produce likewise has raised questions over the viability of abstraction. Abstraction had been thought to have two major advantages: it enabled the designer to arrive at fundamental, true, timeless forms, and to escape the locale and specificity of language in the form of applied decoration. However, structuralists, post-structuralists and all those using broader semiotic approaches to design would immediately deny the possibility of escaping from language as such.[38] For them, there is no possibility of communication outside the world of signs, and signs invariably imply language. As for timelessness, universality and other fundamentalist principles, these have been largely consigned to the domain of religion by a generation convinced of the truth of relativism.

It is a Post-modern truism that an object does not have control over its perceived image. Indeed, it has been suggested that the image is arbitrary

and does not necessarily owe anything to the object at all. In other words, the preconceived rôle of a thing does not necessarily dictate what it means to its audience.[39] The designer cannot control the aura of reinterpretation which hangs over the object he designs. Hanging in front of his creation is a screen of ideas which the consumer and his immediate social circumstances have brought to it. Thus every meaning is always relative. There is therefore no stable value accruable to objects, no universal, permanent or transhistorical quality belonging to them. The idea of aesthetic excellence or timeless validity cannot be maintained when the image insists upon constantly transforming itself.

These ideas violate the inner sanctum of the Modern Movement, in which universal, stable value was considered to be inherently part of the successful object. The search for true form, the quest for transcendence, the unalienated object . . . these cannot be squared at any point with the object–image dichotomy.[40] The Modernist need to reconcile object and image was closely related to the perceived need to reconcile individual consciousness with external reality, to reassociate mind with body, the separation of which had been both a cause and a result of alienation. The idea was that object and image had to be one, that content and form had to be synonymous if the object were not to be an embodiment of a lie. For the Post-modernist, not only is the insistence on holism false, but also the very existence of alienation formulated along these lines.[41] To deny the viability of the quest for wholeness is to deny the viability of the Modern Movement.

Post-modernism has for several decades celebrated the death of the author and focused its attentions on the rôle of the reader.[42] In design and all related disciplines, this has been represented by a shift in emphasis from production towards consumption. Mass, popular culture has become an object of celebration, a source of inspiration for designers and an object of serious study for historians and theorists.[43] The overriding assumption in this switch is that culture is complex and plural, that the consumer is capable of ascertaining quality and satisfying his or her own needs accordingly. The ephemera we choose to surround ourselves with is important and valid in its own terms.

The Modern Movement could not have countenanced such an outlook. Its central pivot was the individual designer, who analysed needs, arrived at solutions and executed them for the benefit of the community. The model of the designer to which it adhered was that of the artist as defined in the post-Romantic era, the struggling genius fighting towards the definitive solution, the dedicated and ethical Bohemian. The product

designer, architect, planner, was the artist and the human environment was effectively his canvas. Emphasis here on the pronoun is significant, for this was undoubtedly a patriarchical vision of design, invented and controlled by a small number of men. Furthermore, the peripheral status enjoyed by the Pioneers in their first years severely reduced their faith in the masses to judge for themselves what was suitable. Indeed, as the masses were considered to be alienated from themselves and their environment, they were judged incapable of determining the value of one design over another. In a sense, this stance merely perpetuated the tradition of design reform established in the nineteenth century, which started from the general premise that the public had no taste and needed education. As had been well demonstrated before the Modern period, it was an outlook which could result in a kind of dictatorial determinism and it ultimately came to be the most extreme of the contradictions that existed within the Modern Movement. One cannot easily be committed to ideals of social equality which – for whatever reason – simultaneously despise the taste and life-styles of the majority of the population. Indeed, there was an inherent loathing of consumption per se in Modernist circles, provoked by fear of the 'greed' of the 'alienated hoards'. This was undoubtedly a factor in the creation of such an austere aesthetic, a design stripped down to its essentials and devoid of the invitation to needlessly consume.[44] The moral and aesthetic domains in this sense were very neatly brought together.

Given the ambitions of the Pioneers, it is surprising that so discernible a style appeared so quickly. Few of their principles actually gave any kind of indication as to how the objects should appear. By 1930, however, most of them were producing designs which looked remarkably similar. Whether these were indeed authentic reflections of the outlined principles or not, the Modern Movement had, against all the odds, created a consistent style. The uniformity of this style should not be pushed to the point of caricature. It is not difficult to tell the difference between the works of key designers. However, when compared to the breadth and variance within, say, Art Deco or Art Nouveau circles, or the range of possibilities that come under the heading of Modernism in the Fine Arts, the Modern Movement is marked by its restrictive nature.

The style was without doubt achieved partly as a result of the technical and material options embodied in some of the principles of Modernism. If one exercised rigour with regard to function, new technology, anti-historicism, abstraction, etc., then one would effectively reduce the range of visual and utilitarian possibilities. In furniture, for example, tubular

steel presented itself as the logical solution for many forms of chair design. There are only certain things that tubular steel is good for and these revolve around cantilever, frame and suspension principles. In architecture, shuttered concrete, ribboned-fenestration, open-plan spaces, white, abstract surfaces and exposed structure similarly led to certain styles of building.

Nevertheless, even taken collectively, the techniques and materials suggested by the principles could not in themselves have led to the specific 'look' we now identify with the Modern Movement, especially as it existed at the time of the International Style. In reality, the uniform nature of the appearance of Modernist furniture and architecture had a great deal to do with disinterested aesthetic cohesion amongst the groups themselves, rather than the dictatorship of their guiding principles. The small band of Modernist designers at work during the 1920s were aware of each other via exhibitions and journals and they influenced each other visually. They liked what they made and they associated their crisp, stark, dynamic products with their ideological position. There is little in their theoretical outlook to explain why the buildings and furnishings exhibited at the *Siedlungen* of Weissenhof (Stuttgart, 1927) or Siemensstadt (Berlin, 1929), given their spatial variance, should be so uniform. Modernist principles thus did not wholly result in the style; rather, the style was a representation of Modernism and therefore of its principles. In the way that the British Labour Party is represented by red and the Conservatives blue, so the style which reached maturity in the 1920s represented an outlook on life. Fundamentally, of course, there is no *a priori* link between colours and political doctrines; the same applies to Modern Movement style and its principles.

If this implies criticism of the Moderns, however, it also condemns Historicism, for it confirms that old styles do not necessarily preserve anything of their original meaning once their context is altered. Especially when a new object is made in an old style, it is unlikely to hold more than a vague resemblance to the original idea. When one walks around mock-Tudor or Neo-Georgian housing estates, the natural tendency is to think not of Elizabeth and George, but of the outlook and aspirations of the people who have chosen to live there. Old styles simply confirm that the designer and his client believe the period in question to be an interesting one, well worth recreating in the context of the late twentieth century. In the absence of the original trade skills, technical devices, the control of the original designer and the appropriate cultural context, styles tend not to excite the aesthetic sensibilities so much as to

Walter Gropius, Siemensstadt *Siedlung*, Berlin, 1929.

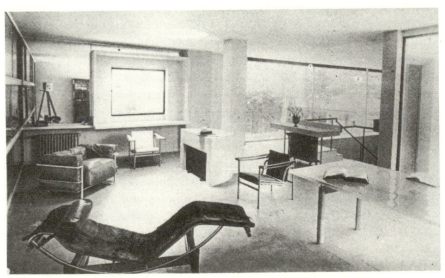

Pierre Jeanneret and Charlotte Perriand, Maison La Roche interior, 1923–30.

reflect social aspirations. Indeed, it is as well that they do not preserve their original meaning intact, since, excluding certain vernacular forms, most historical styles would exude principally oppressive messages of unreasonable power and wealth in relation to mass poverty.

After the initial Pioneer phase, the Modern Movement began, when observed from some distance, to resemble a very small planet surrounded by expansive clouds of material floating loosely around it. Held there by gravity, the material clearly related to the planet but was not necessarily of it. It was the ever-growing body of the International Style; a wealth of design paying homage to the stylistic mannerisms and manifestos of the Pioneers, but having quietly abandoned aspects of the theory in order that objects could be realised in practice. By 1950, the Modern Movement, via the International Style, had come overwhelmingly to mean a particular range of formal/economic solutions, which in certain contexts carried a socialist, or at least moral, significance. Indeed, many of those who used Modernist forms and ideas during the International Style phase were passionate socialists. It would be wrong, therefore, to depict the shift from Pioneer to International Modernism as being a uniform one of left to right. That would be so crude as to constitute an historical falsehood; it should rather be seen as a move from idealism to pragmatism. Dragged along in the nets of pragmatism were those of the left, centre and right, all professing different motives for designing in the way that they did. Moreover, purity of style was no indicator of theoretical purity; office blocks in the City were, if anything, stylistically purer than any left-wing council housing scheme that was put up in the period; and the harmonious composition of the hifi stack is most certainly achieved in the absence of a thesis for social reform. Regardless of the excuses we might make for it, however, the International Style has been, at its best, acceptable in certain genres, and at its worst disastrous. It would also be too simplistic to say that it perverted the Modern Movement; we have to face the fact that some of the central principles *were* carried through to their logical ends. But it would be reasonable to suggest that, by and large, the original trinity of morality, technics and aesthetics was split asunder. The morality aspect was frequently dispensed with and there has been little sign, as we become immersed in the Post-modern age, that it is about to make a comeback.

And as we look back on the designers of the Pioneer phase and locate them properly in their times, we realise that it would be unreasonable to

condemn them in retrospect. Historians and critics usually feel them-
selves capable of averting war and predicting disasters decades after they
have happened. The anti-historicism, commitment to abstraction and
technology of the Modernists in 1920 was informed by the situation they
found themselves in. They had no means of knowing whether their
experimentation would ultimately prove of worth. They were responding
to the social problems around them in an exciting and dynamic way and
were attempting to inculcate profound ideas into the design process.

Had they been practising and writing their manifestos today, it is hard
to imagine them using the same aesthetic or even political logic. Their
focus on morality, on the significance of economy and the need for a
healthy environment would have led them to alternative solutions to
those they had arrived at by the mid-twenties. One might venture to
suggest that additional intellectual forces would have inevitably
reformed their idea of design. Feminism, consumption and popular
cultural studies, and successive waves of development within Marxism
have all complicated our vision of things in a positive way. Technology
has become a far more ambivalent creature. The potential which
computerisation has given us for shorter, individualised runs of objects
would have made Modernists less confident in the regulating harmony of
the machine and would perhaps have provoked a different approach to
mass-production techniques. This, in turn, encourages one towards the
conclusion that Modernists would assure the applied and decorative arts
a dynamic rôle in the design process. Furthermore, it is hard to imagine
contemporary moralists being so unequivocally committed to the ideo-
logy of linear progress; and ecology would surely feature in a way that it
did not in the 1920s.

Amid the agrarian poverty, imperial absolutism and war which
prevailed in much of the Soviet Union, France, Germany and Holland in
the first decades of this century, the factory system and the machine
seemed wonderful indeed. In many ways they were. As the twentieth
century draws to a close, we have many mistakes to learn from, but it
cannot be levelled at those who attempted to design a better future that
they are to blame for the position we are in today. The undoubted crimes
of the International Style should remind us how easily a style can be
divorced from the motive forces which invented it and be attached to
heinous causes. We must be continually wary of attributing these crimes
to the Pioneers.

Had they not constantly made design an issue beyond mere style or
haute couture, and constantly challenged the broad sweep of industry

with new ideas, standards and ethics, the designed world would indeed be far more impoverished than it is. If the solutions were faulted, the questions they asked were the correct ones. In their exhilaration, their striving for physical and emotional liberation, the Modernists sent a shock wave through Europe and America which no designers have since come near to recreating. We should focus now on that exhilaration more than on anything else, for it was born of a sense of impending freedom which has been at the core of the best ideas of the twentieth century. In their attempt to break the barriers which they perceived to be all around them, erected and guarded by jealous disciplines, false traditions, divisive classes and unequal wealth, they did far more than merely invent a style. Many of those who opposed the Modern Movement then, and do so now, are aware of this and have conducted their case against it as much in the political arena as in the aesthetic.

Finally, perhaps, the Modern Movement should serve as a constant reminder that not until well into the twentieth century were the majority of the people of Europe and America given the chance to lead a decent life, with proper access to objects and ideas, in real rather than in rhetorical terms. Regardless of the viability of either the theory or practice of the Pioneers, we should remember that they were part of the same wave of protest which made the dignity of all human beings the absolute prerequisite for cultural activity. Indeed, we can assert that the best Modernist objects and buildings display a sense of self-determination, a willingness to explore beyond the taboo of convention; the objects contemplate themselves with a confidence that confirms that true wisdom lies in invention and in the imagination and is not received from earlier authorities alone.

Modernism separated itself from earlier forms through the self-consciousness of its manifestos and its outright rejection of many earlier ideas, such as the established views on style and function. It divided itself from the past by radicalising the whole design process. It is important to remember, however, that it did not spring fully fledged from the head of Zeus, armed and ready for the struggle ahead. In fact, the Modern Movement was as much a synthesis of certain earlier ideas as it was a rejection of others. The ideological rift which so clearly divides Modernists from their forebears should not be used to imply that the Moderns were in any one aspect absolutely original. This essay argues that there was in fact a direct lineage back to the 1840s and the theory and practice of Augustus Welby Pugin. It has been noted by other writers that Pugin set the preconditions for Modernism by creating an unbreakable tie between design and morality; here, his whole approach to the design process is brought into focus as being of seminal importance for later Modernist strategies. It was the Modernists themselves, of course, who asserted that the past was not a thing to fear or avoid; rather, and as with Pugin before them, they registered a wish only to embrace what was useful from previous generations and to avoid Historicism.

The Legacy of the Nineteenth Century

CLIVE WAINWRIGHT

Most of the ideas which have contributed both to the formulation and the practical application of the principles of the Modern Movement in architecture and design have their origins in the nineteenth century. I believe that by investigating these origins the nature of the current debate concerning Modernism may perhaps be better understood.

The writings of many of the nineteenth-century architects, designers and theorists still have a striking relevance today, as the following two quotations demonstrate:

. . . I find now many characters in many men; some, it seems to me, founded on the inferior and evanescent principles of modernism, on its recklessness, impatience, or faithlessness; others founded on its science, its new affection for nature, its love of openness and liberty. And among all these characters, good or evil, I see that some, remaining to us, from old or transitional periods, do not properly belong to us, and will soon fade away, and others, though not yet distinctly developed, are yet properly our own, and likely to grow forward into greater strength.[1]

Then, several years later:

Is the nineteenth century destined to close without possessing an architecture of its own? Will this age, which is so fertile in discoveries, and which displays an energetic vitality, transmit to posterity only imitations of hybrid works, without character, and which is impossible to class? Is this sterility one of the inevitable consequences of our *social* conditions? Does it result from the influence on the teaching exercised by an effete coterie?[2]

The first is Ruskin writing in 1856 and the second extract is from Viollet-le-Duc's celebrated *Lectures*, first published in the early 1860s. They both felt that by thoroughly and imaginatively studying the past and selecting from it principles relevant to their own day, new forms of architecture and design could be created. As I hope to demonstrate, the Modern Movement was firmly rooted in the nineteenth century — whether its theorists admitted so or not. Although Viollet is too often

neglected by British scholars today, he wrote very interestingly on how to study the architecture of the past for precedents:

In the study of the arts of the past, therefore, we should observe a clear distinction between a form which is only the reflection of a tradition, a form adopted without consideration – and a form which is the immediate expression of a requirement, of a certain social condition; and it is only the study of the latter that issues in practical advantage – an advantage not consisting in the imitation of the form, but in the example it affords of the application of a principle.[3]

Here Viollet is penetrating to the heart of the problem of differentiating between the ornamented exterior of a building and the essential structure itself at periods when one obscured the other, and the importance of structure in architecture is as relevant to us today as it was to Viollet. With Classical architecture, the construction of the building is always hidden by applied ornament – indeed, as we shall see, this was not even considered as dishonest until the nineteenth century. Viollet explained that 'If one undertakes to measure a Roman monument he must perform two operations: the first consists in taking account of the methods employed to rear the carcass, the construction, the structure itself; the second to find out how this construction has taken a visible form more or less beautiful, or more or less well adapted to this body.'[4]

This dichotomy between outward form and internal construction was widely recognised by nineteenth-century theorists to have been entirely absent in mediaeval architecture. 'The architecture and the construction of the Middle Ages cannot be separated, for that architecture is nothing else than a form commanded by that very construction. There is not a member however minute it be . . . which is not prescribed by constructive necessity . . .'[5]

I have initially quoted from Viollet not just because he so clearly articulates these ideas but because his works were read by architects and designers throughout the world in the later nineteenth century. Indeed the translation from which these last two quotations come was made by an American architect and published in both London and New York in 1895. Because of the strong tradition of American architects studying at the Ecole des Beaux-Arts in Paris, many more of them were directly exposed to Viollet's theories and buildings than was the case with British architects. H. H. Richardson attended Viollet's lectures whilst studying in Paris and in the next generation Frank Lloyd Wright and his Chicago contemporaries were equally influenced by Viollet's theories. Gaudí also was more deeply indebted to Viollet in his early work than to any other

architect. William Burges spoke for them all when he wrote that 'We all crib from Viollet-le-Duc'.[6]

Let us, however, go back to the generation before Viollet in order to examine the origin of this preoccupation with the moral value of Revealed Construction and consider several related matters. The Gothic Revival style was firmly established by the closing decades of the eighteenth century but, for nationalistic and associational reasons, quite unrelated to any true appreciation of its constructional merits. The Neo-Classical architects of the eighteenth century used the entire repertoire of deceits at their disposal to create appropriate effects: scagliola to imitate marble, *papier-mâché* to imitate plaster, stucco to imitate stone and iron painted green to imitate bronze, whilst cabinet-makers were using veneers instead of solid wood and ormolu instead of solid gold. It had, of course, been thus since the architects of the Renaissance revived the whole gamut of Classical Roman deceits. The vital constructional 'bones' of a building or object were, as a matter of course, completely clothed in applied ornament.

Exactly similar techniques were used in the Gothic Revival buildings of the late eighteenth and early nineteenth centuries: indeed, both Adam and Wyatt were working in both styles with equal facility. The fan-vaulted ceiling in the gallery at Strawberry Hill, though very plausibly mediaeval in appearance, was executed in *papier-mâché*, whilst that designed by Wyatt at Fonthill Abbey was in plaster painted to resemble stone.[7] Even a far more archaeologically minded Gothic Revival architect like Thomas Rickman often used cast-iron pew ends grained to resemble oak and cast-iron window tracery painted to resemble stone. By the 1820s the concept of Revealed Construction as one of the great virtues of mediaeval architecture was beginning to be appreciated and this principle began to be applied in the construction of buildings and furniture. Though the first stone vault of the Gothic Revival was actually constructed by James Savage at St Luke's, Chelsea, in 1824, it fell to A. W. N. Pugin to apply the principle widely and, most importantly of all, to discuss and illustrate it in print.

In 1835 Pugin published his seminal book *Gothic Furniture in the Style of the 15th Century*, where he illustrated a stool (p. 29) as an example of Revealed Construction as it should be applied to furniture. He was to design many pieces of furniture and interior joinery using this 'tusked tenon' and habitually referred to such construction as 'the true thing'. In 1841 he published *The True Principles*, which was later translated into French and became the seminal text laying the foundation for this whole

debate for the rest of the century. He first deplored how 'England is rapidly losing its venerable garb; all places are becoming alike; every good old gabled inn is turned into an ugly hotel with a stuccoed portico, and a vulgar coffee-room lined in staring paper, with imitation scagliola columns, composition glass frames, an obsequious cheat of a waiter, and twenty per cent added to the bill on the score of the modern and elegant arrangements . . .'[8]

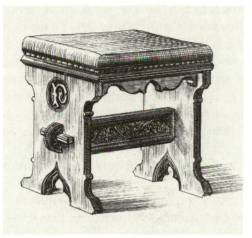

Stool design by Pugin, 1835.

Pugin then put forward his most important principles:

The two great rules for design are these: first, that there should be no features about a building which are not necessary for convenience, construction, or propriety; second, that all ornament should consist of enrichment of the essential construction of the building. The neglect of these two rules is the cause of all the bad architecture of the present time. Architectural features are continually tacked on buildings with which they have no connexion, merely for the sake of what is termed effect.[9]

Though Pugin's influence was widespread, the writings of Ruskin of course had an incalculable international influence and, ironically, they were crucial in further popularising and disseminating Pugin's *True Principles*. For Ruskin swallowed Pugin's theories whole and, far from giving him credit, attacked Pugin in his celebrated diatribe on 'Romanist Modern Art' in *The Stones of Venice*.[10] Pugin, however, had his defenders who also made public Ruskin's debt to him. Coventry Patmore, in an anonymous review of *The Stones of Venice*, noted: 'Now

because some of Mr Ruskin's leading principles are, in the main, the same which Mr Pugin and other influential writers besides himself have enunciated . . . we are somewhat surprised to find Mr Ruskin speaking in terms of unmixed wrath against Mr Pugin . . . it seems to us that Mr Pugin has been long, diligently, and not without success, calling for the introduction into architectural practice of some of the very principles upon which Mr Ruskin lays most stress.'[11]

In 1849 Ruskin had published that wonderful book *The Seven Lamps of Architecture* but all the ideas in it concerning Truth to Materials and Revealed Construction are Pugin's. Here is Ruskin: '. . . one thing we have in our power – the doing without machine ornament and cast-iron. All stamped metals, and artificial stones, and imitation woods and bronzes . . .'[12] Pugin had, however, written in 1841: 'All plaster, cast-iron, and composition ornaments, painted like stone or oak, are mere impositions . . .'[13] Ruskin's genius is nowhere better displayed than in this book which contains so many brilliant ideas quite apart from those lifted from Pugin, but even so Pugin's principles were so self-evidently important that Ruskin was forced to include them.

Of course, the important and, indeed, only relevant consideration for twentieth-century design and architecture is that these principles were still understood in the early decades of this century and were seen to be crucial to the emergence of the Modern Movement. Whether Viollet-le-Duc had read Pugin or Ruskin or had come to the same conclusions independently, and which of them was the conduit which conveyed the ideas to later architects, does not actually matter.

I am interested also in the historical question of how long these principles were associated with the names of their progenitors, and concerned to establish whether those who utilised them recognised that they actually were a legacy from the past. Here there is considerable evidence. So often it has been stated that the Modern Movement was for, and only of, the twentieth century, with no historical basis.

It is not surprising to find Voysey – no Modernist he – acknowledging his debt to the nineteenth century but one would have expected his mentors to have been Morris or at least Ruskin. Instead, in 1915 he wrote of Pugin, who had been dead for more than sixty years, that 'He adopted the forms most suited to the materials and requirements, and was governed by no pre-existing examples, but faithfully met, to the best of his knowledge and ability, all those conditions which were presented to his mind . . . it will be seen that the mode adopted by Pugin was one born

and bred in England alone, thoroughly germane to the climate, and national in character . . .'[14]

A few years earlier, in 1904, Hermann Muthesius, who was responsible for transmitting so many of the latest British architectural fashions to Germany and its rising architects such as Gropius and Behrens, wrote:

> Looking back today at the achievements of the Gothicists in the field of artistic handicrafts, one can have no doubt that Pugin's work stands supreme. Not only did he create the whole repertoire in which the next generation of Gothicists worked but also put into it the best of anything that has ever been done. His flat pattern remained the order of the day, nothing could surpass his glass and metal, his furniture was either imitated or replaced by other inferior furniture. The whole Gothicist tradition that was available in the nineteenth century had been evolved and established by him throughout its whole range.[15]

Writing in 1925, Le Corbusier, however, acknowledged his debt not to Pugin but to Ruskin:

> Ruskin spoke of spirituality. In his *Seven Lamps of Architecture* shone the Lamp of Sacrifice, the Lamp of Truth, the Lamp of Humility. He gave a demonstration of honesty to a population gorged with the first fruits of the nascent machine age: go to San Giovanni e Paulo in Venice and take a very long ladder with you; lean it against the grandest tomb – that of the Vendramin, seen in profile as it lies on the catafalque. Lean over and look at the other side of the head beyond the profile. *The other side is not carved.* Disaster! Cheating! Falsehood! Treason! Everything is false in this sumptuous enormous tomb. This tomb is the work of the devil . . . That is how Ruskin shook our young minds profoundly with his exhortation.[16]

These three very different commentators demonstrate how widely the principles of Pugin and Ruskin were still associated with their names in the opening decades of our century.

(The matter of Truth to Materials which has preoccupied so many twentieth-century Modernists runs very deep in this country and strikes an emotional chord in many ordinary people.\ I have quoted several theorists who wrote on the subject of why wood should look like wood, stone like stone and so on, but taken to its logical conclusion, as it was by some architects and theorists, the appeal is almost primeval. Voysey struck this chord, as quoted above, when he spoke of Pugin adopting modes '. . . born and bred in England alone, thoroughly germane to the climate, and national in character . . .' But logically, local character is merely a sub-division of national character and thus only local materials should be used in building. This principle was already recognised in the later eighteenth century and became enshrined in the theories of the Picturesque: 'Sir Joshua Reynolds used to say, "If you would fix upon the best colour for your house, turn up a stone, or pluck up a handful of grass

by the roots, and see what is the colour of the soil where the house is to stand, and let that be your choice . . ." [17] Wordsworth used this quotation to reinforce his arguments for the preservation of the scenery of his beloved Lake District by causing all new buildings to fit unobtrusively into the countryside. He noted that 'I have seen a single white house materially impair the majesty of a mountain; cutting away, by harsh separation, the whole of its base below the point on which the house stood.'[18]

Writing at much the same time as Wordsworth, the young Ruskin – this time in advance of Pugin – elegantly reinforced this point, with a cottage:

Its colour, therefore, should be as nearly as possible that of the hill on which, or the crag beneath which, it is placed: its form, one that will incorporate well with the ground, and approach that of a large stone more than anything else. The colour will consequently, if this rule be followed, be subdued and greyish, but rather warm . . . Everything about it should be natural, and should appear as if the influences and forces which were in operation around it had been too strong to be resisted, and had rendered all efforts of art to check their power, or conceal the evidence of their action, entirely unavailing.[19]

This image of the cottage being almost part of the geology of the mountain is indeed a compelling one which was not actually fully realised by an architect for another sixty years. In 1898 Ernest Gimson designed and built just such a cottage in the Charnwood Forest near Leicester (p. 33). It is called Stoneywell Cottage and was described thus by Gimson's friend W. R. Lethaby: 'The plan of this cottage was determined by the outcrop of rocks on the site, these being used in lieu of foundations as far as possible. The intractable nature of the rock used for the building and the consequent ruggedness of the walls can clearly be seen in the photograph.'[20] As might be imagined, the 'True Principles' also imbued every aspect of the interior. F. L. Griggs, the Arts and Crafts engraver who had been Gimson's close friend, described Gimson's own cottage in the Cotswolds but the description applies equally to Stoneywell: 'Newly cut stone and oak, bright steel and glass, and white walls reflecting sunshine, nothing was there but for use or comfort, all without any sort of make-believe.'[21]

This concern with matching a material to its setting may seem a mere Picturesque or, at the very least, an Arts and Crafts preoccupation at odds with the principles of Modernism. In fact, as I have shown, it was a continuing preoccupation of architects and theorists throughout the nineteenth century and was seen by them as part of the whole Truth-to-Materials debate and its practical application and, as such, was adopted

Stoneywell Cottage in 1898.

by the twentieth-century Modernists. Interestingly, moreover, the principles pioneered by Reynolds, Wordsworth and Ruskin will speak directly to the neo-vernacular architects of the 1990s.

The application of the principles of Revealed Construction and Truth to Materials to actual buildings, and the decorative arts which furnished them and embellished them, led to some of the most original and exciting architecture and design ever created. It was the visual impact of these existing buildings and artefacts which was to influence the architects and designers of the twentieth century at least as much as the polemical publications of the nineteenth century, though one of course helped to explain the other. Some of the most pioneering structures were created or designed when theory outstripped the practical limits of traditional materials. This is most graphically illustrated in the matter of that most mediaeval of structural forms, the vault. Here pure structure is displayed performing its vital supportive rôle, provided, of course, the correct principles are followed. Ruskin, in his 'Lamp of Truth' chapter, described these:

In the vaulting of a Gothic roof it is no deceit to throw the strength into the ribs of it, and make the intermediate vault a mere shell. Such a structure would be

presumed by an intelligent observer, the first time he saw such a roof; and the beauty of its traceries would be enhanced to him if they confessed and followed the lines of its main strength. If, however, the intermediate shell were made of wood instead of stone, and whitewashed to look like the rest, this would of course be direct deceit.[22]

Such traditional vaults as advocated by Ruskin followed the form of those actually constructed by contemporaries like Savage, Pugin, Street and Butterfield. The use of brick in vaulting was also acceptable if the bricks were visible, and mediaeval precedents such as Albi and the churches of Lübeck were well known by the 1850s. Ruskin and Pugin, as we have seen, abhorred cast iron as a dishonest material along with other cast materials such as artificial stone or *papier-mâché* and they and most of their British colleagues would have been shocked by the combination of cast iron and stone or brick for vaulting. For an architect willing to take the imaginative leap beyond mediaeval practice whilst still preserving the mediaeval spirit of constructional innovation, cast iron had a great deal to offer. It was not a British architect but the celebrated ecclesiologist, scholar and antiquary, Alexander Beresford Hope, who saw the potential of a marriage of iron and the Gothic Revival and wrote in 1857: '. . . the adaptations of iron into architecture must modify our laws of construction for the future. How far it will do so is not for any man to forecast, but one thing seems evident, that if we are to have an architecture of the future founded on that new material, it will rather seek its decorative forms from the vegetant combinations of the Gothic than from the more stiff and less natural system of the classical architect.'[23]

Hope saw that it was the Gothic Revival which had the potential to be the launching-pad for a new architecture and in a lecture at the South Kensington Museum the following year he told his audience of architects: 'If there is one axiom more undeniable than another – I am not attempting to contrast the respective merits of the two principles, but simply venturing a naked statement of fact – it is this: that Classical architecture is horizontal, Gothic architecture is vertical; Classical is an architecture of super-position, Gothic of germination and continuity.'[24]

It was Viollet rather than a British architect who took this step, for on the basis of his minute study of the Middle Ages he was sure that:

. . . if the Gothic builders had had at their disposal large pieces of cast-iron, they would not have failed to use that substance in their buildings and I would not guarantee that they would not sooner have arrived at results more judicious and more logical than those obtained in our time, for they would have taken that substance frankly for what it is, profiting by all the advantages that it presents

and without giving it other forms than those appropriate to it. Their system of building would have allowed them to use at the same time cast-iron and stone, a thing that no one has dared to attempt, during our epoch.[25]

Viollet believed in the architects of his generation being at least as adventurous as their mediaeval predecessors: 'It is time however for our architects to think of the future; it is time we set ourselves to work to invent like our ancestors and to regard what has been accomplished in the past as only a series of advances by which we should profit, and which we should analyse in order to advance still further.'[26] His spectacular resolution of how to combine iron with stone structurally is illustrated overleaf. He described how:

This method of structure in iron and masonry fulfils the conditions which, in our opinion, should characterise such works. Thus the iron framework is visible, independent, and free to expand and contract, so that it cannot cause dislocation in the masonry, whether through oxidation or variation in temperature. The masonry, while concrete in parts, yet preserves a certain degree of elasticity, owing to the small arches which carry the whole. As the system of vaulting only takes up a very considerable height in proportion to the width of the interior, it allows of large windows comparatively elevated – it requires a minimum of materials, and only thin walls . . .[27]

Viollet himself never had a client imaginative enough to allow him to put these principles into practice and it was left to other architects, such as Henri Labrouste, actually to design buildings which did so. The structural clarity, the combination of modern and ancient materials and the sheer architectural daring of Viollet's designs, published as they were in his *Lectures* – one of the most widely read architectural books of all time – excited and influenced a whole generation of architects.

There is no doubt that the avant-garde architects and designers of the second half of the nineteenth century drew their inspiration from the Middle Ages and I have discussed several examples of this. They and the theorists whose research and publications underpinned their work usually proceeded from a close study of actual surviving mediaeval buildings and then applied the principles exemplified in them. Ever since Batty Langley had, in the mid-eighteenth century, published his lunatic book on the Gothic orders, the search for the theoretical and geometrical basis of Gothic architecture had been suspended in favour of a more pragmatic approach.

This whole debate was, however, placed upon a firm scholarly footing in the 1840s largely as a result of the attempts to classify mediaeval window tracery as demonstrated in Edmund Sharpe's *A Treatise on the*

Viollet-le-Duc, iron and masonry structure.

Rise and Progress of Decorated Window Tracery in England, published in 1849. Then, in *Seven Lamps* which appeared in the same year, Ruskin brilliantly discusses and classifies tracery of various periods. The most important and innovatory writings of all were those of R. W. Billings, an architect and antiquary who, in 1840, published *An Attempt to Define the Geometric Proportions of Gothic Architecture as Illustrated by the Cathedrals of Carlisle and Worcester*. He elaborated and illustrated his theories in a number of books and articles throughout the following decade, culminating, in 1849, with his *Infinity of Geometric Design Exemplified*.

In 1851 Billings published the book which refined and clarified his ideas, *The Power of Form Applied to Geometric Tracery: One Hundred Designs and their Foundations Resulting from One Diagram*. The motto on the title-page was appropriately 'Keep withynne compasse, so ye shall be sure'. The Preface begins: 'The Author of this treatise was the first in the field to prove that not only was the whole detail of Gothic Architecture founded upon geometric law, but that the power of design still remained with us, waiting only for its application.'[28] Whilst, as we have seen, most Gothic Revival architects, designers and theorists wished to build upon the actual forms and ideas of the Middle Ages, Billings provided a key to how this could best be accomplished. He demonstrated that

The more we examine the powers of Design developed by the aid of fixed diagrams, or foundations, the more absurd does it appear, that ever since the revival of Gothic Architecture we should have gone on for ever copying – taking it for granted as a preliminary that all possible combinations were exhibited in the works of our predecessors; considering in short that the mine was exhausted . . . So great indeed is the power of this mechanical field of Art, and so simple its cultivation, that it is absolutely easier to produce new combinations than to copy old ones.[29]

Here is the geometrical basis of several of the most important aspects of Gothic design. Not only could new forms of window tracery be derived but also flat pattern designs applicable to tiles, wallpapers, textiles, marble and wood inlay, exterior structural polychromy and interior stencil schemes. Any architect or designer with drawing instruments and imagination could continue from where his mediaeval counterpart left off.

A parallel concern was how to represent natural forms in a geometrical and abstract manner whilst still leaving them recognisably derived from nature. Recent commentators have given prominence to the botanical

activities of Dr Dresser in the field of design but again Pugin and Ruskin have primacy. In his spectacular chromolithographic book of 1849 on the abstract use of plant ornament, *Floriated Ornament*, Pugin wrote: 'Nature supplied the mediaeval artists with all their forms and ideas; the same inexhaustible source is open to us: and if we go to the fountainhead, we shall produce a multitude of beautiful designs treated in the same spirit as the old, but new in form.'[30] Then, a year after Pugin's death, in his wonderful chapter 'The Nature of Gothic' in the *The Stones of Venice*, Ruskin wrote: 'The third constituent element of the Gothic mind was stated to be Naturalism, that is to say, the love of natural objects, for their own sake, and the effort to represent them frankly unconstrained by artistical laws.'[31]

This preoccupation with nature was, like the other mid-nineteenth-century design theories which I have discussed, still important to architects and designers early in our century. In 1925 Le Corbusier wrote: 'My master has said "Only nature can give inspiration, can be true, can provide a basis for the work of mankind. But don't treat nature like the landscapists who show us only its appearance. Study its causes, forms and vital development, and synthesize them in the creation of *ornaments.*" '[32]

When this concern with the geometrical basis of the Gothic Revival was combined with the 'True Principles' of Revealed Construction, the true use of materials and the abstraction of natural forms, the Reformed Gothic style was born. In the hands of architects of genius like Pugin, Street, Butterfield, Jones, Dresser, Richardson, Sullivan, Viollet-le-Duc and Gaudí, this style was deployed to create a remarkable range of buildings and objects. This complex mix of ideas also influenced architects and designers working in the Classical and Renaissance styles although they could not, of course, incorporate the 'True Principles' which were, as we have seen, alien to these styles. Instead they made widespread use of the application of geometrical principles and the abstraction of natural forms to carved foliate decoration and flat pattern.

These principles were applied by those very designers and architects of the second half of the nineteenth century who were most actively promoting the emergence of a new style specific to their own century. They believed that this style would evolve only through the creative application to their designs of forms derived from the historical styles. They believed that Modernism would eventually emerge but as to what form it would take, they knew not. It was from the rich creative mix which I have described that the architects and designers of our own

century derived their inspiration and ideas. The scene had been set for them – this was the legacy of the nineteenth century.

As early as the 1930s doubts were being cast on the future of the new Modern Movement and in a fascinating book, *Modernismus*, the Arts and Crafts architect turned Neo-Georgian, Sir Reginald Blomfield, perceptively wrote:

What the next generation may think it is impossible to say at the rate we are going, but unless we are heading for chaos, I think the new architecture will go the way of other fashions. What is good in it will be absorbed, and the rest of it relegated to the dustbin . . . it is time that the issue should be faced between the Modernists and those who have the sense of the past as well as the present, and refuse to be bullied out of it by clamour and violent assertion. The difference between us is that the 'Modernist' claims to wipe out the past and make an entirely fresh start, out of his inner consciousness, whereas the 'Traditionalist' – a term of opprobrium in the mouth of the Modernists – is bent on carrying on and moving forward from the lines laid down and developed by civilised people . . .[33]

Most architects and designers today consciously or unconsciously apply some or all of the principles which I have described. Others have forgotten them or indeed have returned to pre-nineteenth-century forms of 'jerry-building'. It is perhaps not inappropriate to construct modern Neo-Georgian houses of concrete blocks with a thin veneer of brick since this is no more dishonest than was Georgian stucco itself.

Modernist principles have not only served to provide designers with a rationale for practice, they have also provided the material for successive waves of attack upon the whole idea of Modernist design. The inevitable (and real) association of Modernism with mechanisation has led to accusations that, deliberately or otherwise, it dehumanises its audience. The stark, machine-like visage of Modernist buildings and objects inevitably, the argument goes, reduces their recipients to the status of automata or animals. The most attacked idea in this regard is that of function, or functionalism as it became known. The maxim of 'form follows function' appears, for those inclined to understand it that way, to exclude aesthetics and symbolism altogether. Especially by critics in Britain, functionalism was put forward as the key flaw in the nightmare that was Modernism. Once this had been asserted, the struggle against Modernism could be portrayed as the struggle for humanism.

2

The Myth of Function

TIM BENTON

The itch I propose to scratch in this essay could be described as the baffling philistinism of English architectural criticism, or, more specifically, the different ways in which notions of *function, functionalism* and the *functionalist aesthetic* are handled in English writing as opposed to Continental sources. The period I am interested in is the thirties, but from the perspective of the immediate postwar years – 1948–55. It is, I suppose, a sub-question of the larger inquiry as to why the collapse of Modernism has been so damaging and so complete in this country, but that is another story.

I'm trying here to map out a fruitful terrain for investigation, and this essay must be seen primarily as a ground-clearing exercise. Some of my difficulties come from reading a book which I hoped might provide useful material for this endeavour: Larry L. Ligo's *The Concept of Function in Twentieth-Century Architectural Criticism.* Ligo's method was to restrict himself to the references in the *Art Index*, which immediately biases his research towards English language sources.[1] Most of the writings selected were post-1940.[2] He chose to cover only applied criticism, as opposed to theoretical or more general criticism. And he picked a list of thirteen famous modern buildings as a way of further selecting the extracts.[3] The arbitrariness of this procedure tends to provide extracts which lack specificity and accentuate the iconic status of the buildings and the generalised nature of the criticism.[4]

More seriously, Ligo allows for a creeping inclusiveness in his definition of function to encompass everything from structural articulation, physical function, psychological function,[5] social function,[6] and 'cultural-existential' function.[7] These are, in fact, chapter headings in his book.

On the other hand, the book is of interest precisely because it preserves and displays many of the confusions and contradictions rooted in the period under discussion. Ligo is at pains to point out that few architects

themselves believed that a building's function should determine its form
or be used as a criterion for judging its beauty. It was largely in the post-
hoc criticism that notions of functionalism assumed ever greater signifi-
cance. And he asks the fruitful question: 'How . . . did the idea of
absolute functionalism come to be so dominant, in fact to be thought of
as a synonym for "modern architecture"?'[8] This is the question I would
like to pursue.

First, a few matters of definition. In conventional parlance, the word
'function' means little more than 'use' or 'purpose'. When given the suffix
'-ism' or '-ist', it refers to *values* placed on the satisfying of material
functions (from shelter to planning, etc.). From Vitruvius onwards, most
architectural theorists have found an important place for the premise that
a building should be judged, in part, on the intelligent use of materials,
the way that it performs its purpose and its social utility.[9]

These values invariably spill over into the realms of the aesthetic or the
ethical but they are not necessarily exclusive. Only very few functionalists
ever asserted that architecture *consists in* the satisfying of functions and
that no other values (such as beauty) are relevant.[10] And when they did,
they invariably used the term 'building', or '*Bauen*', instead of 'architec-
ture', or '*Baukunst*'. It is also worth noting that virtually every architect
and writer on architecture of any standing at all has taken pains to
renounce 'functionalism' as the sole guiding principle of architecture.[11]

A functionalist, then, may claim that a building which meets important
practical or social purposes is in some sense a good building, but this is
not to say that it qualifies as Architecture or that it is beautiful. He may go
so far as to claim that an architect is morally bound to adapt his practice
to serve important social functions, but this ethical or political principle,
while determining some of his choices, will not necessarily determine
those which define all the formal or signifying elements of his buildings.

Similarly, a building may be praised which lacks 'social utility' or
Truth to Materials, but only extreme formalists suspend all knowledge of
the world, including a knowledge of how a building serves its purposes,
when forming architectural judgements.[12] Therefore, when discussing
functionalism, we have to try to measure how much weight is being
placed on the satisfying of functional requirements and what causal links
are being claimed between these functional arrangements and the form,
or beauty, of the building.

I am going to use the term 'functionalist aesthetic' to refer to theories
which identify a causal relationship between function and beauty. Here,
too, we will have to distinguish between various versions of this general

argument. The most austere theory simply asserts that what is functional will *de facto* be beautiful. Few writers have made this claim. But even if a writer accepts that satisfying a building's functions can never be a sufficient condition for beauty, he or she may still insist that it is a necessary condition for 'good' architecture and that functionalism therefore necessarily underpins architecture. More frequent are theories which look for common properties or chains of association between the functional and the beautiful (such as the chain between 'truth', 'rationality', 'calculation' and 'functionalism') and therefore argue that the one overlaps with the other. In its weakest form, the functionalist aesthetic simply claims that functionalism prepares the ground for beauty by stripping away inessential details and grounding a design in rational principles. It may often appear unclear whether any causal link to beauty is being claimed, or whether functionalism merely performs an enabling rôle for architecture.

I want now to make a small detour to examine Le Corbusier's *Vers une architecture* in the light of these reflections on functionalism and the functionalist aesthetic, since it was this book, as much as any other, which caused many of the confusions in Britain which I want to address.[13]

In British writing from 1927 to 1939, Le Corbusier was invariably described as a functionalist. But can Le Corbusier properly be described as a functionalist, and do his views conform to what I am calling the functionalist aesthetic? Le Corbusier was clearly not a functionalist of the exclusive kind:

Architecture is the masterly, correct and magnificent play of masses brought together in light.[14]

and:

You employ stone, wood and concrete, and with these materials you build houses and palaces; that is construction. Ingenuity is at work.

But suddenly you touch my heart, you do me good, I am happy and I say: 'This is beautiful.' That is ARCHITECTURE. Art enters in.[15]

There is clearly a separation here between building and architecture and we can identify an independent formal judgement as to what qualifies as Architecture or art. In fact, Le Corbusier specifically considered and rejected the two common functionalist claims that architecture must express its structure and that there is a causal relation between function and beauty.

One commonplace among architects (the younger ones): *the construction must be shown.*

Another commonplace amongst them: *When a thing responds to a need, it is beautiful.* But . . . to show the construction is all very well for an Arts and Crafts student who is anxious to prove his ability. The Almighty has clearly shown our wrists and our ankles, but there remains all the rest!

When a thing responds to a need, it is not beautiful; it satisfies all one part of our mind, the primary part, without which there is no possibility of richer satisfaction; let us recover the right order of events . . . ARCHITECTURE is the art above all others which achieves a state of platonic grandeur, mathematical order, speculation, the perception of the harmony which lies in emotional relationships. This is the AIM of architecture.[16]

So, functionalism is a necessary precondition for 'satisfaction', but not a sufficient condition for architecture. And yet David Watkin felt able to call Le Corbusier's arguments 'functionalist' without qualification.[17] On examination, it turns out that Watkin's mistake is due to his antipathy for Le Corbusier's attitudes to decoration and personal hygiene. Actually, it is hard to examine Watkin's text here since he does not address any of Le Corbusier's principal arguments, preferring to pick about among some of the peripheral examples of what he calls the pathetic fallacy. The fact that Le Corbusier's personal attitudes and Historicist views committed him to trying to create a new kind of architecture has no bearing on his rejection of the functionalist aesthetic. Watkin's distaste for what he wrongly identifies as Le Corbusier's revolutionary message blinded him to the essential humanism of Le Corbusier's intellectual formation.

Watkin stands in a line of British architectural critics who either wilfully or ignorantly conflated political, social and functional considerations in order to condemn Modern Movement architecture as functionalist, when what they really objected to was the spectre of communism, cosmopolitanism, social purpose and the stripping away of traditional detailing. Within a year of the arrival of European Modernism (in the persons of Berthold Lubetkin, Erich Mendelsohn, Walter Gropius, and Marcel Breuer), the term functionalism was being used in this very general sense.[18]

Much of the power of *Vers une architecture* comes from the juxtaposition of images, many of them taken from civil engineering, aeroplanes, cars, and ocean liners. To many critics, the imagery amounted to more than the message, so that it was commonly claimed that the author was advocating the imitation of grain silos or factories. It is remarkable how Le Corbusier aestheticised these images by selecting views to accentuate aesthetic properties he admired, even going so far as to touch up the

photographs. But it is a mistake to imagine that he saw a simple and direct relationship between their functions and forms. His ideas can be paraphrased roughly as follows. Because engineers employ rigorous calculations in order to use their materials as efficiently as possible, they often end up using those geometric forms (the Phileban solids) which invariably satisfy the aesthetic faculties. Similarly, the processes of mass production and competitive marketing will tend to 'purify' and improve the forms of industrial artefacts, just as natural selection works to perfect organic forms. Furthermore, these new forms are the characteristic products of a period of civilisation radically changed in almost every way by industrialisation and urbanisation. A sense of propriety suggests the need to 'learn the lessons' from these objects and see if architecture should follow a similar path. All this, however, amounts only to an argument concerning cultural history or fashion. The criteria for recognising beauty and designing good architecture, according to Le Corbusier, remain independent of these determinants.

We will return to Le Corbusier and the functionalist aesthetic later. But first, we must consider some cases where functionalists, while not actually advocating a necessary relationship between function and form, have held views which could be seen to have had bad aesthetic consequences. These may be described as the negative case against functionalism. I can only summarise them here.

First is the argument that modern architects were driven by functionalist criteria to seek to wipe out tradition and 'history'. It is certainly true that very many architects, by 1900, agreed that it was increasingly difficult to defend architectural eclecticism (*les styles*). And it is true that the main reason for this was the feeling that meaning had gone out of architecture with the loss of any real reference to contemporary life. The 'devaluation of symbols'[19] (banks dressed up as temples, department stores as palaces) was associated with a refusal to accept the new social realities, and the substitution of ersatz materials and processes for skilled hand craftsmanship was coming to be thought repugnant by architects who were not in any sense Modernists. The problem was, how could architects substitute for the imitation of past styles? Most architects, like Le Corbusier, tried to recover what they saw as the essential lessons from the architecture of the past, renouncing the superficial, but some thought that architects could do without any reference to the past. It is said that Gropius used to advise students at the Bauhaus to ignore history. Behind all the rhetoric, however, the influence of the German classical tradition, notably of the Schinkel type, influenced every design Gropius ever made.

On the whole, however, the English tradition in the thirties was to contrast the supposedly rational and organic Georgian architecture with the eclectic and 'superficial' Victorian. A good example is the frontispiece of Yorke's book *The Modern House in England*,[20] which juxtaposes Gropius's house in Church Street, Kensington, with a Georgian terrace row.

To the extent that the eclectic use of style was devalued, however, architects began to look for *reasons* for selecting certain forms and not others. The 'clean sheet of history' was often compared with the 'clean sheet of paper' which architects were encouraged to imagine free of predetermined solutions. And this is why functionalism was blamed for supplying the answers, since it was seen as filling the vacuum left by tradition and style.

They definitely ignore the past. They no longer study it, and in this deliberate ignorance it is easy for them to cut adrift, and start afresh on their own. They have some excuse in the nineteenth century, that disastrous interlude in the arts which, though it had men of genius, undid the work of the eighteenth century, and landed us in our present chaos. But civilisation is far too old and complicated for a complete sweep . . .
 In the second place the modernist view of architecture, its translation into mere functionalism, is absurdly inadequate as a conception of architecture.[21]

It remains to be seen, however, whether architects genuinely did substitute functionalist criteria for the 'masterly, correct and magnificent play of masses brought together in light'. In fact, the most casual reading of Le Corbusier's prodigious output shows that his main aim is exactly to supply a broad, rich and prestigious set of references and arguments in support of modern architecture.

It is significant that, in Frederick Etchells' Introduction to the English edition of *Vers une architecture*, this is well understood:

But it will be said, we cannot escape the past or ignore the pit from which we were hewn. True; and it is precisely Le Corbusier's originality in this book that he takes such works as the Parthenon or Michael Angelo's Apses at St Peter's and makes us see them in much the same direct fashion as any man might look at a motor-car or a railway bridge.[22]

Unfortunately, however, Etchells placed a subtle emphasis on Le Corbusier's supposed functionalism and radical Modernism. For a start, he changed the title from *Towards an Architecture* to *Towards a New Architecture*, perhaps assuming that the English reader would not understand the cultural implications in the original title, with its connotation of restoring a lost unity. It was precisely Le Corbusier's

project to attempt to reunite the skills of the architect and the engineer, rent asunder by the Industrial Revolution. Secondly, Etchells' Introduction places great emphasis on innovation in engineering and materials, and his illustrations emphasise the stark brutality of these new realities. In particular, an illustration of Walsh and Maddock's Operating Theatre offered a hostage to fortune for the next decade.[23]

Here we come close to the heart of the problem. British architectural critics and commentators, compared to their Continental colleagues, have always been reluctant to include a highly theorised or aestheticised vocabulary. The central British tradition was that of 'Good manners', 'Common sense' and practical experience[24] and its characteristic vocabulary that of a patronising explanation to the man in the street. In this kind of writing, humour and practical wisdom were always rated most highly, and the touchstone of functional efficiency was invariably given great value, long before Continental Modernism came to Britain after 1927.

In England, perhaps more than in any great European country, there has obtained, and still exists, a natural antipathy to any application of logic or analysis to questions of art . . . Hence we find installed, most particularly in England, the great conservative system of 'Follow your betters' and 'Don't think out loud about abstract principles of design'.[25]

Whether it is profitable to make comparisons with the British utilitarian and empirical traditions in philosophy or with the characteristic forms of British painting and sculpture, the dominant impact made by Pugin, Ruskin, Morris and Lethaby set the agenda for architectural discourse until well into the twentieth century.

Another negative argument against functionalism was that it was the agent of social revolution. The fact that most of the protagonists of the Modern Movement in architecture had political aims which envisioned at least some kind of radical change in society, made it seem only too probable that they proposed to use architecture as part of a revolutionary levelling process. In France, when the articles for *Vers une architecture* were being written, the political atmosphere was deeply conservative and nationalist. Le Corbusier's social idealism was tempered by a natural tendency towards élitism and an urgent practical need to curry favour with the industrialists, bankers and bourgeois dilettantes who made up the bulk of the readership of *L'Esprit Nouveau* magazine. When he added the chapter 'Architecture or Revolution' to the book, it was precisely to appeal to the men in authority to patronise the new architecture.

In Germany, however, Modernism grew up in social chaos and fuelled by the fervour of political radicalism. Furthermore, the idealism of the early twenties was actually channelled into practical housing projects in cities like Berlin and Frankfurt, where Social Democrat local governments placed Modernists like Martin Wagner and Ernst May in positions of real power. By 1929, therefore, when European Modernism with a German flavour first began to penetrate the English consciousness, it was natural to associate modern architecture with socialism. The key text here was Bruno Taut's book for Studio Vista, *Modern Architecture*. Taut had been building social housing of various kinds since before the war and had by then a mature political outlook. Like most of his European contemporaries his views were formed in the Historicist and holistic Hegelian tradition, so that he took for granted a two-way relationship between 'ideas' and social progress. Just as the 'Spirit of the Age' dictates to the architect where society is going, it is part of the architect's job to help this 'progress' with his buildings. And Taut does seem to link this to a functionalist aesthetic:

If everything is founded on sound efficiency, this efficiency itself, or rather its utility, will form its own aesthetic law. A building must be beautiful when seen from outside if it reflects all these qualities . . .
The architect who achieves this task becomes the creator of an ethical and social character; the people who use the building for any purpose, will, through the structure of the house, be brought to a better behaviour in their mutual dealings and relationship with each other. Thus architecture becomes the creator of new social observances.[26]

This is not the place to put Taut's statement into its German context. As it happens, Taut very rarely espoused the functionalist aesthetic in this crude form, but it is highly relevant that he did so here, and linked it to a social message. The illustrations in the book, showing a decade of solid achievement in a range of types of architecture, from social housing and factories to private houses, must have seemed unbelievably exotic to the English reader.

To such readers, the link between functionalism and socialism (normally referred to as 'Bolshevism'), could be identified as the wish of the modern architect to reduce people to robots.

France having discovered the dramatic implications of 'fitness for purpose', a ruthless and wholly material functionalism now directs French modernist architecture. This functionalism is objective; but the buildings designed by the modernists are designed for creatures that have lost their human characteristics . . . Le Corbusier is always designing for the standardised, mechanised beings

that he considers so much more efficient and desirable than humans. He and his disciples are creating the architecture of inhumanism.[27]

It is interesting that Gloag's pragmatism forces him to accept the 'objectivity' of functionalism and look to the dehumanising processes of Le Corbusier's supposedly revolutionary social planning to deliver the clincher. Larry Ligo cites a number of articles by Lewis Mumford from the 1920s which make a similar point,[28] defending logical and non-aesthetic American architecture against the politicised and puritan extremists of Europe. Ligo also cites Banham's judgement, which was that many Modern Movement architects decided to fight on the 'narrow front' of common-sense solutions and economic realities, in order to win support in 'politically-suspicious Fascist Italy, aesthetically-indifferent England and depression-stunned America'.[29]

By the mid-thirties, however, the political debate within the Modern Movement had been radically altered by Stalin's rejection of Modernism in the USSR. Now the key issue on the left was, 'Should architects lay their skills at the feet of politicians in the interests of a greater good, that of raising standards and political awareness in the proletariat?'[30] It now seemed as if the stripped Rationalism of Modern Movement architecture was an indulgence which did not serve the interests of the poor and homeless whose plight had always been used as an argument for the materials, methods and forms of Modernism. By the end of the thirties, modern architects in Britain were distancing themselves rapidly from the cold, hard look of 1920s European Modernism, introducing curves, organic forms, 'natural' materials, irony, ornament, and symbolism. A key moment in this transition was Lubetkin's Highpoint II block in Highgate, with its explicit reference to Vitruvius (a caryatid) and its abandonment of the symbolism of social engineering.[31] Paradoxically, as modern architects were abandoning the forms associated with the functional aesthetic, critics were fixing functionalism into the currency of architectural debate.

The thirties in Britain has often been described as a period of increasingly polarised attitudes. A whole generation of young artists and architects came to feel themselves excluded by those who held positions of power both in government and in the professions. It was a decade in which appeasement in politics could be contrasted to the just cause of Spanish Republicanism, and the continued stranglehold of the senior members of the newly professionalised RIBA could be contrasted with the exciting prospect of Continental Modernism. Furthermore, the increasing bureaucratisation of the processes of planning permission

brought Modernists repeatedly into conflict with hostile representatives of the community.[32] Berthold Lubetkin, who always reserved a very important rôle for the artistic in architecture, noted that these struggles led to a diversion of attention from the aesthetic to the practical:

The result of this tremendous body of prejudices and obstructions, supported as it is by the authority of the law, has been to lend a disproportionate importance to very small points. To obtain permission to build a flat roof is in itself such an achievement that it is likely to overshadow, in the mind of the architect, the significance of his original conception. The result is that at present it is almost impossible to judge objectively the aesthetic qualities of a building.[33]

It is hardly surprising that the political rubbed off some of its flavour on to the aesthetic, even when the real links were often extremely superficial.

You are a writer, a critic, you *must* find a word for this new thing, which disturbs your critical equilibrium. You look about, and find a word which is already an important one in the vocabulary of architectuure . . . you add an 'ist' or an 'ism' to it, and you call it 'functionalism'.
 The new word has a 'modern' ring about it, it's 'smart' and 'hard', and perhaps a bit 'bolshy' too. (That will be very useful later on.) And thus, for the time being, the critical balance is restored, by a fresh bright word.[34]

Now, it is often the case that the most extreme statements of the functionalist aesthetic in Britain did coincide with an extreme political position held at the time by the writer. Here is Herbert Read:

If an object is made of appropriate materials to an appropriate design and perfectly fulfills its function, then we need not worry any more about its aesthetic value: it is *automatically* a work of art.[35]

This was written in 1941, after Read's conversion to anarchism. But in *Art and Industry*, published in 1934, Read had preserved the notion of an abstract art in the service of industry whose field was purely aesthetic: 'art implies values more various than those determined by practical necessity'.
 A key circumstance to explain the nature of the debates in Britain during the thirties was the impact of the postwar economy and Depression on the building industry. The pricing out of hand craftsmanship presented all architects with problems for which they were ill prepared. The consensus response was to look to Scandinavia, Holland, and North Germany, where a style of stripped Rationalism in brick and wood seemed to offer a mixture of functionalism with a judicious traditionalism and humanism. By 1930, while Le Corbusier was moving

away from white, rendered, reinforced concrete to an increasingly 'organic' approach to materials, and while modern architects everywhere were re-evaluating the tenets of functionalism, a generation of young British architects were presented with the *fait accompli* of 1920s Modernism in the form of a number of books and articles. These books increased the austere appearance of modern architecture by stripping out colour and texture and wrapping them in a defensive argumentation often remote from that of their creators. Furthermore, the arrival of the emigrés from Europe (notably Walter Gropius, Erich Mendelsohn, Berthold Lubetkin and Marcel Breuer) tended to perpetuate and set in aspic developments which elsewhere (at least outside Germany) continued on a more organic path.

It was Gropius' partnership with Maxwell Fry which set the real agenda for postwar British Modernism. Gropius' dry austerity, mixed with Fry's sensitivity to English landscape, created the housing scheme for St Leonard's Hill, Windsor Park, with its housing slabs based on Gropius' Wannsee apartment blocks of 1928. This scheme was wittily and appealingly promoted in the *Architectural Review* under the title 'Cry Stop to Havoc'. The concluding sentence reads:

This can be regarded as one of the first efforts to reconcile the English tradition of good living with the requirements of contemporary town and country life.[36]

But this appeal to a consensus reasonableness was not a real one. Thirties culture was fragmented not only across the 'schools' of Modernist, Rationalist and traditional architects, but within the Modernist tradition. The deeply imbued notion of pragmatic relativism, allowing everything its proper place within the scheme of things, provided that it does not challenge the main hierarchies, emerges from a characteristic article in the *Architectural Review*. Entitled 'Beauty in Machinery', the article included some immensely seductive photographs of machinery, lit and composed by photographers Francis Bruguière and E. O. Hoppé.

We are bidden to seek the purpose for which a thing was made, and advised that if we put ourselves into sympathy with that purpose we shall find by trial the literal truth that the more efficient a device is, the more beautiful *in its own style* it becomes.[37]

Rejecting the functionalist aesthetic, the author argues for a pluralistic aesthetic, where the *right kind* of purpose, perfectly fulfilled, will engender a feeling of appropriateness and admiration akin to the aesthetic.

Modern Movement architects even accepted this hierarchic and compartmentalised view of the world as a constraint on their own freedom of action. When the partnership Connel Ward and Lucas submitted a competition entry for the civic buildings in Newport, South Wales, they were arraigned before a tribunal of MARS (Modern Architectural Research Group) to explain why they had the temerity to betray the movement by pandering to official commissions. It was such a fixed notion at the time that different styles had their proper place (Classical for government buildings and banks, stripped Rationalism for minor public buildings and schools, Modernism for fringe commissions such as zoos, health centres and private houses)[38] that it seemed impossible to break out from the appointed station of buildings in society. The consequence was that modern architects in Britain never had to concern themselves with the large issues of meaning in architecture. Confined to a subculture, they were able to exchange with their painter friends and their political allies on the left an empty rhetoric of 'hard' functionalism and grim social purpose, precisely because they were largely deprived of the opportunity to carry any of their schemes out in practice.

As a result, much of the debate in the magazines or on the radio was safely contained within a fantasy of 'opposition' between two camps, neither of which had much standing or importance in the community.[39] After the war, however, many of these same architects found themselves suddenly in positions of power (rebuilding city centres, designing new towns and cathedrals), untrammelled by either legal or established constraints. And the poverty of their architectural theory was rather suddenly exposed.

There has been a tendency in the literature surrounding Modernist furniture to divide it off from the trades and practices from whence it sprang, to analyse it as a commodity floating free from such things as artisan traditions, retail outlets, popular demand and government legislation. Once the division has been made, a history of style can be constructed which develops a convincing internal logic. In this essay, the 'proto' period, as it were, of modern French furniture is reunited with the specific conditions prevalent at the time, in an attempt to explain why, exactly, one style succeeded another, and why the formal innovations of Modernists at the end of the 1920s were so rapidly and easily appropriated into the repertoire of even the most pragmatic of Parisian artistes décorateurs. Ultimately, one is left to wonder whether indeed there was a Modern Movement in French furniture at all, and if there was, what it constituted and when exactly it occurred.

3

The Struggles within French Furniture, 1900–1930

PAUL GREENHALGH

The incoherence in which we live from the point of view of the rapport between Art and the State makes aesthetic evolution, from which we hoped for decisive results some years ago, very miserable, very difficult and very hesitant . . . If the crowds made their own judgement without inquiring for the opinion of the State, the meddling of a Minister in the aesthetic question would hardly matter. Unfortunately, by a kind of atavism born of sad servility, the public shows an irrestistible and childlike need to hang on to a tutor, a teacher, a prophet, a master who can show them what to like and hate. In this way, an artist noticed or chosen by the State becomes a genius, and the misunderstood genius, or someone simply kept in the background by the Offices of the Rue de Valois, can become so grotesque or dangerous that it becomes necessary to hunt him down.

Francis Jourdain, *Art et Décoration* (1904) XVI

For much of the twentieth century, there has been a battle between disparate factions within French culture for the privilege of occupying the space identified as 'the modern'. It became clear during the course of that debate that there were profound differences within the design world as to what the word actually meant. It was also obvious that the motives of those engaged in the struggle were, with the odd exception, irreconcilably opposed. The designers who succeeded for some time in absorbing the word 'modern' into their respective curricula vitae did not hand it on happily to successors.

French design is usually reported as being dominated by Art Nouveau, Art Deco and the International Style during the first three decades of this century. The period is normally structured around the shift from one style to the next, each successor leaving behind it the destroyed and decadent carcase of the previous style. Art Nouveau grew to prominence in the last years of the nineteenth century, triumphed at the Exposition Universelle of 1900, and then went into decline. The seeds of Deco were

sown in the years immediately before the First World War. It matured by 1920, before acquiring both its name and its great renown at the Exposition des Arts Décoratifs et Industriels Modernes of 1925, the legendary 'Art Deco Show'. Shortly after this, a simple, sleek Modernism gradually asserted itself in most areas of design. Art Deco went into slow decline as the International Style came to the fore.

I don't wish to cast doubt on this basic picture, since it seems to me that, generalised though it is, it accurately represents the stylistic change through the period. Rather, I wish to complicate the picture by examining in some detail the reasons for the shift from style to style. I would like to demonstrate in this essay that styles don't simply change due to mass transformations in the taste of the market, or because individual designers suddenly come up with new ideas. Neither do they sway under the shadow of some abstract, all-pervasive *Zeitgeist*. They change principally because significant groups within society make them change.

In some senses, design in France was shackled by the privileges bestowed upon it. Designers often appear to have been as much compromised by the importance accorded to them as their English equivalents were compromised by neglect. Throughout this century, and for most of the last, Paris has been a centre of extraordinary practice and patronage in the visual arts. Practitioners expected, and not infrequently received, a great deal for their efforts. This has been no accident, for successive governments have poured resources into the capital, both to guarantee its status and to nurture those who practise there. The French have always considered culture to be an intrinsic part of the national profile[1] and, therefore, they have also considered support of the arts to be an essential activity of the State.

The insistence upon the need for a high cultural profile can be seen to have come from deeply rooted political expedience. In the wake of the Revolution, it was one of the few things the State could play on in order to generate some measure of unity. In the absence of both a common language (less than half the population spoke French as a first language in 1789) and a monarch, the fledgling Republic was dangerously short of demographic cohesion and of an identifiable focus. By the beginning of the nineteenth century, the search for a national identity was resolved, in the determination to emphasise the one thing that all Frenchmen might agree to be proud of – their taste. Despite disparate languages, climates and traditions, it was persistently suggested that their innate sense of *bon goût* was a binding factor within the peoples of France. Indeed, every kind of commodity produced by the human hand was dragged under the

aegis of 'Frenchness', until taste was finally wrested from the domain of the subjective and made into the psychological property of all. On the lower rungs of the cultural ladder, it was expressed in a delight in hedonism, on the higher it was a quest for civilisation.

This 'corporate identity' strategy clearly worked, for by the end of the last century, not only had the average citizen come to believe in the superiority of all things French in the artistic domain, but he had convinced a large proportion of the rest of the world of his countrymen's abilities. An American writer in 1889 was not untypical in commenting that: 'In France there is no quality more clearly apparent than respect for the arts and works of all kinds connected with them. This trait belongs to no condition or class, but pervades alike all ranks of society.'[2] Thus the original expedient had matured into something which was good for more than political stability. It now also had the potential of paying material benefits. The funding of the arts pushed France to the forefront of practice in most spheres, and made her cultural produce the most sought-after in the world by 1850. French furniture, jewellery, food, wine, clothing and paintings, for example, were valued outside France as much if not more than inside. Consequently, by 1900, the decorative and applied arts were a vital part of the French economy, and constituted a substantial part of her export trade.

There was nothing passive or superficial, then, in the State's interest in the design of commodities. The look of goods, as opposed to their usage or durability, determined their saleability in a market which had come to see France as the ultimate generator of style. Design was the difference between economic prosperity and decline.

Adding to the tenuousness of this extraordinary economic situation – in which 'the look' of things tempered the condition of the nation – throughout the period leading up to Second World War, the State was particularly interested in goods at the luxury end of the trade, since this was where French designers had come to control large parts of the market. By 1900, in fact, luxury goods generated the hard cash which enabled the State to maintain the nation's essential services. It is hard to believe now that the French could export a greater value of hats and 'fancy feathers' to Britain than the British could sell them coal, iron and steel. Britain, after all, was still the third largest industrial nation. Yet in 1905, the British bought £4,225,000 worth of hats and feathers from the French, and in return sold them all the coal, iron and steel they needed, but could not themselves produce, for £4,151,000.[3] In economic terms, it seems, feathers could weigh heavier than steel beams. It is against this

background that the fate of the furniture trade in France has to be considered.

Up to 1914, design literature was dominated by Art Nouveau and what I shall loosely term Historicism. The two openly disliked each other, the antagonism between them often bearing the hallmarks of irrational obsession. Broadly speaking, Art Nouveau stood for progress in design, for stylistic and technical innovation. The Historicist lobby, as the label implies, was keen to preserve the French tradition, especially the three major Louis and the Empire styles.

Those who so opposed Art Nouveau, however, were not a single, stable camp. Whilst virtually all Historicist designers between 1900 and 1914 worked within the scope of the Louis or Empire styles, the nature of their commitment to the past varied considerably. Broadly speaking, they can be divided into two types: there were those who wished simply to copy the styles, particularly Louis Seize, in exact detail, and there were those who felt that the grand tradition should be subject to innovation and change. The former are best referred to as 'Reproductionists' and the latter as 'Progressive Traditionalists'. This difference of opinion, amongst what were essentially the high-stylists, was animated by the amorphous mass of the trade as a whole, which worried little about the niceties of aesthetics, or moral content, but which was obsessed with that omnipotent determinant, money. The bulk of manufacturers and retailers, whenever they considered the debate which raged about them, undoubtedly sided with the Reproductionists; the innovators correspondingly were their *bêtes noires*.

It would be wrong for the most part to suggest that any of the Historicists had systematically worked-out ideas as to the rôle of furniture in the world. They were barely self-conscious enough even to perceive of themselves as a lobby with a specific ideological outlook. Even the Progressives, when their words were submitted to print, tended to be remarkably dour about what they did for a living. One had to have a look, a function and, not least important, a price which could attract the buyer. To achieve all of these, history had to be blended with modernity. In most cases, modernity simply implied modification of the historical mode. Surfaces were flattened where they might have been bowed; sunflower decoration was used where acanthus was the convention; oriental details and materials were integrated into the cabrioles, scrolls and triglyths.

In short, the Progressive Traditionalists were keen to carry their trade into the twentieth century without losing the paraphernalia of French-

ness. They remained alert to innovatory work, and they introduced aspects of it into their own. They most clearly differentiated themselves from the Reproduction Historicists by their insistence on referring to themselves as Moderns. The catch-phrase 'evolution through tradition' has been subsequently attached to them and indeed it is a reasonable way of describing their self-conscious eclecticism.[4] Their supporters attempted to make claims for their simultaneous combination of old and new which sometimes touched the boundaries of absurdity: 'Louis XV had similarities to the Futurist, Marinetti. He attacked archeology in order to make something modern. That's the evolution of art, it's the same tradition . . .'[5] In order to put Louis XV into the same context as the quasi-Fascist Marinetti, the writer had to exclude every trace of the socio-political context from his vision of the design process.

Undoubtedly, the Progressive Traditionalists would be best character-ised as being veteran pragmatists. They understood their own business inside out and they saw the need to adapt it to twentieth-century tastes. Some of them had tinkered with more radical ideas in their first years: Follot and Dufréne had been mainstream Art Nouveau, André Mare had been involved in the décor of the seminal 'Maison Cubiste'. But by 1914 they understood well that their clients did not expect radical discourse in their furniture. They wanted something elegant, exclusive, and, in some cases, something which took a little risk. Maurice Dufréne, for example, came to see the design problem mainly in terms of the relationship of style to market. He was aware of the aims and ideals of Modernism, but he could not see how he could adapt his business in order to fit in with it:

Decorators do not work for the rich because they want to, or because they have no sense of social duty. They do so because they have no choice. In so far as he is an artist, the decorator can do what he likes. In so far as he is a businessman, he unfortunately has to do what he can. He creates for the people who ask him to do so.[6]

But this stoicism was not caused simply by their cynical vision of the market, it was also a result of their understanding of the trade they were in. The crafts at the heart of their profession moved at the pace of the skilled artisans who practised them. It was a slow, steady pace. Traditional techniques and workshop practices were not changed gladly in a world where innovation was not a priority. More than this, the trade as a whole had immense pride in its techniques and traditions; they stood for more than mere style, they represented a way of living.

It is all the more understandable, then, that the Historicist camp would resent Art Nouveau; its innovations posed a direct threat to the

workshop practices and hence social infrastructure that they knew. Their anger, on the whole, was born of a fear of the unknown and exacerbated by the knowledge that quite a number of the Art Nouveau furniture studios were run by *artistes décorateurs* who didn't have a background in furniture. Guimard, Tony Selmersheim, Plumet and Sarazin, for example, were architects, Gallé was a glass-maker, de Feure and Bonvalet started in metalworking and Bellery-Desfontaines was a painter. Thus they tended to be regarded as dilettantes and amateurs. For the Historicist designer and his retailer, the object was to make furniture, to create interior spaces of a particular quality, and sell them. Additional concepts rarely held the attention for long.

If examples from the three camps are compared, the differences between them can be easily identified. The ensemble by Paul Croix-Marie (p. 60) was shown at the Salon des Artistes Décorateurs in 1904.[7] The interior assembled by a M. Sorel featured in *Art et Décoration* in 1910, in an article entitled 'Décoration et le Mobilier d'une Villa Moderne' (p. 60). The 'Intérieur de Salle à Manger Louis XV' (p. 61) is taken from the catalogue of the 'Au Confortable' company, *c.*1908, of Rue de Rome, Paris.

The pieces by Paul Croix-Marie, whilst they still have an echo of the Louis', depend for their power upon the use of natural forms. The legs, arms and struts of the pieces appear to be bent in tension, ready to spring free violently at any second. The relationship between them is maintained not through the acknowledgement of their functional or historial rôle but through an organic symbolism. The designer has refused to allow his furniture to follow the conventions which have been established for it. The picture frame has more in common with the chair than it has with earlier picture frames; as such, it ignores the forebears of its genre. The pieces flow into each other, challenging the space they are in through this fluidity. They are not passive; an explicit sensuousness thinly disguises an implicit sensuality, this sensuality welling out of the designer's insistence on ritualising nature, for this is not nature in the raw, but nature reformed to suit human desires. Hiding in the curves and planes of this furniture the subjective consciousness of the designer is at work, denying the accepted canon of 'style' as a historically determined, immutable way of looking. The methodology denied prevailing social and aesthetic conventions in a way that those with highly formalised lives found hard to accept.

By contrast, the uncredited Louis XV dining room from 'Au Confortable' is as close to the original as the designer could get, within the

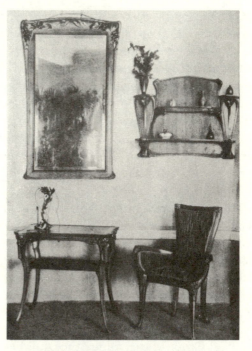

Paul Croix-Marie, *c.*1904, Paris.

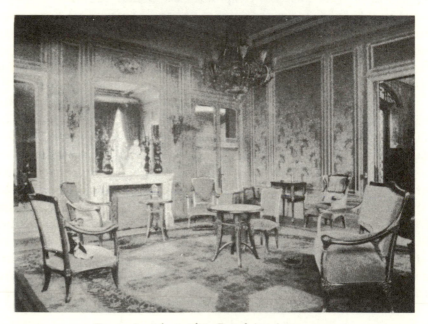

Decoration of a modern French interior, *c.*1907.

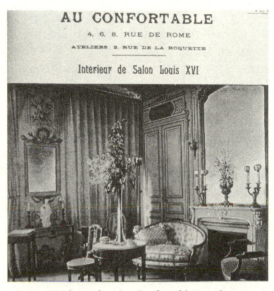

AU CONFORTABLE

4, 6, 8, RUE DE ROME

ATELIERS 2, RUE DE LA ROQUETTE

Intérieur de Salon Louis XVI

Salon Louis XV from the 'Au Confortable' catalogue, *c.*1908.

budget he had at his disposal. It is well crafted, yet as a piece of twentieth-century design it is almost invisible, so heavily does the eighteenth century impose itself on the whole. 'Au Confortable' provided furniture for a market which in general wished to have a particular set of values reinforced, not transformed, as in the case of Croix-Marie. The challenge here was not understood in terms of aesthetics, but of archaeology. Therefore it would be unfair to provide an aesthetic critique of the interior; the aesthetic issue was sorted out during the reign of Louis XV.

Wedged in between these two, Sorel's interior attempted to woo the consumer by revealing innovation in the details but not in the ensemble. This is Louis XV gently subjected to a process of simplification and distortion which the designer wished us to recognise as an implication of the modern world. His knowledge of progressive art and design, such as it was, had obviously told him that such liberties with established convention were the appropriate way to signify the new century. The whole collection appears to be Louis XV 'thickened'. It is stronger, bolder and rounder than its model, yet at the same time it seems to lack its tension and verve. The quasi-geometry of the carpets, the smoothed-off, pared-down frames of the tables and chairs put the whole firmly in the twentieth century, yet we are not given a clear message, as a twentieth-century audience, as to how to respond emotionally to it all. The decision-making process is fogged by ulterior motives, making it difficult

for us to analyse the forms in terms of themselves. Surprisingly, the only clear reading we can make of it is, obliquely, a politico-economic one; it is French and it is expensive.

All these observations operate in an ideological way. The variance in the shapes, colours and complexities of the three interiors, if observed by someone utterly unaware of their signification, would be slight. In the world of shapes, the difference between a cabriole and a whiplash leg was minor. In the world of ideas, however, it was profound. It was not the extent or quantity of the curves which counted with Art Nouveau or Louis Seize revival, but what they meant in a context wider than the furniture trade. That is where the conflict lay. In 1900, the qualms of the Historicists were well known but insufficient to stem the growth of Art Nouveau; it would take weightier forces than these to prevent its wide acceptance as a legitimate style. By 1910, however, they had entered the arena.

It would be a mistake to assume from what has been said so far that the State necessarily operated in a direct fashion upon designers, or that the many bodies which helped create the national outlook in France were part of a co-ordinated policy. In a complex and plural society, power rarely operates in so simplistic a way. Much rather, over a long period of time, disparate power groups attempted to naturalise into society their own attitudes towards commodities. Such attitudes had factors in common and it was these which eventually gelled into a widely accepted ideology. As well as the State executive itself and its various organisations, such as the museums and academies of art, those sections of the private sector which controlled the mechanisms of production and consumption contributed towards the prevailing socio-cultural climate. Industrialists, the Bourse, retailers and the press, all had an interest in establishing within the community particular modes of living. These grand power-blocs contained within them many smaller ones, carrying messages out to a wide sweep of audiences. Some of them believed that they themselves stood to benefit from the ideology they promoted, others thought it would improve the lot of all.

Regardless of morality, by 1900, part of the intellectual baggage of all groups with a power base, no matter how small or philanthropic they were, was a clearly defined idea of 'Frenchness'. To all, this was equated with cultural sophistication. In this way French design was animated by a

powerful superiority complex which made innovation of any kind problematic.

The furniture trade was given shape and direction by numerous organisations which had come into existence with no other *raison d'être* than the promotion of French design. Principal amongst them were the Union Centrale des Arts Décoratifs (founded in 1889 under the name Union Centrale des Beaux Arts Appliqués à l'Industrie), the Société d'Encouragement à l'Art et à l'Industrie (founded in 1889 and under direct State control by 1905), and the Société des Artistes Décorateurs (founded in 1901). They tended to duplicate each other's activities, and so, by 1905, had begun to co-operate in order to avoid impairing their own interests. The published manifesto of the Société des Artistes Décorateurs gave a reasonable description of what they were all trying to do. It had four objectives: (1) To rejuvenate all of the applied arts. (2) To organise exhibitions of design. (3) To participate in, and promote, all events which carried the words Industrial Art / Decorative Art / Applied Art. (4) To promote design education.

These three bodies gained support from others with more specific functions. The Comité Français des Expositions à l'Etranger (founded in 1886 and made into an official State agency in 1904) was responsible for the organisation of French contingents, both official and private, in foreign exhibitions. From 1889, when it took control of the 'French Exhibition' held at Earl's Court in London, it proved an invaluable publicity machine. In 1916, the Comité Centrale Consultatif Technique des Arts Appliqués was founded in Paris, with offices in most of the major regions. This was an organisation directly connected to the Ministry for Trade and Industry, and had one aim, 'to consolidate in the world the predominance of French art and taste'. It was particularly concerned with organising activities in the regions. The year after, La Fédération des Sociétés d'Art pour le Developpement de l'Art Appliqué met for the first time. This was a composite organisation founded and presided over by François Carnot. Essentially, it co-ordinated the efforts of all the others. Finally, in 1922, the Société de l'Art Appliqué aux Métiers became active in Paris. The workings of this particular group before 1925 are still shrouded in mystery; it first gained a distinct profile in that year by having its own section at the Art Deco Show.

The *Sociétés* acted more than anything else as a go-between on behalf of the State and private enterprise. The public bodies over which they exercised influence were those involved in the training of designers and in the selling of goods. The Ecoles des Beaux-Arts, Ecoles de Dessin and

Ecoles des Arts Décoratifs had grown far more numerous in the last twenty years of the nineteenth century, providing a rich ground for design propagandists to ply their wares. At the retailing end, the *Sociétés* were helped by the French Chambers of Commerce, often collaborating with them on projects. For example, they and the Sociétés d'Encouragement Artistes Décorateurs and the Union Centrale liaised with the major department stores in Paris in order to maintain the interests of French designers, especially those working in a modern idiom. The final triumph of this co-operation was the employment of M. Guillieré, president of the Société des Artistes Décorateurs, as house advisor to the prestigious Magazin du Printemps in 1912. The Ministries of Commerce, Trade and Industry, Public Instruction and Fine Arts shared the responsibility for design education and marketing, all three being allocated funds to organise exhibitions, award prizes and encourage retailing initiatives. They worked closely with the *Sociétés* in all aspects of their activity.

The Union Centrale des Arts Décoratifs and the Société des Artistes Décorateurs (SAD) were both enthusiastic supporters of Art Nouveau in the first years of the new century. The pavilion of the Union Centrale at the Exposition Universelle of 1900 was dominated by it, as were the annual Salons of the SAD up to 1907. Even after that date, through to 1912, a considerable proportion of the exhibited work was mainstream Nouveau. Until 1907, therefore, Art Nouveau enjoyed quite an amount of patronage, having arrived at the threshold of becoming an accepted establishment style in furniture and the applied arts. Not the least of its achievements was to gain space in popular stores and trade catalogues. Apart from this, it was well represented in the regular exhibitions held at the Pavillon de Marsan, which eventually became the Musée des Arts Décoratifs. In 1903 an exhibition of the Ecole de Nancy was held there, and in 1907 it housed the SAD's annual Salon. The Comité Français des Expositions à l'Etranger, the official body controlling French contingents in foreign Expositions Universelles, had an essentially positive, albeit pragmatic, attitude towards Art Nouveau. At the 1905 Liège Exposition, the French sections bristled with it, while there was virtually none in the official sections of the St Louis World's Fair of 1904 or at the Franco–British Exhibition in London in 1908. This was because the Comité believed that the Belgians would appreciate it, but that the Americans and British were too conservative – and too fond of the Louis' – to be able to cope with it. Like the Comité Français, the Société d'Encouragement was not particularly for or against Art Nouveau in the first years of the

century; it simply saw it as another potential vehicle for the boosting of sales.

Thus it would appear surprising that, after 1907, official enthusiasm for Art Nouveau should wane, before turning decidedly hostile. By 1912 the Historicists decisively had the upper hand, and by the end of the First World War, Art Nouveau as a movement had collapsed. No organisation took it seriously by 1916, some saw it as a threat, no magazine gave it coverage and most of its leading practitioners had either disappeared or changed direction in order to survive. By 1925, the climate had gone against it so heavily that critics found themselves able to insult designers by suggesting that their objects had a feel of Art Nouveau about them.

The switch in attitudes on the surface appears to defy explanation, especially against a backdrop of earlier acceptance. French Art Nouveau was not overtly politicised, and it certainly never subscribed to the kinds of idealism of Belgian and German equivalents. Art Nouveau manifestos, if that is the appropriate term, were in the main vibrant but vague. Nevertheless, objects produced by adherents of the Ecole de Nancy clearly came to represent unacceptable trends for those in establishment circles.

In some ways, Art Nouveau took the French establishment by surprise. Whilst many correctly understood it as being the first, broad-based Modern style which the design world had experienced, they did not initially understand its implications in a broader sense. During its first flourish, up to 1907, it was normally read simply as 'moderne', and accepted by an affluent, confident and occasionally liberal establishment as being a potential means of keeping the progressive end of French design up with the rest. As the decade wore on, it became clear that this was not the only purpose it served. Even if many of its exponents were politically and socially ignorant, the essence of the practice they were engaged in signified forces beyond the confines of the furniture show-room. In several ways Art Nouveau had anticipated radical Modernism proper, being part of the general European trend that might be labelled 'Proto-modernism'. Accordingly, it had features which were, ultimately, unacceptable both to the trades and to the majority of Frenchmen. By 1910, when it revealed a disposition and a staying power few had anticipated, the antagonism towards it grew dramatically. This was exacerbated by a local economic factor which the various authorities felt they could not ignore.

The vociferousness of the attack on Art Nouveau after 1910 was at least partly caused by a general economic slide and subsequent loss of

confidence in the furniture trade as a whole. The first decade of the twentieth century had not been a good one in terms of foreign trade, and an important section of the overseas market, the educated liberal middle classes, appeared to have been lost. Unthinkably, the same section of the home market had been severely infiltrated by the Germans and British. Despairingly, in 1910 the Société des Artistes Décorateurs sent a circular out to manufacturers and retailers asking them to pay greater attention to the progressive end of the market, since this was being lost to France: 'A modern French movement exists, and yet more than twenty foreign shops are open in Paris for the sale of their modern furniture, against four French ones.'[8] Whether this was true or not, the trade figures with Britain for the period were alarming.[9]

	Exports to Britain	Imports from Britain
	£m	£m
1907	2.3	1.7
1908	2.1	1.6
1909	1.7	1.8
1910	1.3	1.8
1911	1.4	2.8

Between 1850 and 1906 the French had enjoyed a substantial slice of the English market, without ever imagining that the English might one day reach a point where they exported twice as much furniture to France as they imported from her. By 1911, it was hard not to conclude that there was something wrong with the look of some of the products favoured by the organising bodies within the industry, especially those in the style which had come on to the scene recently. Critical attention was thus turned towards Art Nouveau.

This attention settled on the three self-conscious elements which differentiated Art Nouveau from other design options: its anti-historicism, internationalism and naturalism. The first two were felt to be the most significant. A rejection of past styles for formal reasons would have been an unusual but nevertheless innocuous occurrence, but this is not what happened in Art Nouveau circles. Indeed, most designers were open about acknowledging the beauty of earlier work; Croix-Marie, Guimard, de Feure, Jallot, Selmersheim, Marjorelle and many others owed obvious formal debts to the French tradition, most noticeably Louis XV and Empire. Old shapes were acceptable; it was the use of past styles as signifiers of earlier periods which was proscribed. Thus it was not the form but the language of the past that Art Nouveau abandoned.

In a broad political sense this proscription was of importance, as it

could easily be read as a derogatory comment on French history. The past, for those who believed in it, was the key to nationhood and as such it provided a telling definition of what it was to be French. *Bon goût* based on the past could function as the soul of the nation. In 1900, a professor at the Beaux-Arts, after having given an aggressive formal critique of Art Nouveau furniture, added with venom: 'It is advisable not to make modernism a simple mania and reject systematically all that was made by our fathers, unique because they made it.'[10] In other words, when creating new forms, designers should be careful to preserve indicators of their French ancestry.

The international stance was as close as most of the key practitioners came to having an overt and articulated political position. Having said this, internationalist attitudes invariably arose more out of a hedonistic cosmopolitanism than open anti-nationalism. One of the major critiques of Art Nouveau, from the time of its greatest influence until after its final disappearance, was that it had evolved abroad, and therefore did not reveal in its forms the glory of the French tradition: 'I'd ignore all [its faults] if in future, by a series of transformations, it would achieve a French appearance.'[11] Worse still, it was perceived to be a hybrid style, owing debts to Japan, England, Belgium, Holland and Germany.

Perhaps the most widely read books on contemporary furniture in France during the early 1920s were Emile Bayard's *Le Style Moderne* (Paris, 1919) and Emile Sedeyn's *Le Mobilier* (Paris, 1921). The publication dates are significant, as the authors wrote at a time when Art Nouveau was at its lowest critical ebb. Both were firm in their insistence that it was not a French style. Bayard, for example, aggressively constructed an idea of modernism which excluded it at all points:

Modern art [read design] is in its essence French; in spite of the pseudo style that came from Austria under the name of 'Secession' (Society of Artists of Munich), this was preceded by a 'New Style' towards 1895, which was hardly French, followed by 'Art Nouveau' and a 'Modern Style'. It was only in 1912 that a reaction came against this discord in the search for harmony, and this came from a return to past styles.[12]

'New Style', 'Modern Style' and 'Art Nouveau' are all oblique references to Britain, Italy and Belgium. Sedeyn is less aggressively nationalist than Bayard, but like him he could not accept that Art Nouveau as a style could ultimately be of much use to France. Rather, it was a necessary transition before French design returned to the true path. He saw the style as coming from England in the first instance, before being developed into its definitive form in Belgium. Whilst acknowledg-

ing, along with most writers of the time, that the initiators of Art Nouveau were the Arts and Crafts Movement and the Pre-Raphaelites, he also had a nationalist note to add:

It is clear that the English furniture commercialised by the more far-sighted and observant manufacturers, came less from the theories of Ruskin and Morris, than from the taste of the citizens of the United Kingdom for that which is simple. One tires quite quickly here of its excessive simplicity; but one should remember its neat proportion and its comfortable disposition.[13]

Combining the idea of tradition with that of French taste, Sedeyn came to the conclusion that the kind of revolution which Art Nouveau attempted to bring about in moving away from the past was impossible:

A style as one understands it when speaking of Louis XIV or Louis XV, of the Empire, does not emerge from one idea. It forms slowly, by virtue of successive contributions, sharing the same ideals albeit arriving along different roads. There has never been a style which was first of all a personal effort or original creation.[14]

After 1914, however, it was the German connection which proved to be the real stumbling block for Art Nouveau. In 1910, largely through the initiative of the progressive designer Francis Jourdain, Secession designers from Munich were invited to show at the Salon d'Automne. Both at the time and later, this exhibition was widely portrayed as having great significance for French design. Most monographs, both on Nouveau and Deco, continue to refer to it as being a seminal event. In 1921, Emile Bayard saw it as important, but not because of its aesthetic qualities:

For the ignorant public, it was a shock to their habits to see 'Munichois'! But the style Munichois was not new, even though there were Frenchmen who spoke such slanders! The Munichois exhibition at the Autumn Salon of 1912 was a beneficial surprise. It showed the existence of a German art. A German art with all its faults, but nevertheless German, which we did not take as an aesthetic example, but rather from which we sought emancipation . . . that which is called Munich style is really a pot-pourri of Greek, eighteenth century, Louis-Philippe and Second Empire.[15]

Accepting his anti-German aggression, he had a point. By 1910, Paris and Nancy had provided furniture and work in metal, glass and ceramic which was as radical as any of the German work exhibited at the Salon. Much of the latter, in fact, was staid and traditional in appearance. In retrospect, the German work appears to have been given an artificially positive image by those amongst the French avant-garde who were internationally-minded, and an unrealistically notorious one by critics

who could not bear the idea either of German furniture or of French Art Nouveau. The only solace of the latter was the hope that the hated Modernism would come to maturity somewhere other than in France. Thus, the 'Munichois Salon', both at the time and later, acquired a profile that it did not particularly deserve.

'Munichois', to the chagrin of progressive French practitioners, forged a connection between Germany and Art Nouveau which proved impossible to sever. By 1916, with the trenches full of troops, the Comité Centrale Consultatif Technique des Arts Appliqués issued fiery propaganda against German applied art of all kinds. Its aim was: 'To prepare, in accord with our regional committees, the defence of our industries . . . (against) the light from the lamps of Nuremburg, warmth from the heaters of Leipzig, carpets with material from Gladbach and Crefeld, furnishings from Darmstadt and from Munich.'[16] The combination of economic need and national hatred doomed any commodity which had the faintest suggestion of Germany. Ironically, two decades later, it was German Historicism that encouraged the French to usher Modernism into the limelight.

The international and ahistorical appearance of Art Nouveau was achieved through the use of nature as a source. More than anything else, a style evolved from natural form allowed for the elimination of the classical syntax that had effectively dominated French design for two hundred years. Undoubtedly, the conjunction of internationalism, anti-historicism and naturalism also gave the style its peculiar ability to appear anti-hierarchical. In its very appearance it seemed to negate the class structures which older design forms had reinforced. It could not be measured and classified easily; rather like the liberal–progressive factions of the bourgeoisie who patronised the new designers, it slipped categories in an uncomfortable way. Thus Art Nouveau was correctly perceived by those opposed to it to be capable of subversion. In this way it heralded the Modern world.

1911 was a tense year for design-related industries because, had the convention been followed, there should have been an Exposition Universelle in Paris. The Expositions were the most lucrative events in the decennial calendar for all the visual arts. It was clear however, some time before 1911, that central government was dragging its feet over the issue. Eventually, the Société des Artistes Décorateurs, the Société d'Encouragement and the Union Centrale sent a letter to the Under-Secretary for the

Fine Arts requesting that an Exposition Universelle be held in Paris in 1914 or 1915 instead. During the course of 1911, in the absence of a clear response from government, the three *Sociétés* took the initiative and held meetings with the Chambers of Commerce about the prospective Exposition, in order to formulate a policy for the design arts. A progressive lobby at these meetings attempted to get a general agreement that historical styles be excluded. It was defeated, mainly by the Chambers of Commerce. This mattered little at the time, as the war precluded any possibility of an Exposition.

However, when the Exposition finally did become a reality, in 1925, the radical element appeared to have won the day. The opening clause in the prospectus to potential exhibitors stated that:

Works admitted to the Exhibition must be those of modern inspiration and of genuine originality, executed and presented by artists, artisans, manufacturers, model makers and publishers, in keeping with the demands of modern industrial and decorative art. Copies, imitations and counterfeits of antique styles are rigorously excluded.[17]

Surprisingly, this bold rejection was not inspired by adherents of some new movement, or even by survivors of the (by then beleaguered) Art Nouveau camp. It came mainly from the Progressive Traditionalist lobby, which had grown increasingly powerful as the war progressed. They were now ready to take up their definitive position in the canons of design history, as members of the 'Art Deco' school, having evolved their practice to the point where they could talk of themselves confidently as being 'moderne'. At the Art Deco Show, in fact, almost everyone was 'moderne', with only a tiny number having the vaguest inkling as to the implications of 'Modernism'. With the demise of Art Nouveau and the exclusion of reproduction furniture, the determinants within the debate had changed.

The Art Deco lobby had two tendencies within it. Olmer Pierre, a professor at the Ecole Boulle, perceived these as having evolved after 1910. He labelled them the *'constructeurs'* or *'logiciens'* and *'les fantaisistes'*:

One is able to say that at the end of the Great War, there were two schools of thought in design. There was beautiful luxury furniture, studied with great refinement and perfectly executed, connecting itself in this way with great examples from the past in its architectural sumptuousness: the furniture of Ruhlmann; the other is furniture of the present, rational without being pedantic, spiritual and lively, logical and simple without being austere: this is the furniture of Francis Jourdain.[18]

Ruhlmann had been the leading Progressive Traditionalist, and his Pavillon d'un Riche Collectionneur was the icon of the group he led (p. 72). Those associated with his outlook included Paul Follot, André Groult, André Domin, Michel Roux-Spitz, Maurice Noël, Maurice Dufréne, André Fréchet, Louis Sue and André Mare. Francis Jourdain had inhabited the world of Art Nouveau without ever really being of it. He was an inheritor of the rationalism of Viollet-le-Duc and so persistently associated technical honesty with modernity. He had also inherited elements of the Gothic Revival's social morality. In his early championing of designers like Tony Selmersheim, he showed allegiance to those who had eliminated historical decoration by integrating function into decoration. By 1920 he had dispensed with nature as his key source, had reintegrated history and had adopted a quite severe geometric form. (p. 73). Other designers of this persuasion, such as Eric Bagge, Pierre Chareau, Perret frères, André Levard, Georges Champion, Dominique, Pierre Legrain, J. J. Adnet and René Gabriel, shared Jourdain's visual sense, but not his morality.

Ruhlmann's Traditional Progressives now took on a rather reactionary rôle, whilst Jourdain's band fashioned themselves radical stylists committed to the transformation of the appearance of French furniture. The space between them is revealed most clearly by the frequent extremity of the eclecticism employed by the latter, rather than by any fundamental, philosophical difference. Some of the radicals revealed a shocking willingness to abandon the limited range of French Historicism in order to embrace any visual stimulus that appealed to them. They were also more prepared to experiment with new forms and materials. Their interiors tended, in the end, to be concoctions of the old, the new and the popular. In successful instances, this congealed into an integrated whole; in others, it remained an extraordinary mélange of contradictory stylistic messages, which neutralised themselves out in confusion.

The method employed by virtually all Art Decoists to achieve their 'look' was one of embellishment; existing practice was decked in trappings recognisable as innovative. Even where there was more striking experimentation with structure, as with Pierre Legrain or Eileen Gray, the motive remained essentially the same, in that it generally entailed the integration of different stylistic traditions. The most pillaged sources were either those that had been legitimately avant-garde, or which were so distant in time and place that they would appear to be new. Avant-garde painting and sculpture, especially the post-Cubist work of the Delaunays, Léger, Metzinger, Laurens and Lipchitz, provided good

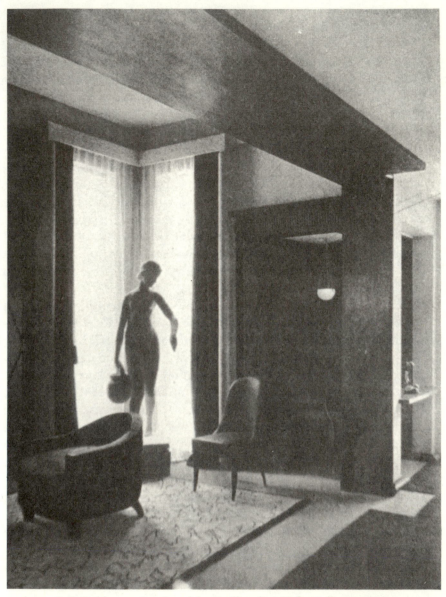

J. E. Ruhlmann, interior of the Pavillon d'un Riche Collectionnaire,
Art Deco Show, Paris, 1925.

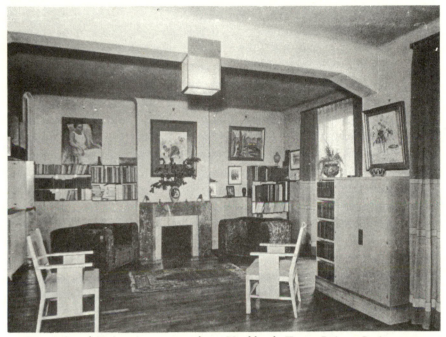

Francis Jourdain, interior, *c*.1929, from *Meubles du Temps Présent*, Paris, 1930.

sources. After these, ancient and oriental styles were liberally used. Pre-Columbian, Ancient Egyptian and Roman structures and details were popular, as were North and West African forms and surfaces. Use of ancient and non-Western art was partly legitimised by the long tradition of its use by avant-garde artists. In the case of the traditionalists, additions to the Louis' and Empire styles were usually restrained, sometimes being no more than experimentation with new veneers and timbers. The norm for them was one whereby an overall profile of tradition was maintained, with new sources creeping into the details.

These methods of achieving a contemporary profile were unashamedly cosmetic, in so far as they focused on the transformation of appearances rather than on the technology, economy or cultural rôle of the furniture. Nevertheless, in terms of the trade, it constituted a brave attempt to render the profile of French furniture more appropriate to the twentieth century. The basic aim had been to create an additional French style which could compete successfully with the various foreign ones. At least, this had been the aim of the organisers and supporters of the Art Deco Show. Arguably, they succeeded.

But there was a new approach in evidence at the Art Deco Show, which

had grown steadily over the previous decade, largely in isolation from the trauma of French cultural politics. Moreover, the creators of this new approach saw all factions within Art Deco as utterly futile. Between 1918 and 1925, Purism, one of the founder Modern Movements, became audible and visible in Paris. For most of those years it went unnoticed or was ignored by the bulk of the furniture trade and its associated journals and organisations. This was due mainly to the fact that its leading figures were not from that world, but tended to be architects or painters. Neither was Purism, in the first instance, a commercial venture, making it invisible to those involved exclusively in commerce. It acquired a focus in 1920 with the foundation of the magazine *L'Esprit Nouveau*. Several books and exhibitions further reinforced the movement, gaining it the attention of a small but vociferous audience, drawn mainly from the Fine Art, political and poetic circles of Paris.[19] The leading lights associated with the movement were Fernand Léger, Amédée Ozenfant, Paul Dermée, Pierre Jeanneret and Charles Edouard Jeanneret, known as Le Corbusier. These men, and especially Le Corbusier, were uncompromisingly committed to the reconstruction of the urban environment in accordance with moral and technological codes that they had helped to determine.

Again, a comparison will serve to show the differences between the available approaches. The 'Chambre de Madame' in the Pavillon d'un Ambassade Française by André Groult was in the Art Deco Show[20] (p. 75); the interior of the Pavillon de l'Esprit Nouveau was also in the Art Deco Show (p. 75); the 'Salle à Manger Chez M.R.' by J. J. Adnet appeared in the publication *Meubles du Temps Présent* in 1930.[21] (p. 76).

The Pavillon de l'Esprit Nouveau was the most uncompromising example of Modern Movement design ever erected in a major international exhibition. Essentially it was a prototype for a dwelling which had been subjected to the forces of prefabrication and mass production. Its interior décor and furnishings were as near to standardised elements as the architect could manage. Most of the furniture and fittings were either ready-made, mass-produced items or adaptations of them; so, despite the radical appearance of the ensemble, the artefacts were not 'designed' by Le Corbusier at all.[22] The complex range of craft skills associated with furniture was eliminated at a stroke, surfaces and forms being stripped of decorative additions. The designer sought to achieve poetic and emotional goals through the juxtaposition of geo-metricised form and the manipulation of space. The rest was determined by the economy and technology of modern living: 'Furniture is: tables for working on and for dining / chairs for dining and for working / easy

André Groult, 'Chambre de Madame' from the Pavillon d'un Ambassade Française, Art Deco Show, Paris, 1925.

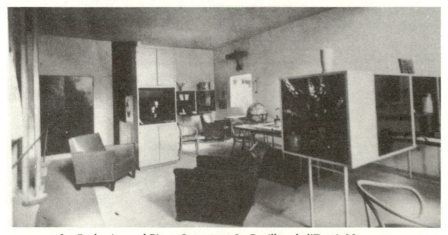

Le Corbusier and Pierre Jeanneret, Le Pavillon de l'Esprit Nouveau, Art Deco Show, Paris, 1925.

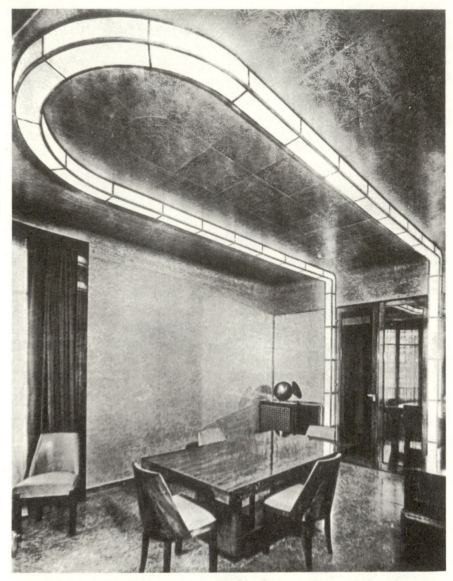

J. J. Adnet, interior, *c.*1929, from *Meubles du Temps Présent*, Paris, 1930.

chairs of different kinds for relaxing in various ways / and *casiers* for storing the things we use . . . Besides chairs and tables, furniture is nothing other than *casiers*.'[23]

By absolute contrast, André Groult's bedroom is the sum of many additions, as opposed to subtractions. The form is Empire, mixed

strangely with Louis Quinze, yet reference to both is absent from the details. Here, Pre-Columbian meets Roman by way of Egypt. The feet of the bed and the sunburst motif across its bottom reveal a knowledge of modern painting and sculpture. The light fittings are the ultimate Deco statement: a flawless combination of the old, the ancient, the foreign and (fine art) modern. The whole is about luxury and the celebration of power and wealth. The woman who slept in the bed would be surrounded by signifiers of her status, the oriental departure from the French tradition revealing the growing rôle of her nation in the world and the cosmopolitan nature of the twentieth century.

Adnet's dining room has the same type of eclecticism in it as Groult's bedroom, but a different meaning and temperature are achieved through the aggressiveness of his combinations. He had a penchant for overpowering geometric form both under and over his interior spaces. Often he would have carpets composed out of violent triangulations; in this case, he has created an extraordinary lighting system. The fitting in itself is a celebration of technology and geometry and reveals the extent to which Adnet understood the possibilities of new materials and functions. It presides, however, over Ruhlmannesque furniture, chairs that are a quiet fusion of old and new, of the richness of the Empire and the simplicity of the new century. Every element in the room works well with the table and chairs except for the lighting. The former remind us of the gentility of a France long past, the latter carries us forward into the striplighting of cinemas and coffee bars. Such a vulgar suggestion would, of course, have horrified Adnet, whose parameters were exclusively *haute couture*. The juxtaposition of elements in the room gains its interest through the brutality of contrast, unlike the work of Jourdain, Champion, Bagge or Chareau, but the method of combination is the same. Besides this, every aspect of the room, as with Groult's bedroom, reveals the loving attention of individual craftsmen. In the richness of their finish, the two rooms belong together.

If we did not know, we might well have suspected that there was a political and moral impetus behind the Pavillon de l'Esprit Nouveau. Amid the uniform opulence of the Art Deco Show, its sparseness bordered on the religious, its simplicity revealing an egalitarianism which was absent from the rest of the French contingent. It questioned the morality of consumption by preventing us from consuming, and in its economy it preached availability rather than exclusivity. It was a celebration of collective, not individual, design. Had it commanded more attention than it did, undoubtedly commentators would also have

noticed that it was internationalist in outlook and that it bore a distinct resemblance to contemporary German projects.

Harnessing its utopianism was a vibrant dogma, most clearly revealed in the willingness of the designers to engage in what were, for 1925, wholly impractical (and expensive) prefabrication techniques, in order to demonstrate their future potential. They also carefully skirted around the devastating effects of mass-production systems on the workers they were proposing to house. There was more than a little irony in what was an essentially socialist project which wished to eliminate traditional trade practices. In a very real sense this stood to strip the workforce of its key negotiating weapon in the push towards economic and political recognition: their skills. But then the whole pavilion was no more or less than a manifesto; as with all political statements, it did not say what it did not wish to be known. It remains important because it offered solutions to problems which had not been considered by Groult, Adnet and their ilk as being anything to do with design.

It would be logical to assume that the creators of the Pavillon de l'Esprit Nouveau saw the Art Nouveau designers as their forebears. In fact they did not, beyond recognition of a common struggle away from Historicism and acknowledgement that the furniture issue was part of a much wider debate. Indeed, the Purists loathed Art Nouveau virtually as much as the Deco and Historicist lobbies. The principal source of Art Nouveau – nature – was not deemed appropriate to a design form committed to the rehousing of mass, urban society. More than this, the open hedonism of its asymmetrical twists and curves, its mystical symbolism, allusions to leisure, physical indulgence and sexuality, was not the stuff of Le Corbusier's new world. For most Pioneer Moderns, the search for value and meaning was a Platonic one, informed by the ethic of work and the rigour of a Puritan outlook. For Le Corbusier, the higher planes of consciousness were arrived at via the mind, not the body, and Art Nouveau was to do almost entirely with bodies. There could be nothing but decadence in its sepals and tendrils and so it was proscribed. In his determination to eliminate what he thought to be a *fin de siècle* aberration, Le Corbusier was at one with the Art Deco lobby. Together, they squeezed the final breath out of it and reserved the arena for debate entirely for themselves.

Unlike ideas, styles very rarely remain enemies for long. If the Pavillon de l'Esprit Nouveau was an alien creature in 1925, by 1930 its principal

visual traits had been understood and absorbed into the language of the
Art Deco school. Its white walls, partitioned spaces, black leather, canvas
and tubular steel soon became decorative features available to all. Then
as now, this revealed the most difficult problem for any designer
attempting to explain a moral thesis via material construction. The
morality of an object is easily dispensed with by those who simply wish to
use form for stylistic gratification or ironic commentary. There is no *a
priori* link between form and idea. Rather, the idea is merely a temporary
occupant of the object.

The power to appropriate other forms and thereby transform their
meaning was one which grew markedly in France after 1925. Before that
date, the idea behind a style clung far more stubbornly to its object, or at
least, those who wished to appropriate styles found it difficult to rid them
of their intended meanings. For example, the appropriation of the
principal features of Art Nouveau by Historicists was never really
accomplished, its flippant radicalism remaining with it as a background
aroma. Ironically, this stubbornness was a legacy of nineteenth-century
Historicism. Unlike their twentieth-century counterparts, many earlier
Historicists placed great importance on the meanings which styles had
carried at the time of their invention and they often utilised them so as to
preserve the integrity of the original signification.

The Modern Movement received no such consideration. Despite the
fact that the Purist, De Stijl, Bauhaus and Constructivist designers were
preaching far more revolutionary ideas than Guimard, Jallot or Bellery-
Desfontaines ever dreamed of, their forms were employed without qualm
shortly after they were invented. In 1925, Maurice Dufréne, Traditional
Progressive turned Art Decoist, must have walked around the Pavillon de
l'Esprit Nouveau, if he bothered to visit it, in dismay. By 1930, he had
borrowed from its furniture in order to sharpen the profile of his own,
increasingly staid, range of chairs. Aesthetic potential, allied to fashion,
was all that concerned this most insatiable of *artistes décorateurs*.

In many ways, therefore, the struggles within French furniture during
the Art Nouveau years were of greater potency than later debates and
confrontations. This was because Art Nouveau came close to becoming a
legitimate mode of practice before it was stripped of its meaning. Had it
survived the extraneous forces at work before 1914, it might have carried
its ideas into the mainstream. It would not have been a revolutionary
form of Modernism, of course; it would have been decidedly revisionist.
Nevertheless, it came close to legitimising a methodology which went
well beyond mere machinations of style. Purism, on the other hand, was

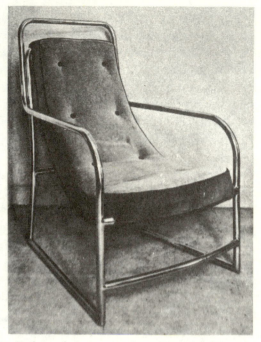

Maurice Dufréne chair, c.1929, from *Sièges Modernes*, Paris, 1929.

as radical as design could hope to be whilst on the periphery; when it aspired to the centre, and its forms were utilised by designers other than its originators, it speedily lost its point.

It was not only old pragmatists like Maurice Dufréne who saw the stylistic potential of the Modern Movement. The realisation that style could be utterly dislocated from its intended meaning allowed larger institutions considerable licence to appropriate whatever imagery they liked. Amazingly, at the last Exposition Universelle held in Paris, in 1937, the International Style was turned on its head and used to reinforce the idea of French nationhood. At that point, as far as Modernism as a force for change was concerned, the struggles within French furniture were over.

Throughout the period, the French kept a constant if haphazard eye on the progress of their design. Whilst there was never a violent edge to this surveillance, in that no one was proscribed, expelled or jailed for their adherence to particular movements, it would be fundamentally wrong to assume that it was concerned with disinterested issues of taste. It was not. It was to do with the way a nation saw itself and the way its economy worked. Even though such large issues seem somehow distant from the

rarefied atmosphere of the *artiste décorateur*'s workshop, in the end they came to tell on his products.

The Modern Movement, from its tentative growth through to its most vocal proclamations in the later 1920s, was internationalist and socialist. The French government and its agencies were concerned principally with the maintenance of demographic harmony within its boundaries, with self-protection and with trade. Put more brutally, it was committed to the furtherance of nationalism and capitalism as instruments of government. The space between it and the Modern Movement could not be bridged without one or the other fundamentally changing its outlook. In so far as this was achieved, it was through the appropriation of stylistic mannerisms into the body of the trade. The Modern Movement, as it were, was converted into 'moderne' in order that it should be acceptable. As an ideal, it barely had a chance to appear before it was gone.

The centre of German Modernism in design was the Bauhaus. Between 1919 and 1933, when it was closed by the National Socialists, the Bauhaus constantly advanced ideas and prototypes which were at the very fountainhead of radical activity. Obviously this extraordinary institution did not spring from nowhere, but was a result of debates which had been conducted over the preceding decades. Neither did it offer the only interpretation of 'modern' or the only solutions as to the rôle of politics and economy in design. Opposing its idea of collective life based on socialist principles were ideas which emphasised the significance of the individual within both culture and society and espoused capitalism as the most apposite economic form. The interior space then became an arena not only of aesthetic debate, but of pyschological and political struggle. 'Interiority' in its widest sense seemed to imply anything from certain modes of decoration through to personal morality and political affiliation. Bound up in this confused struggle to occupy the terrain of 'the modern' were the objects themselves, commodities designed to reflect or rebuke particular ways of living.

The intensity of the debate in Germany was undoubtedly due in part to its intellectual tradition of idealism, which inevitably led to the creation – both on the right and the left – of absolutist models. It was also due to the extraordinary condition of Germany in the first four decades of this century. A massive industrial power almost constantly fractionalised and on the edge of chaos, the search for an appropriate order by thinkers on every level of German society meant that culture and politics would ultimately converge, and that factions would be violently opposed. Germany was probably the only country in the interwar period where a project like the Bauhaus could have been set up; equally, it was also probably the only place where a school of art and design of any description would have been closed down in such a manner.

4

The Cultural Politics of the German Modernist Interior

MARTIN GAUGHAN

In 1928 Ernö Kallai, the Hungarian cultural critic and editor of the *Bauhaus* journal, wrote an article in that journal which expressed unease about aspects of contemporary design culture related specifically to domestic architecture and the interior: 'We live not simply to be housed, but are housed to be able to live'. He went on to make a surprising, if not totally inapt, comparison between the present and the relatively distant past, asking: 'Does the advanced technical state of our domestic building arrangements merely amount to a displacement of the clutter of the Makart-period by the present-day clutter of machines and apparatuses?'[1] What Kallai would seem to be referring to in this particular instance is the danger of replacing one process of fetishism (the Historicist fantasies furnished by Makart (p. 84) for bourgeois speculators) by another (that of a reformist utopianism over-dependent on a capitalist ideology of the rationalisation of work, whether in society or in the home). The focus of this essay will be the socio-historical space briefly mapped out by Kallai and the rôle of design Modernism in contributing to, or attempting to resist, such fetishism. By proposing that design in its Modernist manifestations may contribute to or resist fetishism, a term I will develop more fully shortly, I am obviously suggesting that cultural Modernism is neither a homogenous nor a neutral term, but a highly problematic and ideological one, and that its meaning may only become clear when it is acknowledged that there is a politics of Modernism.[2]

In order to understand how design Modernism was engaging with social modernisation and its consequences, one must turn to a politics of the sign, a social semiotics. One source is the work of the Soviet theorist, Volosinov, here writing of natural language as a sign system but it may be translated: 'Thus various different classes will use one and the same language. As a result differently oriented accents intersect in every ideological sign. Sign becomes an arena of class struggle.'[3] In a parallel manner the objects of design take up their position within such an

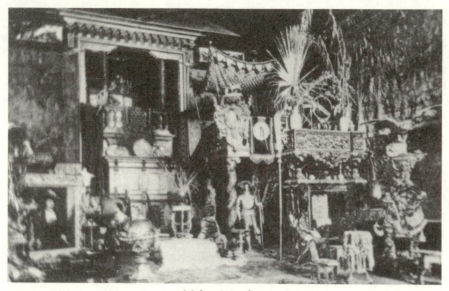

Makart's studio.

ideological contestation. Such contestation was central to the politics of *Sachlichkeit* in Germany during the period of high Modernism: *Sachlichkeit* as the embodiment of capitalist reification, incorporative and disempowering in intent, or *Sachlichkeit* conceived of as the agent of socialisation and empowering. *Sachlichkeit* is not a term which translates readily: within the design context it may be seen as spanning a continuum between the concepts of sobriety, severity and functionalism. (*Sachkultur* – see below – is a related term.)

Before turning to a detailed examination of aspects of the interior I want to define some of the terms I shall be using to establish a particular perspective on the politics of Modernism. I also want to place the issues of design within a broader socio-cultural context by occasionally referring to other over-arching manifestations of the reaction of the bourgeoisie at various levels to the experience of modernity. I will do this by way of what is termed 'sociological impressionism', drawing on the writings of Benjamin and Kracauer in which 'fragments of modernity' are examined and made to yield up evidence of important social shifts, even if sometimes in an apparently highly speculative manner.[4] I realise that in concentrating on the interior there is a certain danger of artificially separating the outer/inner world, as was suggested by the slogan of Marie-Elizabeth Lüders, one of the leading reformers of *Wohnkultur*

during the 1920s, 'from the saucepan to the façade' in an article written in 1926, 'First the Kitchen – then the Façade'.⁵ However, by keeping the macro-levels of the political, the economic and of class in mind I would hope to be able to account for issues such as planning, siting, etc. whilst concentrating on the interior. Although '*Kulturbolschewismus*', cultural Bolshevism, was a term widely used in Germany in the late 1920s and applicable across a wide spectrum of the arts, Bauhaus design became a particular target for bourgeois and, more especially, petit-bourgeois politics of resentment and fear, as witnessed by the attacks made on it since its inception. The interior as a design ensemble betrays a psycho-social politics, embodying a specific social dynamics which is more diffused across individual design products.

In establishing a politics of Modernism I shall briefly consider the work of Marshall Berman, and supplement this in terms of theoretical positions elaborated in Germany during the 1920s and 1930s. Berman's book *All that is Solid Melts into Air*, subtitled *The Experience of Modernity*,⁶ demonstrates how closely the operation of the triangulation of forces outlined ('social modernisation', 'the experience of modernity' and its representations through forms of cultural Modernism) relate to Germany between the 1880s and the 1930s. Rapid industrialisation, urbanisation, the penetration and rationalisation of the life systems (as described by Habermas) and the resistances this gave rise to – an organised working class and the proximity of social revolution – were all key factors. 'The motor force for social modernisation', Berman writes, 'is the ever-expanding, drastically fluctuating capitalist world-market, itself the product of many different social processes'; nowhere was this more descriptive of what was happening than in Germany, with the move into monopoly capital and the imperialist phase of the struggle for world markets. Proponents and propagandists of Jugendstil and Werkbund *Sachlichkeit* engaged culturally with the social contradictions of that economic phase of capitalist development; indeed, the Werkbund was criticised, after the First World War, for being an arm of that imperialist economic policy.⁷

In claiming that cultural Modernism is a mediated/mediating term within the triangulation of forces, as set out above, I am proposing that its forms may be released from distinctions based on purely formalistic attributes. As a mediated/mediating term we may put more useful questions to it: What are the ideological discourses within which its objects are embedded? What broadly cultural work does it perform within other discursive practices? – for instance, the rôle of formal

innovation in the ennobling of work as a means of overcoming alienation, a concept much under discussion in Werkbund circles. A number of such questions were put to it in the great theoretical debates around the politics of cultural Modernism in the mid-1930s in Germany between members of the Frankfurt School – Benjamin, Lukács and Brecht.

In the dispute over Modernism and realism Brecht argued with Lukacs that realism was not a matter of style but rather of epistemology: consequently Modernist innovation, as for example Brechtian montage, could produce socially progressive representations of the real. Central to this definition was the idea that Modernism was a question of politics, of social knowledge, and not of appearance. In 'The Author as Producer'[8] Benjamin added to this notion of what it was to be socially progressive as a cultural producer, that technical progress was the foundation of political progress but that the possibilities of that technical progress had to be wrenched from the hands of those who owned the means and turned around to be used for more broadly social purposes. This latter concept might be at least applied to distinguish between the *Sachlichkeit* of the prewar Werkbund and that of the late 1920s Bauhaus. Such application allows us to move away from the dangers of fetishising form, quality, etc., to the larger questions of the social and the political which may make such issues meaningful.

A somewhat similar intervention is necessary in Berman's analysis of the effects of 'social modernisation', what he describes as the 'experience of modernity': 'the amazing variety of visions and ideas that aim to make men and women the subjects as well as the objects of modernisation, to give them power to change the world that is changing them, to make their way through the maelstrom and make it their own'.[9] Such agency or pseudo-agency as might be promised was not to be achieved unproblematically: the experience of modernity 'pours us all into a maelstrom of perpetual disintegration and renewal, of struggle and contradiction, of ambiguity and anguish'. Questions addressed to cultural Modernism should also raise questions about constituencies. What rôle would design play in its engagements with the forces of social modernisation and in mediating these through socio-cultural forms? Would it be one of bourgeois incorporation, as Muthesius probably envisaged? Julius Posener summarises Muthesius' philosophy as follows: 'Let us create a bourgeois culture of the industrial age, and let us see to it that by a continuous process of elevating the working classes these, too, can participate in ever-increasing measure in the new bourgeois culture'.[10] This was articulated more polemically by Walther Rathenau – the aim of

design would be to 'hit doctrinary socialism in the heart'.[11] Here, too, concern with the appearance of form will not get us as far as we need to go: Gropius and Muthesius, as mentioned, shared certain *Sachlichkeit* principles of design practice, but on different ideological premises.

It is against the background of such issues that I want to turn now to instances of design practice relative to the domestic interior, using 'Modernism' not as appearance but as a mediating term between other terms, not as free-floating but as becoming intelligible relative to a politics of class.

Jugendstil possesses some of those qualities which M. Bradbury and J. McFarlane suggest may establish a common base for a definition of Modernism: 'the movement towards sophistication and mannerism, towards introversion, technical display, experimentation and formal innovation'.[12] To the extent that it moved away from Historicism and the representational mode of Wilhelmine decoration towards abstraction, a claim for a degree of progressiveness may be proposed. But questions other than those of formal typology must be raised and cultural critics such as Benjamin and Franco Moretti, amongst others, do raise them: such questions were to be raised again by Kracauer concerning the designed world of the white-collar workers (*die Angestellten*) towards the end of the Weimar Republic.

In his essay 'Louis-Philippe or the Interior', Benjamin directs attention towards a number of issues around the socio-politics of the interior. 'For the first time,' Benjamin wrote of the mid-nineteenth century, 'the living space became distinguished from the place of work. The private citizen who in the office took reality into account required of the interior that it should support him in his illusions.'[13] Franco Moretti, in a recent essay on a particular manifestation of the Modernist imagination, entitled 'The Spell of Indecision', also points up this drift:

From this point of view, modernism appears once more as a crucial component of that great symbolic transformation which has taken place in contemporary Western societies: the meaning of life is no longer sought in the realm of public life, politics and work; it has migrated into the world of consumption and private life . . . [14]

. . . a migration also documented by Richard Sennett in his book *The Fall of Public Man*. From this separation of public and private spheres, Benjamin declares, 'sprang the phantasmagorias of the interior. This represented the universe of the private citizen.' Although Benjamin does

not make the connection here, the relationship to the phantasmagoric
nature of the commodity under capital underlies the phantasmagoria of
the interior. There is also the relationship between the interior and the
developing sense of psychological interiority, again a possible site of
fantasy. Art Nouveau or Jugendstil played a particular rôle in this
developing history of the interior and interiority, a contradictory mani-
festation which, Benjamin claims, appeared to shatter the concept of the
interior but simultaneously perfected it: 'the transfiguration of the lone
soul was its apparent aim. Individualism was its theory. With Van de
Velde there appeared the house as expression of the personality.' Given
the social-utopian dimension of his work, Art Nouveau designers other
than Van de Velde would be more appropriate in the German context –
Riemerschmid, Bruno Paul – but the general principle stands. However,
there was another dimension to Jugendstil, intimately related to the
above, and upon which it was premised: it concerns the rôles of art,
technology and the designer. Here Benjamin points to a problematic set
of relationships which have also concerned others, including the founders
of the Deutscher Werkbund. Art Nouveau/Jugendstil

represented the last attempt at a sortie on the part of Art imprisoned by technical
advance within her ivory tower. It mobilised all the reserve forces of interiority.
They found their expression in the mediumistic language of line, in the flower as
symbol of the naked vegetable Nature that confronted the technologically armed
environment . . . Ibsen's *Master Builder* summed up Art Nouveau: the attempt of
the individual, on the strength of his interiority, to vie with technical progress
leads to his downfall.[15]

A more closely textured cultural-historical account to supplement
Benjamin's speculations may be found in the work of Hamann and
Hermand, in their *Stilkunst um 1900*.[16] They quote the poet Peter
Altenberg writing ironically in *Jugend* in 1899, on the '*Heimat-Klause*' or
'domestic den': 'What is on my table, what hangs on my wall, belongs to
me in the way that my skin and hair do. It lives with me, in me, of me . . .
Without it I would be more uncouth, atrophied, impoverished.'[17] The
original rejection of nouveau-riche osentatiousness had become another
aestheticism, 'an applied arts-based interiority' (*ein kunstgewerblicher
Innenbereich*).[18] Across the whole cultural world of the Jugendstil
phenomenon – painting, poetry, the dance, operetta, as well as design –
the connection with the real givens of the social order (the experience of
modernity) was increasingly severed, in favour of an art world con-
structed around a 'villa culture furnished with stylised living rooms'.[19]
What is important in the work of Hamann and Hermand is their

delineation of the constituency for Jugendstil cultural products and the socio-political implications of its representations. The social dynamics of its development, from being a high-bourgeois manifestation to becoming available through industrial reproduction to the wider constituency of the petit-bourgeoisie, is documented elsewhere.[20] This phenomenon was also to be repeated towards the end of the 1920s with Art Deco and 'Der Stil um 1930' (the Style of 1930 – to be dealt with below), in which the symbolised world of one class became more widely available for habitation by another.

Whilst Hamann and Hermand generally exempt the more geometrising work of Van de Velde and later Behrens from aspects of their criticism, their judgement on the 'nature motifs' phase is important within a German context, where the turn to nature was also to mark some Expressionism and also dimensions of National Socialist ideology. Writing about the artist Fidus, with his 'theosophical-vegetarian cult of nudism', in the context of many others, Hamann and Hermand characterise this work, with its constituency, as already marked by the signs of proto-fascism. A constant focus within German socio-historical studies is the conflict between *Zivilisation* (industrial culture) and *Kultur*, culture as traditionally understood, and the social effects of the confusion, fear and resentment generated within that social modernisation programme – fear of displacement, of proletarianisation, of disempowerment. It is within this context that cultural artefacts are to be read. Meurer and Vinçon, in their book *Industrielle Ästhetik*, point to this problem of maintaining agency and significance in a social order subject to modernisation. The sense of lost agency was to be greater towards the end of the Weimar Republic, the goal more focused and the consequences much more disastrous.

Meurer and Vinçon place the broader manifestations of Jugendstil within the socio-economic conditions of the period and argue for its essentially conformist rôle. Its design ideology, they claim, was based on an abstract understanding of industrial production, in which the decorative was used to gloss over the alienation of that production: its propagandists and designers 'pursued an ideology based on the separation of work and leisure as the separation of rationality and the sensuous inherent in the relations of industrial production'.[21] What they point up by implication is the inability or unwillingness of those associated with Jugendstil to take into account the full social implications of the mode of production, or to resolve the 'phantasmagoric' nature of the commodity with its repressed relations of social class by proposing a

design product solution: one effect of the failure to confront this problem was the retreat into interiority and the interior. Questions about the nature of Jugendstil's modernism only make sense within such a context: the ease of its appropriation is symbolised by a drawing published in 1900 in *Deutsche Kunst und Dekoration* by one of its foremost practitioners, Eckmann, where 'the evil ravens of capital are decorated with the feathers of an elegantly ascending snow-white swan'.[22]

The proponents of a *Sachkultur*, highly critical of Jugendstil, had been advancing their ideas since the turn of the century. Whilst rejecting the ornamentation of Jugendstil, *Sachkultur* shared with it, as a design philosophy, an important objective – the centrality of the artist as designer within the industrial order, although that rôle would be different, less idiosyncratic, more subject to what were perceived as the rational demands of the production process and the materials used. Friedrich Naumann recognised this central rôle when he addressed visitors to the 1906 Dresden Exhibition of Applied Arts. He emphasised the presence of artists who marked the epoch, 'the work of whose hands and eyes is visible in tens of thousands of homes . . . the phantasy/ imagination (necessary for) the provision of the accommodation for living is raised to a specialist profession'.[23] The original German allows for a drift in meaning between imagination and fantasy but within Naumann's design ideology, fantasy and its association with the more extreme manifestations of Jugendstil must be ruled out, at least on the formal level. Whether, in their understanding of the experience of modernity, the proponents of *Sachkultur* shared a degree of fantasy with those of Jugendstil is another issue – they certainly shared individuals: for example, Behrens, who progressed from Jugendstil to *Sachlichkeit* design ideology.

Muthesius was critical of interior design on a number of important counts: like Benjamin's later critique he singled out, in his book *Stilarchitektur und Baukunst* (1902), late-bourgeois notions of intimacy which resulted in a widespread neglect of responsibility to a public. In his address to the School of Commerce in Berlin, in 1907, on 'The Importance/Significance of the Applied Arts', Muthesius devoted a couple of paragraphs to the design of the interior. The ostentatious bourgeoisie of the late nineteenth century were compared unfavourably with their late eighteenth- and early nineteenth-century counterparts – the furnishing of the Goethehaus at Weimar was given as an example of

that earlier period. Muthesius cites class as the origin of that decline: 'in the conflict of social classes for domination originated social pretension', a parvenu pretentiousness which he intended to replace with a bourgeois *Sachkultur*, as he had written in the journal *Die Rheinlande* in 1903.[24] It demanded more than a formal solution, it must also be one of cultural education which would be essentially ideological ('*ein kulturelles Erziehungsmittel*'). The purpose of the applied arts was to lead the social classes back to genuineness, truth and bourgeois simplicity. The simplicity and purity of the work of artists like Orlik, Weiss, Lehmbruck, Kolbe and others complemented what Karl Scheffler called a 'healthy objectiveness' ('*gesunde Sachlichkeit*'). The redesigned interior would bring about positive change over the generations, it would have an educational effect on character: like Lukacs later, but for different reasons, Muthesius was pointing back to a pre-lapsarian bourgeoisie.

Such a reformist programme would also be seen as overcoming the problems addressed by Ernst Kühn, another speaker at the 1906 Dresden Exhibition: his concern was for the building programme for rural and urban workers. He criticised the homes provided for them on the grounds that little account was taken of the 'inner requirements of these simple people for whom they were designed. Built for speculation, such provision lacked all individuality.'[25] Here also, as with Jugendstil, the characteristics stressed were those of 'individuality' and 'inner requirement', although a claim might be made for a very different over-arching ideology. Hamann and Hermand summarised the distinguishing character of the *Sachkultur* interior thus: as against the '*Gemütlichkeit*' (cosiness) of the contemporary bourgeois interior, 'the clarity and simplicity of design transformed the traditional living room (*die gute Stube*) into a workroom for the creative individual'.[26] Compared with the flight into the interior of Jugendstil, here the interior is seen as complementing some form of social agency, the individual as active and creative. The extent to which this objective might be successful would depend on the access to an effective social agency at other levels: Kühn's constituency stands in a very different relationship to the forces of social modernisation than that of Muthesius.

At one level this early, prewar phase of *Sachkultur* might be seen as an intermediate stage between a return to Biedermeier principles and the principles of the later *Sachkultur* of the Bauhaus: as such, its designation as being Modernist in formal terms might appear to be problematic. However, it is the manner in which it attempted to mediate between the other two terms, 'social modernisation' and 'the experience of

modernity', to which one should attend if one wishes to make significant distinctions. The proponents of *Sachkultur* did not articulate a unified ideological position, but scattered throughout their writings and pronouncements are statements that are ideologically consistent. Hamann and Hermand described their aims for the ennoblement of work, *Veredlung der Arbeit*, through the applied arts as the 'idealism of community capital', but in which the relations of production would not be changed. Naumann accepted the condition of monopoly capital and its imperialist solution, but believed that it would enable a unified economy to be established, in which a national-social union, a non-antagonistic union of 'capitalism' and 'socialism', would come into being. Such a future would be bourgeois, in opposition to what he called the 'utopias and dogmas of a revolutionary Marxist communism'.[27] Rathenau, on the other hand, believed that the present class-based state (*Klassenstaat*) would evolve into an ideal *Volkstaat*.[28] In their analysis of the Deutscher Werkbund *Sachlichkeit*, Meurer and Vinçon pointed to the fetishising nature of the design philosophy of *Sachlichkeit* as the ornament of a capitalist industrial order. Again, as with Jugendstil, it is against the broader background of the political and socio-economic that the design programme of this *Sachkultur* must be seen. To the extent that it attempted to harmonise social conflicts without fundamentally changing the system, it proposed solutions that would later be tried in Weimar and the Third Reich. Fritz Schumacher wrote of the 'aestheticisation of the product and of the world of work', and of 'Freude in Arbeit', 'joy in work', ominously anticipating how Benjamin would characterise National Socialism's political practice, the aestheticisation of politics. Schulze-Naumburg, who was to be an important figure in National Socialist design ideology, was also part of that backward-looking tendency of early *Sachkultur*.

It is not the terms one must be concerned with, but their circulation – what is the context in which they are being used? How might one propose a *Sachkultur* that espoused a different set of relationships to 'social modernisation', from within a different conceptualisation of what the 'experience of modernity' might be? It is in the Weimar Republic of the late 1920s that one finds a recapitulation of some of the issues raised by Jugendstil and prewar *Sachkultur*, but now within the changed context of different social dynamics.

*

Sachlichkeit, more especially in its post-Dawes Plan[29] phase as *Neue Sachlichkeit,* was a concept subject to vigorous debate within the left across a broad cultural field during the 1920s – painting, photography, film, literature and design. I will briefly summarise that debate through some comments made by the contemporary East German historian, Harald Olbrich, who points to the distinction made by Alfred Durus in 1929 between 'new' and 'revolutionary' *Sachlichkeit*: 'revolutionary art and functionalist architecture and design (*Sachkultur*) are not indebted to *Neue Sachlichkeit*';[30] the latter being seen as an immediate set of manifestations in reaction to the Americanisation of the German economy, and the introduction of Fordism and Taylorism. Olbrich sketches out the alternative *Sachlichkeit,* the aim of which is to change the system and which is to be found in the activist tradition of social utopianism from Morris, the Expressionist and avant-garde experiments of the 1920s, and the use of new materials and the setting of new objectives for production. He concludes his article with a reference to Brecht: 'In Brecht's terms, this *Sachlichkeit,* removed alike from bourgeois technicism and technocracy and petit-bourgeois retreat into the self, develops the art forms of a scientific age in the sense of an engagement with the social real.' Olbrich is again identifying the set of problems outlined above and commented on by other recent cultural historians – Jugendstil as retreat, prewar *Sachkultur* as 'ornament' – and proposing an alternative: a new *Sachkultur* engaging with the 'social real'. To what extent could such a programme have been realised?

When the second phase of the Weimar Bauhaus opened with Gropius' declaration of a new unity between art and technology, what now was the rôle of a '*Sachlich*' design ideology? In a later statement on the Bauhaus Masters' houses at Dessau he wrote:

Smooth and sensible functioning of daily life is not an end in itself, it merely constitutes the condition for achieving a maximum of personal freedom and independence. Hence, the standardisation of the practical processes of life does not mean new enslavement and mechanisation of the individual but rather frees life from unnecessary ballast in order to let it develop all the more richly and unencumbered.[31]

Would such a standardisation and rationalisation of the practical processes of life remove the productive capacities of technical development from the dominant order and transform their value from that of exchange into that of use in a significant sense, fulfilling Benjamin's requirement for a socially progressive rôle for the cultural producer? Would such a programme overcome Kallai's reservations, with which I

opened this essay, about the dangers of fetishising the technical? Under
the socio-political conditions of the Weimar Republic, with its domi-
nantly bourgeois conservatism, could the rôle of such design ideology be
anything other than that of a social democratic reformism, a kind of
analogue to that of the bourgeois reformism outlined above? Did not
prewar *Sachkultur*, as already suggested, regard its interior design
ideology as also producing 'working space for creative individuals'? The
particular significance of late Bauhaus and Neues Bauen design ideology
can best be understood, I feel, in association with other competing
contemporary design ideologies. At an important level, the relatively
isolated position of the Neues Bauen – at the Bauhaus, Frankfurt, Berlin
or other centres – makes direct evaluation difficult: the *Siedlungen*, for
example, the housing estates built by Gropius, Max Taut and others,
were described as 'islands of socialism'. A way of evaluating the period
c.1925 into the 1930s might be to consider other manifestations of
Modernism – Art Deco and the related 'Der Stil um 1930' – with a view
to establishing the various constituencies for the different design manifes-
tations.

Here again, one must engage in, at worst, a type of sociological
impressionism. I shall begin with those for whom the Bauhaus and Neues
Bauen objectives had little or no appeal, who found them cold and sterile,
felt they had no immediate antecedent and thus offered no basis for their
fantasies. This constituency I shall identify as sectors of the petit-
bourgeoisie, more narrowly characterised as '*die Angestellten*' or white-
collar workers, a rapidly developing social group during the rationali-
sation period of the mid-1920s, achieving a five-fold increase by 1930, to
reach a total of three-and-a-half million. Benjamin referred to the
ideology of the petit-bourgeoisie as 'a unique kind of delusion relative to
economic reality, a reality which approximates closely that of the
proletariat', and continued, 'There is no class whose thinking and feeling
is more alienated from the concrete reality of everyday life than that of
the white-collar workers'.[32] Siegfried Kracauer described Berlin as a city
of '*Angestelltenkultur*', and noted how the 'pleasure barracks' ('*Pläsier-
kassernen*'), the cinemas and palaces of variety, structured their illusions
through the most modern forms and materials available, a style charac-
terised by Kracauer, a trained architect, as '*Vergnügungssachlichkeit*',
inelegantly translatable as pleasure or distraction *Sachlichkeit*. A con-
temporary design historian, Gert Selle, to whose work I am indebted
here, writes:

but not only distraction and commercialised public leisure, also the interior around and after 1933, and above all the white-collar worker's rented apartment merits attention. Here, as it were, private myths are fostered and through the consumption of styles are apparently realised. Naturally, here, as little as in the public sphere, could *Bauhaussachlichkeit* prevail.[33]

There are a number of levels of fantasy operating within this burgeoning social class: Benjamin points to their misrecognition of their historical rôle, Kracauer to their dependence on distraction as a basis for their leisure, and Selle to the rôle of the interior to reinforce that relationship between leisure and fantasy. Reference was made earlier to the manner in which the industrialised forms of Jugendstil made elements of that bourgeois style available to the petit-bourgeoisie: a similar process is observed in the handing down of Art Deco/'Modern' elements during the later phase, an ostentatious cultural form being made available for those lower down the social scale. Again I quote Selle: 'This domestic world was marked by a particular artificiality . . . a mixture of handed-down Art Deco elements and traces of the elegant "1930" style rearranged in ever new variants ostensibly individual.'[34] By comparison with the 'cold, objective, depersonalised' Bauhaus forms, these industrially reproduced forms seemed to reflect a rich combination of art-derived product design and individuality, far removed from the objectives of a classless design ideology, through which the petit-bourgeoisie could not signify their specialness, their difference from the proletariat. They were only too ready to accept the National Socialist designation of Bauhaus culture and other forms of Modernism as '*Kulturbolschewismus*'.

It is within this complex and contradictory context that any evolution of the aims and achievements of what were perceived as the rationalist and functionalist programmes of the Neues Bauen and Bauhaus should take place. Post-revolutionary conditions in both the Soviet Union and Weimar Germany provided an opportunity for an international and classless mass design culture which was based on industrial rationalism, or at least on some form of state socialism. Such an enterprise was obviously more difficult to achieve in Weimar Germany with a massively entrenched bourgeoisie and petit-bourgeoisie and where product design, including architecture, signified the cultural norm and symbolised its social dominance. Whilst the challenge of the organised working class was real and immediate, the challenge of the Bauhaus and Neues Bauen was on the plane of the symbolic: the bourgeoisie and petit-bourgeoisie collapsed the threat of '*Bolschewismus*' and '*Kulturbolschewismus*' together. In reality, the conditions of the working class in general did not

allow them to participate in the classless '*Sachlich*' design culture being produced: those who occupied the Neues Bauen *Siedlungen* were often white-collar or better-off 'blue-collar' workers.

This culture was a subject of discussion on the left and not always uncritical, although by the late 1920s the Communist Party began to defend the Bauhaus against National Socialist attacks. The SPD journal *Frauenwelt* addressed itself to the new '*Wohnkultur*', advising the housewife about the rationalisation of housework which 'would give the woman more time for her family', adding significantly 'and for the duties of her class',[35] an objective reminiscent of Gropius' 1926 statement that mechanisation and rationalisation of the interior was to free the individual for more important activities. This emphasis on the public-social dimension of the woman's rôle would also remove it from the professionalisation of the housewife, a familiar theme in the writings of bourgeois reformers, as, for example, in Marie-Elizabeth Lüder's article, 'Has the housewife a profession?', or in the 1922 series, 'The organisation of household management as a profession'.[36] The marking out of separate spheres for women's work and their world was an emphatic response of various bourgeois women's organisations' to National Socialism, as detailed in Claudia Koontz's book *Mothers in the Fatherland*.[37] The SPD also organised exhibitions of '*Sachlich*' interior design. The Communist Party, suspicious of the reformist nature of the SPD and its perceived drift towards the acceptance of middle-class standards in general, proposed to its readers the example of the Soviet Union, particularly the collectivist dimension of its housing and interior provisions.[38] Contributors to this recent publication on working-class life in Hamburg in the late 1920s and early 1930s interviewed some people who had been setting up house during this period. Some had been aware of the new '*Wohnkultur*', including the Bauhaus, but not many were aware of the particular cultural politics that prevailed. Needless to say, fewer still were able to afford the products it created.

How, then, do we attempt to resolve issues relating to Modernism and design, to place the designed object – a material artefact possessing certain formal characteristics – within a context which reflects the complexities of the social and technological process by which the object was produced? Modernism, or its cognate 'modern', is a term of difference but with substantive referents in the political arena. The National Socialists recognised that this was so in their onslaught on visual representation, although,

as some commentators have established, the persistence of aspects of design Modernism survived, even if marginalised, well into the regime. A crucial distinction which must be made, I believe, is the difference between the rôle of the commodity, an embodiment of repressed social relations, and the work on the physical product through design practice; what Benjamin in his writings on Paris refers to as the phantasmagoric nature of the commodity and the phantasmagoria of the interior. Of all the variants of Modernism which I have considered – Jugendstil, early *Sachkultur*, Art Deco, 'Der Stil um 1930' and the Bauhaus/Neues Bauen – it is only the latter which would have raised that distinction. Unlike the propagandists of the Werkbund-related *Sachkultur*, the later proponents of such a design ideology did not suggest a return to the idyll of an earlier bourgeois formation and the perfectly competitive free market of early capitalism, nor to socialising monopoly capitalism on terms laid down by the capitalist mode of production itself, as Friedrich Naumann and others proposed. Whatever the nature of the socialism involved – the utopianism of post-war Expressionism and the German variant of Constructivism,[39] the Fabianism of May, the SPD adherence of Martin Wagner or the Marxism of Hannes Meyer – implicit in it was the questioning of the social relations embodied at the centre of material production.

John Thackara writes: 'Because product design is thoroughly integrated in capitalist production it is bereft of an independent critical tradition on which to base an alternative'.[40] As a consequence of the particular development of capitalism in twentieth-century Germany, it may be possible to separate the two ideas in Thackara's statement, with greater emphasis being placed on 'an independent critical tradition'. The crises in German capitalism were deeper, the mobilisation of its classes more marked, than elsewhere. The Weimar Republic came into being as a result of the spontaneous uprising of soldiers, sailors and workers: armed resistance was not finally suppressed until November 1923, at Hamburg, after which the Americanisation of the economy was set in motion through the Dawes Plan. Cultural Modernism, in its many and wide-ranging forms, had a much more significantly oppositional rôle to play here than in other bourgeois democracies, where Modernism was essentially concerned with aesthetics. Critical Modernism in Weimar Germany did provide the possibility for thinking through an alternative to the social relations of the capitalist order but the difficulties it confronted must be recognised. A more socio-historical and less aesthetic appraisal of this Modernism would allow us to see that its claims were not naïvely universalistic in an Enlightenment sense (as Post-modernists

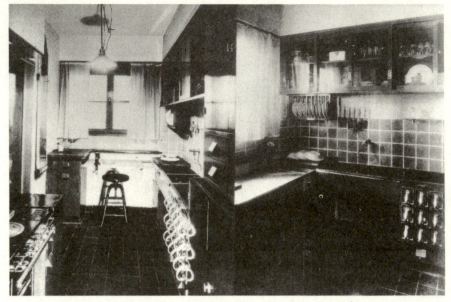

G. Schütte-Lihotzky, 'The Frankfurt Kitchen', (from *Das Neue Frankfurt*, no. 5 1926–7).

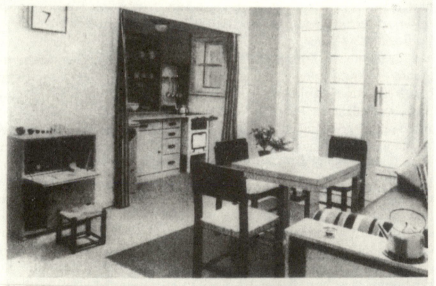

Die Wohnstube dieser Wohnung — hell und freundlich

'A Model for the New Living Style' (*Wohnkultur*) from *Die Form*, 1930.

claim), nor did it refuse to consider heterogeneity, otherness or difference – social class and gender were on its programme. Its major problem was that the battle for social modernisation had been lost early in the Weimar Republic, when bourgeois Europe was generally recast and stabilised,[41] but cultural Modernism continued to wage that battle at other levels. An understanding of German Modernism demands that we recognise that the politics of Modernism must be conducted at these different levels.[42]

POSTSCRIPT

Much has happened since the developments in German Modernism outlined above, as a result of the processes of social modernisation – National Socialism, the Second World War, Stalinism, and, more recently, what some commentators see as the 'last act' of that epoch, the demolition of the Berlin Wall. The critical dimensions of Modernism, its discursive as well as its material practices, were suppressed before the outbreak of war. Briefly resurrected in Germany after the war, they were again marginalised in the newly established Federal and Democratic Republics during the early 1950s: in the West in general by the hegemony of American abstraction and its formalist criticism, and by the formalism of International Style architecture. By the end of the 1960s, and during the 1970s, aspects of Central and Eastern European Modernism became more widely known. What is the future of that tradition now, under the impacts of capitalist triumphalism and Post-modernist pluralism?

Two points at least need to be made: Post-modernist culture is not homogeneous, its critical practitioners and commentators acknowledge their indebtedness to work and ideas of the 1920s and 1930s, extending that period's greater concern with class to issues of feminism and race. Nor, despite the writings of Baudrillard, Lyotard and others, is the questioning of the relationships between capital, consumerism and commodification at an end: David Harvey's response to these thinkers, *The Condition of Postmodernity* (1989), is evidence of that. Harvey insists on the same in-depth analysis of culture as Benjamin or Adorno. Writing of perceptible relationships between the rise of Post-modernist cultural forms and shifting dimensions of 'time-space compression', he concludes: 'But these changes, when set against the basic rules of capitalistic accumulation, appear more as shifts in surface appearance rather than as signs of the emergence of some entirely new postcapitalist or even postindustrial society.'[43] Critical Modernism was not a style, the validity of its mode of questioning still stands.

Despite the claims of the major protagonists to a disinterested internationalism, the Modern Movement has been seen to be remarkably Euro-centric. The result of this has been that both at the time and later, the Modern Movement in America has been explained via activities on the East Coast, where all the visual arts maintained a distinctively European slant. This is most evident in the exhibiting policies of the Museum of Modern Art, New York, from its inception in 1929 through to the Second World War. This bias reached over as far as Illinois, where the Bauhaus was to be relocated, but led to a reduction of attention on anything further west. The balance is corrected here, as our attention is focused squarely on the West Coast, in an examination of some of the earliest and most impressive pieces of Modernist experimentation. There were particular reasons why, in a cultural climate at some remove from European idealism, the patrons of modern architecture considered it to be appropriate for their houses. In many ways this essay is an exploration as to what exactly, in practical terms, was possible, and what, despite the reams of theory, were unrealisable dreams.

5

Building Utopia: Pioneer Modernism on the American West Coast

WENDY KAPLAN

Until recently, modern meant 'European Modernism', or the International Style – the functionalist, anti-ornament, 'start from zero' aesthetic championed by avant-garde European architects after the First World War. Now that the architecture of the International Style can be judged as a genre, rather than the one correct, historically inevitable way of building, other styles of the teens and twenties are recognised as equally valid manifestations of the modern.[1]

In 1957, the architect Harwell Hamilton Harris gave a talk to the American Institute of Architects in Eugene, Oregon. A second-generation Modernist who had trained with Richard Neutra, Harris was in a good position to evaluate the special development of California architecture. He observed: 'In California in the late Twenties and Thirties modern European ideas met a still developing regionalism. What was relevant was accepted and became part of a continuing regionalism. In New England, on the other hand, European Modernism met a rigid and restrictive regionalism [i.e., the Colonial Revival] that at first resisted and then surrendered. New England accepted European Modernism whole because its own regionalism had been reduced to a collection of restrictions.'[2]

California provides a rich introduction to the synthesis that defined early American Modernism, with the architecture of Irving Gill, Frank Lloyd Wright, Rudolf Schindler and Richard Neutra as exemplars. While the East Coast intelligentsia, led by Henry-Russell Hitchcock and Philip Johnson at the Museum of Modern Art, were disdaining most American efforts and coveting the buildings of Walter Gropius, Mies van der Rohe, and Le Corbusier, architects on the West Coast were developing their own modern architecture, one which took the best of earlier Arts and Crafts Movement goals and combined them with a more radical use of abstraction, new materials, and manipulation of space.

In 1960 Reyner Banham revised the accepted canon by pointing out

that the International Style architects of the 1920s were more involved with machines as symbols. They did not produce forms resulting from the latest building technology but 'produced a Machine Age architecture only in the sense that its monuments were built in a Machine Age, and expressed an attitude to machinery . . . '[3]

Therefore zigzag and streamlined Art Deco buildings, whose architects had never professed to supply anything *but* machine imagery, provide just as valid an expression of the age as International Style structures. This essay will only briefly discuss the work of such commercial firms as Parkinson and Parkinson, and Morgan, Walls & Clements, which produced some of Los Angeles' best Art Deco buildings. Instead, it will focus on another form of Modernism in southern California – the work of the adventurous architects described by Harris who, like the Europeans, advocated exposed structure and the latest machine technology but retained the individuality and integration with nature that the International Style rejected.

Since the objective of this essay is to explore early Modernism, all the work discussed will predate 1930. None of the architecture was produced by native Californians. In the teens and twenties there was practically no such thing – everyone came from somewhere else to pursue some aspect of the California dream. In the case of Schindler and Neutra, it was artistic freedom. For Wright, it was an opportunity to build on a scale denied him in the Midwest. In Gill's case, it was better health.

They witnessed a period of phenomenal growth and prosperity in southern California. In Los Angeles, the population more than doubled in the 1920s. In Hollywood, the motion picture capital, the construction industry boomed as the population soared from 36,000 in 1920 to 235,000 by 1930. Los Angeles has always held the promise of Utopia; its benign climate, distance from more established cities, and open society attracted unconventional settlers. Free thinkers, free lovers, health faddists, political radicals, evangelical preachers – all came to a city that was more receptive to new ideas than anywhere else in America.[4] The clients of Wright, Schindler and Neutra were part of an artistic avant-garde who believed in progressive politics, equality between the sexes and in patronising architects who would give them a modern statement. Gill was able to take advantage of this patronage to some extent, but not as much as the other three.

Before moving to San Diego in 1893, Gill worked for two years in the Chicago office of Dankmar Adler and Louis Sullivan (Wright was there at the same time) and was influenced by Sullivan's search for an organic

architecture based on geometric forms. In his early work Gill experimented with most styles prevalent at the turn of the century – the Colonial Revival, Shingle, English half-timber, and Arts and Crafts. By 1905 he became fascinated with the eighteenth- and early nineteenth-century Spanish colonial architecture of southern California. He wrote that the missions were an 'expressive medium of retaining traditions, history and romance, with their long, low lines, graceful arcades, tile roofs, bell towers, arched doorways and walled gardens'.[5] Hispanic architecture, however, was not to be imitated but was only to provide inspiration for a new California architecture. In the Douglas house (1905), Gill began to employ the abstract, geometric forms he took from Spanish missions to evolve his own style. The open porch, pierced parapet and, above all, the arch are features that would become characteristic of his work.[6] The Melville Klauber house (1907–8) was another harbinger of his future style – his use of smooth walls with clean, punched openings would constantly be repeated on his later concrete buildings.[7] The interiors of these early houses are in the Arts and Crafts style; the rooms are wood-panelled, with fireplaces and Craftsman furniture, but are pared down and less heavy.

With the Allen house (p. 104) Gill created the first anti-ornament architect-designed building. The building stands testament to Gill's belief that all architecture should be based on fundamental geometry, 'the straight line, the cube, the circle and the arch'. He wrote, 'We must dare to be simple, must have the courage to fling aside every device that distracts the eye from structural beauty.'[8] Gill's work, which reflected his pleas for simplicity and his passionate denunciation of ornament, has often been compared to that of Adolf Loos.[9] No evidence exists, however, to document that Gill even knew of Loos' architecture. Furthermore, Gill's 1907 Allen house predates by three years Loos' Hugo Steiner house, usually considered to be the prototype of anti-ornament structures. In the period photograph the Allen house looks even more severe than Gill had originally intended, since it was taken before the planting that Gill always planned had a chance to soften the building's uncompromising geometry.

By 1910 Gill was receiving commissions in Los Angeles as well as San Diego. The Miltimore house (1911), built in the wealthy Los Angeles suburb of Pasadena, provides a good example of Gill as a transitional figure. He followed Arts and Crafts principles in his desire, through mission imagery, to continue a local vernacular using common, everyday materials. His intention to keep his buildings small-scale and modest

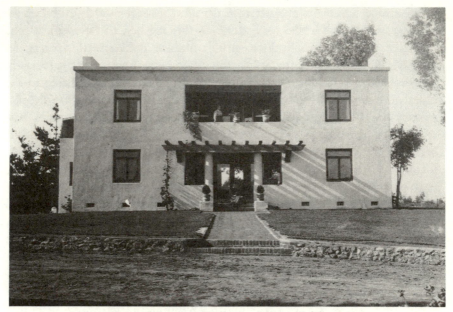

Irving Gill (1870–1936), Allen house, Bonita, California, 1907.

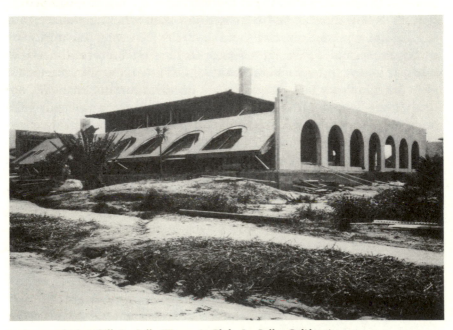

Irving Gill, La Jolla Women's Club, La Jolla, California, 1912–14.

in appearance, even if they were actually quite large, was also characteristic of the Arts and Crafts Movement, as was his belief in a wholesome, out-of-doors life – what movement aficionados liked to call 'the simple life'. Gill employed all the Arts and Crafts stratagems that served to integrate the house and the surrounding landscape – terraces, pergolas, courtyards, porches, and walled gardens. He insisted that nature should provide the sole ornamentation for a house; his reverence was such that he designed the Miltimore house to go around existing trees so that he wouldn't have to disturb them.

Gill comes closer to the International Style than the Arts and Crafts in his cubistic volumes and abstract forms. His mission imagery is so stripped down that his inclusion among the early moderns is fully justified. Gill's geometric austerity is seen in the window treatment; no windowsills or decoration, but only a simple casement with a ventilator to catch the breeze. Unlike International Style architects, however, Gill was not ashamed to use classical motifs; simplified Doric columns support the vines on the Miltimore pergolas. Later he would abstract still further, retaining the columns, but omitting their bases.

Gill's passion for the 'perfectly sanitary house' and for labour-saving devices was both Arts and Crafts and Modernist.[10] In the Miltimore house Gill moved away from a Craftsman interior to completely unornamented surfaces. He made cabinets flush with the wall both to save space and to prevent dust from gathering. Simple mouldings were retained but Gill would soon eliminate them entirely and, as in the Barker house of 1911, cove the edges of kitchen walls so that dirt would not collect. In a 1916 article Gill declared that in his houses, 'the walls are finished flush with the casings and the line where the wall joins the flooring is slightly rounded, so that it forms one continuous piece with no place for dust to enter or to lodge, or crack for vermin of any kind to exist. There is no molding for pictures, plates or chairs, no baseboards, paneling or wainscoting to catch and hold the dust.'[11]

Gill embraced any new technology that would promote cleanliness and 'economy of labor'. He installed outlets for vacuum cleaners to carry dust to the furnace, garbage disposals in the kitchen and automatic car-washing devices. He advocated 'the placing of the ice-box that can be filled from the outside without tracking through a clean kitchen, or the letter box that can be opened from within the house.'[12]

Flexible, accessible, and if developed properly, inexpensive, concrete was for Gill the ideal material. Although many architects had experimented with concrete, Gill was the first to use the material consistently

and for domestic structures. He loved concrete floors because, being seamless, they would not harbour dirt but even more, he loved concrete walls. In 1912 he purchased equipment from the United States government (used for constructing barracks during the Spanish–American War) that enabled him to develop a tilt-slab system of construction whereby concrete for a wall could be poured out and then erected as a single unit.

This technique was used for the La Jolla Women's Club (1912–14), one of Gill's most successful buildings (p. 104). Here Gill combined the traditional vocabulary of arcades and pergolas with innovative technology to create a modern vernacular. Casting the walls horizontally, workmen poured the load of concrete on to a huge table, upon which were rows of hollow tile – the forms for the wall. Metal frames were inserted for doors and windows. When the concrete had cured, it received a top coating of fine cement and then the entire wall was slowly raised into place.[13] Unfortunately, Gill did not receive enough commissions to make the system economically viable and he lost a lot of money on the venture.

Other experiments were to prove more successful. Gill, whose commitment to minimalism was moral as well as aesthetic, was deeply concerned with low-cost housing and believed it could be made viable with less attention to useless ornament and more to structure. Gill was a pioneer of low-density housing for labourers and the unemployed as well as for company towns. His favourite of these designs was a low-cost garden court in Sierra Madre, called Bella Vista Terrace or Lewis Courts (1910).[14] In his innovative plan, the outside walls of the house were flush with the street to create more space inside the court. Each unit, therefore, had a private garden that led into the community garden at the centre. Gill further promoted both privacy and a feeling of community by separating the cottages with porches and connecting them by roofed arcades. Careful spacing ensured that none of the units obstructed the others' light.

As Esther McCoy has pointed out: 'There was a reverence for the individual in the plan that has never been equalled in the field of minimum housing . . . Gill had demonstrated that he could build a good house at a price which would allow a landlord to rent it for a nominal sum.'[15] In fact, Lewis Courts and other low-cost housing projects by Gill were unsuccessful in the long run only because they were so appealing that the companies who owned them raised the rent and only middle-class people could afford to live there. This was certainly not the case

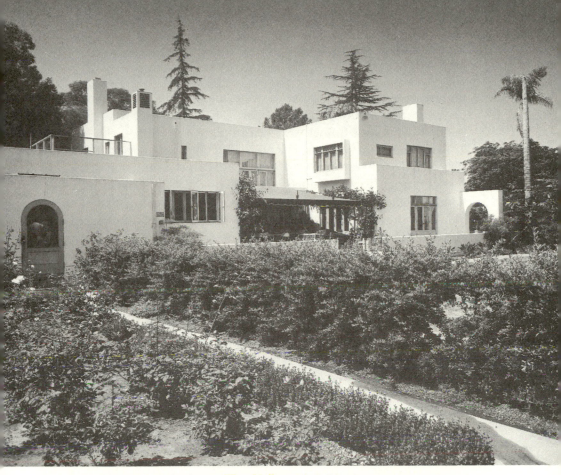

Irving Gill, Dodge house, West Hollywood, California, 1914–16.

with the highrises for workers designed in the International Style. Most of such housing, built for workers or the unemployed, was considered uninhabitable by its residents and lived in only when no other options were available.

The Dodge house (1914–16), built in West Hollywood of reinforced concrete, was Gill's masterpiece. Representing both a Modernist and an Arts and Crafts aesthetic, the Dodge house embodies all the qualities Gill believed to be most important in a building. A stripped-down, abstract composition of interpenetrating cubes, the house was also integrated with the landscape and revealed Gill's passion for fine craftsmanship and meticulous execution of details. Their storage cabinets flush with the wall, the interiors had the same geometric clarity as the exterior; the cabinets, however, were superbly crafted with Honduras mahogany left in a natural finish.

Gill used new materials as well as traditional ones. In 1910 he began to develop steel trim for doors and windows. Since no one was manufactur-

ing steel trim that early, he went to sheet metal shops to have the material broken for him from his own designs.[16] For the Dodge house, the steel windows and door-frames were cast in place.

The architecture of Irving Gill exemplifies the individuality and respect for place that characterised California Modernism and set it apart from that of Europe. Reyner Banham summed up the difference between Gill's approach and the shrill ideology of European architects when he wrote: '[Gill's] difference from them lies in his lack of mechanistic pretensions, and also that lack of ferocious introspection that gives European work of the twenties that air of *angst* which has become its guarantee of probity in the eyes of later generations.'[17]

Frank Lloyd Wright's 1920s work in L.A. also exemplifies individuality and regionalism at the same time that he was recognised as a giant of early Modernism. People like Mies van der Rohe and Walter Gropius freely acknowledged their debt to him and the influence that the publication of the *Wasmuth Portfolio* in Germany (which introduced Wright's work to Europe) had on them. However, they discuss him as if he were dead, as if his work stopped in 1910, and he did not continue to be a major force in architecture for fifty years.

Wright's contribution is disparagingly treated in Hitchcock and Johnson's book on the International Style that accompanied their hugely influential exhibition at the Museum of Modern Art in 1932. They did note that 'one cannot deny that among the architects of the older generation Wright made more contributions than any other' and recognised his innovations in open planning and the conception of architectural design as planes existing freely in three dimensions rather than as enclosed blocks. They chastised him, however, for remaining an individualist, and for not submitting to what they called 'the discipline of the international style'.[18]

Like Gill, Wright believed in developing an *American* architecture and, furthermore, one particular to the region where it was built. Since this would require the recognition of the past, their goals would have to have been in opposition to those of the International Style, which consisted of rejecting the past and turning to the machine to provide both form and imagery for modern life. American Modernists working on the West Coast believed that the machine and individual expression were not irreconcilable. They believed that buildings should be designed so as to be *of* the landscape and not, as was the case with European Modernists, *in* the landscape. But unlike Gill, Wright had little concern for his clients' tastes or financial resources. In fact, one thing Wright shared with

European Modernists was an equal indifference to the wishes of his clients and a supreme belief in the sanctity of his own personal vision.[19]

Wright came to California at the lowest point in his life. In 1914 his mistress and two of her children had been brutally murdered by a deranged servant who had also set fire to the house he had built for them. Wright's recovery from this tragedy was aided by receiving two important commissions in the late teens: the Imperial Hotel in Tokyo (1916–22) and a house (1917–21) and arts complex for Aline Barnsdall in Hollywood.

Aline Barnsdall was a wealthy, left-wing patron of the arts. The complex she commissioned was to include a theatre and artists' residences as well as a house for her. Because she and Wright were hardly ever there and relations between them were stormy, only two buildings in addition to her own house were ever constructed. Built primarily of concrete and stucco, the U-shaped house surrounded large walled garden courts. Like Wright's earlier work in the Chicago area, the house reflected his belief in developing an indigenous architecture. Although he never admitted it, he was inspired by native American architecture for his California houses, specifically Pueblo complexes of the South-west, and Mayan architecture. Unlike his Prairie work, however, which was integrated with the surrounding landscape through materials, colours, and siting, the Barnsdall, or Hollyhock, house was placed on the crown of a hill, in apparent violation of Wright's statement that 'natural' houses should be situated on the brow of the hill.[20]

Although many historians consider the Barnsdall house to be one of Wright's masterpieces, others make a convincing case that the house is deeply flawed.[21] Not only does the siting contradict Wright's belief in the house as 'a broad shelter seeking fellowship with its surroundings', but its dark, hidden entrance, massive proportions, and walled-off courtyards create the impression of a Mayan fortress cut off from the world.[22] The repetition of the hollyhock, Barnsdall's favourite flower, as a motif on the exterior as well as the furnishings brings the house closer to Wright's conception of a natural house. More characteristic, however, is the house's atypicality in such details as the placement of the fireplace. As the critic Brendan Gill pointed out, the living-room fireplace is always the heart of a Wright house, but here access to it is cut off by a fishpool whose water was circulated to outside basins.[23]

Wright himself questioned whether the romantic, expressionistic Hollyhock house could be called modern, writing: 'Conscience troubled me a little . . . That "voice within" said, "What about the machine crying

for recognition as the normal tool of your age?" '[24] In terms of modern building technology, Wright did better with his four other Los Angeles houses, which were built between 1923 and 1925: the Alice Millard house, 'La Miniatura', in Pasadena and the John Storer, Charles Ennis, and Samuel and Harriet Freeman houses in the Hollywood hills. All were made with concrete blocks, which Wright called his 'textile-block system'. It was his solution to the quest for a new style of architecture, suitable for both the climate and the culture. Wright wanted a technology of construction that could utilise cheap, unskilled labour and inexpensive materials so that housing could be made available to millions of Americans. Wright found in concrete blocks a building material that could be at the same time structure, skin and ornament and thus could be used to produce truly organic architecture.[25] He also loved the way the material could be cast to create a wide variety of interesting shapes and patterned surfaces. Working with his son Lloyd, he developed a method of casting the blocks and then linking them together with steel rods. Once the rods had been fastened, they were sealed in place by concrete grouting.

Like the Barnsdall house, Wright's three Hollywood houses sit perched on hills. All are fortress-like, with the Ennis and Storer houses conveying the most monumental, forbidding massing. Some historians have speculated that given Wright's emotional state at the time of construction he 'built aloof and impregnable bastions to protect him vicariously through his extended family of clients from the tongues and intrusions of a cruel, hostile world'.[26] Certainly the houses seem closed, removed from the landscape rather than connected, their access routes guarded. For example, after passing through the substantial gate of the Ennis house (p. 111), one enters a low dark lobby leading to a staircase. The visitor could not predict from the closed exterior that at the top of the stairs, the hallway would be suffused with light and the space would become expansive. The swimming pool and a spectacular view of the mountains is on one side of the hall and on the other, the living room overlooks panoramic views of Los Angeles. Wright repeated this drama of progressing from dark, hidden entrances to light-filled rooms in all his Los Angeles houses. From his Prairie School days, he continued the development of the open plan. In the Ennis house, no doors or other enclosures divide the living and dining rooms and the hallway. Wright referred to all three spaces as 'The Great Room'.[27]

The most successful of the textile-block houses, the Freeman house, has a more livable scale than the Ennis and Storer houses. Samuel and

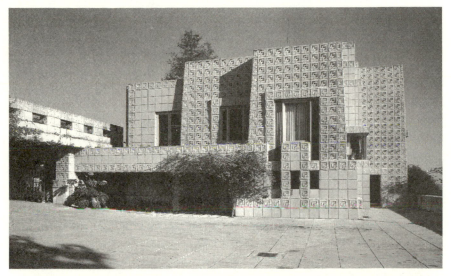

Frank Lloyd Wright (1867–1959), Ennis house, Hollywood, California, 1923–5.

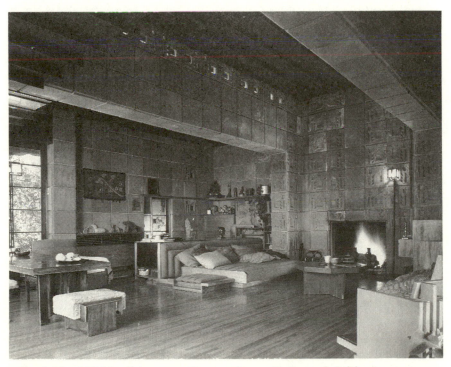

Frank Lloyd Wright, living room, Freeman house, Hollywood, California, 1923–5.

Harriet Freeman had the typical profile for clients of modern architecture; they were passionately involved in the arts (Harriet was a dancer) and progressive politics, and committed to the creation of a new, more open society in California. For them Wright designed a textile-block pattern in harmony with the landscape – an abstraction of a house and a eucalyptus tree. He used the pierced version of the blocks very effectively in the living room in order to let in light and create interesting shadows (p. 111).[28]

Just as Wright liked to move people from the darkness of the entry to the light of the living room, so too he liked to choreograph the movement from private to open sides of the house. The Freeman house's two primary façades are very different. The north street elevation seems fortress-like, while the south, garden elevation responds to the cityscape below. Wright opened the space by moving from closed concrete blocks to perforated ones, then to single mullion windows, finally ending with double-storeyed bands of windows.

Wright achieved his aim of producing a versatile building material that would provide a cooling retreat from the Californian sun, but, like Wright's other textile-block structures, the Freeman house is in a precarious condition. The roof leaks (a constant problem with Wright houses) but most significant is a fundamental problem with the concrete blocks. They are deteriorating because they were stacked on each other without mortar, and the unsealed joints allow moisture to penetrate the system.[29]

Structural problems would be a source of contention between Wright and his clients throughout his career. The greatest conflicts would arise from cost overruns – an inevitable accompaniment to a Wright commission. Such conflicts, however, provided an opportunity for a young protégé of Wright's, Rudolf Schindler, who had come to the United States from Vienna in 1913. Schindler had always wanted to work with Wright, was hired by him in 1918, and two years later was sent to Los Angeles to supervise the construction of the Hollyhock house. After Wright's final falling-out with Aline Barnsdall, Schindler was retained to help with repairs and changes in her house and the two other residences.

Wright and the Freemans became alienated after the budget for their house escalated to more than double the original estimates. When the Freemans eventually saved enough money to buy furnishings, they asked Schindler to design them. All the furniture in the living room was designed by Schindler over a long period of time – from 1928 to the 1940s.

Schindler set up an independent practice in 1921, but remained greatly

influenced by Wright's romantic Modernism. His training under Otto
Wagner at the Vienna Academy of Fine Arts, however, gave him a
background to develop more radical designs than even Wright was
producing in the 1920s. The 'co-operative house' he built for himself, his
wife and their friends, Clyde and Marian Chace, on Kings Road in West
Hollywood (1921–2) was one of the most innovative structures in
America.

Four studios of equal size were arranged in pairs in a pinwheel
configuration, with a guest studio and garage forming an 'L' to the west.
The plan was designed for both egalitarian and communal living. Each
member of the two couples had his or her own room; the pairs of studios
were joined by a single shared kitchen.

Schindler had been inspired by the simple camp buildings he had
experienced when on a trip to Yosemite National Park. In an article for
T-Square in 1932 Schindler explained that his goal for the house was to
fulfil 'the basic requirements for a camper's shelter: a protected back, an
open front, a fireplace, and roof'.[30] The ideal was to combine the shelter
of a solid cave with the freedom of a lightweight tent. To ensure privacy,
the more public side of the house, facing Kings Road, was constructed of
concrete. Schindler used a tilt-slab system of construction similar to
Irving Gill's (Chace was an engineer in Gill's Los Angeles office). In
contrast, the garden front was open, with sliding canvas doors and glass
panels. According to Schindler:

This opening is protected by an overhanging cave, carried by two cantilever
beams crossing the rooms. These beams serve at the same time as supports for
sliding light fixtures, and for additional moveable partitions. The shape of the
rooms, their relation to the patios and the alternating roof levels, create an
entirely new spatial interlocking between the interior and the garden.[31]

He considered the whole lot to be living space, only divided between open
and enclosed zones. One way Schindler connected the zones was by using
shubbery to continue the lines of the house into the landscape – the
gardens became the unroofed rooms of the house, with outdoor fire-
places. He built what he called 'sleeping baskets' on the roof, in the
optimistic belief that the weather would always permit sleeping outside.
They soon had to be enclosed, because even California weather isn't
always salubrious. Schindler's faith in the efficacy of 'natural' living was
such that the indoor and outdoor fireplaces provided the only source of
heat. Modern in its experimental materials and plan, the Schindler house
reflected the Arts and Crafts ideal of leading 'the simple life', but on a
scale that had never been dared before.

Dr Philip Lovell, who was part of the Schindlers' avant-garde circle of friends, was famous for his promotion of natural remedies for illness and emphasis on exercise, a vegetarian diet, nude sunbathing and open sexuality. In 1926 Schindler contributed a series of articles to Lovell's column in the *Los Angeles Times*, 'Care of the Body'. In it he expresses ideas basic to the Arts and Crafts Movement that he had carried out in the design for his house: 'Our rooms will descend close to the ground and the garden will become an integral part of the house . . . Our house will lose its front-and-back-door aspect . . . Each individual will want a private room to gain a background for his life. He will sleep in the open. A work-and-playroom, together with the garden, will satisfy the group needs.'[32] His insistence on natural materials was a quality that Modernists continued from the Arts and Crafts Movement. Schindler described his house as 'a combination of honest materials, concrete, redwood, glass, which were to be left to show the inner structure, and their natural color'.[33]

As a struggling young architect, Schindler built the 'co-operative' house on an extremely limited budget. Experimental by nature, Schindler was compelled by necessity to invent solutions to problems. Many of these innovations became part of the vocabulary of California modern architecture: the concrete slab level with a garden, flat roofs, sliding doors, the clerestories, and movable non-bearing partitions. With his interpenetrating indoor and outdoor living spaces, Schindler rethought the whole concept of spatial divisions and produced one of the most original buildings of the twentieth century.

Schindler's friendship with Philip Lovell and their similar ideas for healthy living brought him the commission for his other masterpiece, a vacation house in Newport Beach, designed in 1922 and completed in 1925 (p. 115). Unrecognised by the architectural press at the time, the Lovell beach house is now acknowledged to be as important in the history of modern architecture as Le Corbusier's 1930 Villa Savoye or Mies van der Rohe's 1929 German Pavilion at Barcelona.[34]

With the Lovell beach house, Schindler designed in response to the site even more intensely than with his own house. He had many practical reasons, other than aesthetics, for his innovative placement of the house on five free-standing concrete frames. First, it provided a skeletal system both solid and flexible enough to withstand the stress of earthquakes. Second, a public footpath to the beach ran past the property so, by raising the living quarters, privacy was gained for the family, together with a good view of the ocean. In addition, Schindler explained: 'The motif used

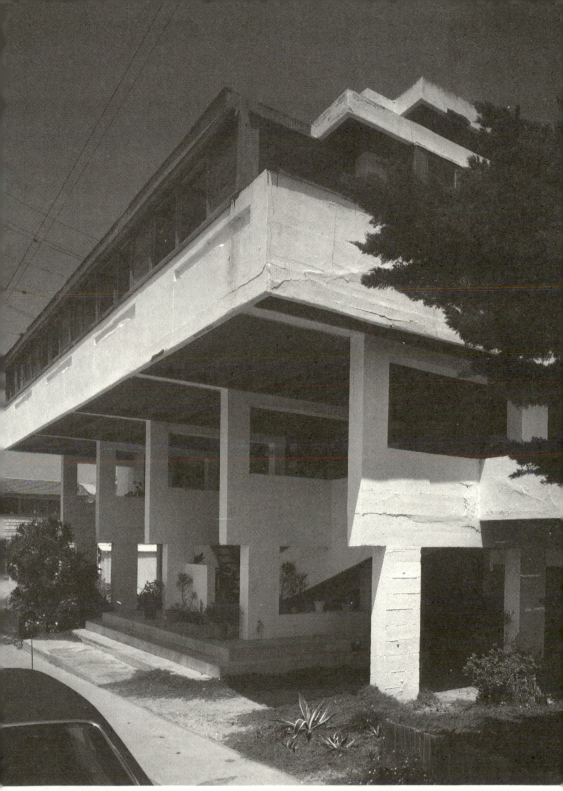

Rudolf Michael Schindler (1887–1953), Lovell beach house, Newport Beach, California, 1922–5.

in elevating the house was suggested by the pile structure, indigenous to all beaches.'[35]

As in his own house, Schindler did away with conventional bedrooms, providing only enclosed dressing rooms adjoining an open sleeping porch. And as in his own house, Schindler soon had to enclose the porches, since the wind blew rain in, and the Lovells didn't like hearing the conversation of passers-by below them. Schindler believed privacy wasn't as important in a beach house; most of the space in the house was occupied by a large two-storeyed living room, with a balcony around it leading to the dressing rooms.

Schindler had very much wanted to be included in the Museum of Modern Art's 1932 International Style Exhibition. (So influential was this exhibition that its title named the style.) However, his letter to Philip Johnson asking to participate reveals why he would be rejected: 'I am not a stylist, not a functionalist, nor any other sloganist. Each of my buildings deals with a different *architectural* problem, the existence of which has been entirely forgotten in this period of rational mechanization.' Given the Museum's definition of modern architecture, it is not surprising that Johnson replied: 'From your letter and from my knowledge of your work, my real opinion is that your work would not belong in the Exhibition.'[36]

The rigidity of Hitchcock and Johnson's attitude prevented them from seeing that Schindler actually met their criteria for the modern. For example, the first principle in *The International Style* is 'Architecture as Volume' – opening up the space since, with modern construction, walls function as screens rather than as solid blocks.[37] Schindler wrote of the Lovell beach house, 'all walls and partitions are two inches thick. They are made of metal lath and cement plaster, suspended between the concrete frames.'[38] The windows and doors were pre-milled units hung by steel rods from the free-standing concrete frame. As David Gebhard observed: 'Schindler's concrete beach house realized the central ideal of the new style – of structure and enclosing volumes establishing the form.'[39] In contrast to Le Corbusier and Mies van der Rohe, Schindler placed his supports outside rather than inside the building, and made them expressive. He also patterned his window mullions, an embellishment forbidden by the dictates of the International Style.

Hitchcock later recognised that he and Johnson had done Schindler an injustice. In 1971 he wrote approvingly of the more open-minded assessment of early modern architecture that had replaced the dogmatic purism of the thirties. He now saw it as extraordinary that 'at the time,

the significance of Schindler's achievement in the Lovell house was so little recognised. Designed in 1922, the year of Le Corbusier's Maison Citrohan project, the Lovell house now seems in retrospect one of the really crucial examples of the new architecture of the 20s.'[40]

Hitchcock never had any doubts about Richard Neutra's contribution to Modernism. Like his friend Schindler, Richard Neutra left Vienna in order to come to the United States and work with Wright. His plans were interrupted by the First World War, and he didn't arrive until 1923. After several months in Wright's Taliesin studio, he joined Schindler in Los Angeles and, with his wife Dione, rented two of the studios in Schindler's house on Kings Road.

Through Schindler he met Dr Philip Lovell. Upset by Schindler's 30 per cent cost overrun with the beach house, Lovell turned to Neutra in 1928 to design a house in the city. Lovell later explained that, 'Neutra seemed more businesslike . . . [H]e said if a house was more technological you could control the costs.'[41] (Neutra's Lovell house eventually ran almost 100 per cent over budget.)

The Lovell house was the turning-point in Neutra's career. Completed in 1929, it was included in the Museum of Modern Art exhibition and immediately became a landmark of the International Style. Among the architects working in America in the 1920s, Neutra came closest to European Modernism. He was the least touched by tradition and the vernacular, although he remained sensitive to the natural environment. Harwell Hamilton Harris, who knew Schindler well and had worked for Neutra for five years, wrote that 'Neutra's was a world of the typical and Schindler's of the unique' and that Neutra's passion for mass production was such that 'for Neutra, Sweet's Catalogue [a supply catalogue of standardised parts] was the Holy Bible and Henry Ford the holy virgin'.[42]

The Lovell house, known at the time as the Health House, was the first totally steel-frame residence in the United States (p. 118). Before its construction could begin, Neutra had to contend with the difficult plot that Lovell had purchased in the Hollywood hills, which Neutra later described as 'the so fateful, spectacular, and precarious site . . .' He wrote that Dr Lovell 'would be the man who could see "health and future" in a strange wide-open filigree steel frame, set deftly and precisely by cranes and booms into this inclined piece of rugged nature . . .'[43]

This frame was prefabricated: the individual pieces were brought to the site and in less than forty working hours, the frame was assembled and bolted. Standard casement windows were clamped into place. Concrete Gunite was sprayed on wire lath from hoses leading from

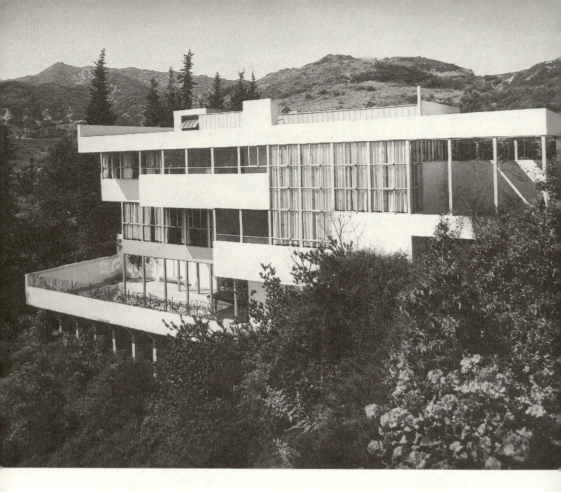

mixers out on the street. As Thomas Hines observed: 'Interstitial areas of thin steel panels and concrete bands alternated with the larger predominating stretches of glass and heightened the effect of industrial assemblage . . . Filled and covered with light concrete, steel and glass, the frame became the essence of the building.'[44]

The interior of the house was on two-and-a-half levels, with the main living room set into a cut in the steep slope. One entered the room by going down a staircase surrounded by two storeys of glass windows (p.119). Suffused with light, the staircase made a dramatic occasion of entering the living room. Neutra designed much of the furniture for the house but ordered as many fittings as he could from catalogues. One of the sinks upstairs is a dentist's hand-basin; the electric light in the staircase wall is a Model T Ford headlight. The use of stock items, the suspended aluminium light troughs and the International Style colour scheme of grey, white and black created the look of severe industrial Modernism.

For the architectural press and the avant-garde, Neutra was, in the words of Museum of Modern Art director Alfred Barr, 'the leading

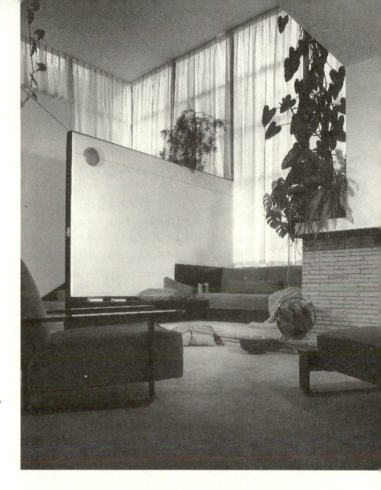

Richard Neutra
(1892–1970), Lovell house,
Hollywood, California,
1928–9.

Richard Neutra,
staircase, Lovell house.

modern architect of the West Coast'.[45] For the general public, however, it was the 'moderne' or Art Deco that came to symbolise the new architecture. The skyscraper became the ultimate expression of the 1920s zigzag moderne in America and no buildng embodied the style more completely than the Richfield Oil Building (1929) in Los Angeles by Morgan, Walls & Clements (now demolished). Characterised by an eclectic drawing from the past, two-dimensional patterning and applied ornament, the Richfield Oil Building had the sharp, linear angularity that expressed the Machine Age. Transportation imagery dominated: in the twenties, images of ships and cars; in the thirties, the aeroplane. In the Richfield building, winged guardian angels of mobility cap the twelfth floor. Night lighting made the building especially dramatic, with a sign in the shape of an oil derrick carrying the company name on all four sides.

The most outstanding surviving moderne building in Los Angeles is the Bullock's Wilshire department store (1928) by Parkinson and Parkinson, with interiors by Jacques Peters. Bullock's was the first building to recognise the new importance of the automobile. Although the street

elevation of the building is imposing, with the message over the front door stating the goal of the founder, John Bullock, 'To Build a Business that Will Never Know Completion', the back of the building, opening directly on to the parking lot, is far grander. Shoppers pass under a monumental porte-cochère whose ceiling is covered with a mural devoted to the store's theme – the spirit of transportation. The god Mercury leads the fastest modes of transportation that the twenties could provide – ocean liners, trains, aeroplanes, and the *Graf Zeppelin*. The ebullient theme continues on the inside – in light fixtures, frosted glass doors and tropical woods.

Purists of the International Style were completely disgusted with buildings such as the Richfield and Bullock's, dismissing them as 'decorative' and 'modernistic' – as false modern.[46] But the skyscraper architects' use of machine imagery was just as valid an expression of the age as was the International Style, which, in most cases, produced imagery disguised as form-giving.

Commercial architects responded to the wishes of their clients for ornament, much to the dismay of International Style champions like Barr, who wrote contemptuously: 'We are asked to take seriously the architectural taste of real estate speculators, renting agents, and mortgage brokers.'[47] The architect imposing his tastes and beliefs regardless of the client's wishes is one of the least attractive legacies of the International Style. Here, too, Richard Neutra was closer to International Style than to romantic vernacular Modernists like Schindler. Although Philip Lovell was delighted with Neutra's Health House (he wrote rapturously about it in his *Los Angeles Times* column and toured 15,000 people through the house during the first month it was completed), in an 1958 interview he expressed reservations: 'Schindler paid attention to our way of living and adjusted to it, which Neutra didn't . . . He called it Health House but RMS [Schindler] gave us more along those lines. And RMS would drive down to the beach with his carpenter when we wanted something changed or repaired. He never made us feel that we were interfering with a work of art.'[48]

In summary, the West Coast was a major centre for modern architecture in the early twentieth century, which took at least three distinct forms – the moderne executed by large commercial firms, the International Style led by Neutra, and the modern vernacular practised by architects who retained Arts and Crafts ideals while embracing new technology and mass production.

The California Modernism of Gill, Wright, Schindler and, even to

some extent, Neutra, never rejected the individuality of the Arts and Crafts Movement, of being particular to a place, of being joined to nature. In contrast, the International Style by its very name was opposed to localism, to being rooted to its surroundings and, instead, championed a formula for architecture that would apply to buildings from Dallas to Darjeeling.

The California Modernists tried to integrate buildings with their surroundings and stressed the importance of individuality and regional expression. Modernism in America was personalised until the early thirties, when the Museum of Modern Art established the standards of anonymous advanced taste, which were then canonised by the arrival of the great theorists themselves – Gropius and Mies van der Rohe. In the teens and twenties, modern architects in California still spoke an Arts and Crafts language, albeit with a different vocabulary.

To say the least, Modernism has had ambivalent success in Great Britain over the past seventy years; few would support with conviction much of what goes under the aegis of Modernism in the popular perception. Whatever arguments might be put forward to explain this ambivalence, lack of presentation cannot be maintained as one of them. From the 1920s onwards, various groups and associations presented the case of the Modern Movement, and not a few of the mainland European pioneers took up residence here. Indeed, some of the official and quasi-official bodies which were set up in Britain to promote 'good design', i.e., Modernism, served as models for other countries. The media was made good use of. However, Modernism was only one of a number of choices available, the competition being just as keen to present their case and sell their produce. This essay explores the presentation of the Modernist cause in Britain, and suggests reasons for its relative failure before the Second World War in terms which go beyond the generalisations of 'national temperament'. It becomes apparent that regardless of its claims to universality, Modernism was more than capable of élitism.

6

'Design in Everyday Things': Promoting Modernism in Britain, 1912–1944

JULIAN HOLDER

In the 1920s the distinguished architectural and design critic W. R. Lethaby was already writing of Modernism as '. . . another sort of design humbug to pass off with a shrug – ye olde Modernist style'.[1] Typical of the reaction of much of the British establishment, such serious misreadings – which reduce Modernism to a style and which continue to our own day – must invite the question: How significant was the Modern Movement in Britain? It is a common view that it was considerable. So it would seem, if areas of design reform alone are considered. Yet with the exception of a few well-known projects in social housing, such as Highpoint, Quarry Hill, Kensal Rise, and Lawn Road, many of its buildings were essentially frivolous when judged against the ideals of more socially concerned European Modernists. However, it should also be admitted that this greater European impact was largely the result of a worsening post-First-World-War housing problem and a correspondingly greater political will to solve it.

Whilst promoting the new aesthetic of the so-called International Style, and often (though not always) the use of new methods of construction and materials, projects such as the De La Warr pavilion (Bexhill), the Midland Hotel (Morecambe), London Zoo's penguin pool, the Glasgow Empire Exhibition, and a number of private houses, many a Modernist unwittingly encouraged the prejudices of an establishment able to dismiss Modernism as 'style-mongering'[2] if it did not agree with its own aesthetic preferences. Given this response, such seaside pavilions, hotels, zoos, temporary exhibition buildings, and villas for wealthy intellectuals could not seriously advance Modernism in this country as anything other than a style.

The principal aim of this essay is to describe Modernist design propaganda broadcast on the BBC from 1932 to 1944. Whilst exhibitions, journals, and the work of design reform groups such as the DIA

(Design and Industries Association), the ATO, and the MARS group did much between these years to promote various forms of Modernism, the radio, along with other forms of mass, as opposed to minority, media have rarely been apportioned much influence or attracted much attention in relation to design.[3] Yet in 1932 there were an estimated 5,000,000 licence holders representing an audience in excess of 24 million listeners. A central concern of many of the radio programmes I shall be describing was housing. This was perhaps the crucial issue for Modernists of this period, representing as it did the opportunity to solve social problems through the agency of the designer. Indeed, it is when witnessing disagreements over housing that the various shades of Modernism can be most clearly seen. Yet when set against the formation of public tastes by powerful new marketing methods, Modernism rarely achieved the popularity its principles deserved, but rather saw the International subverted by the National, the Functional by the Symbolic. In the perpetuation of old values, no less than in the formation of new ones, the popular media played a vital rôle.

However, if the design of mass-produced objects and buildings was now to be conducted along functionalist lines where style, usually understood within Modernism to mean Revivalism, was not to be an issue, how was design to be discussed? As one self-confessed British Modernist put it, '. . . if a thing fulfils its purpose . . . beauty comes in as a sort of by-product'.[4] Paradoxically Lethaby, too, claimed that 'we need not worry ourselves about beauty for a long while yet; there are many prior questions of decency, cleanliness, order, fitness'.[5]

As so many of the accounts of the history of the Modern Movement in Europe were written by participants in the struggle to achieve the 'conquest of ugliness' in social, as well as aesthetic terms, their accounts have necessarily coloured our reading of much of the first fifty years of this century. It has fallen chiefly to Nikolaus Pevsner in his *Pioneers of the Modern Movement* of 1936 to create the lineage and form of much of the debate.[6] In Pevsner's account, Britain is often left out of considerations of Modernism. The Pevsnerian tradition had been only to credit Britain, largely in the shape of the Arts and Crafts Movement, with lighting the touch-paper, whilst leaving the display to Germany. However, other figures such as Herbert Read, John Gloag, J. M. Richards, Noel Carrington, Anthony Bertram and W. R. Lethaby need to be considered as they could all be regarded as both historians of Modernism and at the same time critics of contemporary design.[7] Whilst history as a discipline, by reason of the necessity to select events from the past, is inevitably a

critical, and ultimately a moral endeavour, this approach has bequeathed a troublesome legacy today not least to design education.[8]

The name W. R. Lethaby may seem to sit uneasily amidst the names of these younger men. However, as one of the key figures of the Arts and Crafts Movement and someone not automatically averse to the so-called 'machine age', he provided an essential, and often neglected, link. Of common concern to all these writers over a period of some thirty years (with the notable exception of Pevsner in his *Pioneers*) was what was variously termed 'everyday life' or 'everyday things', the obvious focal point for Modernists committed to harnessing industrialisation to the cause of social equality.[9] That the study of 'everyday things' was regarded as important can be seen not only in the writings of Modernists during this period but also in the popularisation of history as a discipline. One of the best examples of this is the 'Everyday Life' series of books written by Marjorie and C. H. B. Quennell from 1914 onwards. Interestingly, as an architect, C. H. B. Quennell had undertaken a large number of commissions in an Arts and Crafts manner before his own Modernist work of the interwar years and his promotion of Modernism in the 'Everyday Life' series.

Equally noticeable in British Modernist polemic was a concern with notions of 'civilisation' and 'culture'. Many writers of the period saw 'civilisation' in decay due to the unchecked rise of capitalism in the nineteenth century.[10] Evidence of this decay was taken to be the survival of period styles. 'Culture' as one of the essential attributes of 'civilisation' was paradoxically threatened by both the challenge to its reliance on uniqueness by mass production, and the corresponding erosion of 'meaning' in objects of cultural importance. Civilisation, in the terms of, say, Noel Carrington's work of 1935, *Design in Civilisation*, could be saved by raising the standard of design in cultural objects, albeit mass produced. However, the standard by which mass-produced objects were judged, and found lacking, was that of craftsmanship. Furthermore, in terms of their relationship with the public, the conception of designers, and in particular of architects, as guardians of civilisation, engendered a cultural superiority best exemplified by their attitude towards the everyday things their reforms were aimed at. This was especially noticeable in the case of the cinema.

This concern with the 'everyday' posed serious theoretical problems for the Modern Movement in a Britain torn between an Arts and Crafts Movement committed to high standards but inappropriate products, and a new body of opinion seeking to work with industry to reform the design

of 'everyday' products for the home and to improve the provision of housing.

The common view of the 1920s in Britain is of a time of little significance for Modernism.[11] This is partly due to the greater attention paid by the polemic historians of the Modern Movement to the 1930s when the more clearly identifiable 'style' could be recognised, and to Pevsner's insistence that the important contribution of this country ended with the Arts and Crafts Movement. It is also largely a consequence of viewing the First World War as a 'watershed', irreversibly separating 'pre-' and 'post-'. However, certain continuities between the pre- and postwar years, together with the efforts applied during, and as a consequence of, the First World War, need to be considered if the poor profile of Modernism in the 1920s is to be understood.[12]

I take it as axiomatic that a major concern of British Modernists, like their European counterparts, was with what was variously termed social, workers', or mass housing. New materials and methods of production were thought to be employed most appropriately on mass housing, where the economies of scale which lay behind industrial production could be of greatest benefit. Their use for building private houses was seen as unnecessary and almost as wasteful and 'sham' as Victorian ornament. Only by careful application of Taylorised management and Fordised production – rationalisation and standardisation – could the products of twentieth-century culture lead to the postwar restoration of order that, it was felt, both connoted and enabled a civilised existence. What rationalisation and standardisation allowed, given the political will, was the tackling of a mass problem – poor housing – on a mass scale for the first time.[13]

The economies of scale which could be achieved through Taylorist principles were well realised in Britain by the end of the First World War. The apparent variety of a munition workers' estate such as Well Hall, Woolwich, belied the use of standardised elements such as lintels, roof trusses, doors and windows.[14] House plans were reduced to a few standard types and the apparently random variety of site plan was a result of careful planning. The provision of housing by the State in the form of munition workers' housing in the First World War was an able, early demonstration of rationalisation and standardisation. With the creator of the Garden City, Raymond Unwin, as the head of the design team of the Ministry of Munitions, Department of Explosives Supply, and fellow designers Frank Baines and R. J. Allison, principal architects at HM Office of Works, it is little wonder that these lessons of

standardisation and rationalisation found their way into much of the housing provided between 1914 and 1918 and ultimately into the Tudour Walters Report of 1918. If 'civilisation' was threatened by nineteenth-century industrial capitalism, as feared by Ruskin and Morris, it was Ebenezer Howard's concept of the Garden City which most clearly theorised its containment. Identifying the root cause of poor housing standards as land ownership, Howard's theory was in many ways a key foundation of British and European Modernism.[15]

The alliance of Howard's theory with Unwin and Parker's practice created the Garden City and Garden Suburb, at Letchworth (1904) and Hampstead (1906) respectively. The introduction of standardisation and rationalisation could allow greater benefit. The Tudour Walters Report claimed that the higher standards of housing it was advocating for '. . . the proper carrying on of family life' could be achieved partly through the use of standardisation '. . . on the lines adopted for the manufacture of a motor car'. Similarly the *Housing Manual* of 1919, which resulted from the report, embodied the same principles of planned growth, standardised parts, and rationalised production. The use of car production as a model for housing production was to bewitch European Modernists for much of this century and reaches its apogee in the post-Second-World-War temporary housing campaign and introduction of systems building.[16] There can be little doubt that in the years preceding the First World War the British Garden City Movement represented the most advanced ideals in the provision of social housing anywhere in the industrialised world.[17] That this momentum was not lost during the war, but was consolidated, was a remarkable achievement. No less was its ultimate triumph, the 'Homes Fit for Heroes' campaign of the postwar years. However, although Howard's theory was radical, and the method of production could have been likewise, the Garden City, and subsequent council housing, was seen by most Modernists later in the century as hopelessly reactionary and romantic, offering a 'timeless' image of rural escape which failed to address the 'Modern Age' as presented in Le Corbusier's *Towards a New Architecture*, or Walter Gropius' *The New Architecture and the Bauhaus*.[18]

The timeless image of the Garden City, created originally by philanthropic industrialists such as Rowntree, Cadbury, and Lever, has been characterised as suggesting 'communities without conflict'.[19] As the large-scale provision of state housing was mainly achieved through fear of social unrest, if not outright revolution, this was a particularly inappropriate, even if effective, image. A more 'honest' and appropriate

approach was that of C. H. B. Quennell and W. F. C. Crittall in their design of Unit Concrete Cottages at Braintree, Essex, in 1919. Reporting their completion in *Country Life*, R. Randall Phillips sounded various notes of alarm at their flat roofs, but otherwise praised the standardisation of the building elements in the context of the postwar housing need.

As a maker of steel frame windows Mr Crittall felt the need for standardisation before the war; for, obviously, there was a loss of time and unnecessary expense involved in making casements which were always differing from one another by mere fractions of an inch this way or that; and the need for standardisation became insistently clear to Mr Crittall when his firm turned during the war from the making of windows to the production of munitions.[20]

The Unit referred to in the title of the experimental cottage project was in fact a modular scheme which governed the size of concrete blocks, used in conjunction with standardised steel casements and doors. Individual rooms and passageways were also laid out according to a module although there was no standardisation of plan. By eliminating wood from the flat roof (and throughout the cottages), and using expanded metal covered with sand and tar, a saving of £28.00 per cottage was claimed. 'This matter of appearance,' Phillips concluded, 'is, of course, all-important. The sprinkling of unsightly cottages up and down the land would be a calamity. But also we have to bear in mind the sheer inability for all the houses that are needed to be built of brick in the familiar fashion. We shall have to build in other ways also; and concrete is one of them.'

Thus a new image for housing implied the existence of a new social order. The 1920s witnessed the gradual and painful emergence of this new order as European politics struggled with nationalism and internationalism, as did housing style.

The Design and Industries Association, as a promoter of Arts and Crafts ideals during this period, was one of the most significant bodies.[21] Founded in 1915 after members of the Arts and Crafts Exhibition Society had succeeded in persuading the Board of Trade to allow an exhibition of German design, its early presiding influence was W. R. Lethaby. 'If I were learning to be a modern architect, I'd eschew taste and design and all that stuff,' he had written earlier to Sidney Cockerell, 'and learn engineering with plenty of mathematics and hard building experience. Hardness, facts, experiments – that should be architecture, not taste . . .'[22]

During and after the war years Lethaby's concerns turned increasingly towards the subject of housing and planning. He had little time for 'style-mongering' as he called it, preferring the vague and troublesome notion

of 'fitness for purpose'. Addressing the Arts and Crafts Society in November 1916 on the topic of 'Town Tidying' Lethaby gave an example:

. . . of what I mean by art where order, construction, beauty, and efficiency are all one, may I instance the Navy? We must not be content until our railways are as ship-shape as a squadron. What other arts have we that hold the same beauty of efficiency, carried forward in an unconsciously developing tradition: . . . I am here to beg you all to play this best of games – town tidying.[23]

Similarly, the *Hibbert Journal* in 1918 found Lethaby writing on 'Towns to Live In' when he claimed, 'We need not worry ourselves about beauty for a long while yet; there are many prior questions of decency, cleanliness, order, fitness.'[24] However, although beauty had become a bourgeois concept for many by the early twentieth century, and formalism was, as it remains, the chief method of design theory, the insistence that considerations of style and beauty were inappropriate luxuries was clearly a mistake, however well intentioned, if the Modern Movement was to achieve its objectives in the field of housing. The apparent 'timelessness' of the Garden City was of course a partial result of the appeal to rural values as an essential constituent of national identity. A forceful example of this ideology was its use by Shell in advertising campaigns under the direction of Jack Beddington, the growth in owner occupation of vernacular-type semis, and the success of Batsford's series of books devoted to such concerns. Published between 1932 and 1940, three series, 'Face of Britain', 'English Life', and 'British Heritage' became particularly successful, due in no small measure to the colourful book jackets designed by Brian Cook in the Jean Berte process.[25]

Lethaby's influence on the DIA was to charge it with a duty to consider order, efficiency, and fitness for purpose in everyday life rather than style. Order, what Art recast as Design could bring, was to become a synonym for State control and intervention as opposed to the unrestrained capitalism and workings of a free market which had produced the disorder and misery of the industrial city. Lethaby is often presented as the Judas of the Arts and Crafts Movement for recognising the benefits of machine production, even imploring Ernest Gimson to design for Ambrose Heal. Like Pevsner later, he was constantly to uphold the example of German design. As such he did much to calm the Arts and Crafts xenophobia concerning machine production which partly necessitated the formation of the DIA.

When the young John Gloag, a member of the DIA, began writing in the 1920s his approach, like many of his generation, may be seen to have

borrowed a great deal from Lethaby. In 'Artifex; or the Future of Craftsmanship' of 1926 he argues not only for the centrality of craftsmanship to civilisation but warns of the danger posed to civilisation by the destruction of the crafts in the nineteenth century. Gloag argued for '. . . the dawn of a new era of craftsmanship . . .' as '. . . the war between craftsmanship and machinery in the nineteenth century was an utterly false and misleading picture'.[26] Looking at the new world order, and the industrial might of America, Gloag campaigned for what he called 'machine craft' and cautioned against British jingoism in design, for 'Americans cannot be dismissed as cocksure rustics in Ford cars'. The yearbook of the DIA for 1926–7, entitled *Design in Everyday Life and Things*, which Gloag edited, was '. . . an attempt to bring facts about planning into focus'.[27] Here, echoing Lethaby's notion of order, he claims that 'Good planning is really clear thinking . . . We see it in the work of the engineer, in certain forms of traffic organisation, occasionally in public buildings, and sometimes in domestic architecture; but it does not affect our industrial civilisation as a whole.' Order, the order imposed by careful planning, whether Beaux-Arts or Picturesque, was thus to be a chief consideration in this civilisation which was being rebuilt.

agressive nationalism

However, 1927 saw the DIA's enthusiasm, in the person of Harry Peach, run away with itself. Ineffective at bringing pressure on the Board of Trade to promote British design at an international exhibition of Kunstgewerbe in Leipzig, organised by a friend of Peach's, the DIA decided to '. . . take the lead where officialdom had failed'.[28] It turned out to be an unwise decision, with the Association's resources being badly stretched and major manufacturers not showing sufficient interest in the work exhibited. The result was a display more appropriate to the Arts and Crafts Exhibition Society than to the DIA. In contrast, at Leipzig, the Germans showed only a few well-displayed industrially produced products. At the DIA's first meeting after the exhibition, the textile designer Minnie McLeish told her fellow members that what the exhibition had taught them was that '. . . we do not understand this modern movement in design, and we do not like it. We may be right or we may be wrong, but at any rate we have no part in it.'[29]

It fell to industrial philanthropy based on a nineteenth-century model to create in 1927 the first Garden City in a Modernist style. Capitalising on the work at Braintree, Thomas Crittall employed Thomas Tait and Sir John Burnett to design a whole factory town at Silver End, Essex. Writing about the scheme in the DIA's *Quarterly Journal* of 1930, W. F. C.

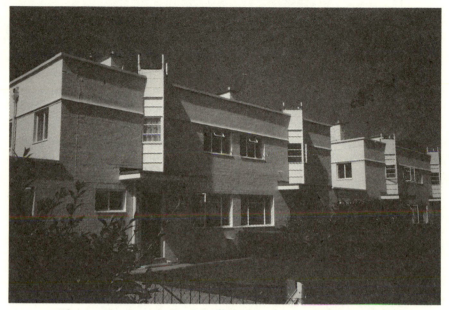

Thomas Tait, housing for Crittall workers, Silver End, Essex, 1927.

Crittall maintained that the '. . . houses have had a great deal of publicity, and are generally supposed to represent a definite step towards modern architecture in Great Britain'. Nonetheless the materials were largely traditional, as were the house plans, and the development may be seen as a Modernistic rather than a Modernist one. Together with two private houses in the Modernist style, Peter Behrens' 'New Ways' of 1926 for model engine manufacturer Bassett-Lowke, and Amyas Connell's 'High and Over' for Professor of Classical Archaeology Bernard Ashmole, it brought public attention to the new clothes of Modern concerns.

Stylistically the Silver End development formed a radical break with the Arts and Crafts philosophy. Although it couldn't be assumed, in looking at these buildings, that Lethaby's admonitions to ignore questions of style had been listened to, the absence of any Revivalist elements may well have persuaded many that a style was not being practised here. Where Lethaby misrecognised the Modern Movement as 'only another kind of design humbug', Le Corbusier made the vital link between housing and social democracy which was to appeal to the younger architects. Where much of the debate in the 1920s can be seen as a more specific version of an Arnoldian choice between 'Culture and Anarchy', Le Corbusier rewrote the equation in the final chapter of

Towards a New Architecture as a choice between 'Architecture or Revolution'. Yet it was not until the late 1930s that anything much beyond private housing was built in the International Modern style in Britain. The British Modern Movement hence became associated with privilege, patronage, and the private wealth necessary to commission Modernist villas or the speculative builders' versions of 'jazz-moderne'. It was also attracting the reputation of being socialist with its insistence on planning and State intervention. However, the experiments of the 1920s in using standardised elements to lower housing costs were not being undertaken on a scale to help the least well-off in any significant way other than in council housing. As government support for this was reduced and the private sector encouraged, council housing assumed a traditional Neo-Georgian character to clothe its modern methods, rather than the Modernist one it might have achieved.

With increasing European contacts and a worsening political situation in Europe, a younger generation was eager to wrest the design debate from the more traditional approach of the DIA and direct it towards International Modernism. In practice, however, it was the DIA-approved design which continued to be seen and, more importantly, heard on the radio.

Initially encouraged by the success of a series of talks in the spring of 1930, entitled *Today and Tomorrow in Architecture*, the BBC followed this with a DIA view of 'modern art'.[30] The *Quarterly Journal* for January 1932 announced that:

Mr J. E. Barton, the headmaster of the Bristol Grammar School and a member of the Association, has been selected by the BBC to give a series of talks on Modern Art as part of the *Changing World* series. The talks will range over architecture and pots and pans as well as sculpture and painting.[31]

Together with an associated book by the speaker, this series marked a new method of promoting modern design by the DIA beyond exhibitions and pamphleteering. Having recognised the truth of Minnie McLeish's pronouncement after the Leipzig exhibition, there was clearly a more determined approach within the DIA to address this Modern Movement which it didn't understand.

By 1930 the future Lord Reith, as Director-General of the BBC, had instigated a radical restructuring of the Corporation which led to centralised operations in London, the establishment of a Listener Research Department in 1936, and a concerted effort to raise the profile of the Talks Department.[32] Up to this point the BBC had been prohibited from discussing controversial subjects, which modern art was considered

to be. Its subsequent broadcasts on modern design were to show 'that interest in the subject was extensive'.[33]

Such talks fulfilled not only Reith's policy of cultural enlightenment and enrichment but were broadcast to encourage 'intelligent listening'. Early fears amongst broadcasters (soon to be substantiated by early audience research) were that radios were being left on in the home for long periods of time to provide background sound. To counteract such bad habits on the part of its listeners, talks were seen as a method of training the public in the correct use of their sets. To this end the first publication of *The Listener* in 1930, pamphlets associated with the talks, and the setting up of listener groups, were but part of a wider policy. Better listening habits, it was assumed, would also provide benefits in weaning listeners off the programmes of popular music with an American inflection that the BBC felt obliged to offer, and combating the popularity of commercial stations such as Radio Luxembourg and Radio Normandy.[34] However, by some Modernists this opportunity to be presented as experts within the format of Talks programmes was only partially welcomed. Recalling the work of MARS, Maxwell Fry made it quite clear that:

we, as a group, and I always insisted very strongly on this, had nothing to do with the general press, with the general media, because the ideas were too difficult to bridge the gap between ourselves and the *Daily Mail*, or even with television when it came. We had to go through another stage to spread our ideas. We had first to present our ideas to the talkative intellectuals of the age.[35]

J. E. Barton, one of the first 'talkative intellectuals', structured his broadcasts around a series of questions: 'Is beauty a luxury?', 'Are we getting saner?', 'Do we use our eyes?', 'What is taste?', 'When shall we be civilised?' and 'Will the new city make new men?' Defining modern art as 'The art that has escaped from the tyranny of nineteenth-century ideas', Barton's ideas were in a clear intellectual tradition derived from Ruskin and Lethaby with their insistence upon the need for joy in labour and that 'Fitness for purpose, down to the smallest detail, is the test of a good thing' so that 'The beauty of some things ought to be stark'.[36] The associated pamphlets for the *Changing World* series represented 'a new form of Talks pamphlet, larger than the earlier ones', boasted the BBC *Yearbook* of 1933.

In the same year, John Gloag, Geoffrey Boumphrey and Edward Halliday chaired a further series of talks for the BBC entitled *Design in Modern Life*. Contributors included Elizabeth Denby, James Laver, Gordon Russell, Maxwell Fry, Frank Pick, A. B. Read, Robert Atkinson

and Wells Coates. This came hard on the heels of an earlier series which
Gloag had been involved in, entitled *Design in Industry*. The initial
discussion in the new series was held between the three main contribu-
tors, or, as they wished to be known, 'the listener's friend'. Entitled
'What's Wrong with Design Today?' the programme tossed the subject
around in order to discuss the dishonesty of period styles, the preference
for functionalism, and the problem of influencing manufacturer and
retailer. Geoffrey Boumphrey concluded that:

If a thing is designed to do its job really well – honestly designed without any frills
on – you do get, whatever you like to call it, beauty or satisfaction or anything
else. And that, I take it, is exactly the feeling we all agree we don't get nearly often
enough from the things we use in everyday life.[37]

The Listener claimed that the series had been '. . . one of the most
popular of recent years and showed . . . that nothing short of a revolution
in thought is taking place within our time'.[38]

The programmes were well planned to coincide with the exhibition
'British Industrial Art' at Dorland Hall which, though effectively a DIA
exhibition, bore the imprint of *Country Life* magazine – a considerable
promoter of what it saw as Modernist in this period due mainly to the
efforts of Christopher Hussey.[39] When examined closely, Hussey's
attitude to Modernism bore all the hallmarks of the British establishment
in crisis. Modernism could not be accepted as totally new but had to be
related to a tradition. This tradition was usually that of the eighteenth, or
late seventeenth, century when craftsmanship was still apparent and
British 'genius' was all around. Modernism was thus just the new
dressing, or undressing, of English Classicism. Of the very few Modern
architects whose work was promoted by *Country Life*, Oliver Hill was
clearly favoured. Favoured as a friend of Hussey's and also because his
work was amenable to being read as part of the tradition of the
Picturesque.[40]

The year after Gloag's radio discussions Anthony Bertram reviewed
the resulting book of essays which Gloag had edited and asked: 'Think
what the world today would be if this book had been a bible for the last
one hundred years, if Gloag and his like had been Ministers of Design
with autocratic powers?'[41]

This use of the new medium of radio in the cause of design reform was
to be further exploited in 1937 when Bertram himself presented a series
of twelve talks entitled *Design in Everyday Things*, accompanied by a
series of articles in *The Listener* and a BBC booklet. It was also tied to a

weekend conference of the DIA held at Bexhill.[42] Broadcast between 8.00 and 8.30 p.m. from October until December 1937, topics covered were 'What is a House?', 'Living-rooms and Kitchens', 'Bedrooms and Bathrooms', 'Heat, Light and Sound in the Home', 'Housing the Workers', 'Towards a Healthy Social Life', 'Our Streets', 'Public Buildings', 'Places of Work', 'Places of Pleasure' and, finally, a conclusion entitled 'From Aeroplanes to Nutcrackers'.

An advance announcement in *The Listener* claimed that:

An unusual tour of the country was made early this year in the preparation for a series of broadcast talks to be given in the autumn. Architects, manufacturers, shopkeepers, designers, housing authorities, and estate managers were interviewed. So were housewives and other members of the great consuming public. A broadcast appeal for letters brought in a vast and varied response.[43]

Bertram began the series with a general talk entitled 'What Does the Public Want?' in which he outlined the results of his research. Directed towards investigating '. . . those people with under £8.00 a week income' it is clear that much of his evidence was drawn from letters which had come from a self-selecting sample, unlike the more rigorous approach of Pevsner in his *Enquiry into Industrial Art in England*. Bertram broke the respondents down as follows:

. . . for every woman who wrote to me there were five men, although the greater proportion of the letters dealt with domestic matters. As to occupations, there were 93 different ones mentioned, so my correspondents represented a pretty good cross-section of society. $22\frac{1}{2}$% had something to do with supply – shopkeepers, salesmen, housing authorities, and so on – but only two letters came from manufacturers. Then over 20% were from people connected in some way with art, as teachers, designers, architects, or students. The rest – that is 57% – wrote simply as people who buy things. Among them, manual workers led, but teachers and clerks pressed them pretty close.

Bertram travelled the country in 1937 not only to interview manufacturers, etc., but also the writers of some of the letters. The chief concern of the letter-writers was with town planning, not its implementation so much as its absence. Housing came a close second. 'The most striking thing about them was the really very considerable appreciation of municipal housing and the almost universal condemnation of what the speculative builder has put up,' Bertram claimed.[44] Such a claim in the face of the popularity of the speculative builders' semis necessarily casts further doubt on the representative nature of Bertram's respondents. The same desire for design autocracy which Bertram had craved when reviewing Gloag's work of 1934 he was pleased to find from

'a correspondent who wanted a controller of design in every city, an official responsible for lettering, lamp posts, refuges, subways, public lavatories, in fact everything in the street'.[45]

Early in the series Bertram unfurled his own colours by attacking 'sham' housing and defending Le Corbusier's concept of a house as a 'machine for living in'. 'You may be a little surprised', he declared:

> . . . if I say now that what I think people have forgotten is tradition, and that though I am going to spend all my time advocating new architecture and new design in everything, I am going to make a claim right away that we so-called modernists are the real traditionalists. Because after all the tradition of design is to make new things for new purposes, new things for new kinds of people, to use new materials and new methods of manufacture in new ways.[46]

That the weekly broadcasts were popular is at least evidenced by the regular letters about them to *The Listener*. A running battle was fought between correspondents over one or two swipes at 'graining' made by Bertram – was it, or was it not, dishonest? More telling were letters clearly aware of Modernism and prepared to argue its shortcomings. The most spirited correspondent attacked Bertram's advocacy of what he termed 'domestic modernism' from a number of points, including the greater likelihood of 'modern plain surfaces' becoming 'unsightly' with use, disputing whether 'meaning' could ever be found in ornament, and claiming that the attractiveness of a car was due to its styling – its absence of 'straight lines and right angles'.[47] 'The public should be left alone,' concluded another respondent with 'thirty years' experience in designing domestic buildings and their appliances', 'for it knows quite well how to look after itself. All this bullying about art which began with Ruskin has led us into the mire of rubbish in which we wallow today.'[48] When Bertram promoted new ways of heating and denied their adverse effects upon the atmosphere of a modern home, correspondents were adamant that he was wrong. When he seemed in danger of promoting the importance of shape over that of materials he was taken to task by a correspondent who claimed that: 'Many of the materials in common use are simply unfit for any purpose, no matter how good the shape may be'.[49]

Despite the public's apparently informed opinion, it is clear that Bertram, like Gloag before him, felt that they too readily mistook the Modernistic for the Modernist and, like the BBC, felt that the public didn't know what it wanted. 'Present-day architects and artists are heartily sick of the word Modernism,' wrote another listener. 'We all, even the humblest of us, try to design by traditional methods.'[50] Bertram

took great pains at several points during the talks to distance himself, and the programmes, from the 'sham' of the Modernistic. One of the period charts which had been drawn by Raymond McGrath for Gloag's *Design in Modern Life* was used again in *The Listener* to highlight the distinctions between the Modernistic of, inevitably, 1925, and the Modernist of 1933. For many members of the public, Modernism meant simply the Art Deco style associated with the 1925 Paris exhibition, and sunburst motifs formed part of the vocabulary of the speculative builder of the period. To many a Modernist this treatment, restricted to surface decoration, was as 'bogus' as the mock-Tudor and accordingly described as Modernistic, a derogatory term.

Reflecting the concern of the letter-writers, the major attention of the programmes was directed towards housing and planning. Apart from occasional discussion with members of 'the public' following his talks, Bertram only abandoned the chair for one session: a discussion on town and country planning between Sir Raymond Unwin, Thomas Sharp, and R. A. H. Livett. With the exception of land values making flat-dwelling desirable, Bertram's advocacy in this area had always been for the Garden City type of development. Opening the discussion, Sir Raymond Unwin clearly had little trouble agreeing as to the merits of the Garden City. What was most remarkable about the programme was Thomas Sharp's fairly vicious attack on the 'style' of Garden City housing. In the area where it might have been least expected to cause problems – planning – style became a major issue. Whilst Sharp readily agreed with Unwin on the aims of town and country planning – to limit growth by the construction of new satellite towns:

. . . I don't at all agree that these new towns should be built of detached and semi-detached cottages . . . it's romantic, cottagey, arty-and-crafty playing-at-being-a-village instead of being a town . . . the town as a huge cottagey hamlet has become the law of the land . . . it has made people ashamed and afraid of genuine towns. It has made them think that no really urban town can be decent, or civilised, or fit to live in.[51]

Livett, as Housing Director for Leeds where the Quarry Hill estate had only recently been completed and speaking on 'Inner Ring Development', could hardly have been expected to have come to Unwin's aid. He didn't. If detached and semi-detached cottages, even therefore Silver End, were romantic, what was now to be admired in the provision of modern housing?

In 1937 the Gas, Light and Coke Company had just completed a block of flats, the Kensal House estate in London.[52] The design of a team led by

Maxwell Fry and including Robert Atkinson, C. H. James, G. G. Wornum and Elizabeth Denby, the blocks provided dwellings for 380 people in 68 flats. Each flat had a living room, separate kitchen, separate bathroom, three bedrooms, and two balconies. Fry, who with Denby had taken part in Gloag's earlier talks, was considered one of Britain's leading Modernist architects.[53] A founder member of MARS in 1931, as a sort of English CIAM, and a contributor to the 'Circle' anthology, he was also a sometime colleague of Walter Gropius. The design was the result of an internal competition amongst the group of architects who worked in rotation for the Gas, Light and Coke Company. The site was far from spectacular, being between the railway lines and canal in a disused corner of the company's large plant in North London. As Fry later recalled: 'I won by the trick of including the site of an old gasholder not specified as available.'[54] The team conceived of the estate as a '. . . community in action – with social rooms, workshop, a cornershop, with large flats, better balconies, even a separate drying balcony, and in my disused gasholder hollow a nursery school, one of the first of such buildings'.

Clearly the estate was not simply an exercise in industrial philanthropy on the part of the Gas, Light and Coke Company but a good means of advertising its services and combating the increasing specification of electricity by the London County Council in its new estates. Advertisements for the company in the national press featured the estate under a headline 'Healthier, happier living at a new low level of cost'. At a time when an average working-class family was reckoned to spend between 5s.6d. to 6s. a week on fuel, advertisements proudly claimed 'an average of less than 4s.6d. a week' for 'a complete labour-saving, smokeless fuel service, including an automatic hot water supply'. Towards the end of Bertram's talk, 'Housing the Workers', where he interviewed a 'housewife' from the new estate, he proclaimed Kensal House to be '. . . the last word in working-class flats'.[55]

The influence of European Modernism on Fry had clearly been immense, as it had on many others. There he '. . . found what astonished me, being no less than the proposition of an architecture in its own right, relying upon no past style whatsoever'.[56] For Bertram too the emphasis on function, rather than style, was found to be one of the most heartening results of his research. 'One fact that impressed me very much about the letters,' he wrote, 'was that hardly anybody worried about appearances. Of course appearances are very important, but in the useful arts utility must come first, and if a thing fulfils its purpose and is honestly made of

good stuff, the chances are that beauty comes in as a sort of by-product.'[57]

When Penguin Books began promoting the 'new architecture', one of the first writers of a Pelican Special, *Design*, was Anthony Bertram in 1938. Largely a reworking of the talks as published in *The Listener* (unlike Gloag's *Design in Modern Life*), the front cover carried a photograph of the model of Quarry Hill. J. M. Richards' *An Introduction*

Front cover of Anthony Bertram's Pelican Special, *Design* (1938).

to Modern Architecture, written in 1938 but not published until 1940, carried on its front cover a drawing of Kensal House. 'Today,' he wrote, 'the most urgent problem before the modern architect in England is not one of perfecting his ideas in theory, but one of getting opportunities to put his theories into practice.'[58]

If concern about housing was high on the public's agenda in 1937 (the BBC had previously broadcast discussions on the subject of urban sprawl, seen as the result of a lack of national planning, in *Suburbs or Satellites* in 1935), it was to become an urgent topic of conversation in the latter years of the Second World War.

Accordingly, from 21 March to 4 April 1944 the BBC broadcast a series entitled *Homes for All*. The form of the programmes was announced in *The Listener* of 6 March 1944 as follows:

A Court of Inquiry will be set up before the microphone, presided over by a distinguished KC, and it will hold nine broadcast sessions in the course of fifteen days. Witnesses will appear before it and their evidence will be made instantaneously available to all who choose to listen. The Chairman will be assisted by two 'assessors' sitting with him; one a Glasgow businessman representing, in a general way, the caution of age and experience, the other a young wife from Bermondsey representing – again in a general way – the aspirations and enthusiasms of youth.

Despite the subsequent assertion of the producer, I. D. Benzie, that the series contained 'nothing much about architecture or the design of the inside of the houses, and no glorious illusions about electric dish-washing machines for all', this comment was clearly more a reflection of the assumed divide between housing and architecture which bedevilled Modernists than factually correct.[59] The expert witnesses included not only figures closely connected with housing, such as Lord Balfour and Captain Reiss, but also a preponderance of architects. Among them were the then President of the RIBA, Percy Thomas, L. H. Keay, the City Architect and Housing Director of Liverpool, and F. R. Yerbury. The programmes interrogated both a speculative builder and a building worker, together with a convenor of shop stewards from an aircraft factory. Apart from Lord Balfour's outspoken comments in the first and last broadcasts, where he outlined the size of the problem, pointed out the pitfalls, and, like Captain Reiss, gave a gloomy prognosis, the principal interest centred around the contribution which standardisation and prefabrication could make towards solving the problem.

Estimating the immediate postwar need for housing at between $1\frac{1}{2}$–2 million dwellings, with a subsequent increase to 4–5 million, the Court of Inquiry concluded that temporary, factory-made housing was essential both to provide homes and to save labour whilst permanent homes were built. Having been advised by F. R. Yerbury on the best foreign housing developments, it concluded that their emphasis on communal facilities was not desirable. For, as the housewife, Mrs White, put it, 'We don't go in for blocks of flats so much, do we?' Yerbury replied: 'No, Mrs White, that's true. There's nothing on the Continent anywhere to equal the cottage estate when it's nicely developed.'[60]

Not only were cottage estates still the ideal but Yerbury went on to compare Continental flats with their British counterparts and claimed of the latter that 'although these flats are so well built, they are grim'.

Percy Good of the British Standards Institute proved to be a particularly impressive speaker in explaining the work of the BSI and declared

that a house should be 'permanent in the structure, with ease of replacement for the parts that wear out'.[61] If, overall, the assessors were convinced of the ability of architects, working in co-operation with industry, to solve the impending postwar housing crisis, they were less convinced that traditional craft-based attitudes and the use of national planning regulations to protect, rather than develop, the countryside would not defeat such efforts. Issuing a warning to this effect, after an energetic advocacy of the factory-made Unit house, Sam Bunton, consultant architect to Clydebank, concluded that:

Everyone should remember that sectional interest, tradition and convention will come to be known as the Fifth Column of reconstruction. Anyway that's the way I view it.[62]

Within a month, the 'factory-made house', developed by the aircraft industry in advance of its own postwar need to diversify, was on show in London.[63] Despite the reforms advocated by the DIA and other bodies, the influence of refugees such as Gropius and Breuer, the use of the radio and cheap paperbacks, Modernism – as a force for improving 'everyday life and things' by the provision of well planned, orderly cities with good-quality housing and fittings – was still only partially established. Nevertheless it had, by 1944, come to be synonymous for many with social housing.

The broadcasts of the BBC Talks Department represented a significant attempt to create a larger public for Modernist design. For its message to become more effective, however, it would need a still wider and more compelling medium which was not liable to be pushed into the background due to the poor listening habits of the public, a fear substantiated by the BBC's own research together with that of the commercial operators.[64]

Having recommended the pioneering work done in a few museums to advance the cause of Modernism, Noel Carrington, in his 1939 publication *The Shape of Things: An Introduction to Design in Everyday Life*, wrote:

Fortunately there are other media for educating in design: broadcasting, television, and film. In the first field much has been done in this country. The second has only recently made a start, but has obviously great advantages. The film has possibilities that make the mere writer of books sick with envy, and already a few instructional films have shown the way.[65]

Of particular note here was the work of the British documentary film movement centred around John Grierson and the GPO Film Unit. In

1935, very much in this vein, the British Commercial Gas Association had employed Arthur Elton and Edgar Anstey to direct *Housing Problems*, an early documentary on slum housing in London and attempts at housing reform which featured new, Modernist, gas-equipped estates.

The effect of the commercial cinema on the British population was one of the chief interests of the Mass Observation group. What is evident from even a cursory glance at its findings is the considerable attraction provided by American films (notwithstanding the comfort of the individual cinema building, which was also considered), at a time when, to take 1939 as an example, weekly cinema audiences were in excess of 19 million. To be able to break into the illusory world of film, the accoutrements of the stars would help. With Hollywood's new marketing methods this was now possible.[66] Speculating on such influence, one of Mass Observation's researchers for its 'Worktown' project in Bolton, Len England, noted that 'The influence of Hollywood on clothes is now greater than that of Paris, and hairstyles of such as Veronica Lake are copied by millions'. Hence, to take one seemingly trivial example, Mass Observation noticed that, as advance publicity for Walt Disney's *Snow White* in Bolton, replica dwarfs were being sold in Woolworths. Such 'celluloid imperialism', as it was termed, was arguably at its most effective in the films depicting 'ordinary' family life, the family melodrama. These findings must have been galling to the British Documentary Movement, the creators of the sort of films which Carrington hoped would take up the cause of design reform as *Housing Problems* had done so effectively in 1935. A review in the *Documentary News Letter* of one of the box-office successes of 1942, *Mrs Miniver*, reported: '. . . you can sit at the Empire and hear practically the whole house weeping – a British audience with three years of war behind it crying at one of the phoniest war films that has ever been made'.[67]

Whilst considerable effort by Modernist design reformers was being put into influencing consumer behaviour, much of the public's taste was being formed by American films, music, and products. And whilst Modernist designs could be seen in some the films, the norm was far more Revivalist. This trend became accentuated in Britain with the rising popularity of the Gainsborough-period melodramas during and after the Second World War – period styles in furniture and fittings, streamlining of products, a continuing preference for Art Deco to connote the Modern, and a tendency to 'gadgetise' subverted Modernist design reform.

If it can be argued that the Modernist dream of the factory-made house

came true after 1945, it can equally be said that the dreams of those who lived in it gave short shrift to the puritan progress of Modernist design. The voice of the BBC as the 'Voice of the Nation' was unable to combat the Americanisation of British taste during this century. Whilst the power of film may have been recognised, reactions to it remained too rigidly class-bound to provoke anything other than contempt from Modernist design reformers until the effect of the Independent Group was felt. The irony here is that the industrial methods which were to enable housing reform were born in the same country whose commercial methods were to sow the seeds of dissatisfaction.

This rift between the popular and the professional, which has largely characterised Modernist practice in Britain, was recognised by Bertram towards the end of the Second World War. Revising his 1935 publication *The House: A Machine for Living In*, in 1944, Bertram perceptively wrote:

I prefer, in this dark interim, to be less cocksure than I was in 1935 . . . I do not, you understand, wish to modify in the slightest degree my attack on the bogus Tudor or anything else bogus. But I am trying to understand these phenomena better . . .[68]

Advertisement in *Design in Everyday Life and Things*, DIA handbook 1926–7, claiming the influence of cinema on consumer behaviour.

When we think of Belgian design we are inclined to focus on Art Nouveau and in particular on the work of two men, Henri Van de Velde and Victor Horta. The First World War tends to dissipate our interest in the subject and we look no further into the century with regard to Belgium. An important corrective to this failing is offered here. The significance of Modernism in Belgium can be seen to have been heavily determined by its interwar situation. In a small nation buttressed by major powers, designers found themselves constantly struggling against, amongst other things, a potent ethnic nationalism and a difficult economic climate. In design-historical terms, this article is important for its discussion of the grand tradition the Belgians maintained, amid constant political and economic strife, of the staging of Expositions Universelles. The Exposition staged in Brussels in 1935 features here. Most illuminating, however, is the depiction of the continuing career of Henri Van de Velde. After the demise of Art Nouveau in Belgium, practitioners either drifted back into Historicism, following the lead of Victor Horta, or they advanced on into Modernism behind Van de Velde. The two are depicted here as mortal enemies; at no stage in its evolution in Belgium could Modernism be described as being a movement concerned principally with style.

7
Henri Van de Velde and the Struggle of Belgian Modernism Between the Wars

MIMI WILMS

It has often been said that in terms of modern design Belgium is Europe's best-kept secret. In an attempt to explain this situation I will analyse the international exhibitions held in Brussels in 1935 and Paris in 1937. The 1935 exhibition left visible traces on the map of the Belgian capital. Its main characteristics were prestigious displays of industrial products and processes, and a global survey of human activities, including the Fine Arts. In Paris two years later, Art and Science were brought into close proximity, the Belgians this time charging Henri Van de Velde with responsibility for their pavilion. On this occasion the attempt was made to present production methods of manufactured goods with the specific aim of teaching the general public about the rôle of aesthetics in objects of daily use. I will compare and contrast the two exhibitions.

In order to give a fuller picture of Belgian design during the 1930s, I will also outline some of the political, socio-economic and aesthetic features of the period. Although the negative consequences of the worldwide economic crisis of 1929 were a heavy burden on the small country's economy and political structure, various strategies were evolved to get it through the worst of the crisis.

The situation of Belgium in the 1920s and 1930s

The design landscape immediately after the First World War is best characterised by the negative attitude towards Modernism, not only because the international avant-garde at that time was strongly associated with Germany and the Soviet Union, but also because a traditional regionalism, mixed with a mannered Art Nouveau, had prevailed in Belgium since the end of the nineteenth century. In general, the architects, designers and artists who had already established a strong artistic reputation before the First World War still had a dominant influence on aesthetics after it. A long time before 1914, Victor Horta (1861–1947)

Victor Horta, Belgian Pavilion, Paris Exposition Universelle, 1925.

had undeniably been one of the leading designers of his generation, and he also seemed to possess a very strong will. Since becoming director of the Académie Royale des Beaux-Arts of Brussels after the First World War, he dominated the Belgian design scene, and frequently tried to impose on his colleagues his views concerning public buildings. He also derived profit from the fact that his only real competitor, Henri Van de Velde, had been working in Germany since 1901.

Horta's personality influenced an entire generation of idealistic architects, urbanists and designers who were preparing themselves for the rconstruction of their badly damaged country. Few groups resisted his personality, which was virtually synonymous with Belgian style. Amongst those who did was a small group of Flemish architects, designers and artists who were influenced by the rise of the Flemish Movement. Many of these had fled to the neutrality of the Netherlands when the Germans invaded in 1914. There they participated in the cultural life of Holland, facilitated by the fact that they shared a common language with the Dutch. Not insignificantly, Henri Van de Velde had always found hospitality in Holland. After the war, when the émigrés returned, they brought the ideas they had developed with them. Suffice it to say here that such groups have usually been depicted as part of a broad, negative, nationalistic upsurge. Belgian ethnicity, especially out-

side the country, was widely thought to lead to little more than folkloristic tribal war, rather than to a healthy growth of self-consciousness amongst the Flemish-speaking peoples. Sadly, both this phenomenon and the personality of Victor Horta are mostly beyond the scope of this essay.

Overall, in fact, there were three different nationalistic attitudes, the first two of which were essentially reactionary. One group, of so-called traditionalists, favoured a nostalgic reconstruction of the demolished historic cities like Ieper, Leuven, etc. In the construction of '*vieux neuf*' the Belgians already had enough experience, as had been demonstrated at various Expositions Universelles. A second group of traditionalists was openly in favour of nineteenth-century eclecticism and aimed at the reproduction of rich showpieces in the historic centres of cities. A third group was internationally orientated and was associated with the international avant-garde in design. This included a generation of younger urban architects and interior designers like Bourgeois, De Coninck, Eggerickx, Hoste, Hoeben and Pompe, and planners such as Van der Swaelmen and Verwilgen. Through their strong social commitment they could have brought Belgium to the fore as a 'modern' country. Influential people had other ideas, however.

Immediately after the war 'poor little Belgium' was frequently considered as a victim by the rather paternal victors of the violent conflict and a romantic patriotism was frequently attributed to the 'brave Belgians'. During the traumatic aftermath of the war a climate of confusion generally dominated the country. Citizens mourned their dead compatriots and were absorbed by such basic activities as providing shelter for themselves in their devastated towns and villages. Although there existed a generally optimistic mood, helped by the accession of the sympathetic young Leopold III in 1934, the country was still in deep economic crisis. Many Belgians were still unemployed, designers, craftsmen and artists were barely able to survive.

Understandably, governmental plans to organise an international exhibition in Belgium to celebrate the centenary of Belgian independence (1830–1930) were beset by internal disagreements caused, among other things, by differences of opinion between political and linguistic groups. The issues were so intensely connected that it became impossible for the government to find a solution without at the same time turning the situation into a farce. It was finally decided, therefore, that the Exposition Universelle of 1930 should take place in two cities at the same time: in Antwerp, where stress was laid upon international trade and colonial

relations with Africa, and in Liège where the emphasis was on industrial activities, namely coal, iron, steel and machine construction. In Brussels, in the meantime, a new, permanent infrastructure, the 'Palais des Beaux Arts', designed by Victor Horta, was built not far from the historic centre. As part of the same sequence of events, architect Jozef Van Neck was given the task of building a new sports stadium in the north of the capital, on land owned by the Société de l'Exposition. Actually begun in 1928, this was the (now infamous) Heyzel Stadium. As with many of his colleagues at the Académie Royale des Beaux-Arts, Van Neck was an admirer of French Beaux-Arts architecture. He was also influenced by more functionalist tendencies, which he first encountered at the Paris exhibition of 1925. Both traits were visible in his design for the Heyzel.

In general, those who received commissions for public buildings during the 1920s and 1930s were the traditionalist architects and designers. Only in private building did Modernist architects get commissions, from enlightened patrons who appreciated experimentation. These designers looked up to Henri Van de Velde, respecting him as their spiritual father even whilst he was living away from Belgium. His controversial appointment as professor at Ghent University in 1926 caused an upheaval in some architectural circles. When he was also offered the chance – after the intervention of King Albert and Camille Huysmans – to lead the new design school in Brussels in 1927–8, the Institut des Arts Décoratifs, his enemies fulminated. The broadly influential positions enjoyed by his opponents tend to explain why Van de Velde was effectively 'banned' from many official manifestations.

The Universal and International Exhibition in Brussels, 1935

Whenever mention is made of the Brussels exhibition of 1935 it is often represented as a challenge to the prevailing economic crisis of the time. This is only partly true because the initiatives behind the exhibition had been taken a long time before. There existed in Belgium a specific and permanent committee that had been in operation since 1922 for the purpose of organising large-scale exhibitions. And before this, Belgium had enjoyed an impressive tradition in the organisation of major Expositions Universelles.

Nevertheless, the staging of the Exposition Universelle et Internationale de Bruxelles was a real challenge at a time when many European countries were similarly facing economic crises. A new government, under the young prime minister Paul Van Zeeland, was appointed and in March 1935 the Belgian franc was devalued. This measure was

Interior of first-class compartments designed by Henri Van de Velde, 1935.

introduced deliberately on the eve of the Exposition, as it was anticipated that foreign tourists would bring money into the country. The measure proved successful, as the Exposition did help to bring about the stabilisation of the economy for which the Belgians had been hoping for so long.

In order to counter the prevailing economic difficulties, the official policy of the 1935 exhibition was to emphasise Belgium's progress as a modern developed country. The Belgian contingent was therefore focused on the following:

(1) The Centennial of Railway Communication in Belgium. This was commemorated inside the central building, which was designed by Victor Bourgeois as a model railway station. Inside the huge hall the different Belgian railway engines in use since 1835 were exhibited; the focus, however, was on electric locomotion. A range of European electric trains was on show, including the latest Belgian electric train, designed by the engineers of the company in collaboration with Henri Van de Velde, who had been appointed '*adviseur artistique*' with the help of Hendrik de Man. The railway station's interior was dominated by a majestic vault of parabolic concrete beams and the walls were decorated with murals by contemporary artists such as Jespers and

Minne. A restaurant, waiting rooms, a cinema, shops, etc., illustrated how the crisis could be pushed to one side with industrial effort.

(2) Electricity was celebrated in a special pavilion but also in the infrastructure of the exhibition itself. Electric light was placed beneath artificial waterfalls and in fountains. The hillside parkland was in the immediate neighbourhood of the bucolic royal residence of Laeken. The pleasantness of the location undoubtedly made the exhibition more popular.

(3) Radio was emphasised in a Modernistic building by J. Diongre (1878–1963), who had been commissioned in 1933 to design the Belgian Broadcasting Company INR/NIR building in Brussels.

(4) The efforts of the Belgian dynasty to enrich the country with a colony in Central Africa were also celebrated. The Congo colony was therefore exhaustively presented in a group of vernacular pavilions.

The 'battle of the styles' already mentioned was not only strongly visible in the design of the Belgian contingent but also in those of the foreign nations. From a numerical point of view, the traditionalists were the winners. This was due mainly to the very conservative organising committee, some members of which had organised the previous Exposition in Brussels in 1910, and who undoubtedly had a nostalgic vision of 'the good old days' before the First World War. Shortly afterwards changes would take place as a new generation of officials was appointed.

As far as good design was concerned, what did Belgium show to the world? Unfortunately, one has to conclude that she did not show a great deal, due to the underlying emphases of the exhibition. One can outline these in general terms. Heavy industry and raw materials, including those from the Congo, and semi-finished materials such as those from the glass and iron industries were put on show as products of a modern, industrialised country. Despite the fact that a large number of people in Belgium worked in agriculture, it was widely understood that the economic survival of the country depended on the ability to export industrial goods. In reflecting these concerns, the exhibition was not the ideal place for Belgian designers to show off their talents.

The desire for stability was implicit in the extent to which 'traditional' themes were integrated into the Belgian sections, notably the insistence on 'old' art, and the way that the whole suggested an unreal affluence. The Belgian Pavillon des Arts Décoratifs consisted of fashionable high-style *objects de luxe*, designed for the happy few of the time. One of the

main palaces housed 'Five Centuries of Art from Brussels', including many fourteenth-century masterpieces. In general the public was very enthusiastic about it, but perhaps was even more enchanted by another traditional feature: 'Vieux Bruxelles 1750'. A recreation area designed by architects Blockx and de Lange, this was a reconstruction of Belgium in the eighteenth century, a time of stability and peace. When the exhibition closed at night, this authentically reconstructed sentimental oasis of the past remained open and the good life could be obtained by drinking Belgian beer.

The central buildings of the exhibition – designed by Jozef Van Neck – contained the majority of the Belgian official sections and were intended to remain as permanent buildings in which commercial fairs could be staged in the future. The principal building, which became the virtual trademark of the exhibition, was characterised by the verticalism of its gigantic pillars crowned with symbolic statues representing modes of transport (p. 152). These were sculpted by Egide Rombaux. The building covered fourteen thousand square metres and was built on a rectangular plan; the height under the vault was thirty-one metres and was constructed with twelve parabolic arcs of reinforced concrete. Many of the technical problems were overcome through the use of recent innovations, such as tubular pillars in the foundations, fast-hardening cement, and autogene welding with electricity. As can still be seen today, much attention was paid to the surroundings of the buildings, with the strategic placing of many works by Belgian sculptors representing modern allegories. These served to heighten the representational character of the building itself.

The official Belgian sections were in the tradition of the great nineteenth-century exhibitions and featured the following themes: sciences and arts, raw materials and ore, transformation industries, energy, civil engineering and transport, building, general economy, sport and tourism. As already mentioned, one of the main emphases in the principal building was transport. The first electrified line – between Brussels and Antwerp – was inaugurated on the same day as the Exposition opened by the popular Belgian royal couple. The trains which came into use then were the only mark that Henri Van de Velde was permitted to make on the whole event.

The Exposition's Official Guidebook shows that the organising committee regarded the main exhibition building as a worthy showpiece for Belgium. They praised themselves for the 'moderate modernity' of the architecture, which was characterised by 'straight and simple lines

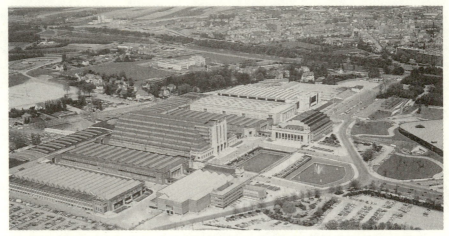

General view of the Brussels Exhibition Centre, now the Heyzel Stadium, 1987.

View of the façade of the Grand Palais, designed by Jozef Van Neck (1880–1957),
Brussels Exhibition, 1935.

without any superfluous decoration'. For many years afterwards, how-
ever, the building would be criticised for the ambiguity caused by its inner
horizontality and its outer verticality.

As already suggested, the general public was not given much oppor-
tunity to sample modern design, though the organising committee did

make an effort to give some of the young modern architects commissions on the site. Victor Bourgeois not only designed the model railway station in a very functional style, but was also the architect of the beautifully situated restaurant 'Leopold III', in which he could more freely express his Modernist views. Georges Minne created a new house style for this environment and other artists got commissions for monumental artworks. As an architect-planner and a Modernist, Raphael Verwilgen whose contribution to the Exposition was the Pavillon de Gaz, defended the views of Van de Velde on architecture. Not every Modernist was lucky enough to have his project presented without alterations. L. H. De Coninck's design for the Pavillon du Tourisme was entirely spoiled by the tourist authority which decided to decorate the outside of the building with large posters and flags without permission from the architect. The general rule, as far as Belgian design and architecture went, was that traditionalists had the largest impact on the exhibition. The influence of the Paris Exposition of 1925 (the Art Deco Show) was still omnipresent in Brussels a decade later. Modernism was the exception, not the rule. Despite the fact that the second meeting of CIAM (Congrés Internationales des Architects Modernes) had taken place in Brussels in 1930, when important statements were made by leading members of the international Modern Movement, the Belgian architectural establishment was still influenced by the 'Beaux-Arts' and by regional historical styles.

Not only did Belgium as host show few signs of being Modernist, neither did her guests. Even countries with a strong avant-garde reputation didn't allow this to feature prominently in architectural and design terms. The French republic was the ally par excellence of Belgium and due to this political relationship she was present in force with eight large pavilions. This French 'settlement' included the colonies and a broad traditionalist panorama of her manifold industrial, artistic and intellectual activities. The French gained their effect mainly through heavy use of decoration. A very remarked-upon architectural presence was the Padiglione del Littorio Italiano by A. Libera (1903–63). Although the Fascists were in power Italy was still a kingdom, the Italian presence being mainly due to family ties between the two Royal Families. This was one of the last occasions when the authoritarian states would wear a friendly mask. Although Britain was as important to Belgium as France had been in the First World War, the United Kingdom was very self-effacing at the 1935 Exposition Universelle, for reasons unknown. The Scandinavian democracies excelled with an architecture that was characterised by a very human functionalism and integration of nature.

The Swedish and the Finnish sections also included displays of vernacular products for daily use.

The question needs to be asked whether Belgium, by organising the exhibition of 1935, succeeded in presenting a clearly defined image of itself and of the quality of its design. Was the French correspondent for *Figaro* correct in asserting that 'La Belgique qui donne au monde, une fois de plus l'exemple de l'initiative courageuse de la perseverance, de la confiance en soi'? As far as I can determine, the image which Belgium presented to the world was characterised by self-assurance concerning its capacities as an industrialised nation that still had a civilising rôle to play in Africa as a colonial power.

Belgium and the 1937 Paris Exposition Universelle des Arts et Techniques dans la Vie Moderne

Even before the opening of the Brussels exhibition, the French Commissaire-Générale, in the form of a M. Labbe, had been busy preparing the thematic Exposition Universelle of 1937. Henri Van de Velde recorded that as early as 1934 he had assisted at a presentation in which it was stressed by M. Labbe that a 'pseudo-civilisation' was advancing, which was spoiling the taste of the general public without being concerned about their education. He also made it clear that the proposals he was expecting for the Exposition would be geared towards the determination of the future evolution of good taste in general. The exhibition should demonstrate that people's lives should be designed more harmoniously, so that there would be no contradiction between beauty and utility, with art and technics insolvably joined to each other. Later, in 1936, concrete form was given to this theme with the Exposition's title, 'Art et Techniques dans la Vie Moderne'. In his autobiography, *Geschichte meines Lebens*, Van de Velde himself admitted how pleased he was by the choice of theme for the Paris exhibition of 1937, because it echoed ideas very close to his heart and which he had already put forward for the Werkbund Exhibition of 1914.

By the end of 1935 the Belgian Minister for Economic Affairs appointed Van de Velde president of the technical commission of the Commissaire-Générale. This was an excellent chance to show appropriate Belgian design to an international public, he wrote in his introduction to the Belgian *Livre d'Or*, and he openly criticised the quality of the design at the Brussels Exposition of 1935. He regretted that a small country that possessed rich traditions, and promised much for the future, had not taken advantage of the political and economic situation it found

itself in. He also regretted that the opportunity to educate the taste of the general public was not taken, although he accepted that 'quality' could only be realised when technical perfection and good taste were combined with artistic merit. Van de Velde was himself aware of these difficulties because manufacturers did not favour themes for exhibitions. He remained optimistic, however, that a number of them would be inclined to follow his guidelines for the 1937 show in order to increase their chances of commercial success. Finally, he regretted that at the Brussels exhibition of 1935 the manufactured goods showed a lack of cohesion between technics and art.

Van de Velde was aware of the fact that the theme of the Paris Exposition was inexhaustible and could therefore lead to a variety of approaches, depending on how the different participating countries chose to interpret it. As things turned out, many of them made no effort

Cover of the commemorative book edited by the Commissariat-Générale of Belgium on the occasion of Belgian participation at the Paris Exposition Universelle, 1937.

to follow the proposed theme of the exhibition, and others interpreted it according to their internal political situations. In the opinion of Van de Velde, only Sweden, Norway, Finland and Belgium made an effort to comply with M. Labbe's guidelines by presenting displays of their respective national industrial arts. In Belgium, one of the forerunners of the Industrial Revolution of the European continent, there was a strong

opposition between art and technics, although the mechanical pro-
duction of manufactured goods was only introduced gradually and
diffidently.

A large piece of land at the northern foot of the famous Eiffel Tower,
on the left bank of the Seine near to the Pont d'Iena, was allocated to
Belgium. The pavilion was designed by Van de Velde and his collabor-
ators Jean Eggerickx and Raphael Verwilgen. The terraces leading down
to the river made it possible to add an element of playfulness to the
Modernistic outlook. The front of the pavilion, which faced the river,
was dominated by a magnificent glass rotunda that covered the different
levels of the building. From the terrace of the main level visitors could
enjoy a splendid view of the Champs de Mars. A special emphasis was
placed on gardening since cultivated flowers were an important export
item at the time. The landscape designer, Buyssens, who was responsible
for the gardens at the Brussels exhibition, was employed again at the
Paris Exposition. To enhance the vernacular tradition of Belgian bricks,
Van de Velde ordered a very special type of hand-made building brick
from the firm Comptoir Tuillier de Courtrai. Not only did these bricks
have symbolic qualities as they were moulded out of pure Flemish soil,
but their use provided the manufacturers with an opportunity to show
their material at work. In the large and quiet building the industrial and
artistic renovation of Belgium was on show throughout the different
floors, as a symbolic invitation to the visitor to penetrate into the inner
halls. These portrayed the daily life of the different industrial classes. The
selection of exhibits was made in such a way that visitors could feel 'at
home' while looking at complete interiors where familiar things like toys,
utensils and even small household objects created an atmosphere of joy,
health and work.

On the main floor of the pavilion the visitor was confronted with a
profusion of indoor flowers, and on entering the rotunda, with more
conventional showpieces, works of art in lacquer, lace, ceramic, glass,
etc. Next one passed into the Hall of Fame, built out of finest Belgian
marble and decorated with fine contemporary tapestries designed by
Floris Jespers, Edgard Tytgat and Rodolphe Strebelle and produced by
arts and crafts studios in Brussels and Malines/Mechelen. The circuit
gave access to a section of cut diamonds, the product which had made
Antwerp world famous, and lace craftsmanship from several towns.
There were also sections dedicated to specific materials. Textiles, for
example, were exhibited in a very creative way, accompanied by
photographs which explained the manufacturing processes. Also on

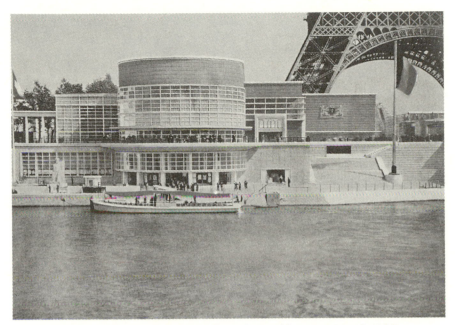

General view of the Belgian Pavilion, designed by Henri Van de Velde,
Paris Exposition Universelle, 1937.

Scale model of the Belgian pavilion, 1937, designed by Henri Van de Velde, Jean
Eggerickx, Raphael Verwilgen (architects), Paul Celis (engineer), René Moulaert (interior
architect) and René Pechère (garden architect).

Inside view of the *rotonde d'honneur* in the Belgian pavilion,
Paris Exposition Universelle, 1937.

The *mobilier de luxe* by Ateliers d'Art de Courtrai/de Coene Frères (B).

Dining room produced/designed by SA Magasins, Au Bon Marché, Brussels.

Artisan bedroom by Ateliers d'Art de Courtrai/de Coene Frères (B).

ground level there was a more conventional display devoted to tourism. As Gisele Freund mentioned some time afterwards, a remarkable use of photography in this section enabled Belgium to be revealed in all its variety. The photomontages of graphic designer Jos Leonard were particularly impressive, as were the individual posters designed by former students of Van de Velde from the Institut des Arts Décoratifs.

The interiors mentioned above were designed by various manufac-turers for different social classes, without any sense of competition. The upper, middle and working classes were divided up, but care was taken that the quality of the design and living conditions was not seen to deteriorate in the lower orders. Only the price of the goods provided evidence as to the class it belonged to. Van de Velde had control over the choice of exhibits; he was very selective, including manufactured pro-ducts from big stores such as Bon Marché in Brussels and the produce of small companies, such as the arts and crafts firms in Malines, as well as products from such progressive design studios as Marcel Baugniet from Brussels. Everywhere, the rigour of the selection revealed the eye of the master himself.

As we can see from the Belgian section of the *Livre d'Or*, Van de Velde and his collaborators succeeded in showing austere 'good design' in the official part of the Belgian show, unlike at the 1935 Brussels exhibition where a profusion of traditional, academic design was displayed in the Belgian sections. In 1937 Van de Velde showed all kinds of products from daily life in the interiors for the three different classes, keeping in mind that '*art et technique*' should harmonise in 'modern life'. Fine craftsman-ship and good use of materials were important criteria for their choice. Of course, a number of unique crafts products were made especially for this exhibition by artists or craftsmen. Since the economic crisis still made it very difficult to get official artistic commissions, this was a unique opportunity for professors and students of the Institut des Arts Décoratifs in Brussels to show what they were able to produce. They chose not to display superfluous luxury, but rather put emphasis on simplicity. The mass-produced items on show, such as ceramics and textiles, were chosen using the same criteria, even if many of the products had not just arrived on the market.

Conclusion

It is striking how many of the nations in their presentations at the 1937 Paris Exposition deviated from the programme established by M. Labbe based on the theme of 'Art et Techniques dans la Vie Moderne'. Belgium,

thanks to the commitment of Henri Van de Velde, was one of the few countries which tried to respond faithfully to the original goal of the Exposition. Yet even in the large commemorative exhibitions held in 1987, there was practically no stress on the serious efforts made by one of the most famous designers of the twentieth century for his tiny democratic country. Perhaps the political polarisation of the late 1930s caused the widespread deviation from the Labbe programme; it is striking that those countries which respected its aims, the small democratic nations, had hitherto escaped notice.

Belgium's economic situation, after a brief recovery in 1935–7, deteriorated again so that the design solutions presented by Van de Velde in Paris were not acted upon. In fact, a lot of the objects on display were not even available in Belgium, as it was difficult to find manufacturers to produce them. The fact that Belgian manufacturers were never very daring at least partly explains the difficult situation of the time.

In retrospect, we can see that within Belgian Modernism between the wars there were two tendencies. There was a moderate, romantic Modernism and a far stricter international form. Van de Velde, in his own person, managed to reconcile these two strands, as can be witnessed in the successive stages of his busy professional life. As head of the Institut des Arts Décoratifs in Brussels he appointed, from the start, representatives of the two strands and so created a breeding-ground for a broad Modernism across all the arts.

His teaching staff belonged to the Belgian avant-garde and in times of economic and political crisis this alarmed conservative observers. Even so, before 1937 the prevailing attitude seemed to be that as long as these Modernist eccentrics didn't capture the attention of the general public, they were harmless enough. The Belgian pavilion at the Paris exhibition, however, attracted wide attention, and consequently there was a considerable furore in the Belgian press. In real terms, Modernistic design was not accepted by the Belgian general public until after the Second World War.

Van de Velde was unfortunate enough to return to Belgium in 1926 when the country was trying to cope with various crises. There was severe political strife, with successive unstable governments attempting to resolve the demands for equal treatment for the Flemish-speaking parts of Belgium. Such a fundamental struggle obviously claimed the national attention and made innovation in design difficult to achieve. There was also serious monetary inflation and an unemployment rate which climbed steadily between 1926 and 1935. Opportunities for designers

were few and far between, the national focus being on large-scale works, such as the modernisation of the mines and the building of the Albert Canal (1939). The only opportunities for innovative design work tended to be in the department stores and in some of the larger interior design offices. Van de Velde was right in the middle of the tensions caused by politico-economic unrest and the constant antagonism of the musty academicism which still effectively reigned in Belgium. Eventually the stresses told on him and, in 1947, he emigrated for a second time.

Swedish design, as with so many aspects of Swedish society, came to be held as a paradigm amongst Modernists across much of Europe after 1930. Especially in Britain the Swedes enjoyed a reputation for being leaders in the field, their pure forms and rational structures contrasting starkly with standard practices here. It was with admiration and not a little envy that British Modernists walked around the site of the Stockholm Exhibition of 1930, and with a sense of resignation that British critics acknowledged the superiority of the Swedish pavilion over the British at the Paris Exposition Universelle seven years later. The story was not quite as simple as it may seem, however; it would be more than a bland generalisation to suggest that Swedish designers got it right when others did not. Equally it would be wrong to assume that there was a seamless continuum in the flow of ideas from Pioneer Modernist thinkers into the studios of eager Swedish designers. Rather, there were particular conditions at work in Sweden which led, on the one hand, to social policies impinging directly on design, and on the other to a fruitful relationship forming between design and the crafts.

8

Swedish Grace . . . or the Acceptable Face of Modernism?

GILLIAN NAYLOR

This essay is based on a discussion of two Architectural Press publications – the August 1930 issue of the *Architectural Review*, which was largely devoted to the Stockholm Exhibition of that year, and the book *Modern Swedish Decorative Art*, published a year later, which also commemorated an exhibition – 'Swedish Industrial Art' – held in Dorland Hall, London, in March and April 1931.

Both publications present an ideal of 'modernity', but there the comparison ends. For P. Morton Shand in the *Architectural Review*, the Stockholm Exhibition demonstrated a complete and triumphant break with the past; it also demonstrated that Sweden was the only European country capable of producing a viable form of Modernism. According to Shand, 'Sweden could do it better' than the Germans and the French, and most certainly the English: 'The world will look up to Sweden,' he wrote, 'as the supreme exponent of a Modernism which has succeeded in finding its own soul and embellishing itself with a purely mechanistic grace.'

Dr Nils G. Wollin, designated 'Chief Teacher at the High School of Arts and Crafts in Stockholm', and author of *Modern Swedish Decorative Art*, was more circumspect. He saw Swedish achievements in the 'decorative' or 'industrial' arts as part of a historical process, leavened by the 'characteristically democratic tendencies of the Swedish community'. And although he acknowledged the Modernist premises that 'individualism has been replaced by universalism', and that 'modern economic requirements have more and more urged forward standardization', he could not deny the rôle of tradition and handicraft in modern Swedish production:

The legitimate demand for standardization which we know from centuries preceding the 19th has now appeared in the foreground and been sharpened, as a result of the economic conditions of today. It is possible that in certain cases we have gone too far, that the sanctity of the home has been all too much invaded by the heat and bustle of the factory and the office, but in that case it is due to the

unavoidable exaggeration of a creative period. A beneficial factor is the wholesome traditionalism which is represented by a small number of architects, who claim a more or less free hand to maintain contact with the older native types, especially from the latter half of the 18th century and the first half of the 19th century.

It may, of course, seem spurious to compare a magazine article – a piece of polemical journalism – with a prestigious book dedicated to His Royal Highness the Crown Prince of Sweden (the Honorary President of the Swedish Association of Arts and Crafts). Nevertheless, the contrasting approaches of the two authors highlight the controversies surrounding contemporary interpretations of Modernism in Sweden, and they also give some indication of the ambiguities inherent in British attitudes to Swedish design and architecture in the 1920s and 1930s.

P. Morton Shand, who, according to his friend J. M. Richards, was 'more responsible than anyone else for the *Review*'s, and therefore for English architects' contact with modern Continental building',[1] was one of a handful of proselytisers for a radical Modernism in Britain (he was a co-founder of MARS – the Modern Architecture Research Group – in 1933). The majority of Britain's design reformers, on the other hand, shared Dr Wollin's admiration for 'wholesome traditionalism'. For them, Swedish experience and practice seemed to present an ideal model, but it was a model founded on the inheritance of British Arts and Crafts values (which, of course, had played a significant rôle in Swedish design reform). The Swedes, it seemed, had absorbed these values, and, unlike the British, had succeeded in their ideal of producing 'beautiful goods for everyday use' – the slogan adopted by the Swedish design reform movement in 1917.

This success was largely due to the energetic campaigns of the Svenska Slöjdföreningen (the Swedish Society of Craft and Industrial Design, now known as Svensk Form), which had been founded as early as 1845. With its motto 'Swedish handicraft is the father of Swedish independence', the Society had launched practical programmes to ensure the survival of Sweden's traditional craft industries, as well as to promote new ones. These efforts helped, over the years, to ensure the establishment of a design profession (the State School of Arts, Craft and Design was founded in Stockholm in 1844), and they also promoted that democratic and essentially domestic ideal of design that was so admired by the British.

Of equal importance to the British, however, was the fact that the Swedes actively encouraged the survival of vernacular skills. (Sweden

was the first country to create an open-air museum of vernacular buildings: its *Skansen* was inaugurated in 1891, under the auspices of the Nordiska Museum, which had been founded in 1873, and which was one of the first museums to be entirely devoted to *national* design and peasant culture.) In 1910, for example, the Studio had published a book on *Peasant Art in Sweden, Lapland and Iceland*, edited by Charles Holme, who provided his readers with a neat definition of the Swedish term for handicraft: 'It (*sloyd – sic*) is applied to the making of things by individuals and families in the home, as opposed to mass-production in factories . . . the Swedish peasant was, and to a certain extent still is', he continued, 'his own smith, carpenter, joiner and painter':

When we examine these sloyded things from our forefathers' time, we hardly know what to admire most: the vast length of time that was spent on the decoration of the various articles, or the original manner in which every peasant sought to employ in his own compositions the styles of art that prevailed at particular periods.[2]

The campaigns to ensure the survival of 'sloyded things' had the support of the middle-class intelligentsia in Sweden; it proved more difficult, however, to persuade Swedish manufacturers of the value of designing for an egalitarian market. In 1914, for example, when Sweden took part in the important Baltic Exhibition in Malmö, the Svenska Slöjdföreningen stepped up its efforts to achieve reforms in industry; Erik Wettergren, then the Society's secretary, redefined the priorities, and the need for inexpensive designs that the factory and the farmworker could afford:

Our furniture manufacturers have marked time . . . simple and inexpensive pieces for the industrial and farm worker still do not exist, and our more modest town homes still lack furniture specially designed to meet their needs. Generally speaking we have made progress only with exclusive and individual *de luxe* pieces.[3]

These criticisms were also applied to Sweden's glass and ceramics industries which, according to Wettergren, ignored their responsibilities to their most important customer – the man in the street.

By this time, Britain could no longer provide any inspirational or theoretical model for the Swedes; the Arts and Crafts Exhibition Society was in disarray, and the policies of the newly formed Design and Industries Association still had to be fully formulated. It is significant, however, that at this time both countries were looking to Germany, and to the example of the German Werkbund, for what were considered new and progressive policies that encompassed social and economic as well as

design reform. In its early years the Werkbund aimed to promote the 'best in art, industry, craftsmanship and trade' – a seemingly bland, but potentially explosive, combination which involved redefinitions both of style and of the rôle of the individual in the creation of style – redefinitions which were, of course, to contribute to emerging concepts of Modernism in the years leading up to the First World War.

The chief spokesman for the founding Werkbund ideologies was Hermann Muthesius whose fact-finding mission in Britain (from 1896–1903) had, significantly enough, convinced him that concentration on a craft ideal spelled economic disaster for an industrial nation. ('The curse that lies upon their [British] products,' he wrote, 'is one of economic impossibility.') Muthesius, who had studied philosophy before training as an architect, believed that 'true modernity' lay in 'reason and practicality', and could be found not only in the vernacular traditions of a truly popular culture, but also, significantly, in the pure forms created by those 'children of the new age – the engineer and the industrialist'.[4] Similar ideas were, of course, being formulated by other European theorists (most notably Adolf Loos); what distinguishes Muthesius' theory, however, is its obsession with the transcendental qualities of form.

Until recently, the primary concern of the *Werkbund* has been with quality; so much so that the need for quality, both in workmanship and material, has generally been accepted throughout Germany. This does not mean that the *Werkbund*'s task has been fulfilled. For spiritual considerations are more important than material ones, and higher than function, material and technique stands form.[5]

Muthesius' ideal of form was essentially classical and classicising (in his speech to the Dresden Congress he quoted Greek, Roman and eighteenth-century precedents); at the same time, however, he stressed that this ideal strove towards the universal . . . towards what he described as the '*typisch*' – the expression of a collective ideal. Therefore, in Muthesius' philosophy, objectivity, reason and intellect replaced intuition, individuality and creativity as the inspiration for form, and ideal form acquired the classical connotations of the pure, the absolute and the universal.

By 1914 (the year of the Werkbund Exhibition in Cologne, and the Muthesius/Van de Velde confrontation – when Van de Velde countered Muthesius' demands for standardisation with a plea for individuality and the autonomy of the artist's rôle within craft production) the Swedes were well aware of Werkbund arguments. Erik Folcker had read a paper

by Muthesius to the Svenska Slöjdföreningen in 1911, and in 1912 Gregor Paulsson, a young art historian then working for the Stockholm National Museum, had visited Berlin where he had met, and admired, members of the Werkbund. Erik Wettergren's reactions to the Malmö exhibition, therefore, have a distinctly Werkbund ring; at the same time, however, Wettergren's preoccupation with 'simple and inexpensive pieces for the industrial and farm worker', and the furnishing of 'modest town homes' was also integral to Slöjdföreningen policy, so that Werkbund theories in the years leading up to the First World War reinforced rather than polarised the Society's ideals.

These ideals, however, were first and foremost related to the craft traditions of the domestic industries, so that the Society continued to concentrate on practical policies to democratise craftsmanship. In 1914 it set up an agency to link artists and craftsmen with industry, and in 1917 the Society organised a series of competitions for the design of one- and two-room apartments, to be realistically furnished with 'beautiful everyday goods' – designs that could be economically produced in a period of recession. The results of these democratising policies were displayed in the important 'Home Exhibition' which was held in the Liljevalch's Gallery in Stockholm in 1917. The focus of the exhibition, as its title indicates, was the home, in this case, the working-class home – town flats and farmworkers' cottages. All the designs exhibited, including furniture, textiles, wallpapers, ceramics and glass, were specially created or commissioned, but they had to be capable of serial production. And since this was essentially a social experiment, there was to be no striving for prestige. All the work on show was intended to be modestly priced, and it was displayed in simple, unpretentious room settings (including a kitchen by Gunnar Asplund).

The 'Home Exhibition' also showed the results of the Society's efforts to link artists with industry. Gustavsberg, the ceramics manufacturer, had begun to work with Wilhelm Kåge, a young painter and poster designer, and in 1917 the firm introduced Kåge's 'Liljebla' tableware – more popularly known as the 'Worker's Service'. Simon Gate, a painter and illustrator, was working for the glass manufacturer Orrefors, producing simple designs in soda glass, and Edward Hald, a painter who had trained with Matisse, had also begun to work for Orrefors and Rörstrand. This collaboration between the artist and industry in order to achieve a democratic ideal had obvious implications for British design reformers, since the intention was to preserve the individuality and integrity of the artist. As well as working on the production ranges, the

Baskets made of birch roots, anon., 1931. Glass flower vase by Edward Hald, 1929.

Silver coffee service by Nils Fougstedt, 1930.

'artists' were given their own studios where they were free to experiment, so that they could develop new ideas, and at the same time gain experience of the restraints of production – a policy which was reflected in the prestige of Swedish design in the 1930s and again in the 1950s.

Until 1917 the Slöjdföreningen had remained an essentially practical and pragmatic organisation; it had set out its ideas, and its criticisms, in

its magazine and its pamphlets, but it had not produced a major theorist, or a major theoretical statement. In 1919, however, Gregor Paulsson, then the Society's secretary, published *Vackrare Vardagsvara* (usually translated as *More Beautiful Everyday Goods*).

Paulsson was at that time the most radical of the Society's polemicists; he was, as we have seen, well aware of Werkbund ideals and controversies, and he obviously supported the Muthesius faction in the 1914 debate. What was needed, Paulsson wrote, was 'a definite change from the isolated production of individuals to the conscious work of a whole generation for a culture of form on a broad social basis'.

At the same time, however, like the majority of the Society's members, Paulsson had inherited the utopian idealism of William Morris, so that there is much of Morris in *Vackrare Vardagsvara*. Paulsson believed that the worker should be happy in his work, and like Morris in his later writing, he insisted that this did not imply the elimination of factory production:

It is important that the workers should take joy in their work. Is it necessary that modern work in factories should be so painful? Of course not. Joy can be introduced into most work and a good way to do this . . . is to make the products of the work and the milieu at work beautiful . . . [6]

He departs, however, from Morris and British Arts and Crafts theory in his insistence that the factory product was more socially viable than handwork ('Twenty beautiful mass-produced designs are of greater value than one hand-made object'), and he also believed that machinery could create its own style:

Now that we have the machines let us, instead of imitating former products and techniques, try to design goods that are characteristic of machine production . . . Do not let us imitate former designs. Let us, with the help of these technical aids, produce the new. [7]

The production of the new, however, depended on the rationalisation of working processes as well as products; in other words, it involved standardisation. Standardisation, Paulsson wrote, eliminated the proliferation of superfluous goods, and it also ensured that every working hour was used 'in the best possible way'. Moreover, the rationalisation that standardisation implied was essential in the current economic climate: 'The economic conditions of society cannot be improved by increasing sales, but by improving working methods.' And like the rationalists within the Werkbund (and unlike the majority of his

British counterparts at that time) Paulsson was convinced that these changes could only be achieved through a radical change in social attitudes:

All over the world, various social groups are freeing themselves from their dependence on the social factors that prevailed in the nineteenth century – economic individualism, free competition and unplanned exploitation. They are all striving – if one may venture to use a few slogans – for better organisation and improvements in the quality of working methods as well as in the product. The natural consequence of these developments is a change in the individual as well as in the social and cultural structure of society. The twentieth century will probably not allow such a display of the unplanned waste of human beings, time and raw materials, with 'culture' reserved for the few, the situation that prevailed in the nineteenth century.[8]

In the interwar years the seminal 'Home Exhibition', of 1917, and Paulsson's subsequent text were a constant source of reference for Svenska Slöjdföreningen polemics. For both, it seemed, had established a viable and workable code of practice. In spite of an economic recession, artists were working with industry, standards in low-cost housing were slowly improving, and the democratisation of design seemed achievable. More important, perhaps, for Sweden's international prestige, the country was becoming more widely known for its products and its policies. According to P. Morton Shand (in the *Architectural Review* article): 'The Gothenberg Exhibition of 1923 revealed Sweden to an astonished world, not merely as an "artistic" nation, but as almost the only one that really counted as far as design and craftsmanship was concerned'. He also referred to the 'perfectly edited Swedish pavilion at the Paris Exposition des Arts Décoratifs' in 1925, so 'perfectly edited', in fact, that two years later the Metropolitan Museum of Art in New York staged an important exhibition, 'Swedish Contemporary Decorative Arts' – the first major exhibition of Swedish design to be held in the United States. And in 1931 Dr Nils G. Wollin was still referring to this success:

Both at home and abroad Swedish industrial art has awakened both interest and admiration. The chief cause of this is to be sought in the circumstance that articles of luxury have not come in the first place, but ever since the Home Exhibition in Stockholm in 1917, the aim has been to produce articles which are fully satisfactory from the technical and artistic points of view, and which are not intended for the moneyed few, but for the general public. The characteristically democratic qualities of the Swedish community – even though aristocratic elements are to be met with – have found adequate expression in these 'beautiful accessories of daily life'. Although this movement for the education of taste is not

yet two decades old, it may be questioned whether there is at present any country in Europe where good taste and the demand for an attractive milieu have gained more ground than in Sweden.[9]

Dr Wollin's optimistic assessment of the progress of 'taste' in Sweden, however, was not shared by all his colleagues and compatriots; during the late twenties, acrimonious debates about the definition of 'good taste' and an 'attractive milieu' were polarising the Svenska Slöjdföreningen. According to the more radical critics, prestigious exhibitions were all very well, but they did not necessarily promote an ideal of democracy in design . . . it was, for example, the expensive engraved glassware by Simon Gate and Edward Hald that was admired, rather than their simpler designs, and ideologies of Swedish craftsmanship were promoted, rather than design for industry. The issue, of course, was tradition versus Modernism, and although the Swedes may well have 'modernised' their craft-based industries, their approach, it was believed, was still essentially conservative, and their ideals rooted in an admiration for the classical models of the eighteenth century, as well as the vernacular traditions which had been so lovingly promoted in the earlier years of the century.

Nevertheless, this celebration of the classical and the folk traditions of the vernacular as representative of an ideal of the 'collective' in design and architecture is characteristic of the genesis of Modernist theory. Hermann Muthesius referred to classical precedents when he was attempting to define his concepts of the type form and standardisation (and when, towards the end of his life, he visited the Werkbund-inspired Weissenhofsiedlung in Stuttgart, he was appalled – to him, this latter-day radicalism was nothing more than *Stilarchitektur*: a formalistic exercise in glass and concrete). This was in 1927, when the German architectural lobbies were beginning to invest the classical and vernacular debates with more sinister political meanings.

The claims of the classical and the vernacular were also demonstrated in several new civic buildings, including a City Hall, Concert Hall and Public Library, that were constructed in Stockholm in the interwar period (a period which began with an economic revival, and with rapid industrialisation largely based on Sweden's natural resources of steel and wood). The first of these was the Stockholm City Hall, designd by Ragnar Ostberg, and completed in 1923 (work had begun on it as early as 1909). The City Hall was the apotheosis of Sweden's National Romanticism, as well as civic pride in craftsmanship, and predictably enough, illustrations

of its Golden Hall and Prince's Gallery introduce the photographic section in Wollin's *Modern Swedish Decorative Art*.

Never since the Royal Palace in Stockholm – one of the noblest buildings in the North – was erected and decorated in the Baroque and Rococo periods has there been provided such a wide field of activity for the arts and crafts and industrial art as in this City Hall building . . . The workshops which were put up in the immediate vicinity of the building, and which housed masons, smiths, copper-chasers, joiners, women weavers, etc., stimulated individual and independent work, which of a certainty developed a feeling for form and colour . . . no modern Swedish architect has succeeded as has Ostberg in blending the native and the foreign, the modern and the antique . . . his City Hall is fascinating, imposing, and stimulating, a monument for centuries, but also the crowning achievement of a stage of development that we have passed.[10]

The City Hall, of course, did not set out to celebrate the skills of peasant *Sloyd*, but to demonstrate their survival and triumph in room after room brilliant with mosaics, sculpture, woven hangings and stained glass. The building rose, in its key position on Stockholm's harbour, from the surrounding huddle of workshops, as a vindication of the viability (and the sophistication) of the craft ideal. According to F. R. Yerbury (writing in 1925), it was 'perhaps the finest building in the world . . . Modern Sweden is producing an architecture which belongs to its own times. It is fresh and progressive, but it exhibits neither a striving for sensation nor a contempt for the past.'[11]

The City Hall, although considered 'modern' in its demonstration of the crafts, was the last of the great Craft Revival buildings in Stockholm; Ivar Tengblom's Concert Hall (1926), and Gunnar Asplund's Public Library of 1928 were neo-classical in inspiration, and according to P. Morton Shand in the *Architectural Review* article all three 'still further enhanced Sweden's rising prestige' (the Concert Hall and the library are also illustrated in Wollin's book). Asplund's library, however, built from brick, and with its pure geometry of square and cone (not dome), was seen by many commentators as 'functional' – a far more derogatory term than 'modern' in some contexts (particularly since Asplund had incorporated small shops within the structure).

Asplund was forty-three when the library was completed, and already well-known as an architect in Sweden, and since he was architect to the National Board of Public Building, and had also been associated with several projects for Svensk Form, he was obviously involved with contemporary social and political concerns. There was little in his previous work, however, to anticipate the revolutionary transformation

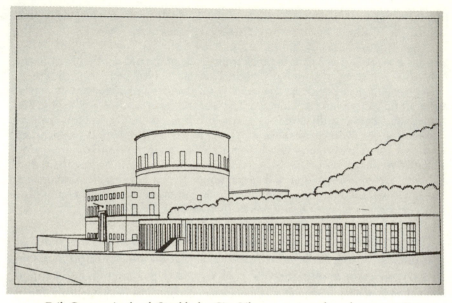

Erik Gunnar Asplund, Stockholm City Library; proposed market, 1920–8.

of style and structure demonstrated in the buildings for the Stockholm Exhibition. It is as though Asplund had adopted an entirely new architectural language for this plaything, which nevertheless had a serious architectural (and political) intent, since it was conceived, in the teeth of bitter opposition, as a showpiece for Paulsson's ideals for the further democratisation of Swedish design and architecture – a fact which was clear to many commentators, including Alvar Aalto:

The biased social manifestation which the Stockholm Exhibition wants to be has been clad in an architectural language of pure and unconstrained joy. There is a festive refinement but also a childish lack of restraint to the whole. Asplund's architecture explodes all the boundaries. The purpose is a celebration with no preconceived notions as to whether it should be achieved with architectural or other means. It is not a composition in stone, glass, and steel, as the functionalist-hating exhibition visitor might imagine, but rather a composition in houses, flags, searchlights, flowers, fireworks, happy people, and clean tablecloths.[12]

P. Morton Shand's description of the impact of the exhibition is equally graphic. Using the analogy of a business firm, reasonably successful but set in its ways, he writes: '. . . they [the Swedes] go and change the management, write off their old stock and start on something the travellers had never as much as seen. Ostberg was the man who put it

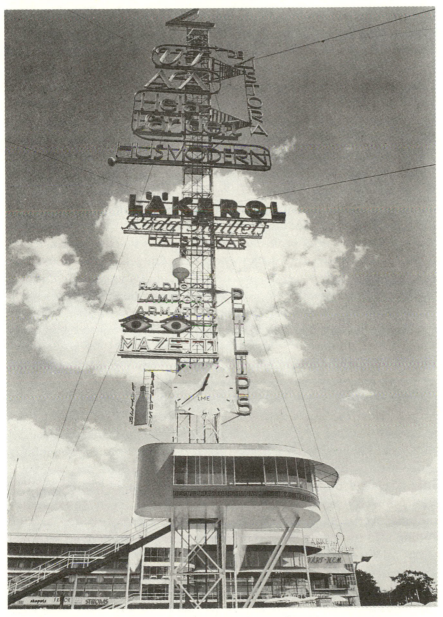

Erik Gunnar Asplund, Stockholm Exhibition advertising mast, 1930.

across for them and collared the gold medals. Well . . . now here's the new boss Asplund, gone clean barmy . . .'

And Sweden, according to Shand, had also 'gone bolshy' . . . 'The old

guard of Sweden,' he writes in a footnote, 'when told that the population
of Stockholm was, unaccountably enough, showing every sign of feeling
thoroughly at home in the exhibition, made the triumphant retort: 'wait
till you hear what the English have to say about it.'

As Kenneth Frampton points out in the article already quoted, the
reasons for Asplund's conversion to '*funkis*' – the Swedish term for
functionalism – are unclear; he was a friend of Paulsson's (they had
visited the Weissenhofsiedlung together in 1928), and the Society's
magazine had illustrated interiors by Corbusier and Gropius.[13]

As far as Paulsson was concerned, therefore, the forms and ideologies
of radical European Modernism reinforced the theories he had put
forward in *More Beautiful Everyday Things*, theories that were reiterated
– in manifesto form – in the pamphlet *Acceptera* that was published to
coincide with the Exhibition, and signed, among others, by Asplund and
Paulsson: 'We must accept the present reality. Only if we do this, have we
any prospect of being in command of reality, of getting the better of it in
order to change it and create a culture which is a flexible tool for life.'

The exhibition, therefore, was intended to display the practicality, as
well as the humanism, of the housing and design policies that were
already being supported by State and local authorities . . . plans for low-
cost mass housing, standardisation within the building industry, and the
further democratisation of 'everyday goods'.

Needless to say, these ideals, associated with Swedish social democra-
tic policies, were not acceptable to the 'old guard' in Sweden, not
necessarily because of their overtly political overtones, but because, as
P. Morton Shand implied, they involved the rejection of an essentially
national tradition that had established Sweden's reputation for design:
'Just when the boom in Swedish grace seemed at its zenith, Sweden
calmly proceeds to jettison the halcyon godsend,' he wrote. ' . . . Sweden
had discovered that the enthusiastic development of her historic
traditions in craftsmanship and the intensive exploitation of her national
genius for decoration had led her to a cul-de-sac, where further progress
is impossible.'

As far as Shand was concerned, the exhibition was 'an act of spiritual
regeneration', and one which only the Swedes were capable of achieving.
'The Swedes,' he wrote, 'less romantic and amateurish than ourselves,
and at the same time more intelligent and better educated, possess a
serenely unprejudiced simplicity of mind combined with a challenging
intellectual fearlessness . . . they do not wallow, like German hippo-
potamuses, in concepts of Sachlichkeit . . . Nor are they seduced by Ecole

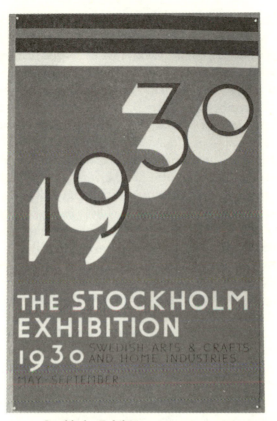

Stockholm Exhibition, poster, 1930.

Polytechnique abstractions of algebraic pulchritude . . . like the French . . . '

The Swedes were the sole representatives of the European races who could 'cope with matter', and the achievements in Stockholm represented the 'aspirations of a great, a golden age, and worthy of man's ultimate enfranchisement from the tyranny of matter . . . from the superstitious terror of his own timid and hidebound imagination'.

One of the reasons why Sweden was able to act so positively, according to Shand, was because of 'the purity of her racial stock' . . . sentiments not uncommon in Britain at that time;[14] another was the country's positive acceptance of the machine and the machine aesthetic. 'She has accepted the aesthetics of the machine with all its corollaries as both right and inevitable,' writes Shand, 'as leading our modern civilisation straight forward by its shortest path'.

And, as he was at pains to point out, since this 'machine architecture'

was 'imbued with wholesome Nordic sanity' – and 'Swedish sweetness and light' – it could never be described as 'the herald of world Bolshevism'. So that, as far as Shand was concerned, the Swedes had got it right: they had turned their back on the past (which was an honourable past), and they were using their native resources to create the ideal conditions for a democratic future ('. . . their instinct is sure', he wrote, and '. . . their technical and intellectual equipment more than adequate').

Although it is obvious that the article concentrates on rhetoric rather than analysis, it is interesting that Shand exonerates the architecture from 'Bolshevism', since, as Kenneth Frampton points out in the essay already quoted, Russian Constructivism is one obvious source for some of the structures Asplund uses on the site – especially for the advertising mast, which could be seen for miles around, by night as well as by day. And the exhibition halls, kiosks and restaurants, with their large areas of glass, and use of light metals for structure and for staircases, seem to have few architectural precedents – apart, again, from the display style of early Modern Movement exhibitions, shops and cinemas. There are, as Shand pointed out, no obvious French or German theoretical or formalist references. For Shand these buildings represent the revitalisation of Swedish grace. In the captions he describes how the ladders and staircases demonstrate 'Swedish charm', combining 'grace and refinement with an austerity that might be called classic'; the restaurant forecourt also displays the 'lightness, fragility, and grace which steel and glass are capable of when delicately handled. Asplund has shown us that "modern" materials are not foreigners to charm . . .', while the entrance structures are described as 'Bach translated into architectural terms'. (The buildings look familiar, of course, because they epitomise the architecture of the Welfare State, as exemplified in the Festival of Britain – an architecture that was popularly designated 'contemporary' in the 1950s, rather than 'modern', and one which was intended, like the Stockholm Exhibition, to evoke an ideal of townscape.)

The *Architectural Review* continued its championship of Swedish architecture in the thirties (its editor until 1934 was Christian Barman, who was half-Swedish; J. M. Richards, who had worked on the *Architectural Journal*, took over the editorship of the *Review* in 1937). J. M. Richards' account of Sweden's contribution to modern architecture in the 1930s is interesting in that it is an essentially contemporary account: in *An Introduction to Modern Architecture*, first published in 1940, he writes:

. . . it was in Scandinavia that an event took place . . . which did more than anything else to arouse public interest in modern architecture: the Stockholm Exhibition of 1930 . . . for which the architect was Gunnar Asplund. Previously modern buildings had been seen only in the form of isolated structures that inevitably looked stranger than they really were when surrounded by the mixed architectural styles of the average city street, but at Stockholm a whole sequence of buildings – as might be a whole new quarter of a town – were designed and laid out in a consistently modern style, and the public, walking among them, was given a first glimpse of modern architecture not as a new fashion in design but as a newly conceived environment.

From then onwards, modern architecture in Scandinavia forged ahead rapidly, outrivalling the picturesque style exemplified by Ostberg's Town Hall . . . which had become so popular with romantically minded architects in England and elsewhere, and the more sophisticated neo-classical style of the equally admired Ivar Tengblom. But the somewhat doctrinaire puritanism typical of Central Europe at this time, and especially associated with the *Bauhaus*, was modified, in Sweden particularly, by a strong craft tradition. A preference for natural materials gave the Swedish brand of modern architecture a more human character which appealed strongly to those who preferred the break with the past to be softened by a charm of manner generally only associated with period reminiscence.[15]

Shand's polemic also stresses the courageous gestures associated with the break with the past, and he reserves his vituperation for certain British nostalgics (and degenerates) who fail to recognise that times are changing:

May our own Viking blood, the only blood that in us matters, rouse itself to join in the massacre of those traitors to our age, the unnatural spavined invertebrates who, in their Neo-Cotswold olde-worlde sanctuaries, daily pronounce anathema on reinforced concrete, chromium steel and plywood in the sacred name of John Ruskin.

At the same time, however, he is convinced that the Swedes have achieved what the British might have achieved, had they not been hamstrung by their romantic and amateurish obsessions:

Sweden, on the other hand, has every chance of being able to do what Britain might have done had not the good seed sown by William Morris been choked by the tares of a spurious simple life rusticity and trodden under the besotted feet of Chipping Campden folk-dancers shod with artily wrought shoon.

The enemies here, of course, are the anti-Modernists, the dyed-in-the-wool survivors of the Arts and Crafts Movement who clung to the idyll of a pastoral Britain. There were similar 'reactionaries' in Sweden, and as has already been pointed out, the Stockholm Exhibition provoked bitter criticism, especially within the ranks of Svensk Form. Prominent among

the critics was Carl Malmsten, the craftsman furniture designer, who had launched his long and distinguished career when he won several prizes for furniture design in the Stockholm City Hall competitions. Malmsten campaigned for the survival of folk traditions in craftsmanship – Swedish *Slojd* – and for the revitalisation of craft, and the qualities associated with craft in contemporary design. He set up his own workshops, was involved in craft training and educational reforms, and he was also invited to furnish a room in the Crown Prince's Palace. He did *not* participate in the 1930 Stockholm Exhibition, however ('an attitude which exposed him to a great deal of criticism', according to one of his biographers), since he was bitterly opposed to Paulsson's and Asplund's policies. Modernism, as far as he was concerned, was a short-lived and short-sighted phenomenon: men did not change, their needs did not change, and there was room, in a modern economy, for expensive quality work (Malmsten produced exquisite cabinets with intarsia inlays), as well as for simple mass-production furniture to meet the needs of modern living (which he also produced).

 Significantly enough, Malmsten has pride of place in the section devoted to 'Home Interiors and Furniture' in Wollin's book, and is associated with 'the wholesome traditionalism which is represented by a small number of architects, who claim more or less a free hand to maintain contact with the older native types, especially from the latter half of the 18th century, and the first half of the 19th century. The leading representative of these is Carl Malmsten, whose interiors are stamped by a striking harmony and unison.'

 Modern Swedish Decorative Art (1931), as mentioned earlier, was published to coincide with the exhibition 'Swedish Industrial Art' held at the Dorland Hall in London that same year.[16] Produced under the auspices of the Design and Industries Association and Svensk Form (Asplund and Paulsson were on the committee, as well as Carl Malmsten), the exhibition, which included work from the Stockholm Exhibition of the previous year, was the ambitious sequel to a number of small displays that had been held in London in the 1920s (following Sweden's success in the Gothenburg Exhibition and at Paris in 1925). Neither the book, nor the exhibition, however, stress Modernism in Swedish design and, in his text, Nils Wollin is at pains to set contemporary developments within a historical context. In fact, he points out that the foundations for contemporary success in areas such as furniture design, textiles, glass, ceramics and metalware lie in the careful nurturing of traditional techniques. 'New tendencies in taste make their appearance,' he writes in

the section on Home Crafts, 'new machines are constructed on which are based capitalist organisations, but the Swedish home crafts persist. Nay, they still constitute the rich soil which gives nourishment to modern production, whether it is limited to hand-work only or comprises large-scale industry.'

Most of the textiles he illustrates (weaves, printed cottons, tapestries, lace, embroideries, and ribbons) are based on traditional techniques and patterns, as are the carpets and rugs, and many of the captions credit regional sources for the designs. (Among the most 'modern' are the upholstery fabrics in simple checks and stripes by Martha Gahn, who was active in the Swedish Home Craft Association – an organisation founded in the 1890s to provide work for women weavers throughout the country.) These, according to Wollin, are 'unmistakably Swedish' and they anticipate the Swedish upholstery fabrics that were so popular on the British market in the 1950s.

The metalwork section describes and illustrates the work that was done in copper and bronze, as well as cast iron, in connection with the building of Stockholm City Hall and other architectural projects, and emphasis is given to the recent revival in the use of pewter, largely engineered by Svenskt Tenn (the Swedish Pewter Company – which was to extend and update its activities to include furniture, interiors and fabrics when it was joined by Josef Frank, the refugee Viennese architect, in 1934). This work is 'modern' in so far as it is simple and undecorated, but (apart from bowls by Sven-Erik Scavonius and silverware by Nils Fougstedt) any demonstrations of the avant-garde in either form or decoration seem to be derived from the geometries of the Vienna Secession and Art Deco. Again, most of the ceramics selected for illustration are traditional in shape and pattern, the most radical being work by Wilhelm Kåge (his 1917 services for Gustavsberg are included, as well as designs from 1929 and 1930, which are remarkable for their simplicity and lack of pretension).

The furniture and interiors section, as has already been pointed out, was dominated by the work of Carl Malmsten (an indication, perhaps, of where Wollin's loyalties lay), although several 'room-settings' from the Stockholm Exhibition were included. Asplund, however, is represented by his music room of 1920, by two neo-classical chairs (one for the City Hall and one for the library), and by a bureau of 1920. No furniture using tubular steel was included in the survey, although some was represented in the Stockholm Exhibition, and it was left to Sweden's glass industry to present the purist aesthetic now associated with Modernism in the

twenties and thirties. Most of the ranges illustrated are simple and undecorated, and the cut and engraved glass is equally restrained (Edward Hald's 'Celestial Globe' for Orrefors having pride of place here, as in the London exhibition).

This dichotomy between the radicalism of the architecture of the Stockholm Exhibition, and the more conventional nature of domestic design, or decorative art, was also evident in the exhibition itself. Asplund's exhibition buildings were, of course, temporary structures, giving him the licence to be experimental and to play delightful games with space and form and structure. The ideals for housing represented there, however, were serious, and were to form the basis of research and reform programmes throughout the thirties to achieve an acceptable quality of life without waste of materials, space or money. And the 'more beautiful everyday goods' that furnished these houses were intended to complement a philosophy that was both practical and humanistic. The fact that the 'goods' were less iconoclastic than the architecture made them acceptable as 'models' for British practice. They were, after all, a demonstration of the Design and Industries Association ideal that artists, or craftsmen, should work with industry to regenerate standards, and as far as the British were concerned, they were a more than adequate demonstration of Swedish grace, and the Swedish ability to preserve tradition as well as to encourage a more radical approach. As Sir Harold Werner (of the Anglo-Swedish Society) wrote in the introduction to the *Architectural Review* article:

Two vigorous trends could now be seen in Swedish industrial art, which were to some extent in opposition to each other – one more traditional, emphasising handwork and following the lines first laid down . . . in the Gothenberg Exhibition and in the Stockholm City Hall . . . the other a more modern style related to functionalism, which concerned itself chiefly in the creation of quite new and good designs suitable for mass production and intended for a wider public . . . Make an inspection of the modern factories and you will see mass products turned out with the precision and beauty of a silversmith.

This, then, was the ideal of Modernism in the British applied arts in the early 1930s . . . to mass-produce in the spirit of craftsmanship. The Swedes, of course, achieved this ideal with very little compromise, as their success in the 1950s and the early 1960s demonstrated. And they also promoted a successful housing policy which had its roots in Svenska Slöjdföreningen radicalism and humanism, and which was actively supported by a Social Democratic government (to the envy of radical architects in Britain). But if the British failed to emulate the Swedes in

either their design or their architectural policies, it was not necessarily because of the reactionary activities of 'spavined invertebrates', nor because their industries, more complex and more fragmented both in their organisation and their markets, failed to gear themselves for change. It was because, following the euphoric demonstration of Welfare State idealism in 1951, no State policy, and no organisation, however well-meaning (the Design Council, after all, adopted many of the policies of Svensk Form) could persuade the patrons, or the public, of the necessity for grace, in any form whatsoever, in a British New Jerusalem.

There has been a tendency for some years now to associate innovation in design, and especially furniture design, with Italy. Milan, in a very real sense, is the capital city of design, against which other European and even American centres play the rôles of regional outposts. Never before in the twentieth century has one city so dominated European and American design.

In the first instance, post-Second-World-War Italian design was surprisingly in keeping with earlier Modernist canons. Quite quickly, however, it can be seen to represent the exhaustion of Modernism both in its ideas and practices. Not a rejection outright, but a reworking, an adding to and a denial of various long-standing precepts. Abstraction as an all-pervading aesthetic seemed untenable, as did the exclusive focus on production, as opposed to consumption. Earlier hostility levelled against Historicism, eclecticism and language in general eroded away, in a move towards a more pluralistic outlook. And the sheer sense of luxury, of symbolic abandon, heralded a new phase. If this was something to do with Modernism, it most certainly could not be mistaken for a design geared towards the needy masses. Indeed, it was only when the middle classes started to grow more affluent that the exuberance of Milan firmly established itself.

9

'A Home for Everybody?': Design, Ideology and the Culture of the Home in Italy, 1945–1972

PENNY SPARKE

The concept of the 'home' has played a crucial cultural rôle in postwar Italy. On both a material and an ideological level, the home has encapsulated a number of the period's dominant themes, related both to the life-styles of the mass of the Italian population, and to the self-image that the country has projected abroad. Linked to traditional values, in particular that of the family, and yet susceptible also to the pull of 'modernisation', the postwar Italian home has served both as an anchor with the past and as a means of demonstrating Italy's will and ability to become part of the twentieth century. In the period 1945–72, however, the concept of the modern Italian home severed its links with the social idealism that underpinned it in the immediate postwar years and became, complete with its interior components, a subject more for the glossy magazines aimed at international markets than a genuine possibility for the majority of the population.

Rebuilding a society

The main reason for the high premium attached to the idea of the home in Italy lay in the continual crisis that had accompanied the question of housing since the early years of industrialisation. In the first decades of this century, for example, urban housing was in short supply and industrial workers lived in ghettoes near the factories in which they laboured. In Milan, for instance, in 1911, over half the city's population – many of them immigrants from the south – lived in one- or two-room dwellings.[1] The situation remained problematic through subsequent decades and it was exacerbated during the Second World War by the severe bombing which left over three million houses either totally destroyed or badly damaged.[2]

By 1945, therefore, the housing crisis had become a familiar theme and the idea of 'a home of one's own' had become a key aspiration for a large sector of the Italian population. In the years of reconstruction, which followed the cessation of hostilities, the Italian architectural and design avant-garde focused, for the first time, upon the physical and spiritual needs of the working classes. The subject of the 'home' featured strongly in this initiative. In spite of a few isolated and mostly unrealised experiments undertaken by the Rationalist architects of the 1930s to develop housing schemes, and Mussolini's 'new towns' which were built on the reclaimed marshland south of Rome, relatively little had been done, under Fascism, to solve the severe housing problems of those years. With the defeat of the Fascist regime and the emergence of a new 'democratic' Italy, a number of Rationalists resurfaced and grasped the opportunity of linking issues raised by the aggravated crisis of housing to the new political, economic, and social idealism which characterised the early years of the new Republic. In the political climate created by the Christian Democrat and left-wing alliance, which constituted the Italian government between 1946 and 1948, they saw a rôle for such an approach, and set out to link their ambitions with the prevailing spirit of democratic idealism and political, moral, economic and social reconstruction.

Writing in the magazine *Domus*, in January 1946, the editor, Ernesto N. Rogers, stated optimistically that 'it is a question of forming a taste, a technique, a morality – all aspects of the same function. It is a question of building a society.'[3] Rogers used the verb 'to build' both literally and metaphorically, and he saw the renewal of housing as a means of fulfilling the greatest need of the Italian people at that time. He considered the problem from a number of perspectives – economic, social, technical, cultural and ideological – and introduced the concept of '*la casa umana*' (the human house) which was predicated upon the continuity of the family and placed the human being firmly at the centre of the contemporary architectural problematic. In practice this involved combining tradition with modernity. Interiors illustrated in *Domus* in these years, for example, depicted eighteenth-century furnishings positioned next to items made of tubular steel. Strong emphasis was also laid upon the inclusion of books and other evidence of human habitation and participation. Rogers' programme operated simultaneously on the level of idealism and on that of the realities presented by the postwar housing problem. While it dealt with the social and economic situation of the day, by proposing such practical solutions to the problem of

homelessness as the use of standardised mass production in the manufacture of domestic furniture and prefabrication in the construction of buildings, it also projected a vision of the 'ideal' home which combined the past with the present and which represented, in a universal sense, a solution to the problem of combining democracy and housing on Italian soil. As Rogers himself explained in *Domus*: 'In the programme of reconstruction, the real and the ideal home must be seen as parts of the same problem.'[4]

At this time a number of young architect-designers – including Paulo Chessa, Ignazio Gardella, Marco Zanuso and Vico Magistretti – proposed ranges of simple furniture designs which could be fabricated economically in series, and which were also both compact and flexible enough to be of maximum use within limited living-spaces. Their designs were modelled on traditional furniture-types, such as the deck-chair, and many of them either combined dual functions or could be easily packed away. Wood, used in the smallest amounts possible because of severe shortages, provided the most common material for the simple beds, tables, chairs, bookcases, wardrobes and sideboards which made up the equipment of the 'minimal dwelling', while tubular steel – a new material used first in the interwar years – made an appearance as well.

Furnishings became an important symbol of regeneration in the middle to late forties. This was made possible, firstly, by the strength, despite its artisanal basis, of the furniture industry, and, secondly, by the predilection for working in this area on the part of the young designers who had trained as architects within the Rationalist traditions of the 1930s, and who saw the components of the interior as an essential element within the contemporary architectural project. By the end of the decade, a significant Italian modern furniture movement had both emerged and been widely disseminated. It was exhibited at the RIMA [Riunione Italiana Mostre per l'Arredamento] exhibition of 1946 which focused on the theme of 'popular furnishings', and subsequently at the first postwar Milan Triennale, held in 1947, which re-emphasised the need, in the words of Pier Bottoni, for '*una casa per tutti*' (a house for everybody).[5]

It was important to the Rationalists of the immediate postwar years, however, that individual furniture items in the modern style were still combined with traditional items and small decorative objects – among them glass and ceramic ornaments and paintings. Writing in the *British Magazine* in 1949 L. Schreiber explained that 'such contrasting juxtapositions as the modern chair beside the old grandfather clock . . . are

characteristic of Italian decoration during this transition period in which
traditional thought and modern expression live close together'.[6]

In simple terms, Rogers' aim was the construction and furnishing of
fifteen million homes which he felt must be built in Italy to make up for
the housing already needed before the war and to replace homes
destroyed during these years.[7] While Rogers felt that it was possible to
initiate the building programme involved with this kind of physical
reconstruction, he foresaw a problem of acceptance of the austere
aesthetic of Rationalism on the part of the mass of the Italian population.
He envisaged the problem of the working classes rejecting the new forms
which he and his group were proposing for them, since, as he put it, 'they
still prefer gaudily decorated furniture'.[8] In spite of the dual advantages
of visual simplicity and easy adaptation to mass production (essential
factors within the new housing programme as far as the economics of
manufacturing were concerned), the modern style appealed to a middle-
class rather than to a working-class consumer. The problem of 'taste'
was, in fact, to prove a central stumbling block in Rogers' attempt to
realise his aims, and was to contribute to the fate of the modern home
within postwar Italian culture as an essentially bourgeois phenomenon.

Consumer goods for the middle classes

After 1950 – the year in which Vittorio Gregotti maintained that realism
in Italian design came to an end – a gap developed between the actual
Italian home and the image of this presented abroad. The working-class
home, usually located in an apartment block built in a suburban area of
one of the large industrial towns, remained small. Urban dwellings
remained scarce and, where the working-class population was con-
cerned, usually far from adequate. In the years between 1950 and 1970, a
huge programme of building was undertaken, but it was executed to a set
of minimum standards, and even what was built proved, by the 1960s, to
be inadequate for the huge numbers of immigrant workers from the
south who flocked into the northern cities at the time. This poor housing
provision became one of the central causes of the grievances which
exploded into the strikes of the 'hot autumn' of 1969.

Martin Clark has described the results of the postwar Italian housing
programme in his book *Modern Italy 1871–1982*: 'Dreary housing
estates arose all round city outskirts, most of them put up without benefit
of planning permission and often without roads, schools, lighting or even
sewerage. The hapless immigrants were often put into huge blocks of
flats, with densities of five hundred people per hectare in some parts of

Rome. Even worse were the hideous shanty towns, providing shelters but little else for thousands of newcomers.'[9]

Federico Fellini's 1960 film, *La Dolce Vita*, is filled with images of these buildings under construction amidst an atmosphere of fervent optimism and renewal. As for Rogers, so for Fellini, the vision of prefabricated, metal-framed buildings rising into the air, as if out of nowhere, represented the physical manifestation of the Italian nation's hopes for the future. In Fellini's film, however, the gain is finally outweighed by the loss of tradition that is undergone in the process and by the corruption that modernisation brings, thereby replacing the innocence of an earlier Italy less dominated by the mass media and the other appendages of 'modern life'.

While mass housing remained inadequate in these years, and its interior furnishings were acquired in a piecemeal fashion, one aspect of 'modern design' associated with the concept of the 'mechanised home' did penetrate the working-class house. During the years of the 'Economic Miracle' – 1958–63 – Italy turned into a consumer society, along American lines. Italians sought those consumer durables – cars, fridges, washing machines, etc. – hitherto classed as luxuries but rapidly becoming transformed into necessities, which would provide them with the necessary social symbolism. The 1950s saw the expansion in Italy of those industries which could supply these goods, while mass-market 'women's' and 'home' magazines extolled the virtues of the 'fitted' kitchen and of the 'labour-saving' advantages of electrical domestic appliances, or *'elettrodomestici'*, as the Italians neatly called them.

The 'ideal home' of these boom years – unlike its counterpart of a decade earlier, which was much more concerned with the basic necessities of everyday life – now contained a version of the American 'dream kitchen' as seen in Hollywood films and American TV soap operas. Numerous Italian manufacturing companies were set up in these years to cater specifically for the expanded demand in this area. Rex Zanussi, for instance, established a large-scale company which concentrated on producing fridges and cookers. In 1956 he brought in the designer Gino Valle to modernise his whole range, thereby making it even more desirable to the expanding numbers of both Italian and foreign consumers. The scale of production of a number of these export-oriented electrical goods was such that they became increasingly available to a widening spectrum of Italian society in a way that goods aimed at home consumption alone were not. Working-class households, for example,

could often afford a fridge and a television set, whereas meat continued to be beyond their means.

The need for Italy to export goods became, in the postwar period, the major force behind much of its manufacturing policy, determining not only the nature of the goods produced, but also their appearance and price. The decision to concentrate on consumer goods, many of them destined for the home, was a result not merely of the importance attached to this within Italian postwar society and culture during the period of reconstruction, but also of the strong viability of such goods in foreign market-places. While the home market was the most important one for Italian manufacturers in the decade 1945–55, the later 'Miracle' years were characterised by a huge growth in exports and a concentration on foreign markets. Italian products competed with foreign ones more on the basis of their strong visual appeal and quality of fabrication than on the level of their technical sophistication. The products Italy chose to make – furniture and household electrical goods – required in fact only the simplest technological input.

As a result of the policy of keeping wages low in Italian manufacturing – a strategy which kept its products competitively priced abroad – the working-class population, unlike what occurred with mass-produced goods, was largely excluded from the possibility of buying many of these export-oriented articles. This was especially the case with items of furniture which were manufactured on an artisanal basis in relatively small numbers but with a high design profile aimed at attracting wealthy foreign customers. As a result, only middle-class Italians could afford such products. Hence, with only a few exceptions – most notably, the fridge, the washing-machine and the television – the domestic products associated with the Italian 'Economic Miracle', and with the 'heroic' years of modern Italian design, were aimed at an essentially bourgeois market, both at home and abroad.

As far as the modern home was concerned, the idealised version of this concept came to be defined increasingly in middle-class terms. After 1950, in the extravagant and stylish form in which it was promoted by manufacturers and glossy magazines and created by the new generation of architect-designers, the home came to have less and less to do with the realistic problems associated with the physical reconstruction of Italy that Rogers had outlined just after the war.

This change in emphasis, from a notion of the ideal home that was based on practical exigencies to one which espoused ideas of status symbolism and stylishness, was reflected in the change in the political

situation in Italy after the left-wing parties had been expelled from the government in 1948. It was also highlighted by Gio Ponti taking over the editorship of *Domus* in the same year, and his introduction of a more élitist approach to the question of design. An intensification of the impact of American culture on Italy also occurred at this time, which helped to swing the emphasis towards private consumption. From 1950 onwards, the concept of modernity, associated increasingly with ideas of comfort and luxury, rather than with necessity, became an ever more important element within an essentially 'bourgeois' culture of the home that provided the base-line for Italy's entry into foreign market-places. Furnishings dominated the picture, and countless new companies sprang up in this period, eager to participate in this international enthusiasm for the modern interior. As American-style consumerism became further entrenched within Italian society, items of furnishing turned increasingly into fetishised commodities rather than simple elements within the interior landscape. The concept of the unified interior as a whole – with its early postwar emphasis on the human inhabitant rather than on its material components – was replaced by a growing emphasis, in magazines and sales brochures, on the isolated object: the light, the sofa, the chair, the table. These became increasingly aestheticised and decontextualised, and they acquired, as a result, associations of individualism and exclusivity through their alignment with the world of Fine Art. This was nowhere more evident than in the pages of the magazine *Stile Industria*, founded in 1954 by the designer Alberto Rosselli, which set out to present the modern consumer products of Italian industry as if they were sculptures. This process of aestheticisation was reinforced through the 1950s by the displays of industrial products at the Milan Triennales of 1951 and 1954, respectively entitled 'La Forma dell'Utile' ('The Form of the Useful'), and 'La Produzione dell'Arte' ('The Production of Art'). The emphasis was firmly placed upon the overtly sculptural forms of the objects – furniture and mechanical consumer goods predominantly – and little attempt was made to place them in any context other than that of the world of Fine Art. While objects of transport and machines for the office played an important part in Italy's 'modern designer' onslaught on foreign markets, objects for the domestic environment, especially furniture, continued to dominate the picture in the fifties.

Modern design and conspicuous consumption

A number of firms established earlier in the century turned in the 1950s from the ad-hoc manufacture of individualised items which conformed to

the existing tastes of customers to the mass production of furniture pieces in the modern style. They were joined by a number of new companies which were established with the specific aim of working in the area of modern design – a concept which was becoming increasingly associated with Italian luxury production at this time. From the former group, the Cassina company collaborated with members of the postwar generation of architect-designers in the production of modern pieces in new materials such as bent plywood and metal. First Franco Albini, and subsequently Ico and Luisa Parisi and Gio Ponti provided stunning modern designs for the company. The most successful was undoubtedly Ponti's little 'Superleggera' chair (p. 193) which was based on a traditional model from the fishing village of Chiavari, but was modified to suit the 'modern' spirit of the 1950s. While Albini's 'Margherita' chair from the same period also recalled tradition in its use of wicker, most furniture designs from these years moved aggressively into the modern world, evolving expressive forms influenced by the use of new materials and evoking an atmosphere of modern comfort and 'good living'.

The use of foam rubber, for example, which was developed by the Pirelli company, is of particular interest in this context. While its very novelty within the area of furniture determined its relevance to the modern age, it also served to represent a modern form of comfort. Replacing the heavy upholstery of traditional seating, it enabled chairs and sofas to be both light and comfortable. Designs by Marco Zanuso for Arflex – a company established in 1949 by Pirelli specifically to concentrate on developing furniture items incorporating the new material – included his famous 'Lady' armchair which quickly became a modern object of comfort *par excellence*. Equally, Osvaldo Borsani's design for the P40 armchair produced by Tecno, with 'wings' of upholstered foam rubber, became an important icon within the modern Italian interior landscape.

New materials provided a stimulus for the designers, who were keen to rise to the challenge of creating a new aesthetic for the new Italy. The democratising potential of materials was, however, transformed into another means of creating *objets de luxe*. Even plastic, the most 'democratic' of all, was turned into a luxury material. This was achieved through a combination of strategies, which included using designers to create strong, modern forms; the use of high-quality craftsmanship; and the presentation of the objects, in publicity and magazine photographs, as items of sculpture. Through these means even such mundane objects as buckets, lemon squeezers, washing-up bowls, and dustpans and brushes

Lamp by Sergio Asti, 1959. (Model 2048/m, Arteluce.)

'Superleggera' by Gio Ponti (Cassina).

were transformed into art objects, symbolising a particular life-style as clearly as a leather sofa or marble coffee table. This appropriation of artefacts into a predetermined 'culture of the home', associated with a particular middle-class, consumerist life-style, succeeded in turning all Italian objects, produced in these years, into highly desirable, élitist artefacts. Transformed by designers, they acquired a form of 'added-value'.

This was particularly obvious in the area of lighting. The 'lighting-object' had a great deal of sculptural potential for Italian designers, who seized on it as the ideal means of expressing their joint commitment to the modern image and to the luxury interior. A modern product in itself – electricity was, in the popular sense, a twentieth-century technology – the light could both perform a sculptural rôle in the interior and, through its illumination, create a particular mood within that environment. Working with the new manufacturing companies in this area – including Arteluce, Arredoluce, and Stilnovo – designers such as Gino Sarfatti, Vittoriano Vigano, Sergio Asti (p. 193) and the Castiglioni brothers produced stunningly expressive forms which stretched the functional possibilities of lighting to their limits. The Castiglionis, in particular, produced some highly minimal designs which became strong visual symbols of the new Italian domestic landscape. One light, in particular, the Arco of 1962, became a familiar appendage of modern Italian interiors in this period. Featured on the covers of glossy magazines and in countless films which depicted the stylishness of modern Italian life, it entered the popular consciousness on a worldwide basis. Combining marble with steel and aluminium – a traditionally élitist material with ultra-modern connotations, which had recently acquired luxury status – it hovered, like a praying mantis, over interior settings, imbuing them, by its mere presence, with a special quality.

The gap between the practical exigencies of mass housing and the idealised Italian home grew rapidly as the 1950s progressed, and by the early 1960s, the two had moved into quite distinct areas. While the latter provided the basis of a fully-fledged, internationally-oriented, bourgeois cultural movement, which had a strong influence on Italy's economic position in these years, the former received little attention.

Along with exhibitions, magazines provided the principal means of reinforcing and communicating the ideology of modern Italian designs. The proliferation of glossy 'home-oriented' magazines – among them *Abitare*, *Casa Vogue* and *Interni* – provided a middle area between the professional magazines and the more general 'down-market', 'women

and home' magazines, many of which had been in existence since the interwar years. The emergence of a group of expensive periodicals pointed to the existence of a receptive, wealthy, lay audience, both in Italy and abroad, which wanted to extend its knowledge of 'design culture' in the context of the domestic environment. Milan became the unchallenged centre for all matters relating to design in these years (the mass-market furniture industry was traditionally located north of Milan, in an area called Brianza), and the new magazines and support systems all had their bases in the city. Above all, numerous shops selling the new furniture and related products sprang up in the years of the 'Economic Miracle', catering both for a local middle-class market and for visitors from abroad who came to see this Mecca of modern design.

Furniture remained at the heart of this phenomenon. It became ever more innovative, both stylistically and technically, and companies such as Cassina, Gavina, Artemide and Flos expanded in these years through the increased production of furniture for a sophisticated international market. An aggressive neo-Modernism underpinned the work of the key designers working for these firms – the Castiglionis, Vico Magistretti, Joe Colombo, Sergio Asti, Alberto Rosselli, Tobia Scarpa, and Marco Zanuso – and certain furniture items, in particular the polyurethane foam-filled sofa (often with plush leather upholstery), the 'light-sculpture', and the coffee table (often in marble) took on an iconic significance in this period as the perpetrators of the new exclusive Italian life-style. Traditional 'luxury' materials were, thus, combined with more modern ones – plastics and metals predominantly. The latter were thereby transformed and, through the simple yet highly sophisticated forms evolved for them, turned into symbols of bourgeois affluence and stylishness. The older materials acted as important vestiges of the past, and as links to the traditional values long associated with the home and the family in Italy. In his book *The Italian Labyrinth*, John Haycraft has explained that: 'The Italian idea of "domus" evokes solidity and permanence. If you have a house you don't normally sell it to buy a better one as you get more prosperous with age. You keep it for your children, who were brought up in it, and add to it if you can when you need more room.'[10] A sense of intransience and stability was therefore retained alongside that of renewal so important to Italy in the postwar years, and the idealised image of the domestic landscape which emerged succeeded in subtly combining tradition with innovation, in such a way as to allow the two forces to influence each other. Thus, while the new materials and forms helped to revitalise the older, more familiar signs of affluence, they

'Zeldadue' sofa, armchair and small table in wood and leather by Sergio Asti, 1961 (Poltronova).

Vico Magistretti, veranda, c.1975 (Cassina).

Zanuso and Sapper television, 1960 (Yades).

Tecno table model T69, *c.*1970.

were themselves given a greater sense of solidity through their juxtaposition with longer-lasting, 'high-quality' materials.

Cassina's inclusion, from the mid-1960s onwards, of a number of 'modern classics' within its range of products by contemporary designers, was a further strategy in the effort to create a 'tradition of the new'. The reproduction of Le Corbusier's leather-covered, steel-framed 'Grand Confort' armchair and his chaise longue, designed in the late 1920s, served, by implication, to raise Cassina's current models to the status of 'classics'.

The importance of the interior, in particular the living room, as an arena for status symbols during this period of heightened consumerism and affluence, cannot be over-estimated. In addition to providing security and shelter, the home became increasingly – particularly for the bourgeois sector of society – the place in which possessions were paraded as signs of affluence. The high degree of 'added-value' injected into the goods which performed this rôle enhanced their socio-cultural function. This was achieved through their close association with Fine Art; their sophisticated modern forms; and their sense of 'quality', both as regards materials and craftsmanship. While the most sophisticated and expensive items of furniture had well-known designers' names attached to them, there was also much imitation of their designs aimed at lower levels of the social hierarchy. Andrea Branzi has written that 'even the smallest joiner's shop soon learnt how to make bar counters that looked like Gio Ponti's own designs; the smallest electric workshops soon learnt to make lamps that looked like Vigano's, and upholsterers played on armchair models that might be reminiscent of Zanuso's'.[11]

From design to anti-design

That such a process came about was due to the proliferation of small-scale furniture manufacturing concerns in these years. While a number of firms expanded, in general they tended to reach an optimum size and to specialise in only one advanced technological process, thereby minimising the amount of capital investment necessary. Thus, for instance, the Zanotta company – formed in 1954 by Aurelio Zanotta and committed from the outset to innovative design – concentrated on the fabrication of expanded polyurethane foam products. Many of its key products from the 1960s – among them Willie Landels' 'Throwaway' sofa of 1968, which was made entirely from foam, and the famous 'Sacco' or 'beanbag' chair of 1969 by Gatti, Teodora and De Pas, which was originally filled with foam offcuts – were completely dependent upon this

material. This concentration upon a single technology meant that collaboration between companies was vital if they were to produce objects for the market-place. By the end of the 1960s, the Italian furniture industry consisted of a large number of relatively small and highly collaborative firms, most of them owned by single families. Their size allowed for great product differentiation and for much stylistic innovation. This was frequently achieved by copying 'designer' items which were then sold at a lower price than the original. Most of the companies were export-oriented and the marketing and distribution of their products were undertaken by agencies which represented a number of firms.

While Italian furniture in the 'modern style' dominated the international picture by the mid-1960s, its production was still concentrated in the north of Italy, in particular in and around Milan, and, despite a presence in glossy magazines, it failed to make a significant impact on the rest of the country. As far as the majority of the working-class population and the people living in the south of Italy were concerned, traditional and reproduction furniture remained the norm. Much of it was supplied on a regional basis by small manufacturers who had been in existence for a number of years. Thus, while the 'modern Italian design' phenomenon was disseminated widely and was, as a cultural ideal, much in evidence in certain cosmopolitan centres, its influence on the interiors of the majority of the Italian population was minimal. While the general standard of living did rise appreciably during the years of the 'Economic Miracle', and more people were able to buy such goods as fridges and television sets than ever before, the concept of the 'good life' remained a myth rather than an everyday reality.

In the late 1960s and early 1970s, a crisis took place in Italy simultaneously on the social, political and cultural front. This can be seen in part as a collision between myth and reality, in as much as the Italian working-class population finally showed its dissatisfaction with its living and working conditions. The grievances which led to the workers' strikes of 1968 and 1969 arose from the continued poor provision of housing and for health and education, and from deteriorating working conditions and low pay. The students' protests of the same years were motivated by sympathy with the workers' cause and by a sense of disillusionment with the cultural achievements of the first postwar generation. The working-class population had expanded enormously in the decade after the war, and, for the first time for almost a decade, it found a voice with which to express itself. The first major wave of strikes had occurred in the early

1960s, but, when the students joined forces with the working class, the crisis of the late 1960s turned into a cultural revolution.

The so-called 'anti-' or 'counter-design' movement grew up as part of the general crisis of the late sixties. It was particularly concerned to show up the growing alliance between design and conspicuous consumption. The protagonists of the new movement – most of them young architectural students or recent graduates, based in Florence, Turin, Milan and Rome – attacked the concept of the isolated 'formal' object, which had, since the fifties, served to carry the ideology of consumption into both domestic and foreign markets. They proposed, instead, a new, more holistic vision of the environment, which sought to realise itself without the intervention of the manufacturing industry. In brief, a generation of young counter-designers trained in architecture set out to present an alternative design which focused on the environment as a whole, rather than on isolated, manufactured items. Inevitably their visions remained utopian in nature, but they served nonetheless to introduce a sense of dialectic into Italian design practice, which threw into doubt the hitherto unquestioned link between design and manufacturing industry. Through their proposals, the home found itself once again at the heart of an idealised vision of the future. This time, however, the aims were defined in social and cultural, rather than in merely economic, terms.

In 1972 a major exhibition of Italian design was held at the Museum of Modern Art, New York, entitled 'The New Domestic Landscape'. In addition to the inclusion of many of the 'classic' designs from the previous decade, it also featured a number of interior environments created both by leading protagonists of the mainstream Italian modern design movement – Joe Colombo and Gae Aulenti – and by a number of designers associated with the 'anti-design' movement – Ettore Sottsass, Superstudio and Archizoom. The aim of the latter was to 'recontextualise' the object and to provide 'micro-environments' which encouraged new ways of sitting, eating, and relaxing, rather than perpetuating object fetishism.

Inspired by a crisis within Italian society – as the postwar Rationalists centred around Rogers had also been – some architects began to define their rôle as one of providing shelters which offered their inhabitants an essential backcloth to their everyday lives, rather than a set of status symbols. This was the 'domestic landscape' defined in its most basic form, emphasising once again the human occupants rather than their life-style accessories. The strong parallels with the immediate postwar period indicated that, on one level, a full circle had been turned, with architects

Ettore Sottsass/Memphis lampstand, *c*.1980.

once again offering a vision of the home which catered for needs other than that of mere status symbolism. The main difference, however, between the efforts of Rogers and the group of Rationalist architects and designers from the early postwar years, and the 'anti-designers' of the late 1960s, lay in the fact that in the 1960s the vision was entirely utopian and unrealisable. The developments of the 1950s and 1960s, which were determined by the growing dominance of the manufacturing industry, had divorced architects and designers from their earlier involvement with society and culture. As a result, they found themselves operating within a limited sphere in which they could only talk to themselves.

Vittorio Gregotti has claimed that it was the move from 'popular culture' to 'mass culture' – i.e., the change in Italian society that occurred with the incursion of American values associated with mass production and consumption – which was responsible for what he calls the 'defeat of design to participate in the realities of national life'.[12] What he means quite simply is that the focus shifted from social to predominantly economic considerations, whereby designers became the pawns of manufacturing industry. Whatever the root cause of this failure, there can be little doubt that, while most contemporary Italian design is still geared to the domestic context, the early postwar social ideals associated with the idea of 'a house for everybody' have long been abandoned.

During the later 1980s Spain emerged as perhaps the most progres-
sive nation with regard to design practice. Barcelona in particular
began to enjoy a profile unprecedented in modern times, excepting
perhaps the era dominated by Antoni Gaudí. There was even
discussion that perhaps Barcelona could eclipse the previously
undisputed centre of advanced design, Milan. It is with great
anticipation, therefore, that we now look to 1992, when the
European market becomes fully open and, in the same year,
Barcelona stages the twenty-third Olympiad. Already critics are
predicting that this will serve as the publicity platform from which
the Catalonian capital will consolidate its bid to become the
premier centre for European design.

 This essay explores the background to Spain's apparently sudden
rise in the design field. It reveals the importance of the situation of
modern designers in Spain before, during, and after the Franco
years and how this shifted the ground of the debate. In Spain at
least, it seems, the relationship between Modernism and Post-
modernism has been more complex than is usually depicted. For
Catalonian designers, certain of the Modernist tenets were un-
acceptable; no one who had suffered under Franco would willingly
subscribe to grand, centralised plans, or would design in such a way
as to reduce the sense of ethnic belonging. On the other hand, the
essentially republican and left-wing position of the radical designers
and critics, bolstered by the proud tradition of the avant-garde in
the Fine Arts, meant that other aspects of Modernism remained of
central importance.

10

Radical Modernism in Contemporary Spanish Design

GUY JULIER

Since Spain's startling success at the 1986 Milan Furniture Fair, European design journalists have increasingly turned their attentions to its new design activities. This *boom de diseño* came on the crest of a wave of social, economic and cultural changes. Spain's transition to democracy in the late 1970s was closely followed in the 1980s by other initiatives which have brought the country back on to the European agenda after decades of economic and cultural isolation. Spain became a member of the EEC and NATO, and has begun preparations for the 1992 Olympic Games in Barcelona and the World Fair in Seville in the same year. These have created the opportunity for establishing new national identities which replaced that of Francoist or tourist Spain. Its design activities were a potent means of conveying such a new identity.

However, actually defining the essence of new Spanish design is a difficult task. A survey of some of the better-known examples of Spanish design to emerge in the 1980s reveals an obvious eclecticism in the finished results: Oscar Tusquets's 1986 'Gaulino' chair quotes both Gaudí and Carlo Mollino; with his 1986 'Andrea' chair, Josep Lluscà reconsidered Charles Eames' 1940s side chairs, again incorporating Gaudíesque visual quotations as well as 1950s Rationalist theory; in urban design one might compare Luis Peña-Ganchegui's baroque towers of the Parque de L'Espanya Industrial, completed in Barcelona in 1985, and the nearby Plaça dels Països Catalans by Albert Viaplana and Helio Piñón completed two years earlier, whose minimalism on one level makes no concession to figuration and yet at another level invokes the artefacts of its immediate railway-station setting.

Certainly there is little aesthetic coherency in these examples. However, it is possible that there is a coherency in approach. Each introduces an element of play on, or even a subversion of, a visual language which may be historical, Modernist, or both. Thus there is an evocation of past

styles or, at times, of local pre-existing elements, whilst at the same time they are provocatively treated.

In my opinion, the methodological context out of which new Spanish design emerged in the 1980s was the result of an earlier architectural debate. This debate was generated in the so-called Escuela de Barcelona, the unofficial coalition of Catalan architects, roughly between 1967 and 1971. Much of it was concerned with the status of the Modern Movement in the context of late-Francoist Spain and was therefore influenced by its changing status before this period. This debate may be followed clearly in the development of the writings of the Escuela de Barcelona's major spokesman, Oriol Bohigas; later we find its resolution being transferred to the activities of designers in Barcelona and then beyond, to the possible identity of Spanish design in the 1980s.

In a country of such regional diversity as Spain it may seem astonishing to take such a specific approach. It must be remembered, however, that on a general level Catalonia has historically boasted a more European-orientated avant-garde tradition than the rest of Spain. Furthermore, the very concentration of avant-garde activities in art, design and architecture in Barcelona generated a certain consistency and coincidence in these early years. As we shall see, whilst the debate was generated within the architectural Escuela de Barcelona, it did not have to travel far to reach other disciplines. The dates 1967–71 will be the focus of this essay, firstly because they correspond, more or less, with the brief existence of the Escuela de Barcelona, and secondly because they correspond with a period during which new and old positions were appraised, accepted, rejected or 'banged together' with greater intensity than previously or than has been the case since. Barcelona was traditionally a city of both artistic and political restlessness. Often these two coincided, as they most certainly did in the five-year period under discussion.

Whilst positions expressed in architecture and design during these years are influenced by movements outside Spain, especially those in Italy, this chapter analyses them largely within a local context. The internationalism of Spanish designers in this period forms an important element of their visionary, if not radical, nature, particularly in relation to the rather xenophobic nature of the State. However, there is little value in drawing up a shopping-list of foreign influences unless we begin to consider why some should be favoured over others. Furthermore, it is precisely these local conditions that provide the interest.

*

The Escuela de Barcelona largely existed as a point of debate over what it actually constituted, rather than a fixed architectural movement. It was dominated by the following architects: Josep Martorell, Oriol Bohigas, David Mackay (making up the MBM group), Frederico Correa and Alfonso Milà, Lluís Domènech and Oscar Tusquets, Lluís Clotet, Pep Bonet, and Cristian Cirici (making up Studio Per).

Formally, these architects were linked to each other by various routes, Tusquets worked in the studio of Correa-Milà whilst a student at the Escuela de Arquitectura de Barcelona; Domènech and all of Studio Per studied under Correa and Bohigas at the same architectural school in 1964–5; Cristian Cirici's father, Alexandre, edited the culture section of the magazine *Serra d'Or* alongside Bohigas, during the sixties, and so on. On a more informal level, they were all frequenters of Boccaccio, the bar which Barcelona's radical chic set, known as the *Gauche Divine*, patronised in the late 1960s.[1]

Again, by formal and informal routes, this group was linked to the wider design spectrum in Barcelona through platforms such as the design school Eina, and its forerunner Elisava, the Architectural Institute, the Colegio de Arquitectos de Cataluña y Baleares and the design association ADIFAD (Agrupación de Diseño Industrial/Fomento de las Artes Decorativas). Within this network, the ideas of the Escuela de Barcelona are the best documented and one also finds that they tended to lead, rather than merely disseminate, trends in theory and practice. However, before moving into the finer details of the debate surrounding design, it is worth looking at the broader social, economic and political context of this period of late-Francoist Spain.

The period we are considering falls within what are known as the *años de desarollo*, the development years. From 1939 to 1957, the Spanish (and particularly the Catalan) people suffered under the Autarchy, during which the government, made up of an uncomfortable alliance of Monarchy, Church and Army, was often dominated by the Falangists, making for a period of extreme oppression, isolation and minimal economic growth. However, the appointment of a host of technocratic ministers from the religious sect, the Opus Dei, to the government in 1957 paved the way for a less protectionist economic policy, encouraging the inflow of foreign capital, capital goods and tourists. Thus, between 1961 and 1973, Spain's economy grew at 7 per cent – faster than any non-socialist country other than Japan. Incomes quadrupled, with a resultant consumer boom. It was also a period of massive internal immigration from country areas to major cities. Between 1951 and 1960,

Barcelona had grown by 450,000 as a result of immigration, that is, by some 18 per cent. Between 1960 and 1970, this figure doubled.[2] As a result, the physical and cultural landscape of Spain was thrown into chaos.

The *años de desarollo* had left behind the Falangist salutes, monuments and Cara al Sol (face to the sun) of the Autarchy. Now Spain's great new urban population was fed on a mixture of 'cars, football and TV', to make up a veritable mass 'culture of evasion', as Carr and Fusi term it.[3] Perhaps official Spain's cultural high-spot during this period was its winning of the 1968 Eurovision song contest with the brilliantly titled entry, 'La, La, La'. Despite the creation of the Ministerio de la Vivienda in 1957, with the aim of 'making a blossoming spring of homes in Spain' (which might have fulfilled the Falangist slogan 'not a Spaniard without a home, nor a home without a fireplace'),[4] the lack of any concrete planning by the government to relieve the pressure of mass immigration to Spain's major cities left each one of them with grave problems of traffic, shantytowns and overcrowding. In Barcelona alone, according to a report by Francesc Candel entitled *Els altres catalans*, there were well over 50,000 people living in *barracas* in the early 1960s.[5]

Not only was there widespread irritation at the lack of government planning; in architectural circles, it was felt that Spain had lost all its rational brains since the Second Republic, the heroic period of Rationalist architecture carried out by the GATCPAC group during the brief period of democracy of the 1930s. A revealing indicator of this is an interview entitled 'Sert or the urbanistic concern', given by Josep Lluís Sert as he was passing through Barcelona in 1967, and published in *Serra d'Or*. Sert had been a leading figure of the GATCPAC group, which had forged a link between themselves and Le Corbusier. It is noteworthy that he designed the pavilion that housed Picasso's *Guernica* at the Paris Exposition Universelle of 1937. Since the Civil War Sert had been in exile in America, teaching at Harvard; his only work in Spain since then had been the designing of Miró's studio in Palma. Oriol Bohigas, who conducted the interview, made several sharp interjections. For instance, as soon as Sert mentioned his work with the GATCPAC group in the Second Republic, Bohigas swiftly replied:

My generation has been without masters, with an appalling immediate past. I could imagine the time we could have gained with people like you in the country . . . [the GATCPAC era] . . . was the only period in the peninsula that avant-garde architecture became official, I think.[6]

Josep Lluís Sert, housing block, Barcelona, 1930–1.

At the end of the interview, Bohigas voices concern about the urban disorder into which Barcelona had fallen since the days of the GATCPAC era:

We leave. In the Plaza de la Catedral, doves fly and there are old and young sleeping in the sun. And an invasion of frenetic, virulent, noisy cars. And [something] criminal [happens]: right there we have to pull out an old woman and a girl almost from under the wheels of a bus, and moreover, a *guardia* tells them off: the bus was in the right.[7]

The equation that Bohigas makes between the absence of Rationalist/Modernist architecture since the Second Republic, and the urban chaos which had resulted under Francoism, is poignant. It would suggest that by ignoring a Modernist/Rationalist contribution to the urban fabric, Francoism had allowed Spain to slip into disorder. The temptation to

equate any Modernist position with an anti-Francoist position, and vice versa, is therefore obvious. However, when we begin to look more closely at positions held in the Escuela de Barcelona at the time of the Sert interview, such a conclusion isn't quite so clear-cut.

In 1969, Oriol Bohigas brought out a collection of essays in a book entitled *Contra Una Arquitectura Adjetivada*. The title, which literally means 'against an adjectivised architecture', is important, for it describes one of the central, but seemingly contradictory, points of the Escuela de Barcelona – which is that it tended to avoid any excessive use of adjectives in describing styles of architecture, effectively negating any '-ism'. I say 'seemingly contradictory' because a possible prerequisite for the agglutination of any group would be that it has several descriptive points in common. However, the Escuela de Barcelona existed more as an idea, or a methodology, than by any distinctive formal criteria. If we are to assess the status of Modernism in design in this context, then Bohigas' deliberate denial of any '-ism' makes things historiographically difficult, but also interesting.

He begins his book with an essay entitled, 'Equivocos "Progresistas" en la Arquitectura Moderna'. In this, he firmly positions himself against the Modernist project of Tomás Maldonado:

We no longer consider the possibility of a 'total design', neither do we believe, in accordance with Tomás Maldonado, in a simple addition of objects or 'well designed' conjunctions coming out of a 'well designed' world, because we are now aware of the fact that this is also the method of all despotisms that often attempt to create such a world in which one expresses the formal order of objects and one ignores, on the other hand, the disorder of men.[8]

On the following page, however, Bohigas revindicates a Modernist position, stating that:

. . . all designers who are seriously preoccupied with the profound problems of these times, feel strongly linked to the renovation of concerns that the [Modern] movement opened up with.[9]

Modernism as opposition. Modernism as social concern. Modernism as a political position. These *general* positions were relevant to the avant-garde architect or designer. However, Bohigas demonstrates an obvious mistrust at the implementation of any Grand Plan to bring about social harmony, if one interprets his statement that a 'total design' is a 'method of all despotisms' as a side-swipe at Francoism. Indeed, the writing of many designers of this period, including Bohigas, was full of such veiled criticism. Following this line of thought, of course, we could venture to

say that the Grand Plan of Francoism was itself a Modernist plan, and
that Bohigas was rejecting Modernism for this reason. This would be
turning my original argument, that a Modernist position was in fact an
anti-Francoist position, on its head.

In the cultural arena, however, there was little room for Modernism in
design. The relationship of culture and Francoism is already covered by
three studies – *La estética del franquismo* (1977) by Alexandre Cirici,
Lluís Domènech's *Arquitectura de Siempre* (1978), and *Arte del fran-
quismo* (1981), a collection of essays edited by Antonio Bonet Correa –
so I will not dwell on it here. The general argument is that Modernist
architecture, as associated with the Republican era, and especially with
the GATCPAC group, was created by 'the Jewish, socialist spirit and the
teachings of 1917'.[10] It was replaced with monumental universal
academicism in the 1940s.

A simple survey of major buildings put up in Barcelona between 1930
and 1950 might serve to illustrate the move away from the Modernism of
the Republic to the Universal Academicism of the Autarchy. Of these we
might move from Sert's Rationalist housing block of 1931, through to
Luis Gutiérrez Soto's 'Gratacels Urquinaona' of 1936–42, which com-
bines functionalist grammar with austere monumentality (Soto later
designed the famous Air Ministry in Madrid), ending with the Banco
Vitalicio de España of 1942–50, which reflected a new wave of Classical
buildings put up by the major financial institutions in the early years of
the *dictatura*. However, whilst some Rationalist buildings were appar-
ently[11] covered up just after the Civil War, and whilst the majority of
teaching and debate in architecture was about a truly national style, there
was not a wholesale political rejection of Modernist architecture.

Domènech argues that elements of the Modern Movement existed
within government initiatives.[12] These may be found in particular in
various agencies concerned with post-Civil-War reconstruction such as
the Dirección General de Regiones Devastasdas and the Instituto Nacion-
al de Colonización. However, they were more often found in the sphere
of rural and agricultural reconstruction but even here they are few and far
between, comprising six rebuilt villages which, it was hoped, would
regenerate the rural idyll so dear to early Francoist ideology. Their
architecture uses standard and interchangeable typologies in its elemen-
tal language. They might be regarded as 'new villages' or even 'new
hamlets' in comparison with the Grand Plans for new towns and urban
planning that we are familiar with from considering the concept of
Modernism in post-war redevelopment. Furthermore, within the 'new

villages', local, traditional variations in detailing, such as balconies, doors and arches were introduced, thus lessening the overall effect of international Modernism. In the realm of official architecture, therefore, we do find a suggestion of Modernist thinking, but this is only a suggestion, and it is overshadowed by gestural or monumental nationalistic projects such as Franco's monument to his fallen heroes of the Civil War, the 'Valle de los Caidos'.

The lack of opportunities for the expression and implementation of Modernist ideas on a large scale is important, for it meant that those architects who formed the Modernist pedigree of the Escuela de Barcelona were forced to work on a smaller, more individualistic scale. A brief look at the writings of Alexandre Cirici, the art critic and design theorist who is consistently linked to avant-garde and Modernist initiatives in Barcelona, may help to explain the significance of this. In 1946 he wrote, in an article in the clandestine magazine *Ariel*, 'One should give no lesser a place in culture to record-players, the toilet, the fork, the hat, the bottle, than the monument.'[13] These well-known words appear at the end of what was essentially a compact essay on Modernism, which aligned the Catalan avant-garde, historically and contemporaneously, with the European avant-garde. Modernism, here, meant the objective analysis of phenomena; Francoism, on the other hand, evaded, mystified and iconographed.

The marginalisation of Catalan Modernists in large-scale projects in design and architecture led them to other areas of interest, which in turn modified their positions. Bohigas' assessment of the state of Catalan architects in a 1968 essay from *Contra Una Arquitectura Adjetivada* drew the following conclusions: the Barcelonese architect was essentially excluded from all State commissions given to large speculative builders because Catalans were discriminated against in favour of architects from Madrid; the result of this was that the Catalan architect was only engaged on small commissions of little importance; it was thus difficult to consolidate any particular formal style in Barcelona.[14]

The end result of this situation was that the Escuela de Barcelona and its historical forerunners were conceptually ambitious, revindicating Modernism in design for its transformatory potential on society, whilst on a practical level their work was limited to a scale which might modify the Modernist project itself. In the same way, whilst Cirici was completely committed to anti-Francoist agitation in the wider political spectrum, the point of departure for the avant-garde was 'the toilet, the bottle, the hat' etc.

The overriding trajectory of design, from which the pedigree of the Escuela de Barcelona derives, comes from the work of Josep Antoni Coderch. His early work of the 1940s and 1950s was recognised by the Escuela de Barcelona as a period during which he didn't necessarily align himself with political movements in architecture; however, the pure formal aspects of his architecture proposed new, more rigorous and cultured ways of living. Also, he did not strictly align himself with a modern or Rationalist architectural vocabulary but instead developed 'a true rational method of dialectically elaborating a project'. With this, he recovered a lost line in the Catalan architectural tradition, that of basing itself more in construction than on abstract form, more in typologies than in pure formal elements.

The influence of this was profound, being carried forward especially through the studio of Correa-Milà in their houses and interiors at various points on the Costa Brava, especially in Cadaqués. Thus, in this line, the Modern Movement was not to be fully embraced. In the same way that the few government projects of rural redevelopment of the forties were subject to local and typological variations, so, too, was the Coderchian house. Between 1957 and 1961, we find a proliferation of interest in Rationalist architecture. This has been seen as both the result of the growing reassertion of the legacy of the GATCPAC era (Bohigas, for instance, published his *Homenaje a GATCPAC* in 1960) and awareness of Modernist projects abroad such as the work of Johnson and Saarinen, or the British Brutalists.

However, there were few opportunities for this wave of interest to consolidate itself, especially in the wider field of planning, and indeed it soon provoked sharp criticism. This came in particular from Oriol Bohigas, from 1962, in line with realist movements in Italian architecture of the same period. The criticism was, of course, that Modernism had fallen back on formulas and mannerisms, embracing 'idealistic evasion' based in a mechanistic, industrial spirit which was irrelevant to a semi-industrialised context such as Catalonia. If the industrial base of Catalonia was still largely artisanal, then one should construct architecture which was realistically situated in this context.

It is also interesting that in this period we find a revival of interest in Catalan Modernista architecture where it was believed that there had existed a coherency between construction and the artisanal base on which it was founded, therefore, by the same criteria, tying together form and national spirit. In 1968 Bohigas published a book on Modernista architecture making precisely this point, as did Domènech in the same

year in a book on contemporary Spanish architecture. And, of course, we also see a revindication of the spirit of William Morris and the early Bauhaus.

The obvious corollary to this argument is the rejection of recent architecture in America of Mies and Johnson, which was seen by Bohigas as being the result of an appropriation of the Bauhaus spirit which in turn resulted in empty abstraction. Their architecture was thought to represent the office building of capitalism rather than the demands of social concern. This in turn had infiltrated the work of 'some architects of Madrid-American cultural roots' who worked 'without a single reference to the functional and productive parameters . . . that condition design', to quote *Contra Una Arquitectura Adjetivada* again.[15]

The dominant perception of architecture from Madrid was that it was conformist – firstly under the Autarchy, following the publication, in 1953, of the *Manifesto of the Alhambra*, an incredible government treatise on architecture which extolled the virtues of the Alhambra as a model for the creation of a true national architecture and, secondly, during the *años de desarollo*, when architecture conformed to the worst of Americanising influences. These influences could mean the Modernism of Johnson or, equally, that of consumer capitalism.

Bohigas, I believe, correlates American influence with Madrid and therefore with consumeristic late-Francoism. On a general level, it was precisely the families connected with the Opus Dei, which controlled much of the government and industry, who were sending their sons to universities in America in the 1960s to learn and bring back its business and architectural styles. However, beyond that, Bohigas associated the banality of American marketing with that of late-Francoism. Stepping back into architectural theory, he furiously rejected Venturi, stating in a review of his book *Learning From Las Vegas*, which appeared in Spain in 1971, that:

In the world of consumerism, with power in the hands of the owners of capital, design is reduced to producing artefacts to be consumed based in false necessities of the people.[16]

Whilst Venturi may well be normally associated with the roots of Postmodernism, Bohigas' criticisms were of his uncritical acceptance of the symbols of consumerism. He reaches the conclusion that Venturi's acceptance of the symbols of consumerism is:

like . . . the attitude of the masses before the election of a North American president, or the apotheosis-like arrival of a head of state.[17]

Having already in this review compared Las Vegas with Hospitalet de Llobregat, a poor immigrant satellite town of Barcelona, it is clear which head of state Bohigas is talking about. Certainly, Bohigas and the Escuela de Barcelona felt isolated in their rejection of Francoism and all points west. Returning from an international conference in Aspen, Colorado, Bohigas declared that he and Frederico Correa were the only ones who proposed that:

. . . in design, there are above any other considerations, ethical problems, and that in its language, in its pure formal construction, one could assume avant-garde positions beyond the conformism of marketing and technology.[18]

The formation of the 'possible' Escuela de Barcelona had been preceded by a vigorous radicalisation among architects, especially associated with Barcelona University.[19] This radicalisation was spurred on by a series of events which began with the boycott of their own student union election in November 1965, led to the famous Caputxinada of March 1966, and culminated in the mass resignation of staff from Barcelona's first design school, Elisava, in September 1966. At the centre of these events we find members of the Escuela de Barcelona, and not least Oriol Bohigas. The boycotted election was intended to elect representatives of the State-controlled students' union, the biggest abstention being among the architectural students themselves. The Caputxinada took place in a monastery on the outskirts of Barcelona and was a clandestine inauguration of an alternative students' union which was subsequently held under police siege for three days. Among the intellectuals invited to attend this meeting were the painters Antoni Tàpies and Albert Ràfols Casamada, Antoni de Moragas, then director of the Colegio de Arquitectos, and the architects Oriol Bohigas, Josep Martorell and Lluís Domènech. (During the siege, these influential figures ran a seminar on art, architecture and town planning.) The break-up of Elisava was precipitated by the exclusion of Oriol Bohigas from the proposed timetable for 1966–7, though it was also the result of dissatisfaction with Elisava's governing body, the Centro de Influéncia Católica Femínína, whose growing dominance was resented. Thus, we may see an increasing resistance to State policies by architects and designers.

The last of these events, the mass resignation of staff from Elisava, led to the creation by them of Eina, a college set up with their own money so that it would have complete autonomy, without any strings attached to any government or related organisation. On its opening day, at the

beginning of 1967, its students, numbering forty-five in all, were handed the following statement:

Eina intends to train professionals, at a university level, in order to enable them to solve the problems presented by the conjunction of art and industry. Its syllabus is directed towards implanting in them a deep humanistic consciousness and to awakening a responsible conscience before society.[20]

We have seen how Modernism in design barely appeared on the Francoist agenda while, for the avant-garde, it symbolised a viable and historical alternative for design in society. We have also noted that the marginalisation of architects such as Coderch and Correa-Milà, who subscribed to the Rationalist tradition of GATCPAC, meant that their energies were directed towards small-scale projects such as individual suburban homes. Furthermore, by the 1960s it was recognised that the Modern Movement had been appropriated by the concerns of capitalism, expressing *technical modernity* rather than radical Modernism. However, the avant-garde in Barcelona became ever more concerned to express their radical views; concerned by the ravages of the consumer boom; concerned by the chaotic urban fabric caused by mass immigration; concerned by the effects of an under-developed economy whose industry merely copied, and copied badly, and saw no need for 'good designers' to produce 'good design'; and concerned, above all, to say goodbye to Franco.

It was precisely in considering the language of the particular that the next step could be taken. One of the first acts of Eina, in 1967, was to invite the Italian group of intellectuals, Gruppo 63, for three intensive days of seminars. The group included Umberto Eco and Gillo Dorfles and was complemented by a number of Spanish and Catalan speakers including the critic Alexandre Cirici, the painters Antoni Tàpies and Albert Ràfols Casamada, and the architects Oscar Tusquets, Frederico Correa, Oriol Bohigas and Ricardo Bofill. Much of the discussion during these three days centred on linguistics and structuralism. Semiotics and the theory of information were not necessarily brand-new to Eina but the event undoubtedly had a great impact. Alexandre Cirici wrote of it:

. . . we don't doubt that it will have a large repercussion. Everything points to the fact that these days of February . . . will constitute an important historical date for our culture . . . [Gruppo 63 was formed] when it was clear that one must work with artistic language in order to struggle against the establishment . . . [21]

This event was to set the methodological scene at Eina for many years to come. It becomes even more significant when we consider it as

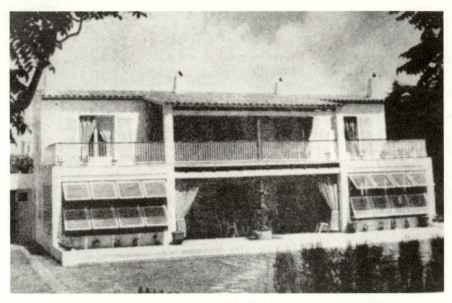

Josep Antoni Coderch and Manuel Valls, house at Sitges, 1947.

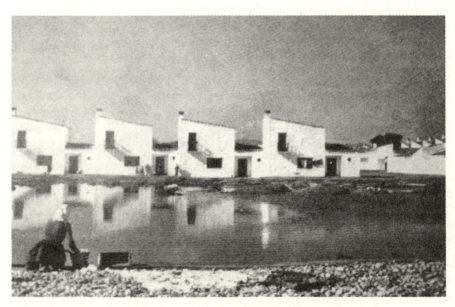

José Luis Fernando de Amo, Pueblo de Villalba de Calatrava, 1940s.

symbolic of a shift away from Elisava, whose teaching had been very much based on that of Ulm. It might additionally be seen to symbolise a reorientation from Germany to Italy, from Northern Europe to the Mediterranean; and, furthermore, it might symbolise the final break away from vestiges of the Modern Movement to a new, but nonetheless still radical, plan of action. And so 'working with artistic language' was likewise taken up in Spain on the broad fronts of art, design and architecture.

In architecture, as we have already seen, the short-lived Escuela de Barcelona was mostly defined by a coincidence of political and theoretical positions rather than being associated with any formal style.[22] The most consistent and overriding of these was that of code-breaking. 'As Roland Barthes said, with language one can introduce subversion into symbolic systems and provoke the de-alienation of those selfsame systems,' declared Oriol Bohigas.[23] The way in which all this was actually carried out in architecture has been a constant source of argument ever since.[24] Exactly *which* architectural language was chosen to 'subvert' or merely to draw attention by its usage depended on each particular group and commission within the Escuela de Barcelona – they might draw on traditional Catalan vernacular styles, Modernisme, or Pop images.[25] What is important to note is the tendency towards the consideration of detail, or the language of the particular, and following on from this, that eclecticism and avant-garde would not necessarily be diametrically opposed.

This theoretical/political position was carried through to artistic practice as well, where there followed an intense interest in conceptual art and, of course, in arts events – territory which was familiar outside Spain too. At the end of 1972, Hospitalet de Llobregat saw two weeks of 'art for the people' put on by artists such as Ferran García Sevilla and Antoni Llena – 'happenings', installations, programmes of ephemeral pieces of communication and ceremonies where, in the words of Cirici, 'A kind of catharsis was produced which meant that the festival didn't become an evasion. It was actually like a ceremony of freedom.'[26] This event was about participation and interaction with the object, through questioning or understanding its meaning, and was lent added significance by the fact that it took place in an immigrant satellite town of mass high-rise housing, one of the results of developing, mass-consumption Spain. Alexandre Cirici himself was the keenest promoter of conceptual art in Barcelona, and it may be fitting to recall the key points in his career. We have already seen his revindication of Modernism in the context of

both art and design and in particular in setting the object – or the particular – against the gestural or rhetorical. In 1955 he undertook a *licencatura* dissertation on the history of industrial design. Having read Umberto Eco's *Opera Aperto* in 1963 he began teaching semiotics at Elisava. Later, at Eina, he was its most enthusiastic supporter and his articles of art criticism from 1968 to 1974 in *Serra d'Or*, when not about Mirò, were concerned with conceptual art.[27]

In design, a plethora of bizarre events within this tendency took place at this time. In 1971 the design institute ADIFAD organised the memorable International Council of Societies of Industrial Design Conference in Ibiza, which included an 'Instant City' of Archigram influence, plus the then fashionable 'happenings', inflatables and 'talking rooms'. Ibiza was internationally recognised for its alternative, 'hippy' atmosphere[28] and, for its organisers, it represented a location away from the stringencies of Francoism.[29] In such an atmosphere, the political mission of the conference achieved greater impetus. One of its delegates, Jordi Mañà, wrote in the national daily, *La Vanguardia*, on his return:

'It's time', [sic] to do, to construct design with the hands, collectively, as its slogan suggests . . .

'It's time', the time has arrived to leave theory, to leave doing 'culture' . . .

'It's time', it's time that a similar experience to our Ibiza was born on our shores.[30]

Jordi Mañà later admitted that what he had written had a dual function:

At this time we were still writing with messages directed at society – 'It's time' [in English] was a slogan of Fortuna [the State-controlled tobacco company] and 'It's time' was an imperative for Spanish society – it was the hour for it to liberate itself – and these words also reflected the enthusiasm for a utopia that existed at that congress. The Instant City was a utopia made real. The Instant City was something self-built, was a city clearly democratic, it was real, despite being a utopia. I therefore was returning from Ibiza with the belief that we really could build what we had built there. And so this was, let's say, a subliminal message for Spanish society saying that it was possible to abandon Francoism . . . and construct a new society.[31]

Immediately after the Ibiza experience, ADIFAD's umbrella organisation, FAD, took part in the Hogarotel Trade Fair in Barcelona, as it had done annually since 1961. The Hogarotel fair was mostly for the display of home, hotel and catering equipment and the FAD stand was a non-commercial point-of-interest within the fair, usually exhibiting the works of its design award winners. The 1971 FAD exhibit at Hogarotel was probably the most ambitious ever undertaken. Inside the FAD's by now

statutory inflatable, the stand was divided into two rooms, joined by a long band of colour, to create a kind of 'voyage into the unknown'.[32] The first room included inflatable toys, and a tape-slide installation which presented themes developed by ADIFAD from their Ibiza conference questionnaire, such as industry, consumption, alienation and the future. The second room consisted of an exhibition of sixty-three objects selected by ADIFAD as representative of 'good design' and displayed in a 'thoroughly modern and optimistic atmosphere'.[33] Putting the two rooms together, the viewer was not just to be presented with a guide to what was 'good design' (the second room) but instead was to pass through a conceptual cleansing process (the first room), before moving among the world of objects with new eyes.

Arising from the activities of this particularly fertile year, the Barcelona Centre of Design was set up on a similar basis to the British Design Council, essentially to educate the public in 'good design'. Their inflatable premises housed the statutory exhibition of such 'good design'; in addition, in 1976, the Barcelona Centre of Design put on an exhibition of work by the conceptual artist Jordi Pablo, entitled, 'A Language with Objects and Forms', which was entirely didactic, encouraging the reconsideration of objects and a move 'towards a language of objects which was more Mediterranean', in the words of one of its organisers, Mai Felip.[34]

In these developments, and the FAD's stand at the Hogarotel Trade Fair of 1971, then, one might detect a mixing of intentions: Modernist, in that they sought to educate the consuming masses in 'good taste' and to the fact that 'good design' meant a good quality of life; Post-modernist, in the way they approached language and significance, provoking a relabelling of phenomena.

The actual visual results in design terms have been varied. Not unrelated to the activities of the official design organisations in the 1970s, Fernando Amat's furniture and household goods shop, Vinçon, also included an exhibition hall; its shows in this period were dominated by similar events to Jordi Pablo's. Its first exhibition, Bigas Luna's 'Muebles con Grupo Teatro', which opened in March 1973, presented art furniture bearing all the traits of irony, subversion and humour which were later to be seen in Italy. It would appear that the pedigree of the new Spanish design considered at the beginning of this essay lies in this play on visual language, the results being as eclectic as the languages chosen to play on.

To return once again to Oriol Bohigas, it is noteworthy that in 1980, with the first democratic city council elections to be held since the 1930s,

Bohigas was appointed as Director of Public Works under a socialist administration. He was thus able to address the long-standing 'urban concern'. Characteristically, his response was not to impose a homogenous plan to cover the whole city, but to employ teams of mostly young architects to concentrate on individual projects – over a hundred in all. The task was not only to build new parks, plazas and paving projects, reintegrating fragmented and exploding towns, but also to decentralise the city, giving character and dignity to each *barrio*. Once again the urban fabric in its totality was considered, as it had been by Cerdà in 1859, Jaussely in 1903, and GATCPAC with Le Corbusier in 1934. This time, however, the emphasis was on a web of small-scale projects which were visually diverse but which, in their individual treatment of each problem and their play on language (whether it be the established languages of Modernism or Modernisme), offered unifying solutions.

The coexistence of what we might label as Modernist and Post-modernist positions, as demonstrated by Oriol Bohigas, and subsequent design projects in Catalonia, calls into question their very value as absolutes. Whether in the seminar room or on the drawing board, the modern designer in Spain was not tied to orthodoxies: this was, perhaps, the advantage of being marginalised – whether Pop, local vernacular or historical Modernist styles were adopted, the whole concept of doing something avant-garde, such as designing, was oppositional. Opposition wasn't just the monopoly of the Modernists; however, the Modernist interest in a new society was a starting-point.

In Spain, the Le Corbusian scale of the Modern Movement could never be fully embraced, and yet intentions of Modernism – that the world would be a better place through design – were always present. Of course, Catalonia is not the only place in the world where one might trace such a development away from the Modern Movement, ending, for some, in a pluralistic manifesto of semiotics, conceptualism and anti-design, particularly over a period of thirty years. What is significant in Catalonia, though, is the local political and economic context. This included a dictatorship with leanings towards a Modernist project from which the avant-garde were marginalised, or from which they marginalised themselves (as in the case of Eina); and an economy based on small production units, which carried added value by acting in opposition to the mass-consumption Spain of the *años de desarollo*.

Luis Peña-Ganchegui, Parque de L'Espanya Industrial, 1982–5.

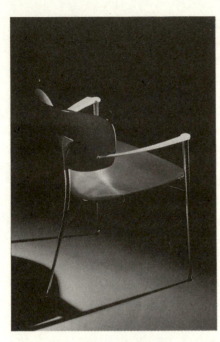

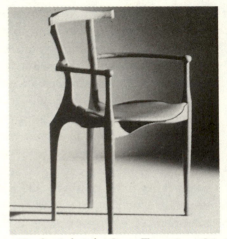

'Gaulino' chair by Oscar Tusquets 1986
(produced by Carlos Jané, SA, Barcelona).

'Andrea' chair by Josep Lluscà, 1986
(produced by Andreu World SA,
Valencia).

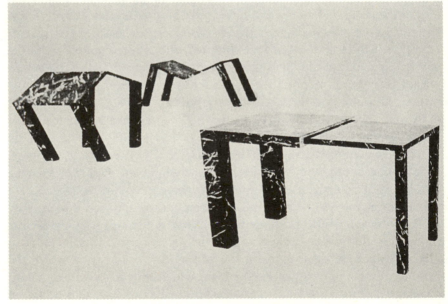

'Taules', Galeria Vinçon, Barcelona, 1973 (Bigas Luna).

So for the avant-garde to impose a grand, Le Corbusian scale of Modernism on the country would have been impossible and undesirable. Instead, as we have seen, the avant-garde architects and designers of Catalonia have worked on a small scale, which favours construction over abstraction, language over rhetoric. This was both a practical and a political choice.

Radical Modernism in Spain did not emerge so much from trying to impose some sense on chaos, but rather by making sense within the chaos. The interraction of the designer with pre-existing images, whether of Modernista architecture, traditional Catalan architecture or those within the consumer society of late Francoism, was to subvert and to challenge. Radical Modernism could therefore be both evocative and provocative.

References

Introduction

1 The emphasis on style in the book is one of the earliest and clearest indications of the shift in thinking. Original title, *The International Style: Architecture since 1922* (New York, 1932); reprint entitled *The International Style* (New York, 1966).

2 See Chapter 8.

3 There was, of course, a very reactionary contingency present as well, provided by the French and other exhibiting nations. See Paul Greenhalgh, *Ephemeral Vistas: Expositions Universelles, Great Exhibitions and World's Fairs, 1851–1939* (Manchester, 1988).

4 This was more than partly due to the more advanced condition of architectural training. In the early years of this century architecture became a more singularly identifiable profession, enabling an intellectual forum to evolve and to forge links with other disciplines. Moreover, architects not infrequently became furniture and product designers. Throughout most of this text, then, the use of the term design implies architecture as well as other forms.

5 Recommended reading: see Select Bibliography.

6 Recommended reading: see Select Bibliography.

7 Recommended reading: see Select Bibliography.

8 Purism is normally used to refer specifically to the painters in the circle of Le Corbusier and Amedée Ozenfant; I use it here in a broader sense to include their whole range of activity.

9 Recommended reading: see Select Bibliography.

10 I believe I first used this term after seeing it in an essay by Irwin Panofsky, in which he attributes the flowering of cultural activity during the Renaissance to a process of decompartmentalisation. I apologise to the reader for my inability to find this reference. The idea of decompartmentalisation in the present context is exemplified in Lewis Mumford, *Technics and Civilization* (New York, 1963) and Jürgen Habermas, 'Modernity – An Incomplete Project' (1980) in Hal Foster (ed.), *Post-modern Culture* (London, 1985).

11 Berthold Lubetkin, quoted from a letter written to Dr Monica Felton in 1947, reproduced in Peter Coe and Malcolm Reading, *Lubetkin and Tecton: Architecture and Social Commitment* (Bristol, 1981).

12 Karl Marx and Friedrich Engels, *The Communist Manifesto* (1872; English trans. 1888, this edn. Harmondworth, 1967, with introduction by A. J. P. Taylor).

13 Karl Marx, 'Alienated Labour', from *Economic-Philosophical Manuscripts* (1844). Quoted from Alaistair Clayre (ed.), *Industrialization and Culture* (Milton Keynes, 1977), pp. 245–50.

14 Ibid.

15 Le Corbusier, *Towards a New Architecture*, trans. Frederick Etchells (London, 1927). p. 17.

16 Walter Gropius, *The New Architecture and the Bauhaus* (London, 1935), p. 20.

17 The term emerged with Wagner, who believed the opera capable of using every art towards a single end. It then became part of the common parlance of Art Nouveau designers, before filtering through into Modern Movement thinking.

18 Serge Chermayeff, 'The Architect and the World Today' (1935) in *Design and the Public Good*, ed. S. Chermayeff and R. Plunz (Cambridge, Mass., 1982), p. 117.

19 Walter Gropius, *Principles of Bauhaus Production* (Dessau, 1926), quoted from Ulrich Conrads (ed.), *Programmes and Manifestoes on Twentieth Century Architecture* (London, 1970).

20 Kurt Ewald, 'The Beauty of Machines' (1925–6), quoted from Charlotte Benton, Tim Benton and Aaron Scarf, *Form and Function* (Milton Keynes, 1975).

21 Le Corbusier, *Towards a New Architecture*.

22 See Charles Darwin, *The Descent of Man* (London, 1871); Raymond Williams, 'Social Darwinism', in his *Problems in Materialism and Culture* (London, 1980); John MacKenzie, *Propaganda and Empire: The Manipulation of British Public Opinion 1880–1914* (Manchester, 1984); Paul Greenhalgh, 'Human Showcases', in *Ephemeral Vistas: Expositions Universelles, Great Exhibitions and World's Fairs, 1851–1939*.

23 Adolf Loos, 'Ornament and Crime', 1908, quoted from Nuenz and Pevsner, *Adolf Loos* (London, 1966).

24 P. Johnson and H.-R. Hitchcock, *The International Style* (New York, 1966), p. 19.

25 There is a vast literature on this period of European painting. Recommended reading: Werner Haftmann, *Painting in the Twentieth Century* (London, 1965), 2 vols.; John Golding, *Cubism: A History and an Analysis 1907–14* (London, 1968); Alfred H. Barr, *Cubism and Abstract Art* (New York, 1936); Virginia Spate, *Orphism: The Evolution of Non-figurative Art in Paris 1910–1914* (Oxford, 1979); Tate Gallery, *Towards a New Art: Essays on the Background to Abstract Art 1910–1920* (London, 1980).

26 Theo Van Doesburg, 'Thought Vision Creation', *De Stijl Magazine*, December 1918, pp. 23–4, quoted from Joost Baljeu, *Theo Van Doesburg* (New York, 1974).

27 De Stijl, 'Manifesto III, Towards a Newly Shaped World', *De Stijl Magazine*, August 1921, pp. 125–6, quoted from Baljeu, *Theo Van Doesburg*.

28 See W. Ray Crozier and Antony J. Chapman, 'The Perception of Art: The Cognitive Approach and Its Context', in Crozier and Chapman (eds.), *Cognitive Processes in the Perception of Art* (Oxford, 1984).

29 A good introductory discussion of this topic can be found in Eric Hobsbawm, 'Waving Flags: Nations and Nationalism', in his *The Age of Empire, 1870–1914* (London, 1987).

30 Museum of Modern Art, New York, 'Machine Art', exhibition held 6 March – 30 April 1934, organised in part by Philip Johnson. Catalogue reprinted by Arno Press (New York, 1966).

31 See, for example, Mary Warnock (ed.), *Utilitarianism by John Stuart Mill* (London, 1962). The logic of the argument was that the 'greatest number' would decide the 'greatest good' if they were in a position to choose properly. This meant that they had to have prior access to knowledge before they decided. In other words, they had to be shown what the 'greatest good' was, in appropriate conditions, before they could be allowed to choose for themselves. Thus populism became paternalism.

32 Gropius, *New Architecture and the Bauhaus*.

33 Le Corbusier, *Towards a New Architecture*.

34 Numbers of the Dadas were also involved in the Modern Movement in design, most

notably Van Doesburg, under the pseudonym I. K. Bonset. In the main, however, both the Dadas and later the Surrealists were aggressively against what they perceived to be an oppressive rationalism within the Modern Movement. André Breton could never have preferred Plato to Heraclitus; the nearest he came to a sustained appreciation of design can be found in his continual championing of Art Nouveau.

35 There is a text which constructs the history of Western architecture around the tension between Rationalism and Romanticism. See Wojciech G. Lesnikowski, *Rationalism and Romanticism in Architecture* (New York, 1982).

36 It is unlikely that all Pioneer Modernists favoured a left-wing revolution. The majority appear to have been Revisionists, committed to change without violence. Nevertheless, most of them recognised the possibility of revolution, and would have embraced it, as indeed the Russian constructivists did, to pursue their dreams. In terms of overt proclamations, Modernists were forced, as the 1920s wore on, to be pragmatic in their affiliations. Gillian Naylor's *Bauhaus Reassessed* (London, 1985) deals most thoroughly, for example, with the diplomatic games Walter Gropius had to play at the Bauhaus in order to prevent its investigation and even closure by the authorities. Some writers have seen the formation of moral consciousness of the Modern Movement, from nineteenth-century thinkers like Pugin onwards, as being essentially socialist and/or revolutionary. See, e.g., David Watkin, *Morality and Architecture* (Oxford, 1977).

37 Antonio Gramsci, 'A Single Language and Esperanto', in *Selections from Cultural Writings* (London, 1985).

38 Good introductory texts for this area are Terence Hawkes, *Structuralism and Semiotics* (London, 1977); Christopher Norris, *Deconstruction: Theory and Practice* (London, 1982); Terence Eagleton, *An Introduction to Literary Theory* (Oxford, 1983).

39 See, for example, Jean Baudrillard, 'The System of Objects' (Paris, 1968), reprinted in Mark Poster (ed.), *Jean Baudrillard: Selected Writings* (Stanford, Conn., 1988).

40 For the most sophisticated development of the concept of the division of idea from essence, T. Adorno and E. Horkheimer, *The Dialectic of Enlightenment* (New York, 1944; this edn. trans. John Cumming, London, 1979); Martin Jay, 'The Fractured Totality: Society and the Psyche', in Martin Gay, *Adorno* (London, 1984); Herbert Marcuse, *The Aesthetic Dimension* (London, 1978) and *One-Dimensional Man* (London, 1964; new edn. London, 1986); Jürgen Habermas, 'Modernity – An Incomplete Project', in Poster (ed.), *Jean Baudrillard*.

41 See Jean Baudrillard, 'The Masses: The Implosion of the Social in the Media', in Poster (ed.), *Jean Baudrillard*.

42 Roland Barthes, 'The Death of the Author', in *Image-Music-Text* (Paris 1968; this edn., Glasgow, 1977); see also Janet Wolfe, 'The Death of the Author', in her *Social Production of Art* (London, 1981).

43 See, for example, Dick Hebdige, *Hiding in the Light* (London, 1988); Bennet, Mercer and Woollacott (eds.), *Popular Culture and Social Relations* (Milton Keynes, 1986).

44 The analysis and condemnation of consumption has been a common feature of twentieth-century social studies, especially on the left.

1 Clive Wainwright: The Legacy of the Nineteenth Century

1 John Ruskin, *Modern Painters* III (London, 1856), p. 263.

2 E. Viollet-le-Duc, *Lectures on Architecture*, I (London, 1877), p. 446.

3 Ibid., p. 451.

4 George Martin Huss, *Rational Building being a translation of the article 'Construction' in the Dictionnaire Raisonné de l'Architecture Française* (London and New York, 1895), p. 318.

5 Ibid., p. 318.
6 J. Mordaunt Crook, *William Burges and the High Victorian Dream* (London, 1981), p. 120.
7 Clive Wainwright, *The Romantic Interior: The British Collector at Home 1750–1850* (New Haven and London, 1989). Plates 85 and 107 illustrate these.
8 A. W. N. Pugin, *The True Principles of Pointed or Christian Architecture* (London, 1841), p. 56.
9 Ibid., p. 1.
10 John Ruskin, *The Stones of Venice* I (London, 1851), p. 370.
11 'Sources of Expression in Architecture', *The Edinburgh Review*, October 1851, p. 371.
12 John Ruskin, *The Seven Lamps of Architecture* (London, 1849), p. 161.
13 Pugin, *True Principles*, p. 45.
14 C. F. A. Voysey, *Individuality* (London, 1915), p. 89.
15 Hermann Muthesius, *Das Englische Haus* (Berlin, 1904), new English edn. trans. Janet Seligman (London, 1979), p. 156.
16 Le Corbusier, *L'art decoratif d'aujourd'hui* (Paris, 1925), new English edn. trans. J. I. Dunnett (London, 1987), p. 132.
17 William Wordsworth, *A Complete Guide to the Lakes* (London, 1843), p. 159.
18 Ibid., p. 162.
19 Kata Phusin [John Ruskin], 'The Poetry of Architecture', *The Architectural Magazine*, V (1838), p. 98.
20 W. R. Lethaby (ed.), *Ernest Gimson: His Life and Work* (London, 1924), p. 37.
21 Ibid., p. 30.
22 Ruskin, *Seven Lamps*, p. 33.
23 A. J. B. Beresford Hope, *Public Offices and Metropolitan Improvements* (London, 1857), p. 22.
24 A. J. B. Beresford Hope, *The Common Sense of Art. A Lecture Delivered in Behalf of the Architectural Museum At The South Kensington Museum, December 8, 1858* (London, 1858), p. 15.
25 Huss, *Rational Building*, pp. 194–5.
26 Viollet-le-Duc, *Lectures*, p. 87.
27 Ibid., pp. 80–1.
28 Robert William Billings, *The Power of Form Applied to Geometric Tracery: One Hundred Designs and their Foundations Resulting from One Diagram* (London, 1851), p. v.
29 Ibid., p. 9.
30 A. W. N. Pugin, *Floriated Ornament* (London, 1849), p. 3.
31 Ruskin, *Stones of Venice* II (London, 1853), p. 181.
32 Le Corbusier, *L'Art decoratif d'aujourd'hui*, p. 194.
33 Sir Reginald Blomfield, *Modernismus* (London, 1934), pp. 165–6.

2 Tim Benton: The Myth of Function

1 'In addition to providing a workable quantity of material, this method, I believe, insures (sic) the material's consistently reputable quality': Larry L. Ligo, *The Concept of Function in Twentieth-Century Architectural Criticism*, (New York, 1984), p. 4.
2 This must in part be due to the vagaries of the *Art Index*. Ligo asserts that 'there was a real dearth of architectural criticism during the first three or four decades of this century' (p. 16). But this simply reflects the Anglo-Saxon bias and ignores the wealth of material in journals such as *Das neue Frankfurt*, *Wasmuths Monatshefte*, *Architecture d'Aujourd'hui*, *Wendingen*, *de 8 en opbouw* and many others.

3 Louis Sullivan, Carson Pirie Scott; Frank Lloyd Wright, Robie house; Gerrit Rietveld, Schröder house; Walter Gropius, Bauhaus, Dessau; Mies van der Rohe, German Pavilion, Barcelona; Le Corbusier, Villa Savoye; Frank Lloyd Wright, 'Falling Water'; Alvar Aalto, Baker house dormitory; Frank Lloyd Wright, Guggenheim Museum; Mies van der Rohe, Farnsworth house; Le Corbusier, Ronchamp; Louis Kahn, Richards Medical Research building; Paul Rudolph, Yale School of Art and Architecture.

4 Many of the articles were written after 1940 about buildings already two or more decades old, and after the first main wave of monographic publications on the history of the Modern Movement (Platz, Giedion, Pevsner, Mumford, etc.).

5 Ligo says that this '. . . refers to the "feelings" which buildings stir in their viewers, users and critics, including vertigo, claustrophobia, directional confusion, psychic comfort, or less specific feelings and emotions'. Clearly the borderline with aesthetic experience is a blurred one. Ligo, *Concept of Function in Twentieth-Century Architectural Criticism*, p. 5.

6 Defined as 'the concretization of social institutions and values characteristic of particular cultures or eras'. Ibid.

7 'Cultural-existential function' refers to the concretization of universal values or subconscious structures of spatial and psychological orientation which are related to man's essential humanity rather than to his life in a specific time and place. Ibid.

8 Ibid., p. 12.

9 Vitruvius' famous formula of *firmitas, utilitas*, and *venustas* was taken out of context; his more complex formula for the 'Fundamental Principles of Architecture' in Bk I, Ch. 2, was more formalistic: 'Architecture depends on Order (in Greek *taxis*), Arrangement (in Greek *diathesis*), Eurythmy, Symmetry, Propriety, and Economy (in Greek *oiconomia*)' (in Morgan's translation, Dover edn., New York, 1960, p. 13). Since many of these terms seemed obscure, and Vitruvius' further explanations deliberately mystifying, later theorists latched on to the simpler triad.

10 Roger Scruton goes to some trouble to assert that the theory of functionalism 'as an account of the nature of building, is simply vacuous'. But he gives no example of such a theory, and indeed has some sensible things to say about the interdependence of functionalism and aesthetic criteria. R. Scruton, *The Aesthetics of Architecture*, (London, 1979), pp. 38–43.

11 Even Wells Coates, who flirted with functionalist rhetoric, was specific: 'As architects we know that there are a great many different solutions of the purely technical and economical problems of efficiency and organisation, and of assembling and construction: from all these we take those solutions which dispose of such problems and give also the qualities of form and space, fine scale and proportion, cleanliness and service and comfort and convenience, which we call architecture.' Wells Coates, 'Modern Dwellings or Modern Needs', a radio debate between Geoffrey Boumphrey and Wells Coates, printed in *The Listener*, 24 May 1933, pp. 819–22. A commonplace in England was to reiterate Wotton's version of the Vitruvian triad 'Commodity, Firmness and Delight'; this was used as the structuring principle for the MARS exhibition in the New Burlington Galleries, January 1938.

12 David Watkin at times appears to believe that architecture can be appreciated intuitively and autonomously, with a knowledge of architectural style and traditions but without regard to the rest of the real world. See his description of architecture 'involving taste, imagination and scholarship', in *Morality and Architecture* (Oxford, 1977), p. 12.

13 John Gloag, a fierce critic of Le Corbusier, noted that 'It is significant that few discussions about modern architecture take place, either in the press or in books, or at the meetings of societies that devote their time to aesthetic analysis, without the name

of M. Le Corbusier being mentioned, either with acrimony or approval'. John Gloag, *Men and Buildings* (London, 1931), p. 200.

14 Le Corbusier, *Towards a New Architecture*, ed. Frederick Etchells (London, 1927), p. 29. Note the comparable assertion by Geoffrey Scott, 'Architecture, simply and immediately perceived, is a combination, revealed through light and shade, of spaces, of masses, and of lines', *The Architecture of Humanism*, (London, 1914), p. 210.

15 Le Corbusier, *Towards a New Architecture*, p. 203.

16 Ibid., p. 10–11.

17 Watkin, *Morality and Architecture*, p. 40.

18 For example, *The Listener* published the results of a 'symposium' based on a questionnaire sent round to a number of British architects on 26 July 1933. This listed as its second question: 'Has functionalism in building gone too far?' Although most of the responding architects tried to qualify the term, it is clear from the debate that the Modern Movement was commonly accused of 'functionalism'. Reginald Blomfield assumed that the new architects were selling the fort of architecture to the engineers, and he called this abnegation of aesthetic responsibility, combined with a denial of tradition, functionalism.

19 The expression was used by Sigfried Giedion to describe the bombast of Percier and Fontaine's designs for Napoleon. S. Giedion, *Mechanization Takes Command* (London and New York, 1949).

20 F. R. S. Yorke, *The Modern House in England* (London, 1937).

21 Sir Reginald Blomfield, response to the questionnaire 'Is Modern architecture on the right track?', *The Listener*, 26 July 1933.

22 Le Corbusier, *Towards a New Architecture*, p. x.

23 Ibid., p. xv. A comparable image did appear in Ozenfant and Le Corbusier's article, 'La Formation de l'Optique Moderne', *L'Esprit Nouveau*, but not in *Vers une architecture*.

24 See Trystan Edwards, *Good and Bad Manners in Architecture* (London, 1924).

25 Howard Robertson, *Architecture Explained* (London, 1927), pp. 165–6.

26 Bruno Taut, *Modern Architecture* (London, 1929), p. 9, cited in Watkin, *Morality and Architecture*, p. 40.

27 Gloag, *Men and Buildings*, p. 205.

28 Lewis Mumford, 'Machinery and the Modern Style', *New Republic*, XXVII, 3 August 1921; 'Architecture and the Machine', *American Mercury*, III (September 1924), pp. 77–80; and 'The social background of Frank Lloyd Wright', *Wendingen*, VII, no. 5 (1925), pp. 65–7 (cited in Ligo, *Concept of Function in Twentieth-Century Architectural Criticism*, p. 15).

29 Ligo, *Concept of Function in Twentieth-Century Architectural Criticism*, p. 16, citing *Theory and Design*, p. 321.

30 See the interview with Colin Penn quoted in Charlotte and Tim Benton, *Thirties British Art and Design Before the War* (London, 1980), p. 61.

31 Where Highpoint I had incorporated a large common vestibule and tea-room as an expression of the theory of the 'social condensor' (based on Russian theoretical principles), Highpoint II has a minimal lobby and direct access by lift to each apartment. Lubetkin's own penthouse suite here, with its exposed brickwork, vaulted ceiling, rough wooden chairs with cow-skin covers, colour and Chelsea dogs, marks a strong contrast with earlier work.

32 See F. R. S. Yorke's introduction to *The Modern House in England*, where he outlines a number of such conflicts.

33 Berthold Lubetkin, 'Modern Architecture in England', in *American Architect and Architecture*, February 1937, cited in Charlotte Benton (ed.), *Documents* (Milton Keynes, 1975).

34 Wells Coates, 'Response to Tradition', *Architectural Review*, November 1932, pp. 165–8. Part of a polemic with Edwin Lutyens, whose article entitled 'Tradition Speaks' was also published in this issue.

35 Herbert Read, 'To hell with culture', *The Politics of the Unpolitical* (London, 1943), p. 55; cited in Robin Kinross, 'Herbert Read's *Art and Industry: a history*', *Journal of Design History*, vol. 1, no. 1 (1988), pp. 35–50.

36 *Architectural Review*, May 1935, p. 192.

37 H. T. Pledge, 'Beauty in Machinery', *Architectural Review*, March 1932, pp. 85–7.

38 See Charlotte and Tim Benton, 'Architecture: contrasts of a decade', in *Thirties British Art and Design Before the War*.

39 This is especially true of the series of radio talks put on between 1933 and 1934 (reprinted in *The Listener*), which, for example, pitted Wells Coates against Reginald Blomfield (see Charlotte Benton, *Documents*, for reprinted extracts of a number of these talks).

3. Paul Greenhalgh: The Struggles within French Furniture 1900–1930

1 See Paul Greenhalgh, *Ephemeral Vistas: Expositions Universelles, Great Exhibitions and World's Fairs, 1851–1939* (Manchester, 1988).

2 *Reports of the American Commission on the Paris Universal Exposition 1889*, vol. 2 (of 5) (Washington, 1890).

3 *Diplomatic and Consular Report 1906–1907, French Imports from the UK*. Foreign Office unpublished document.

4 I took it from an article of that name by Jeffrey Daniels.

5 Emile Bayard, *Le Style Moderne* (Paris, 1919).

6 Quote from 'Ruhlmann'.

7 This illustration came from the *Art et Décoration* of that year, p. 88.

8 Quoted from Olmer Pierre, *Le Mobilier Français d'Aujourd'hui* (Paris, 1926).

9 Taken from *Rapport Général, Exposition Anglo-Latine, Section Française* (Paris, 1913).

10 Louis de Fourcaud, 'Le Bois', from *L'Art à l'Exposition Universelle de 1900* (Paris, 1900).

11 Ibid.

12 Bayard, *Le Style Moderne*.

13 Emile Sedeyn, *Le Mobilier* (Paris, 1921).

14 Ibid.

15 Bayard, *Le Style Moderne*.

16 Ibid.

17 'International Exhibition of Modern Decorative and Industrial Art, Paris, 1925', Department of Overseas Trade translation of Regulations and Classification of Exhibits (London, 1924).

18 Pierre, *Le Mobilier Français d'Aujourd'hui*.

19 See Select Bibliography for further reading.

20 The Groult illustration is taken from the special issue of *Art et Décoration*.

21 Edited by Maurice Dufréne.

22 See Tim Benton (ed.), *Le Corbusier: Architect of the Century* (London, 1987), especially Charlotte Benton on 'Furniture Design', and the Open University Course authored by them, *History of Architecture and Design 1890–1939*, Units 15–16, 'Design 1920s' (Milton Keynes, 1975).

23 Quoted from Charlotte Benton, 'Furniture Design' (see n. 22). In 1925 Le Corbusier and his associates had not fully developed their own designs for furniture, but by 1929 they were able to present a full suite in the recently completed gallery of the Maison La

Roche (illustrated on p. 21). We can thus assume that, had they been able to, the designers of the Pavillon de l'Esprit Nouveau would have furnished their building more like this.

4. Martin Gaughan: The Cultural Politics of the German Modernist Interior

1 *Bauhaus*, no. 1, Jg. 3 (1928), p. 10. All translations from the German are my own unless otherwise stated. Makart was the late nineteenth-century Viennese painter, popular with a certain section of the bourgeoisie. The eclectic clutter of his studio and house, including furniture and fittings from earlier European periods and exotic sources, was a model for his bourgeois patrons.

2 Jeffrey Herf's important study *Reactionary Modernism: Technology, Culture and Politics in Weimar and the Third Reich* (Cambridge, 1986) examines the way in which technological modernisation and modernising tendencies were assimilated into conservative and right-wing cultural ideology. In this essay I am using Walter Benjamin's theorising of the nature of commodity fetishism and its relationship to the phantasmagoric (see below). Marx had described the commodity as 'a very queer thing indeed, full of metaphysical subtleties and theological whimsies' (*Capital*, ch. 1, s. 4): commodity fetishism is a social process, masking the relations of production, displacing the social relationship from the producers and investing it in the product. Benjamin theorised commodity fetishism as 'producing hallucinations of identity out of which appear the phantasmagoria of men and commodities as weird, personified types'. Gillian Rose, *The Melancholy Science* (London, 1978) p. 42. The phantasmagoric arises from the denial of this relationship between the commodity and culture: it is 'the image that it (society) produces of itself and which it generally inscribes as its culture . . . when it distracts from the fact that it is producing commodities' (ibid.).

3 V. N. Volosinov, *Marxism and the Philosophy of Language* (New York, 1973), p. 23. (First published in Russian, 1927.)

4 This term 'sociological impressionism' is used, for instance, by David Frisby in his book *Fragments of Modernity* (Cambridge, 1988).

5 Quoted in *Domus*, 1988, p. 695.

6 London, 1983. Quotes below are from pp. 15 and 16. I am supplementing Berman's characterisation of the experience of modernity with Perry Anderson's commentary on it, 'Modernity and Revolution', *New Left Review*, no. 144. I have found Anderson's structure, 'the triangulation of forces', most useful to thinking through a politics of Modernism.

7 Jugendstil is the German form of Art Nouveau. The Werkbund was an association of industrialists, artists and designers, established in 1907 to address the rôle of German design in the context of the 'ever expanding, drastically fluctuating, capitalist world markets', as described by Berman above.

8 W. Benjamin, *Understanding Brecht* (London, 1973). The Brecht-Lukács argument may be found in E. Bloch et al., *Aesthetics and Politics* (London, 1980), Afterword by Frederic Jameson.

9 Marshall Berman, *All that is Solid Melts into Air* (London, 1983).

10 L. Burckhardt (ed.), *The Werkbund: Studies in the History and Ideology of the Deutscher Werkbund 1907–1933* (London, 1980), p. 22.

11 Ibid., p. 10.

12 M. Bradbury and J. McFarlane, *Modernism* (Harmondsworth, 1976), p. 26.

13 W. Benjamin, *Charles Baudelaire: a Lyric Poet in the Era of High Capitalism* (London, 1983), p. 167. This passage is included in the fragments: 'Paris – the Capital of the Nineteenth Century'.

14 *New Left Review*, no. 164. pp. 27–33.

15 Benjamin, *Baudelaire*, p. 168.
16 R. Hamann and J. Hermand, *Epochen deutscher Kultur von 1870 bis zur Gegenwart*, vol. 4: *Stilkunst um 1900* (Munich, 1973).
17 Ibid., p. 252.
18 Ibid., p. 274.
19 Ibid., p. 273.
20 Gert Selle, *Die Geschichte des Design in Deutschland von 1870 bis heute: Entwicklung der industriellen Produktkultur*, Du Mont Dokument (Cologne, 1981). Selle contains some reproductions of 'declassed' Jugendstil.
21 Bernd Meurer and Hartmund Vinçon, *Industrielle Ästhetik: zu Geschichte und Theorie der Gestaltung, Werkbund Archiv*, vol. 9 (Berlin, 1973).
22 Hamann and Hermand, *Epochen deutscher Kultur*, p. 253.
23 *Zwischen Kunst and Industrie: Der Deutsche Werkbund*, Die Neue Sammlung (Munich, 1975), p. 38, 'Die Phantasie der Lebenseinrichtung erhebt sich zum Spezialberuf'. The Muthesius passage that follows is from p. 39.
24 Hamann and Hermand, *Epochen deutscher Kultur*, p. 442, 'um dieser parvenuhaften Prätention eine bürgerliche Sachkultur entgegenzustellen'.
25 *Zwischen Kunst and Industrie*, p. 38 (see n. 23).
26 Hamann and Hermand, *Epochen deutscher Kultur*, p. 452. These latter qualities, known as Biedermeier, were associated with the early nineteenth-century bourgeois interior, signifying simplicity, honesty, uprightness.
27 Meurer and Vinçon, *Industrielle Ästhetik*, p. 110.
28 W. Rathenau, *Von Kommenden Dinge* (Berlin, 1917), quoted in Hamann and Hermand, *Epochen deutscher Kultur*, p. 452.
29 The Dawes Plan (1924) was an American-backed financial arrangement to stabilise the German economy after the 1923 runaway inflation and massive social disruption. It paved the way for industrial rationalisation and mass-production methods, both of which would affect building programmes, as at Frankfurt or the Dessau Bauhaus.
30 H. Olbrich, 'Die "Neue Sachlichkeit" in Widerstreit der Ideologien und Theorien zur Kunstgeschichte des 20 Jahrhunderts', *Weimarer Beitrage*, Sonderdruck, H. 12 (1980), p. 74.
31 *Bauhausbauten Dessau*, vol. 12, *Bauhaus Books*, quoted in Hans M. Wingler, *Bauhaus* (Cambridge, Mass., 1986), p. 410.
32 Selle, *Die Geschichte des Design in Deutschland*, p. 128.
33 Ibid. A sociological study from the period by Lisbeth Franzen-Hellersberg, *The Young Female Worker: Her Work Life and Life-style*, suggests that young working-class women had a greater sense of reality, 'lacked the overheated illusions – which make the petty bourgeois teenagers prone to mistake novels and film dramas for reality'. There was stronger resistance to the representation of mass culture because of their participation in their own socialist culture. I am indebted to a recent article by Günther Berghaus for this information: 'Girlkultur', *Journal of Design History*. nos. 3–4, 1988.
34 Selle, *Die Geschichte des Design in Deutschland*, p. 129.
35 'SPD – Frauenwelt', H. 6, S. 13i, 1932, quoted in the catalogue '*Vorwärts – und nicht vergessen': Arbeiterkultur in Hamburg um 1930* (Hamburg, 1981), p. 76.
36 Published in *Die Frau*, vol. 28 (1920–1), and by M. Thomae, vol. 29 (1922). Details from Nicholas Bullock, *Journal of Design History*, nos. 3–4 (1988).
37 London, 1988.
38 Hamburg catalogue, p. 77 (see n. 35).
39 The Taut brothers, Gropius and Moholy-Nagy, amongst others, represent this cultural politics. May was urban planner at Frankfurt, Wagner in Berlin. Hannes Meyer was Bauhaus director between 1928–30.
40 *Design After Modernism: Beyond the Object* (London, 1988), p. 22.

41 Charles S. Maier, *Recasting Bourgeois Europe: Stabilisation in France, Germany and Italy in the Decade after World War I* (Princeton, NJ., 1975).

42 The illustrations in a sense construct a narrative for the last five years of Weimar. 'The Frankfurt Kitchen', the type which Kallai may have had in mind, and the more generally reformist *Wohnkultur* interior stand in contrast to the socio-economic reality governing design Modernism and the larger constituency it attempted to address. Chancellor Brüning reduced wages and welfare payments in a period of rapidly rising unemployment.

43 David Harvey, *The Condition of Postmodernity* (Oxford, 1989), p. vii.

5. Wendy Kaplan: Building Utopia: Pioneer Modernism on the American West Coast

Many people went out of their way to help with research for this essay, generously sharing their expertise, photographs and access to private houses. I am especially grateful to Jim Benjamin, Bob Winter, Jeffrey Chusid, Virginia Kazor, Bruce Kamerling and Julius Shulman.

1 For an illuminating discussion of this issue, see David Gebhard's essay, 'The Moderne 1920–1941', in David Gebhard and Harriette Von Breton, *Kem Weber: The Moderne in Southern California, 1920–1941* (Santa Barbara, Ca., 1976). See also Thomas S. Hines, 'Los Angeles Architecture: The issue of Tradition in a Twentieth-Century City', in David G. De Long, Helen Searing, and Robert A. M. Stern (eds.), *American Architecture: Innovation and Tradition* (New York, 1986), pp. 112–29.

2 Harwell Hamilton Harris, 'Regionalism and Nationalism', *Student Publication of the School of Design*, North Carolina State College of the University of North Carolina at Raleigh, vol. 14, no. 5 (1958), p. 28.

3 Reyner Banham, *Theory and Design in the First Machine Age* (London, 1960), p. 329.

4 For more on Los Angeles in the early part of the century, see David Gebhard, *Schindler* (New York, 1972), pp. 45–51, and Kevin Starr's two books, *Americans and the California Dream, 1850–1915* (New York, 1973) and *Inventing the Dream* (New York, 1984).

5 Irving J. Gill, 'The Home of the Future: The New Architecture of the West: Small Homes for a Great Country', *Craftsman* 30 (May 1916), p. 151.

6 Space does not permit the illustration of all Gill houses discussed in this essay. Those not included here can be found either in Esther McCoy's chapter on Gill in *Five California Architects* (New York, 1960), pp. 59–101, or in Bruce Kamerling, 'Irving Gill – The Artist as Architect', *Journal of San Diego History* 25 (Spring 1979), pp. 151–200. The article is available in booklet form at the San Diego Historical Society.

7 Much of the information concerning Irving Gill was derived from conversations with Bruce Kamerling, Curator at the San Diego Historical Society. I am grateful to him for sharing his years of research with me.

8 Gill, 'The Home of the Future', pp. 141–2. Gill had various partners over the years; Frank Mead shared his office at the time of the Allen house's construction. From 1897 to 1906 he was in partnership with William S. Hebbard, and for a few years, starting in 1914, with his nephew Louis. Hebbard preferred English Revival styles and Louis Gill was more of an office manager than creative participant. Gill's one-year partnership with Mead, however, was more important to his developing style. Mead had travelled to study the vernacular architecture of North Africa and the Mediterranean. The white, stripped-down architecture of these regions is similar to the mission architecture Gill admired, and Mead's exposure to it influenced Gill.

9 Richard Neutra, Henry-Russell Hitchcock, and Reyner Banham are three of the many architects and historians who have observed this. See Henry-Russell Hitchcock, *Architecture, Nineteenth and Twentieth Centuries* (Baltimore, Md., 1963), pp. 334–5;

Reyner Banham, *Los Angeles: The Architecture of Four Ecologies* (New York, 1971), p. 61; Neutra's comparison between Gill and Loos is discussed in Hines, 'Los Angeles Architecture', p. 118.

10 Gill, 'The Home of the Future', p. 147.

11 Ibid.

12 Ibid.

13 McCoy, *Five California Architects*, p. 75.

14 Helen M. Ferris, 'Irving John Gill: San Diego Architect', *The Journal of San Diego History* 17 (Fall 1971), p. 13. For a period description of Lewis Courts, see Eloise M. Roorbach, 'The Garden Apartments of California – Irving J. Gill – Architect', *Architectural Record* 34 (December 1913), pp. 518–30.

15 McCoy, *Five California Architects*, p. 85.

16 Ibid., p. 71.

17 Banham, *Los Angeles*, p. 64.

18 Henry-Russell Hitchcock and Philip Johnson, *The International Style* (New York, 1966 edn.), pp. 25, 26, 27.

19 For an entertaining diatribe against the indignities foisted upon clients by International Style architects, see Tom Wolfe, *From Bauhaus to Our House* (New York, 1981), passim.

20 Frank Lloyd Wright, *An Autobiography* (London, 1945), p. 151.

21 For example, Thomas S. Hines thinks the Barnsdall house is 'one of Wright's masterworks'. See Robert Judson Clark and Thomas S. Hines, *Los Angles Transfer: Architecture in Southern California, 1880–1980* (Los Angeles, 1983), p. 64. Brendan Gill is one of the house's detractors. See Brendan Gill, *Many Masks: A Life of Frank Lloyd Wright* (New York, 1987), p. 252.

22 Wright, *Autobiography*, p. 151.

23 Gill, *Many Masks*, p. 252.

24 Quoted in Clark and Hines, *Los Angeles Transfer*, p. 69.

25 Jeffrey Mark Chusid and Virginia Ernst Kazor, *Frank Lloyd Wright in Los Angeles, 1919–1926: An Architecture for the Southwest* (Los Angeles, 1988), unpaged [p. 12].

26 Clark and Hines, *Los Angeles Transfer*, p. 63.

27 *The Ennis-Brown House* (booklet published by the Board of Directors of the Ennis House, Los Angeles, 1988), p. 9.

28 Much of the information concerning the Freeman house and Wright's development of the textile-block system comes from conversations with Jeffrey Chusid, Administrator of the Freeman house. Chusid was most generous in sharing his research and insights with me.

29 Chusid and Kazor, *Frank Lloyd Wright*, unpaged [p. 12].

30 R. M. Schindler, 'A Cooperative Dwelling', *T-Square* 2 (February 1932), pp. 20–21. This article is reprinted in the booklet *R. M. Schindler House 1921–22* by Kathryn Smith, published by the Friends of the Schindler House (1987), pp. 23–4. It is also reprinted in August Sarnitz, *R. M. Schindler, Architect* (New York, 1988), p. 49.

31 Ibid.

32 Sarnitz, *R. M. Schindler, Architect*, p. 47. All seven articles that Schindler wrote for Lovell's column are reproduced in Sarnitz's book, as are many other of Schindler's articles, lectures, and letters.

33 Quoted in Esther McCoy, 'Second Guessing Schindler', *Progressive Architecture* 4 (April 1989), p. 86.

34 See Gebhard, *Schindler*, p. 80; David Gebhard and Robert Winter, *Architecture in Los Angeles* (Layton, Utah, 1985), p. 20; and Sally B. Woodbridge, *California Architecture: Historic American Buildings Survey* (San Francisco, 1988), p. 101.

35 Quoted in Gebhard, *Schindler*, p. 86.

36 Sarnitz, R. M. *Schindler, Architect*, p. 209. The correspondence between Schindler and Johnson is reprinted in Sarnitz's book.
37 Hitchcock and Johnson, *International Style*, p. 40.
38 Quoted in Gebhard, *Schindler*, p. 86.
39 David Gebhard and Harriette Von Breton, *Architecture in California: 1868–1968* (Santa Barbara, Ca., 1968), p. 22.
40 Henry-Russell Hitchcock, Preface to Gebhard, *Schindler*, p. 8.
41 Interview with Philip Lovell in Esther McCoy, *Vienna to Los Angeles: Two Journeys* (Santa Monica, Ca., 1979), p. 68.
42 Harwell Hamilton Harris, Foreword to McCoy, *Vienna to Los Angeles*, pp. 12 and 8.
43 Quoted in Thomas S. Hines, *Richard Neutra and the Search for Modern Architecture* (New York, 1982), pp. 78–9.
44 Hines, *Richard Neutra*, p. 84.
45 Henry-Russell Hitchcock, *Modern Architecture: Romanticism and Regeneration* (New York: Harcourt, Brace, 1929), p. 158.
46 For example, see Barr's Prefaces to both the exhibition catalogues, *The International Style* (first published in 1932) and *Machine Art* (first published in 1934).
47 Alfred H. Barr, Preface to Hitchcock and Johnson, *International Style*, p. 14.
48 Interview with Philip Lovell in McCoy, *Vienna to Los Angeles*, pp. 67–8.

6. Julian Holder: 'Design in Everyday Things': Promoting Modernism in Britain, 1912–1944

Work related to parts of this essay was previously done as a member of the Melodrama group who organised and researched a four-month film season, 'Hollywood as Melodrama', at the National Film Theatre, London, January–April 1988. Associated with this was an exhibition at the National Theatre entitled 'The Melodramatic Imagination', which included a section on 'Consumer Aesthetics'. An abridged form of this exhibition suitable for travelling is available from the British Film Institute. Apart from this group, thanks for help with this article are extended to the Manchester Central Reference Library, Christine Gledhill, Helen Long, the National Art Library, and most importantly Alison MacKenzie.

1 Lethaby to Harry Peach, March 1929. Correspondence held in the Peach Papers at the British Architectural Library, London.
2 'Style-mongering' was another of Lethaby's phrases to show his contempt for architecture and design interpreted as style. For the establishment of Modernist architecture in Britain, see Anthony Jackson, *The Politics of Architecture: A History of Modern Architecture in Britain* (London, 1970), and Jeremy Gould, *Modern Houses in Britain 1919–1939* (London, 1977).
3 Ian Davis's essay, 'One of the greatest evils: Dunroamin and the Modern Movement', in *Dunroamin: The Surburban Semi and Its Enemies*, ed. Paul Oliver, Ian Davis, and Ian Bentley (London, 1981) is one of the few accounts of the history of twentieth-century architecture to pay it much attention to date. Though often mentioned, as above, the programmes have rarely been described.
4 Anthony Bertram, *The Listener*, 6 October 1937, p. 710. J. M. Richards, in *An Introduction to Modern Architecture* (Harmondsworth, 1940), claimed that '. . . even the best modern architecture has at present only a limited amount of positive appeal to our eyes'.
5 W. R. Lethaby, *Form in Civilisation: Collected Papers on Art and Labour* (London, 1922).
6 Nikolaus Pevsner, *Pioneers of the Modern Movement* (London, 1936). This work was largely the result of research undertaken from 1930–32 whilst Pevsner was still

teaching in Germany. For an account of the less polemic, and teleological, work undertaken early in Pevsner's residence in Britain, see Pauline Madge, 'An enquiry into Pevsner's "Enquiry" ', *Journal of Design History*, vol. 1. no. 2.

7 Most of these important figures of the Modernist period still await serious study with the exception of Herbert Read. For Read, see specifically the recent article on his widely influential *Art and Industry* by Robin Kinross in *Journal of Design History*, vol. 1, no. 1. J. M. Richards has written his autobiography, *Memoirs of an Unjust Fella*. Carrington also did, in so far as his involvement with design went, in *Industrial Design in Britain* (London, 1976). Bertram and the prodigious Gloag have received little attention to date.

8 As John Thakara noted in the Preface to *Design after Modernism: Beyond the Object* (London, 1988), p. 7, 'Where theoretical work does take place, it is usually based in history departments – often in disguise.'

9 E.g., John Gloag (ed.), *Design in Everyday Life and Things: the Yearbook of the DIA 1926–7* (London, 1927); 'Everyday Things' exhibition at the RIBA, 1936; N. Pevsner, *Visual Pleasures from Everyday Things* (London, 1946); 'Design in Everyday Life' exhibition by the British Institute of Adult Education, 1942; 'Design in everyday things by a man in the street' in *Design for Today*, April 1936; Noel Carrington, *The Shape of Things: An Introduction to Design in Everyday Life* (London, 1939); Anthony Bertram, *Design in Daily Life* (London, 1937); Anthony Bertram, *Design in Everyday Things* (London, 1937); Winifred M. Gill, *Broadcasting and Everyday Life* (London, 1939).

10 See J. M. Richards, 'The condition of architecture and the principle of anonymity', in *Circle: International Survey of Constructive Art* edited by J. L. Martin, Ben Nicholson, and N. Gabo (London, 1937).

11 See, however, Jonathan Woodham, 'Design and the Empire: British design in the 1920s', in *Art History*, vol. 3, no. 2 (June 1980).

12 See Mark Swenarton, *Homes Fit for Heroes: the Politics and Architecture of Early State Housing in Britain* (London, 1981).

13 For the impact of standardisation and rationalisation generally, see Judith Merkle, *Management and Ideology: the Legacy of the International Scientific Movement* (Berkeley, Ca., 1980) and more specifically Mary McLeod, 'Architecture or Revolution: Taylorism, Technocracy, and Social Change', in *Art Journal*, Summer 1983. On housing, see J. P. Dunleavy, *The Politics of Mass-housing* (London, 1981) and John Burnett, *A Social History of Housing 1815–1985* (London, 1986).

14 See Simon Pepper and Mark Swenarton, 'Home front: garden suburbs for munition workers, 1915–1918', *Architectural Review*, no. 976 (June 1978), pp. 364–75.

15 As Ernst May was to record after Unwin's death, 'the style of architecture may have changed . . . the basic outlook . . . has not changed but has actually developed further in the direction Raymond initiated – that the welfare of men should be the only measure of our endeavours'.

16 See Brian Finnimore, *Houses from the Factory: System Building and the Welfare State 1942–74* (London, 1989).

17 For studies of the Garden City Movement, see Walter L. Creese, *The Search for Environment: the Garden City Before and After* (New Haven, Conn., 1966); Anthony Sutcliffe, *The Rise of Modern Urban Planning, 1888–1914* (London, 1980); and Swenarton, *Homes Fit for Heroes*.

18 Le Corbusier's *Vers une architecture* of 1923 was translated into English in 1927 by Frederick Etchells and Gropius' work was first published in English in 1935.

19 See Manfredo Tafuri and Francesco Dal Co, *Architettura contemporanea* (Milan, 1976). For a general account of the towns of industrial philanthropy, see Gillian Darley, *Villages of Vision* (London, 1975).

20 *Country Life*, May 1919, p. 599.
21 For the DIA, see Nikolaus Pevsner's essay 'Patient Progress' in *Studies in Art, Architecture, and Design*, vol. 2 (London, 1968); Raymond Plummer, *Nothing Need Be Ugly: the First Seventy Years of the Design and Industries Association* (London, 1985); and generally Jonathan Woodham, *The Industrial Designer and the Public* (London, 1983).
22 Quoted in RIBA *Journal*, vol. 64 (April 1957), p. 222.
23 Lethaby, *Form in Civilisation*.
24 Ibid. It was the opinion of many who attended the founding of the DIA that Lethaby went out of his way to never mention the word 'art' for fear of scaring the industrialists; see, for example, Noel Carrington's *Industrial Design in Britain*.
25 See Brian Cook Batsford, *The Britain of Brian Cook: a Batsford Heritage* (London, 1987).
26 John Gloag, *Artifex: or the Future of Craftsmanship* (London, 1926), p. 38.
27 Gloag (ed.), *Design in Everyday Life and Things*, p. xi.
28 Ibid.
29 Carrington, *Industrial Design in Britain*, p. 98.
30 According to the BBC *Yearbook* for 1931 the earlier series 'led to considerable interest and induced two of the speakers to meet later a large group of listeners in order to pursue the subject of modern architectural developments'. Architecture was discussed again in November 1934 in a debate between Sir Reginald Blomfield and A. D. Connell.
31 Quoted in Plummer, *Nothing Need Be Ugly*, p. 35. See also Bruce Holdsworth, 'Art education between the wars', in *Journal of Art and Design Education*, vol. 3, no. 2 (1984).
32 On the BBC, see 'Serving the nation: public service broadcasting before the war' by Paddy Scannell and David Cardiff, in *Popular Culture: Past and Present*, ed. B. Waites, T. Bennett, and G. Martin (London, 1982). On its struggle with popular entertainment, see Simon Frith, 'The pleasures of the hearth: the making of BBC light entertainment', in *Formations of Pleasure* (London, 1983). On the work of the Talks Department, see David Cardiff, 'The serious and the popular: aspects of the evolution of style in the radio talk, 1928–1939', in *Media, Culture, and Society*, vol. 2, no. 1 (1980).
33 *The Listener*, 22 August 1934, p. 341.
34 See the magazine *Shelf Appeal* for coverage of the impact the commercial stations were having in the advertising industry at this time.
35 Maxwell Fry, 'How modern architecture came to England', Pidgeon Audio-Visual, PAV 3/800, n.d. Fry went on to argue how the intellectuals were caught via the MARS group exhibitions at the Burlington Galleries, and that this way of promoting Modern architecture was the right way.
36 J. M. Barton, *Modern Art* (London, 1932).
37 *The Listener*, 19 April 1933, p. 608.
38 Ibid., 22 August 1934, p. 341.
39 See John Cornforth, 'Christopher Hussey and Modern Architecture', *Country Life*, 22 October 1981, pp. 1366–8, and 29 October 1981, pp. 1468–70. This argument also tries surfacing at several points in John Cornforth, *The Search for a Style*: Country Life and Architecture 1897–1935 (London, 1988).
40 In 1927 Hussey had published *The Picturesque: Studies in a Point of View*, where Hill is the only twentieth-century architect mentioned. For a typical example of the application of the Picturesque model, see 'The Morecambe Hotel: the LMS as Maecenas', *Country Life*, 18 November 1933, pp. 539–44. Richards, *Introduction to Modern Architecture* also has interesting points to make about this building and the

failings of the architect and its construction. A constant preoccupation of many writers of the period was to claim a formal, if not moral, relationship between Modernism and eighteenth-century British architecture, primarily the Georgian town house.

41 *Architectural Review*, vol. 76 (September 1934), p. 97.
42 These broadcasts also seem to have provided a model for the Australian Broadcasting Corporation who produced their own series of nine programmes entitled *Design in Everyday Things* between 17 March and 12 May 1941. I have only recently been alerted to this aspect in Tony Fry, *Design History Australia: A Source Text in Methods and Resources* (Sidney, 1988).
43 *The Listener*, 8 September 1937, p. 490.
44 Ibid., 6 October 1937, p. 711.
45 Ibid., 6 October 1937, p. 711.
46 Ibid., 13 October 1937, p. 780.
47 Ibid., 20 October 1937, p. 860.
48 Ibid., 27 October 1937, p. 918.
49 Ibid., 13 October 1937, p. 801.
50 Ibid., 3 November 1937, p. 975.
51 Ibid., 7 November 1937, p. 1069.
52 See Stirling Everard, *The History of the Gas, Light, and Coke Company 1812–1949* (London, 1949), and *Flats: Municipal and Private Enterprise* by Ascot Gas Water Heaters Ltd. (London, 1938).
53 For the work of Fry, see S. Hitchens (ed.), *Fry, Drew, Knight and Creamer: Architecture* (London, 1978), and his *Autobiographical Sketches* (London, n.d.).
54 Fry, *Autobiographical Sketches*.
55 *The Listener*, 10 November 1937, p. 1009.
56 Fry, *Autobiographical Sketches*.
57 *The Listener*, 6 October 1937, p. 710.
58 Richards, *Introduction to Modern Architecture*, p. 81. For Penguin book design, see Jeremy Aynsley in *Fifty Penguin Years* (Harmondsworth, 1985).
59 *Homes for All: The British Broadcasting Corporation Looks at the Problem* (Worcester, 1945), p. 11.
60 Ibid., p. 27.
61 Ibid., p. 43.
62 Ibid., p. 65. As with Percy Good's evidence, both prefabrication and standardisation were shown to be no more advanced than in the case of the Crittall Unit house of 1919 (see n. 20).
63 For the history of the factory-made house in this country, see Finnimore, *Houses from the Factory*, and his 'The AIROH house: industrial diversification and state building policy', in *Construction History Journal*, vol. 2 (1985).
64 See 'Radio listening habits: London and Home Counties', Crossley Incorporated, 1939.
65 Carrington, *The Shape of Things*, p. xiii. As we shall see, this was to be a rare demonstration of confidence in the film industry, arguably a naïve one in the circumstances.
66 For Mass Observation's 'Worktown' project in relation to the cinema, see Jeffrey Richards and Dorothy Sheridan (eds.), *Mass-observation at the Movies* (London, 1987). For a discussion of the new methods of tying-in merchandise to the movies as developed in post-Depression America, see Charles Eckert, 'The Carole Lombard in Macy's window', in *Quarterly Review of Film Studies*, Winter 1978. For a particular example, see Maria LaPlace, 'Producing and consuming the women's film: discursive struggle in "Now, Voyager" ', in Christine Gledhill (ed.), *Home Is Where the Heart Is: Studies in Melodrama and the Women's Film* (London, 1987). The case of product tie-

ins and showcasing of new products in British films is the subject of further research I
am currently pursuing.

67 *Documentary News Letter*, August 1942, p. 112.
68 Anthony Bertram, *The House: a Survey of the Art and Science of Domestic
Architecture* (London, 1945), pp. 109–111.

8. Gillian Naylor: Swedish Grace . . . or the Acceptable Face of Modernism?

1 J. M. Richards, *Memoirs of an Unjust Fella* (London, 1980).
2 Charles Holme (ed.), *Peasant Art in Sweden, Lapland and Iceland* (London, 1910).
3 Quoted from Eric Zahle (ed.), *Scandinavian Domestic Design* (Copenhagen, 1961), p.
56.
4 H. Muthesius, *Stilarchitektur und Baukunst* (Berlin, 1903), quoted from J. Posener,
Anfange des Funktionalismus, von Arts and Crafts zum Deutscher Werkbund (Berlin,
Frankfurt am Main, Vienna, 1964).
5 Quoted from Ulrich Conrads (ed.), *Programmes and Manifestoes on Twentieth-
Century Architecture* (London 1970), pp. 28–31.
6 G. Paulsson, *Vackrare Vardagsvara* (Stockholm, 1919), p. 42.
7 Ibid., p. 12.
8 Ibid., p. 24.
9 Nils G. Wollin, *Modern Swedish Decorative Art* (London, 1931), p. XI.
10 Ibid., p. XII–XIII.
11 Hakon Ahlberg, *Swedish Architecture of the Twentieth Century*, with Preface by F. R.
Yerbury (London, 1925). F. R. Yerbury was also associated with the Architectural
Association, and with the Architectural Press.
12 Quoted from 'Stockholm 1930' by Kenneth Frampton, in *Asplund* (Stockholm, 1985),
p. 37.
13 For a fuller account of Asplund's ideas at this time, see *Swedish Design Exhibitions,
1917–31*; unpublished MA thesis by Denise Hagströmer, Royal College of Art, 1990.
14 J. M. Richards describes P. Morton Shand ('he was always and in full P. Morton
Shand') as 'a meticulously accurate journalist, but a difficult man, with a habit of
taking irrational dislikes to people and a tendency to xenophobia, and especially to
anti-semitism, strange in someone who led a very cosmopolitan life. His anti-semitism
. . . being expressed for the most part in the form of jocular, schoolboyish quips –
repugnant nevertheless . . .' Richards, *Memoirs of an Unjust Fella*, p. 123.
15 J. M. Richards, *An Introduction to Modern Architecture* (Harmondsworth, 1940), pp.
91–2.
16 For further details of the Dorland Hall exhibition, and British reactions to it, see
Denise Hagströmer, *Swedish Design Exhibitions*.

9. Penny Sparke: 'A Home for Everybody?' Design, Ideology and the Culture of the Home in Italy, 1945–1972

The publisher wishes to thank Macmillan Press Ltd. for permission to include this essay,
which also appears in *Culture and Conflict in Postwar Italy*, edited by Z. Baranski and R.
Lumley (1990).

1 M. Clark, *Modern Italy, 1871–1982* (London, 1984), p. 165.
2 Ibid., p. 317.
3 E. Rogers, 'Editorial', *Domus*, January 1946, p. 3.
4 Rogers, *Domus*, May 1946, p. 5.
5 P. Bottoni, 'The 8th Triennale', *Domus*, January 1947, p. 42.
6 L. Schreiber, 'Contrasts in Current Italian Design', *Design*, July 1949, p. 9.

7 Rogers, *Domus*, April 1946, p. 14.
8 Rogers, *Domus*, January 1947, p. 4.
9 Clark, *Modern Italy*, p. 354.
10 J. Haycraft, *The Italian Labyrinth* (Harmondsworth, 1985), p. 222.
11 A. Branzi, *Il design italiano degli anni' 50* (Milan, 1981), p. 29.
12 V. Gregotti, 'Italian Design, 1945–71', in E. Ambasz (ed.), *Italy: The New Domestic Landscape* (New York, 1973), p. 323.

10. *Guy Julier: Radical Modernism in Contemporary Spanish design*

1 For a brief portrait of the *Gauche Divine* of Boccaccio, see Manuel Vázquez Montalbán, 'La Belle et la Bête, ou les Années Trompeuses', in *Barcelone: Baroque et Moderne: l'Exuberance Catalane* (Paris, 1986), p. 22.
2 Charles W. Anderson, *The Political Economy of Modern Spain: Policy-Making in an Authoritarian System* (Madison, WI, 1970), p. 86.
3 Raymond Carr and Juan Pablo Fusi, *Spain: Dictatorship to Democracy* (London, 1981), ch. 6.
4 Quoted by Antonio Bonet Correa, 'Espacios arquitectónicos para un nuevo orden', in Correa (ed.), *Arte del Franquismo* (Madrid, 1981), p. 31.
5 Bohigas himself wrote a long essay in response to *Els altres Catalans*; see Oriol Bohigas, 'Problemas Urbanisticos de la Inmigración' of 1964, in *Contra Una Arquitectura Adjetivada* (Barcelona, 1969).
6 Oriol Bohigas, in 'Josep Lluís Sert o la preocupació urbanistica', in *Serra d'Or*, Any IX, num. 6, juny 1967, pp. 52 and 53.
7 Ibid., p. 55.
8 Oriol Bohigas, 'Equivocos "progresistas" en la Arquitectura Moderna', in *Contra Una Arquitectura Adjetivada*, p. 5.
9 Ibid., p. 6.
10 Ernesto Giménez Caballero in *Arte y Estado* (1935), quoted in Alexandre Cirici, *La estética del franquismo* (Barcelona, 1977); Cirici argues that Giménez Caballero, through *Arte y Estado*, provided the blueprint for early Francoist cultural policy. See also Lluís Domènech, *Arquitectura de Siempre* (Barcelona, 1978) and Correa (ed.), *Arte del franquismo*.
11 See Correa, 'Espacios arquitectónicos para un nuevo orden', in *Arte del Franquismo*, p. 31.
12 See Lluís Domènech, *Arquitectura de Siempre*.
13 Alexandre Cirici, 'L'art de la saviesa', in *Ariel*, Any 1, 1946, p. 32.
14 Bohigas, 'Equivocos "progresistas" en la Arquitectura Moderna', p. 163. Indeed, any representation of Spanish architecture abroad had swung distinctly in the favour of Madrid; see, for instance, review of exhibition of Spanish architecture at the Building Centre, London, in *Architectural Review*, vol. 115, no. 686 (February, 1954).
15 Bohigas, 'Equivocos "Progresistas" en la Arquitectura Moderna', p. 12.
16 Oriol Bohigas, 'el Venturi d'en Tusquets: 2, un disseny per al consumidor', in *Serra d'Or*, Any XIV, num. 149, febrer 1972, p. 18.
17 Ibid.
18 Oriol Bohigas, 'Diseñar Para un Publico o Contra un Publico', in *Contra Una Arquitectura Adjetivada*, p. 71.
19 See Lluís Clotet, 'Els Estudiants d'Arquitectura', in *Serra d'Or*, Any IX, juliol 1967, p. 33, and Josep Ma Colomer, *Els Estudiants de Barcelona Sôta el Franquisme* (Barcelona, 1982), pp. 206 and 238.
20 Quoted in *Eina, escola de disseny i art 1967–1987: Vint anys d'avantguardia* (Barcelona, 1987), Document A.

21 Alexandre Cirici, 'Dialegs d'Eina. el Grup 63 i l'avantguardia', in *Serra d'Or*, Any IX, num. 3, abril 1967, p. 67.

22 These positions were first articulated by Rafael Moneo in 'La llamada "Escuela de Barcelona" ', *Arquitectura*, no. 121, 1969, and Oriol Bohigas, 'Una Posible "Escuela de Barcelona" ', in *Contra Una Arquitectura Adjetivada*.

23 Bohigas, 'Una Posible "Escuela de Barcelona" ', p. 164.

24 See, for instance, Helio Piñón, 'Actitudes Teóricas en la Reciente Arquitectura de Barcelona', in *Arquitectura Bis*, nos. 13 and 14, mayo–junio 1976, pp. 27–32, and more recently Oriol Bohigas and Oscar Tusquets, 'L'Escola de Barcelona com a Tendència Estilística', transcription Xavier Febrés, in *Diàlegs a Barcelona 16* (Barcelona, 1986), pp. 70–6.

25 Charles Jencks, in an assessment of the Escuela de Barcelona in *Architectural Review*, no. 961, March 1977, intelligently dissects the various quotations made in their architecture.

26 Alexandre 'Comunicació a l'Hospitalet' in *Serra d'Or*, Any XV, num. 161, febrer 1973, pp. 39 and 41.

27 See Ajuntament de Barcelona, exhibition catalogue, 'Homenatge a Alexandre Cirici' 1984, pp. 16–24; Albert Ràfols Casamada, 'Cirici i l'ensenyament del disseny', in *Serra d'Or*, Any XXV, num. 285, abril 1983, pp. 223–4; Alicia Suarez and Mercè Vidal, 'Alexandre Cirici, Professor', in *Serra d'Or*, Any XXV, num. 285, abril 1983, pp. 30–1; monthly articles by Alexandre Cirici in *Serra d'Or*, 1968–74.

28 Indeed, it provided the scenario for *More*, a contemporary film of drugs and intrigue with music by Pink Floyd.

29 André Ricard in conversation with the author, 7 June 1988. Ricard was chairman of the conference organising committee.

30 Jordi Mañà in *La Vanguardia Española*, 31 October 1971, reproduced in *Temas de Diseño*, no. 1, marzo/abril 1972, press section, pp. 1–2.

31 Jordi Mañà in conversation with the author, 25 May 1988.

32 Joan Antoni Blanc, 'La Participación de FAD en Hogarotel', in *Hogares Modernos*, no. 65, enero 1972, pp. 53–5, and confirmed by Joan Antoni Blanc in conversation with the author, 12 July 1988; Blanc was co-ordinator of the stand's design team, the Grupo Abierto Urquinaona.

33 Ibid.

34 Mai Felip in conversation with the author, 7 July 1988.

Select Bibliography

Anscombe, Isabelle, *A Woman's Touch: Women in Design from 1860 to the Present Day*, Harmondsworth: Penguin, 1985.

Arts Council, *Art in Revolution: Soviet Art and Design Since 1917*, London, 1971.

——, *Le Corbusier, Architect of the Century*, London, 1987.

Attfield, Judy and Kirkham, Pat (eds.), *A View from the Interior: Feminism, Women and Design*, London: Women's Press, 1989.

Baljeu, Joost, *Theo Van Doesburg*, New York: Macmillan, 1974.

Barr, A. H., 'Notes on Russian Architecture', *The Arts*, 15 February 1925.

Benton, C., Benton, T., and Scarf, A., *The History of Architecture and Design*, Milton Keynes: Open University Press, 1975.

Benton, Tim, *The Villas of Le Corbusier, 1920–1930*, London: Yale University Press, 1987.

Berman, Marshall, *All that is Solid Melts into Air: The Experience of Modernity*, London: Verso, 1983.

Branzi, Andrea, *The Hot House: Italian New Wave Design*, London: Thames & Hudson, 1984.

Brussels, Palais des Beaux Arts, *Henry Van de Velde 1863–1957*, Brussels, 1963.

Burckhardt, Lucius (ed.), *The Werkbund: Studies in the History and Ideology of the Deutscher Werkbund, 1907–1933*, London: Design Council, 1980.

Campbell, Joan, *The German Werkbund*, Princeton University Press, 1978.

Chermayeff, Serge and Plunz, R. (eds.), *Design and the Public Good*, Cambridge, Mass.: MIT Press, 1982.

Cockx, A. and Lemmens, J., *Les Expositions Universelles et Internationales en Belgique de 1885–1958*, Brussels, 1958.

Condit, Carl, *The Chicago School*, Cambridge, Mass.: MIT Press.

Culot, M. and Terlinden, F., *Antoine Pompe et l'Effort Moderne en Belgique*, Brussels: Musée Ixelles, 1969.

De Stijl Magazine, The: reprinted in full, Amsterdam: Atheneum, 1968.

Drexler, A. and Hines, T. S., *The Architecture of Richard Neutra*, New York: Museum of Modern Art, 1982.

Frampton, Kenneth, *Modern Architecture: A Critical Survey*, London: Thames and Hudson, 1980.

Franciscono, Marcel, *Walter Gropius and the Creation of the Bauhaus*, Illinois University Press, 1971.

Friedman, Mildred (ed.), *De Stijl: 1917–1931, Visions of Utopia*, Oxford: Phaidon, 1982.

Futagawa, Yukio and Pfeiffer, B. R., *Frank Lloyd Wright*, vols. 1–12, Tokyo: APA, 1984–8.

Gebhard, David, *Schindler*, New York: Viking, 1972.

G. Gibian and H. W. Tjalsma (eds), *Russian Modernism: Culture and the Avant-garde, 1900–1930*, Ithaca, NY: Cornell University Press, 1976.

Giedion, Sigfried, *Space, Time and Architecture*, Oxford University Press, 1941.

Gloag, John, *The English Tradition in Design*, Harmondsworth: Pelican, 1947.

Golding, J. and Green, C., *Léger and Purist Paris*, London: Tate Gallery.

Greenhalgh, Paul, *Ephemeral Vistas: Expositions Universelles, Great Exhibitions and World's Fairs, 1851–1939*, Manchester University Press, 1988.

Gropius, Walter, *The New Architecture and the Bauhaus*, London: Faber, 1935.

Guggenheim Museum, Solomon R., *Piet Mondrian, 1872–1944, Centennial Exhibition*, New York, 1971.

Harvey, David, *The Condition of Post-Modernity*, Oxford, 1989.

Herf, Jeffrey, *Reactionary Modernism: Technology, Culture and Politics in Weimar and the Third Reich*, Cambridge University Press, 1986.

Heskett, John, Industrial Design, London: Thames and Hudson, 1982.

Hitchcock, H.-R., *In the Nature of Materials: 1887–1941, the Buildings of Frank Lloyd Wright*, New York: DSP, 1942.

——, *Architecture Nineteenth and Twentieth Centuries*, Harmondsworth: Pelican, 1958.

Hitchcock, H.-R. and Johnson Philip, *The International Style*, New York: Museum of Modern Art, 1932.

Itten, Johannes, *Design and Form: the Basic Course at the Bauhaus*, rev. ed., London: Thames & Hudson, 1975.

Jaffe, H. L. C., *De Stijl*, London: Tiranti, 1956.

Jencks, Charles, *Le Corbusier and the Tragic View of Architecture*, London: Allen Lane, 1973.

Johnson, Philip, *The Machine Age*, New York: Museum of Modern Art, 1934.

Kamerling, Bruce, *Irving Gill: The Artist as Architect*, San Diego, 1979.

Lane, Barbara-Miller, *Architecture and Politics in Germany, 1918–1945*, Harvard University Press, 1968.

Le Corbusier, *Towards a New Architecture*, trans. Frederick Etchells, London: Rodker, 1927.

——, *The City of Tomorrow*, trans. Frederick Etchells, London: Rodker, 1927.

——, *The Decorative Art of Today*, trans. J. Dunnett, London: Architectural Association, 1987.

Lloyd Wright, Frank, *An Autobiography*, London: Faber, 1945.

Lodder, Christina, *Russian Constructivism*, London: Yale University Press, 1985.

McQuiston, Liz, *Women in Design: A Contemporary View*, London: Trefoil, 1988.

Mumford, Lewis, *Technics and Civilization*, London: Routledge, 1934.

Mumford, Lewis (ed.), *The Roots of Contemporary American Architecture*, New York: Dover, 1972.

Naylor, Gillian, *The Bauhaus*, London: Studio Vista, 1968.

Naylor, Gillian, *The Bauhaus Reassessed: Sources and Design Theory*, London: Herbert Press, 1985.

Pevsner, Nikolaus, *The Pioneers of the Modern Movement*, London: Faber, 1936.

Radice, Barbara, *Memphis: Research, Experiences, Results, Failures and Successes of the New Design*, London: Thames & Hudson, 1985.

Read, Herbert, *Art and Industry*, London: Faber, 1934.

Reyner Banham, Peter, *Theory and Design in the First Machine Age*, London: Architectural Press, 1960.

——, *Los Angeles: The Architecture of Four Ecologies*, New York: Penguin, 1971.

Richards, J. M., *An Introduction to Modern Architecture*, London: Pelican, 1940.

Royal Academy of Arts, *Fifty Years Bauhaus*, London, 1968.

Sembach, Klaus-Jurgen, *Henri Van de Velde*, London: Thames & Hudson, 1989.

Sert, J. L., *Can our Cities Survive?*, Oxford University Press, 1942.

Smith, Kathryn, *R. M. Schindler House, 1921–2*, Los Angeles: Friends of Schindler House, 1987.

Sparke, Penny, *An Introduction to Design and Culture in the Twentieth Century*, London: Allen & Unwin, 1986.

——, *Italian Design*, London: Thames & Hudson, 1988.

Swedish Institute, *Design in Sweden*, Malmo: ABT, 1977.

Sweeney, Robert, *Frank Lloyd Wright, an Annotated Bibliography*, Los Angeles: Hennessey & Ingalls, 1978.

Thackera, John, *Design after Modernism*, London: Thames & Hudson, 1988.

Troy, Nancy, J., *The De Stijl Environment*, Cambridge, Mass.: MIT Press, 1983.

Watkin, David, *Morality and Architecture*, Oxford: Clarendon Press, 1977.

Willett, John, *The New Sobriety: Art and Politics in the Weimar Period, 1917–1933*, London: Thames & Hudson, 1978.

Whitford, Frank, *The Bauhaus*, London: Thames & Hudson, 1984.

Whitney Museum, *High Styles: Twentieth-Century American Design*, New York: Summit Books, 1985.

Index

Aalto, Alvar 174
Adnet, J.J. 71, 74, 76, 77, 78
Adorno, Theodor Wiesengrund 99
Altenberg, Peter 88
Amo, José Luís Fernando de 216
Andreu World SA 222
Architects and Technicians Organisation 124
Architects Journal 178
Architectural Review 51, 164, 171, 173, 178, 182
Arflex 192
Asplund, Erik Gunnar 173–4, 174, *175*, 176, 179, 180, 181
Asti, Sergio *193*, 194, 195, 196
Ateliers d'Art de Courtrai/de Coene Frères (B) *158, 159*
Atkinson, Robert 133–4, 138
ATO *see* Architects and Technicians . . .
'Au Confortable' 59, 61, *61*

Bagge, Eric 71, 77
Banham, Reyner 49, 101, 108
Barr, Alfred 119, 120
Barton, J.E. 132, 133
Baugniet, Marcel 160
Bauhaus 5, 6, 10, 14, 79, 82, 86, 91, 93, 95, 96, 100, 179
Bayard, Emile 67, 68
BBC: programmes and publications,
 BBC Yearbook 133
 Changing World 132, 133
 Design in Everyday Things 134
 Design in Industry 134
 Design in Modern Life 133
 Homes for All 139
 Listener, The 133, 134, 135, 136, 137, 139

Today and Tomorrow in Architecture 132
Behrens, Peter 31, 89, 90, 131
Bellery-Desfontaines, Henri-Jules-Ferdinand 59, 79
Benjamin, Walter 84, 86, 87, 88, 90, 92, 94, 95, 97, 99
Berman, Marshall 85, 86
Bertram, Anthony 124, 134–7, 138–9, 139, 143
Bigas Luna 219, 222
Billings, Robert William 37
Blomfield, Sir Reginald 39
Bofill, Ricardo 215
Bohigas, Oriol 205, 206, 207, 208, 209, 210, 211, 212, 213, 219, 221
Borsani, Osvaldo 192
Boumphrey, Geoffrey 133, 134
Bourgeois, Victor 147, 149, 153
Bradbury, Malcolm 87
Branzi, Andrea 198
Brecht, [Bertolt] Eugen Friedrich 86, 93
Breuer, Marcel 44, 51
British Broadcasting Corporation *see* BBC
British Standards Institute 140–1
BSI *see* British Standards Institute
Bunton, Sam 141
Burnett, Sir John 130

Carrington, Noel 124, 125, 141, 142
Casamada, Albert Ràfols 214, 215
Castiglioni brothers, 194, 195
Cassina *193*, 195, *196*, 198
Celis, Paul *157*
Cerdà, Ildefonso 221
Champion, Georges 71, 77
CIAM *see* Congrès Internationales des Architectes Modernes

Cirici, Alexandre 206, 210, 211, 215, 217
Cirici, Cristian 206
Clark, Martin 188–9
Coates, Wells 134
Coderch, Josep Antoni 212, 215, 216
Colombo, Joe 195, 200
Comité Centrale Consultatif Technique
 des Arts Appliqués 63, 69
Comité Français des Expositions à
 l'Etranger 63
Congrès Internationales des Architectes
 Modernes 138, 153
Coninck, de *see* de Coninck
Connell, Amyas 131
Corbusier, Le *see* Le Corbusier
Correa, Antonio Bonet 210
Correa, Frederico 206, 214, 215
Correa-Milà studio 206, 212, 215
Crittall, Thomas 130, 131
Crittall, W.F.C. 128, 130–1
Croix-Marie, Paul 59, 60 61

De Coninck, Louis Herman 145, 153
de Feure, Georges 59, 66
De Stijl 5, 14, 15, 79
de Velde, *see* Van de Velde
Delaunay, Robert 12, 71
Delaunay, Sonia 12, 71
Denby, Elizabeth 133, 138
der Rohe, *see* Mies van der Rohe
Design and Industries Association 123–4,
 129, 130, 132, 134–5, 166, 182
 Quarterly Journal 130, 132
Design Council 183, 219
DIA *see* Design and Industries
 Association
Domènech, Lluís 206, 210, 212–13, 214
Domus 186, 187, 191
Dorfles, Gillo 215
Dufréne, Maurice 58, 71, 79, 80, 80

Eames, Charles 204
Eco, Umberto 215, 218
Eggerickx, Jean 156, 157
Eina 214, 215, 218, 221
Elisava 214, 217, 218
Escuela de Barcelona 205, 209, 211, 212,
 214
Etchells, Frederick 46–7
exhibitions, international:
 Antwerp (1930) 4, 147–8
 Berlin (1929) 20, 21

Brussels (1935) 144, 145, 148–54, 152
Chicago (1932) 2–3, (1933–4) 4
Glasgow (1938) 3, 4
Liège (1930) 147–8
New York (1932) 2–3, 116, (1934) 13
Paris:
 Art Deco show (1925) 72, 73, 74, 75
 Exposition des Arts Décoratifs et
 Industriels Modernes (1925) 55
 Exposition Universelle (1925) 70
 Exposition Universelle (1937) 4, 80,
 154–60, 155, 157–9, 163, 171,
 180, 207
 Salon d'Automne (1910) 68
 Stockholm (1930) 4, 174, 175, 176,
 177, 179, 181, 182
 Stuttgart (1927) 20, 172, 176
Expositions Universelles *see* exhibitions,
 international

FAD 218–19
Féderation des Sociétés d'Art pour le
 Developpement de l'Art Appliqué
 63
Felip, Mai 219
Fellini, Federico 189
Folcker, Erik 167–8
Follot, Paul 58, 71
Fougstedt, Nils 169, 181
Frampton, Kenneth 176, 178
Fry, E. Maxwell 51, 133, 138

GATCPAC 207, 208, 210, 212, 215, 221
Gate, Simon 168, 172
Gaudí, Antoni 27, 203, 204
Gill, Irving John 101, 102–8, 104, 107
Gimson, Ernest 32, 33, 129
Gloag, John 124, 129–30, 134, 135, 136,
 137
Good, Percy 140
Gramsci, Antonio 17
Gregotti, Vittorio 188, 202
Grierson, John 141
Gropius, Walter 7, 21, 31, 44, 45, 46, 51,
 87, 93, 94, 96, 101, 108, 127, 138
Groult, André 71, 74, 75, 76–7, 78
Guimard, Hector-Germain 59, 66, 79

Habermas, Jürgen 85
Hald, Edward 168, 169, 172, 182
Hamann, R. 88, 89, 91, 92
Harris, Harwell Hamilton 101, 102, 117

Haycraft, John 195
Heal, Ambrose 129
Hermand, J. 88, 89, 91, 92
Hitchcock, Henry-Russell 3, 101, 108,
 116–7
Hope, Alexander J. Beresford 34
Horta, Victor 144, 145–7, *146*, 148
Howard, Ebenezer 127
Hussey, Christopher 134

International exhibitions *see* exhibitions,
 international

Jaussely, Léon 221
Jeanneret, Charles-Edouard *see* Le
 Corbusier
Jeanneret, Pierre 21, 74, 75
Jespers, Floris 149, 156
Johnson, Philip Cortelyou 3, 101, 108,
 116, 212, 213
Jones, Owen 38
Jourdain, Francis 54, 68, 70, 73, 77

Kallai, Ernö 83, 93
Kandinsky, Vasili 12
Kracauer, Siegfried 84, 87, 94
Kühn, Ernst 91
Kåge, Wilhelm 168, 181

Labbe, Henri-Victor 154, 155, 160, 161
Labrouste, Henri 35
Lange, de *see* de Lange
Le Corbusier 6, 21, 31, 38, 43–7, 49, 51,
 74, 75, 78, 101, 114, 116, 117,
 131, 136, 198, 207, 221
 Vers une architecture 43–4, 47
 (tr. as) *Towards a New Architecture*,
 46, 127, 131–2
Léger, Fernand 71, 74
Lethaby, William Richard 32, 47, 123,
 124, 125, 128–9, 130, 131
Ligo, Larry L. 41, 49
Listener, The see under BBC
Livett, R.A.H. 137
Lloyd Wright, Lloyd-Wright *see* Wright
Lluscà, Josep 204, 222
Loos, Alfred 103, 167
Lubetkin, Berthold 44, 49, 50, 51
Lüders, Marie-Elizabeth 84, 96
Lukács, György Szegedy 86, 91

McFarlane, James 87
Mackay, David 206
Magistretti, Vico 187, 195

Makart, Hans 83, *84*
Maldonado, Tomás 209
Malevich, Kasimir 12
Malmsten, Carl 180, 181
Mañà, Jordi 218
Mare, André 58, 71
MARS *see* Modern Architectural . . .
Martorell, Josep 206, 214
Mendelsohn, Erich 44, 51
Meyer, Hannes 97
Mies van der Rohe, Ludwig 101, 108,
 114, 116, 213
Milà, Alfonso 206, 215
Minne, George 149, 153
Modern Architectural Research Group
 52, 124, 133, 138, 165
Mollino, Carlo 204
Mondrian, Piet 12
Moretti, Franco 87
Morgan, Walls and Clements 102, 119
Morris, William 16, 47, 93, 170, 179,
 213
Moulaert, Rene *157*
Mumford, Lewis 49
Muthesius, Hermann 31, 86, 87, 90, 91,
 167–8, 172

Naumann, Friedrich 90, 92, 97
Neck, van *see* Van Neck
Neutra, Richard 101, 102, 117–19, *118*,
 119, 120, 121

Olbrich, Harald 93
Ostberg, Ragnar 172, 175, 179

Parkinson and Parkinson 102, 119–20
Paulsson, Gregor 168, 170–1, 176, 180
Peach, Harry 130
Pechere, Rene *157*
Peña-Ganchegui, Luis 204, 210
Perret frères 71
Pevsner, Nikolaus 124, 125, 126, 129
Phillips, R. Randall 128
Pick, Frank 133
Piñón, Helio 204
Pirelli 192
Poltronova *196*
Ponti, Gio 191, 192, *193*, 198
Pugin, Augustus Welby N. 25, 28, 29,
 29–32, 34, 38, 47

Quennell, Charles Henry Bourne 125,
 128
Quennell, Marjorie 125

Rathenau, Walter 86–7, 92
Read, Sir Herbert 50
Reith, John Charles Walsham, baron 132–3
RIBA 49, 140
Richards, James M. 124, 138, 165, 178–9
Richardson, Henry Hobson 27, 38
Rickman, Thomas 28
Rogers, Ernesto N. 186–7, 188, 200
Rohe, *see* Mies van der Rohe
Rombaux, Egide 151, 152
Rosselli, Alberto 191, 195
Royal Institute of British Architects *see* RIBA
Ruhlmann, Jacques-Emile 70, 71, 72
Ruskin, John 26, 29–34, 37, 38, 47
 Seven Lamps of Architecture, The 30, 31, 37
 Stones of Venice, The 29–30, 38
Russell, Gordon 133

Saarinen, Eero 212
SAD see Société des Artistes Décorateurs
Sapper, Richard 197
Savage, James 28, 34
Schindler, Rudolf Michael 101, 102, 112–17, 115, 120
Schinkel, Karl Friedrich 45
Schultze-Naumburg, Paul 92
Schütte-Lihotzky, Grete 98
Selle, Gert 94–5
Selmersheim, Tony 59, 66
Sert, Josep Lluís 207, 208, 210
Shand, Paul Morton 164, 165, 171, 173, 174, 176, 178
Sharp, Thomas 137
Sharpe, Edmund 35, 37
Société d'Encouragement à l'Art et à l'Industrie 63, 64, 69
Société des Artistes Décorateurs 63, 64, 66, 69
Sorel, Louis 59, 60, 61
Soto, Luis Gutiérrez 210
Sottsass, Ettore 200, 201
Stijl, De *see* De Stijl
Sullivan, Louis 38, 102
Svensk Form see Svenska Slöjdföreningen
Svenska Slöjdföreningen 165, 166, 168, 169, 170, 171, 172, 179, 180, 182, 183
Swedish Society of Craft and Industrial Design *see* Svenska Slöjdföreningen

Tait, Thomas 130–1, *131*
Tàpies, Antoni 214, 215
Taut, Bruno 48, 94
Tecno, 192, *197*
Tefal 4, *4*
Tengblom, Ivar 173, 179
Thackera, John 96
Tusquets, Oscar 204, 206, 215, 222

Union Centrale des Arts Décoratifs 63, 64, 69
Unwin, Sir Raymond 126, 127, 137

Valls, Manuel 216
Van de Velde, Henri Clemens 88, 89, 144, 145, 146, 148, 149, 151, 154–6, *157, 158,* 160, 161, 162, 167
van der Rohe, *see* Mies van der Rohe
Van Neck, Jozef 148, 151, *152*
Venturi, Robert 213
Verwilgen, Raphael 147, 156, *157*
Viaplana, Albert 204
Vigano, Vittoriano 194, 198
Viollet-le-Duc, Eugène Emmanuel 26–8, 34–5, *36,* 38, 71
Voysey, Charles Francis Annesley 30

Wagner, Martin 48, 97
Werkbund 85, 86, 97, 166, 167, 168, 170, 172
Wettergren, Erik 166, 168
Wollin, Dr Nils G. 164–5, 171–2, 173, 180–1
Wright, Frank Lloyd 27, 101, 102, 108–12, *111,* 113, 117
Wright, Lloyd (son) 110

Yades 197
Yerbury, F.R. 140, 173

Zanuso, Marco 187, 192, 195, 197, 198
Zanussi, Rex 189